Eighteenth-Century French Drawings
in New York Collections

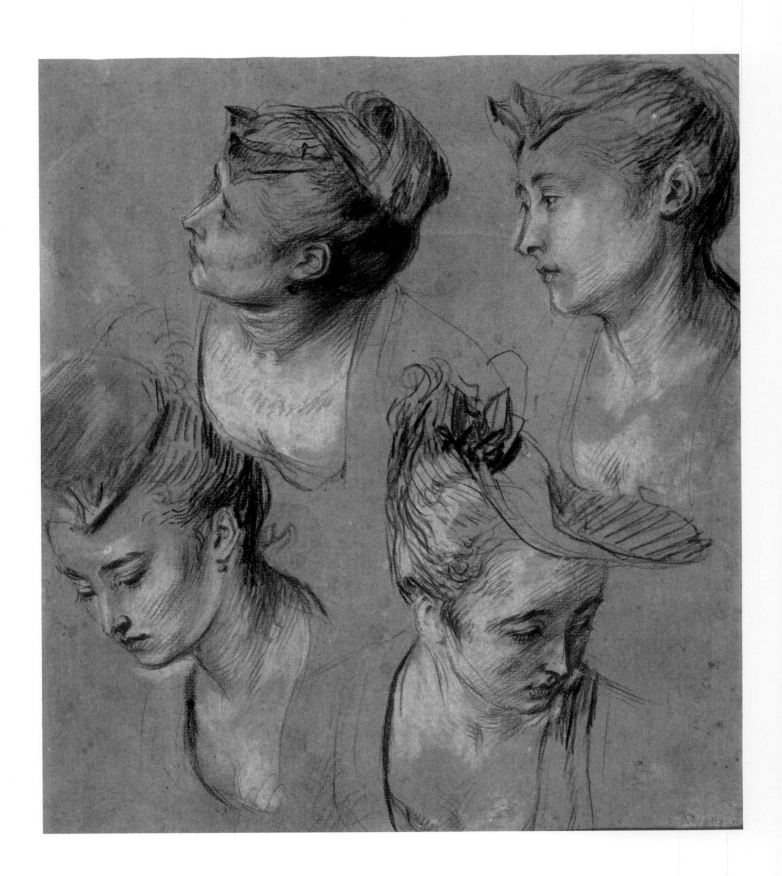

EIGHTEENTH-CENTURY FRENCH DRAWINGS IN NEW YORK COLLECTIONS

PERRIN STEIN

MARY TAVENER HOLMES

The Metropolitan Museum of Art, New York

This catalogue is published in conjunction with the exhibition "Eighteenth-Century French Drawings in New York Collections," held at The Metropolitan Museum of Art, February 2–April 25, 1999.

The exhibition is made possible by The Schiff Foundation.
The publication is made possible by The Drue E. Heinz Fund.

Published by The Metropolitan Museum of Art, New York
John P. O'Neill, Editor in Chief
Emily Walter, Editor
Bruce Campbell, Designer
Gwen Roginsky, assisted by Merantine Hens, Production
Ilana Greenberg, Computer Specialist

Photography of drawings in the collection of The Metropolitan Museum of Art by Susanne Cardone, The Photograph Studio, The Metropolitan Museum of Art.

Typeset in Adobe Garamond by Professional Graphics Inc.,
Rockford, Illinois
Printed on 128 gsm New Espel
Color separations by Professional Graphics Inc., Rockford, Illinois
Printed and bound by CS Graphics PTE Ltd., Singapore

Library of Congress Cataloging-in-Publication Data
Stein, Perrin.
Eighteenth-century French drawings in New York collections/
Perrin Stein and Mary Tavener Holmes.
p. cm.
Catalog of an exhibition held at The Metropolitan Museum of Art, Feb. 2–Apr. 25, 1999.
Includes bibliographical references and index.
ISBN 0-87099-892-7
1. Drawing, French—Exhibitions. 2. Drawing—18th century-France—Exhibitions.
3. Drawing—New York (State)—New York—Exhibitions. I. Holmes, Mary Tavener.
II. Metropolitan Museum of Art (New York, N.Y.) III. Title.
NC246.S75 1999
741.944'09'0330747471—dc21 98-47341
CIP

Jacket illustration
Jean-Honoré Fragonard (1732–1806), *A Gathering at Woods' Edge*,
The Metropolitan Museum of Art (no. 70)

Frontispiece
Antoine Watteau (1684–1721), *Four Studies of the Head of a Woman*,
Private collection (no. 8)

Contents

Director's Foreword

The study of eighteenth-century French art has been well served over the past twenty-five years by the monographic exhibition, which has clarified the oeuvres of numerous individual artists. In the United States, as opposed to France, such ventures have been limited largely to artists of the first tier. Yet despite the utility and pleasures of monographic shows, there is also something to be gained from stepping back and periodically surveying the field more broadly. For the artists already well known and well loved (Watteau, Boucher, Fragonard), seeing their work in a historical milieu deepens our understanding of both their context and their originality. For those names less familiar to American audiences—Pierre-Charles Trémolières, Jacques Dumont, Jean-Simon Berthélemy—their inclusion may serve as an introduction.

Draftsmanship of the Rococo era provides particularly fertile ground for such a survey, as the institutions and methods of artistic training of this period produced a high level of artistic accomplishment across a broad spectrum. The Académie Royale de Peinture et de Sculpture and its affiliated school, the École Royale des Élèves Protégés, provided for an elite body of students intensive instruction in drawing, followed, in many cases, by several years of study in Rome underwritten by the crown. In addition, the eighteenth century saw a transformation in the display and collecting of drawings. While drawings continued to play a utilitarian role in the artist's creative process, they were also increasingly made to feed a market hungry for drawings as art objects: to be framed, displayed, and admired for their beauty and virtuosity.

Americans have long felt a spiritual kinship with the French Enlightenment, perhaps because it coincided with the birth of their own nation. The wealth of French drawings to be found in North American collections was first glimpsed in Pierre Rosenberg's 1972 traveling exhibition "French Master Drawings of the 17th and 18th Centuries," and collecting activity has continued unabated in the intervening quarter century. Indeed, it is a tribute to the devotion and connoisseurship of local collectors that the one hundred sheets included here are drawn exclusively from New York collections. I am grateful to the trustees of the Cooper-Hewitt Museum, the Pierpont Morgan Library, and The Frick Collection for parting temporarily with some of the gems of their collections and to the many private collectors who have been similarly generous. It is my sincere pleasure to recognize the generous support of Mr. and Mrs. David Schiff, whose commitment and interest in the exhibition are greatly appreciated. The Museum is also most grateful for the support provided by The Drue E. Heinz Fund toward this publication. For the organization of the exhibition at the Metropolitan Museum and for lending their talents to the writing of the catalogue, I wish to thank Perrin Stein, Assistant Curator in the Department of Drawings and Prints, and Mary Tavener Holmes, Guest Curator.

Philippe de Montebello
Director
The Metropolitan Museum of Art

William Hood, Patricia Ivinski, Gabrielle Joudiou, Alastair Laing, Didier Lardy, Elizabeth Marcus, Phyllis Dearborn Massar, Simon Matthews, Suzanne Folds McCullagh, Marianne Roland Michel, Edgar Munhall, Christine Nicq, Stephen Ongpin, Donald Posner, Louis-Antoine Prat, Richard Rand, Pierre Rosenberg, Kate de Rothschild, Charles Ryskamp, Marie-Catherine Sahut, Guy Sainty, Xavier Salmon, Alan Salz, Scott Schaeffer, Guilhem Scherf, Anne L. Schroder, Katie Scott, George Shackelford, Regina Shoolman Slatkin, Miriam Stewart, Suzanne Stratton, Barbro Stribolt, Marilyn Symmes, Daniel Ternois, Udolpho van de Sandt, Nathalie Volle, Dietrich von Bothmer, Mia Weiner, Eunice Williams, and Alan Wintermute.

In addition, many members of the Museum staff lent their time and talents to the project, including, in the Department of Drawings and Prints: George R. Goldner, Colta Ives, Carmen Bambach, Matthew Choberka, Samantha Rippner, and Kirsten Auerbach; several interns also assisted in the research for the entries: Jonathan Gilmore, Heidi Overing, and especially Christine Giviskos, whose dedication and insights have added significantly to the catalogue.

We would like to thank, in the Editorial Department, under John P. O'Neill, our sensitive and diligent editor, Emily Walter, as well as others who worked on the catalogue: the designer Bruce Campbell, chief production manager Gwen Roginsky, assisted by Merantine Hens and Rich Bonk, bibliographic editor Penny Jones, and computer specialist Ilana Greenberg. Marjorie Shelley and her staff in the Department of Paper Conservation, Sarah Bertalan, Margaret Lawson, and Akiko Yamazaki; Nina S. Maruca in the Office of the Registrar; Barbara Bridgers and Susanne Cardone in The Photograph Studio; and Deanna Cross and Diana Kaplan in The Photograph and Slide Library. The galleries were designed by Michael Batista, the graphics by Sue Koch.

Perrin Stein
Assistant Curator of Drawings and Prints
The Metropolitan Museum of Art

Mary Tavener Holmes
Guest Curator

Lenders to the Exhibition

Cooper-Hewitt, National Design Museum, Smithsonian Institution (19, 40, 74)

The Frick Collection (100)

The Metropolitan Museum of Art (1, 2, 3, 4, 5, 9, 10, 12, 13, 14, 15, 17, 20, 21, 25, 30, 31, 32, 33, 34, 37, 38, 39, 42, 43, 44, 45, 50, 51, 52, 53, 58, 60, 64, 67, 70, 72, 76, 77, 82, 83, 84, 86, 87, 88, 90, 91, 92, 95, 98)

The Pierpont Morgan Library (27, 28, 41, 46, 62, 78)

Philippe and Edith de Montebello (85)

Mr. and Mrs. Patrick A. Gerschel (36, 61)

Janet Mavec (16)

Lansing and Iliana Moore Collection (59)

Mr. and Mrs. Robert E. Morrow (65)

Roberta J. M. Olson and Alexander B. V. Johnson (47, 66, 97)

The Phillips Family Collection (54, 55, 56, 94)

Mr. and Mrs. Felix Rohatyn (24)

Charles Ryskamp (99)

Mrs. A. Alfred Taubman (11)

Robert Tuggle (73)

John W. Straus (71)

Alan Wintermute and Colin Bailey (26, 29)

Dian Woodner and Andrea Woodner (96)

Private Collections (6, 7, 8, 18, 22, 23, 35, 48, 49, 57, 63, 68, 69, 75, 79, 80, 81, 89, 93)

CATALOGUE

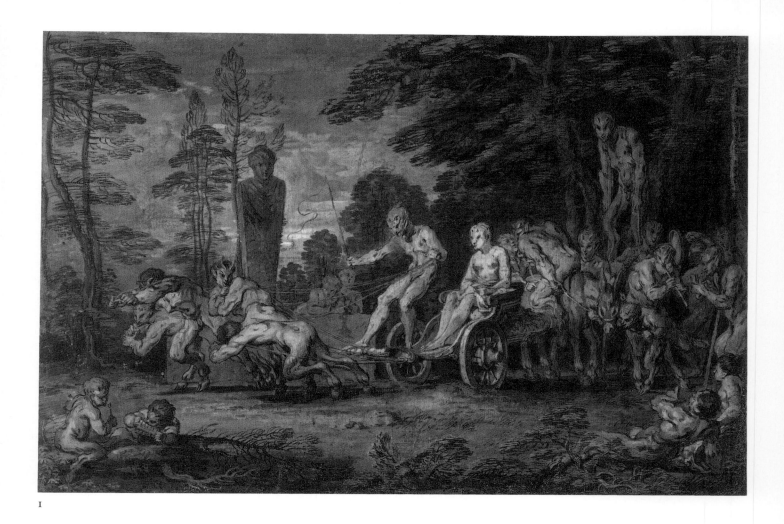

1

CLAUDE GILLOT

Langres 1673–1722 Paris

1. The Stalled Procession

Point of brush with white gouache and red wash, over pen and black ink underdrawing, on prepared white laid paper, 8⅝ x 13¼ in. (22 x 33.5 cm)

The Metropolitan Museum of Art, Purchase, David T. Schiff and The Charles Engelhard Foundation Gifts, 1998 (1998.207)

The origins of the Rococo style owe much to the fertile climate of cross-pollination that existed in the first decades of the eighteenth century between the decorative arts and those art forms considered more elevated. While the emergence of the Rococo aesthetic cannot be traced in a linear fashion, Claude Gillot was undoubtedly a central figure in its unfolding, being among the first, according to the renowned collector Pierre-Jean Mariette, to merge elements of the theater and contemporary life with more established pictorial traditions.[1] The *fêtes galantes* of his famous student Antoine Watteau owe a strong debt to the

enigmatic scenes invented by Gillot, scenes peopled by *commedia dell'arte* figures, acrobats, and satyrs. Gillot also worked, as would Watteau, largely outside the mainstream of the Académie Royale, his designs for ornament providing a conduit for the light and delicate sensibility that would become a hallmark of the Rococo style. Indeed, it is the coexistence of the base and the refined that gives these works their particular and appealing tension.

Many of the most ambitious drawings by Gillot that survive relate to one of his series of prints depicting the life of satyrs. This sheet, recently acquired by the Metropolitan Museum, is most certainly an unexecuted design related to such a project. It is identical in format and scale to a pair of drawings in the Albertina made for *La vie des satyres*,[2] and in technique to a smaller sheet in the Morgan Library for *L'enfance*, one of the designs for *Les quatre ages du satyre*.[3] The incised outlines of the Morgan Library drawing, not present

in the Metropolitan's sheet, relate to the process of transfer.

Like other Gillot bacchanales, *The Stalled Procession* mines the established pictorial vocabulary of the pagan deities of the woodlands to idiosyncratic, even satirical ends. A chariot bearing a seated female faun has become stuck in the mud. Four muscular satyrs, in an apparently futile attempt, strain to free the wheels. Unable to proceed, the requisite band of revelers huddles behind the chariot, to the amusement of onlookers. Like Domenico Tiepolo's Punchinello drawings of half a century later, the humorous predicament of Gillot's faun driver rings more of a comic stage routine than of an antique source, and figures such as the satyr on stilts introduce a presence more acrobatic than woodland.[4]

From what survives of Gillot's oeuvre, one senses that he was more at ease working on paper or with the etcher's needle than he was painting on canvas. In the Metropolitan's sheet he employs an unusual technique with fluid dexterity in which white gouache and red iron oxide wash are applied separately and in various mixtures, creating, with painterly effect, the pearly glow of the female faun, the ruddy tones of the satyrs, the shadowed grove from which they emerge.[5]

PS

PROVENANCE: Sale, Sotheby's, New York, January 28, 1998, lot 51; [Katrin Bellinger Kunsthandel, Munich]; purchased by The Metropolitan Museum of Art.

LITERATURE: *MMA Recent Acquisitions,* 1997–98, p. 31 (entry by Perrin Stein).

1. Mariette 1851–60, vol. 2, pp. 306–7.
2. Otto Benesch, *Meisterzeichnungen der Albertina: Europäische Schulen von der Gotik bis zum Klassizismus* ([Salzburg, 1964]), p. 370, no. 214.
3. Denison 1993, p. 78, no. 33.
4. Observation by Christine Giviskos (verbal communication, February 23, 1998).
5. Bacchanales by Gillot in this technique are recorded in at least two eighteenth-century sales: the Jullienne sale, Paris, March 30–May 22, 1767, lots 766–67, and the d'Argenville sale, Paris, January 18, 1779.

CLAUDE SIMPOL

Clamecy ca. 1666–1716 Paris

2a. Le bain

Pen and gray ink, brush and gray wash, heightened with white, over traces of graphite, contours incised, 2⅞ x 4⅜ in. (7.4 x 11.2 cm). Inscribed and dated in pen and brown ink at lower left margin: *B. Picart f.1716*

The Metropolitan Museum of Art, Rogers Fund, 1963 (63.167.5)

2b. Le goûter

Pen and gray ink, brush and gray wash, heightened with white, over traces of graphite, contours incised, 2⅞ x 4⅜ in. (7.4 x 11.2 cm). Initialed and dated in pen and brown ink at lower left margin: *B.P.f. 1716*

The Metropolitan Museum of Art, Rogers Fund, 1963 (63.167.6)

These two small genre drawings, along with two others, also in the Metropolitan Museum, were long considered the work of Bernard Picart (1673–1733), an important figure in the print world of the early eighteenth century. The attribution was based both on the inscriptions and on the resemblance of the four drawings to engravings of the Five Senses, after Picart.[1] However, Blaise Macarez has convincingly recognized them as the work of Simpol, establishing their relationship to engravings after Simpol (figs. 2.1, 2.2) in a group of forty-three entitled *Différents sujets composés d'hommes et de femmes, habillés à la mode française,* published by Jean Mariette (father of the collector and critic Pierre-Jean).[2]

Claude Simpol was one of the many French artists involved in the designing, engraving, editing, and selling of mass-market prints in the seventeenth and early eighteenth century, some of the most popular of which were trade scenes, role pictures, and fashion plates—*gravures à la mode.* The use by Watteau and his followers of this material for style and imagery, and its importance in the evolution of the *fête galante,* has been widely discussed.[3] Simpol figures prominently in

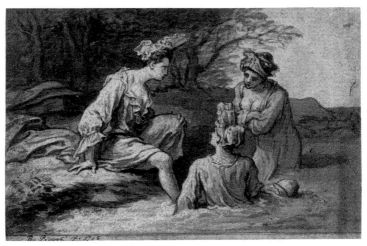

2a

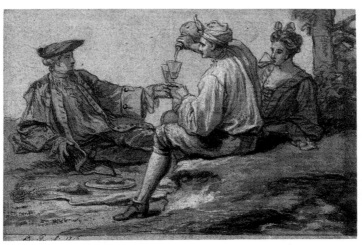

2b

2.1. Gérard Jean-Baptiste Scotin (1671–1716), engraving after Claude Simpol, *Das Bad*. 3¼ x 4⅜ in. (8.1 x 11 cm). Albertina, Vienna

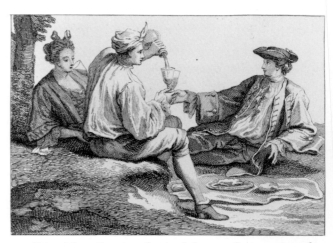

2.2. Gérard Jean-Baptiste Scotin (1671–1716), engraving after Claude Simpol, *Der Geschmack*. 3⅛ x 4⅜ in. (8 x 11 cm). Albertina, Vienna

that relationship. His *Le cavalier achetant des dentelles* stands behind *Gersaint's Shopsign*,[4] and it is not difficult to trace a line from *Le goûter* to the toasting trio in Watteau's *L'amour au théâtre français* (Staatliche Museen zu Berlin, Gemäldegalerie) or from *Le bain* to Lancret's bathers, such as those in the Musée des Beaux-Arts, Rouen, or in the Louvre. MTH

PROVENANCE: Probably in the collections of Jean Mariette and Pierre-Jean Mariette; Baron Jérôme Pichon; Pichon sale, Hôtel Drouot, Paris, May 17–21, 1897, lot 109, "La Coquette. –Le Bain. –Le Repos. –Le Goûter. 4 dessins pour dessus de boites"; John Postle Heseltine (Lugt 1508); Heseltine sale, Sotheby's, London, May 27–29, 1935, part of lot 261; Sir Bruce S. Ingram (Lugt supp. 1405a); [Colnaghi, London]; purchased by The Metropolitan Museum of Art.

LITERATURE: Mlle Duportal, "Bernard Picart, 1673 à 1733," in Dimier 1928–30, vol. 1, p. 385, no. 126; *MMA Annual Report*, 1963–64, p. 62; Bean and Turčić 1986, pp. 211–12, nos. 235, 237 (as Picart); Grasselli 1994b, p. 51 (as Picart).

1. Bibliothèque Nationale, Cabinet des Estampes, Ed 56a fol., vol. 2, p. 185.
2. Letters from Blaise Macarez, Lille, [August 1996] and September 19, 1996. The engravings are in the collection of the Albertina, Vienna (inv. HB114). All four drawings are listed under Simpol's name in "Notes manuscrits de Mariette," at the Bibliothèque Nationale, Cabinet des Estampes, H(Ya 24, pet. in-fol.), vol. 8, p. 220, under the titles "Une femme se rependant dans un miroir de poche," "Un homme et une femme fumant du tabac," "Trois femmes se baignant," and "Des personnes faisant le collation sur l'herbe." The Mariette sale included small folio volumes of drawings used for prints, some of which may have included the present sheets. See, for example, the Pierre-Jean Mariette estate sale, Paris, 1775, p. 216, no. 1420, and p. 220, no. 1438.
3. See Hélène de Vallée, "Sources de l'art de Watteau: Claude Simpol," *Prométhée* [*L'Amour de L'Art* 20], no. 3 (April 1939), pp. 67–74; and Holmes 1991, pp. 14–18.
4. Vallée, "Sources de l'art de Watteau," p. 69, figs. 4 and 5, and p. 71.

ANTOINE WATTEAU

Valenciennes 1684–1721 Nogent-sur-Marnes

3. Standing Savoyard with a Marmot Box

Red and black chalk, on cream paper, 12 15/16 x 8 in. (31.2 x 20.3 cm). Inscribed in pen and black ink over black chalk at lower left: *Watteau*

The Metropolitan Museum of Art, Bequest of Therese Kuhn Straus, in memory of her husband, Herbert N. Straus, 1977 (1978.12.1)

Antoine Watteau was born in Valenciennes, a town that, until six years prior to his birth, had been a part of Flanders, ceded to France as part of the treaties of Nijmegen in 1678–79. His arrival in Paris in 1702, after training briefly with a local artist, coincided with a surge of interest in Netherlandish art on the part of artists and their patrons in the French capital, an interest that would work to the advantage of Watteau and French genre painters throughout the century. Watteau did at least a dozen drawn representations of Savoyards, often single figures, recalling his Netherlandish roots, all dating early in his career, to about 1715. This drawing, another in the British Museum (fig. 3.1), and a lost drawing known from plate 35 of *Les figures de différents caractères...*[1] all depict the same model (drawn, it is generally supposed, the same day), and are the only known depictions of women among the group of Savoyard drawings. The immediacy and poignancy of these drawings owe much to the stark contrast between the rich technique and the figures' exotic, if tattered, clothing, and their sad, emaciated faces, so carefully drawn. They have, in this respect, much in common with Rembrandt's portraits of old people in exotic costume, the beauty of the image in cruel contrast to the humble circumstances of the sitter.

In the present drawing the figure stands in resigned isolation, leaning on a cane, her marmot box on her hip. Watteau initially drew the figure in red chalk, then added black chalk for accent, then finally another layer of red chalk more heavily applied.[2] There is none of the suggestion of a setting that one finds in the British Museum drawing of the same woman, seated.

The dating of Watteau's drawings is a matter of continued debate, but in general, he moved from simple to complex,

as one might expect. The use of red chalk alone is the earliest manner, followed by red and black chalks together. Pierre Rosenberg and Louis-Antoine Prat, in the recent catalogue raisonnée of Watteau's drawings, call 1715 the year "où triomphe l'alliance du rouge et du noir,"[3] when Watteau produced his masterpieces in this medium, the drawings of the Persians and of the Savoyards. Later he introduced white, in the ravishing *aux trois crayons* technique. This is of course a very broad description, and these techniques eventually coexist.[4] MTH

PROVENANCE: Frederick Locker Lampson (Lugt 1692); given by him to his son-in-law, the Right Honourable Augustine Birrell; [Richard S. Owen, Paris]; Herbert N. Straus, 1929; his wife, Therese Kuhn Straus; bequeathed to The Metropolitan Museum of Art.

LITERATURE: Goncourt 1875, under no. 441; R[obert] R[attray] Tatlock, "Two Watteau Drawings," *The Burlington Magazine* 38, no. 217 (April 1921), pp. 156–57 (ill.); Paul Jamot, "Gillot and Watteau: A Study of a New Acquisition of the Louvre," *The Burlington Magazine* 43, no. 246 (September 1923), p. 135; Louis Réau, "Watteau, 1684 à 1721," in Dimier 1928–30, vol. 1, no. 24; Émile Dacier, "Caylus, graveur de Watteau," *Amateur d'Estampes* 6 (1927), p. 58, no. 49; *The Gainsborough Memorial Exhibition,* exh. cat., Ipswich Corporation Museum (Ipswich, 1927), no. 102; Dacier, Hérold, and Vuaflart 1921–29, vol. 1, pp. 154–57, fig. 62; K[arl] T. Parker, *The Drawings of Antoine Watteau* (London, 1931), p. 19, and n. 7; Parker and Mathey 1957, vol. 1, p. 68, no. 496 (ill.); Rotterdam, Paris, and New York 1959, no. 86, pl. 31; Inna S. Nemilova, "[Essays on the Oeuvre of Jean-Antoine Watteau. I : Determining the Date of Execution of the Painting 'The Savoyard,' Conserved in the State Hermitage Museum, and the Problem of Periodization of Watteau's Genre Painting]," *Troudy gosoudarstvennogo Ermitaja* 7 (1964), p. 102, fig. 49, in Russian with French summary; Edgar Munhall, "Savoyards in French Eighteenth-Century Art," *Apollo* 87, no. 72 (February 1968), p. 94, n. 13; [Iurii Konstantinovich Zolotov], *Antuan Vatto—Starinnye teksty* [Antoine Watteau—Old Texts] (Moscow, 1971), ill. p. 71; Gillies and Ives 1972, no. 48; Donald Posner, "An Aspect of Watteau 'peintre de la réalité,'" *Études d'art français offertes à Charles Sterling,* edited by Albert Châtelet and Nicole Reynaud (Paris, 1975), pp. 282, and 285, n. 22; *MMA Annual Report,* 1977–78, p. 36 (ill.); *MMA Notable Acquisitions,* 1975–79, p. 57 (ill. p. 56); Hulton 1980, p. 23, under no. 9; Margaret Morgan Grasselli, "Watteau Drawings in the British Museum," *Master Drawings* 19, no. 3 (Autumn 1981), p. 311; Bean and Turčić 1986, pp. 291–92, no. 328 (ill.); Grasselli 1987a, vol. 1, p. 189, no. 115, fig. 188; Grasselli 1987b, p. 96, n. 6; Grasselli 1987c, pp. 185, and 194, n. 14; Grasselli 1994b, p. 51; Rosenberg and Prat 1996, vol. 1, pp. 476–77, no. 299.

1. Jean de Jullienne (1686–1766) published two volumes of engravings after studies by Watteau, *Les figures de différents caractères . . . ,* which appeared in 1726 and 1728, respectively. Two additional volumes of etchings after drawings and paintings by Watteau, the *Recueil Jullienne,* were published in 1735.

2. Grasselli 1987c, pp. 185–86, has noted that as Watteau became more practiced in using two and three colors, he applied them together, rather than one after the other, which resulted in greater blending.

3. Rosenberg and Prat 1996, vol. 1, p. xx.

4. Rosenberg and Prat 1996, vol. 1, pp. xx–xxi, date Watteau's earliest red chalk manner to 1711–14, the addition of black to about 1715, and the addition of white to after 1715. Grasselli 1987c, p. 181, discusses the progression of Watteau's chalk technique, and suggests 1712–13 as the year Watteau added black and white chalks to his "cherished sanguine."

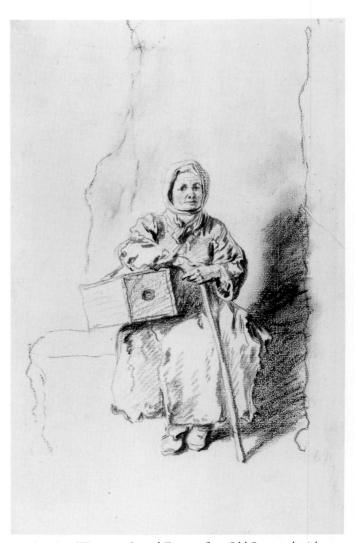

3.1. Antoine Watteau, *Seated Figure of an Old Savoyard with a Marmot Box,* ca. 1715. Red and black chalk, 12 x 7⅞ in. (30.8 x 19.9 cm). British Museum, London

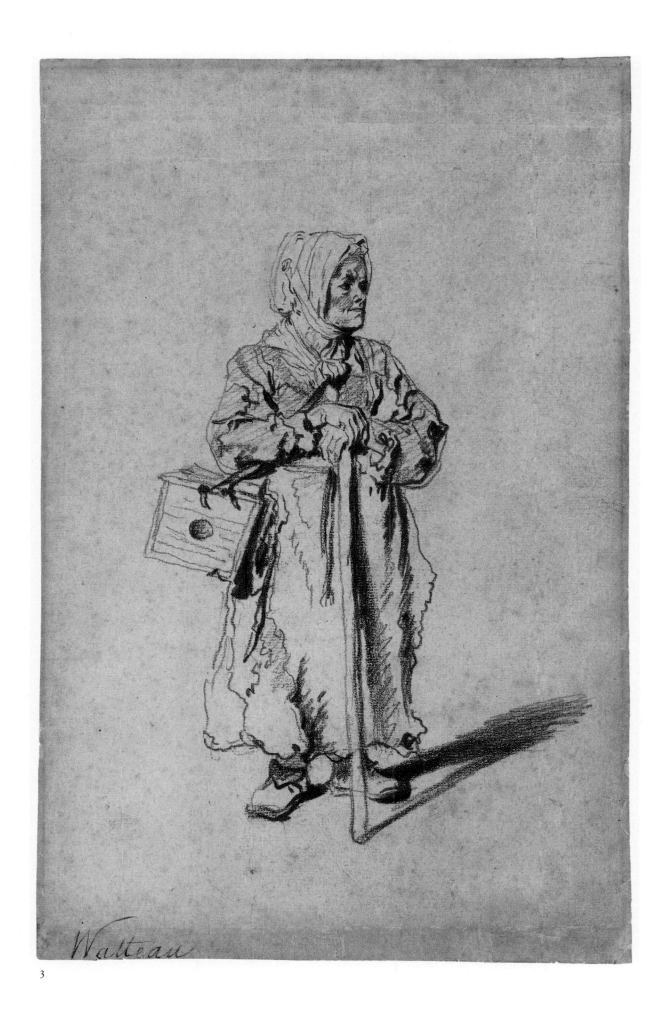

Watteau

3

ANTOINE WATTEAU

Valenciennes 1684–1721 Nogent-sur-Marnes

4. *Standing Nude Man Holding Bottles*

Red, black, and white chalk, 10¹⁵⁄₁₆ x 8¹⁵⁄₁₆ in. (27.7 x 22.6 cm)

The Metropolitan Museum of Art, Bequest of Walter C. Baker, 1971 (1972.118.238)

When he made this drawing Watteau was at work on his most challenging commission, the set of four large ovals depicting the Four Seasons for the dining room of his patron Pierre Crozat (1665–1740).[1] Watteau did a number of works around this time, both painted and drawn, that address problems posed by the Crozat commission.[2] This drawing is a study for the painting *Autumn*, now known only through an engraving (fig. 4.1). Another drawing for the same figure, in which the pose is closer to that in the painting, is in the Courtauld Institute (fig. 4.2). In the present drawing and other similar sheets (in particular, *Nude Man Kneeling and Pulling a Drapery*, a study for the painting *Jupiter and Antiope,* both Musée du Louvre, Paris), Watteau shows an assurance of stroke and a boldness of accent that breathe energy into the kind of preparatory work that can often be lifeless and dry. A comparison with his drawing of the Savoyard in this exhibition (no. 3) reveals the strides Watteau had made in his use of colored chalks, and this drawing surely postdates the Savoyard. Here, the black and red are used together, skillfully and organically blended.

In his foray into large-scale history painting, Watteau entered the realm later commanded by Boucher and Le Moyne. A comparison of a male nude by Watteau with a male nude by Boucher or Le Moyne—Boucher's superb figure study of Apollo for the *Rising of the Sun* (National Gallery of Art, Washington, D.C.), for example[3]—reveals the difference in their method. Boucher trained at the Académie and drew after the live model his entire professional career, and his studied drawing displays the poise and polish of long practice. Watteau, though never formally trained, used all means available to him: he made studies from the nude, sketches of passing citizens, and copies after the old masters, an ad hoc approach that resulted in studies that one would never describe as *académies*, but rather as "from the life."

MTH

4.1. Étienne Fessard (1714–1777), engraving after Antoine Watteau, *L'autonne,* for the *Recueil Jullienne,* 1729–31. 15¾ x 12⅞ in. (40 x 32.7 cm). The Metropolitan Museum of Art, Gift of Mr. and Mrs. Herbert N. Straus, 1928 (28.113.2)

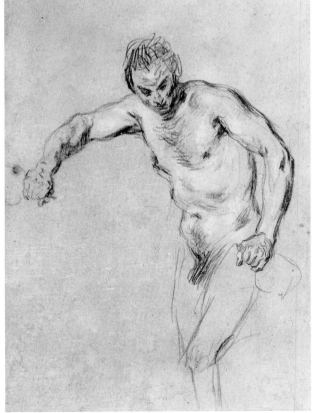

4.2. Antoine Watteau, *Nude Man Holding Two Bottles,* 1715–16. Red, black, and white chalk, 11¼ x 8¼ in. (28.5 x 21.1 cm). Courtauld Institute Galleries, London

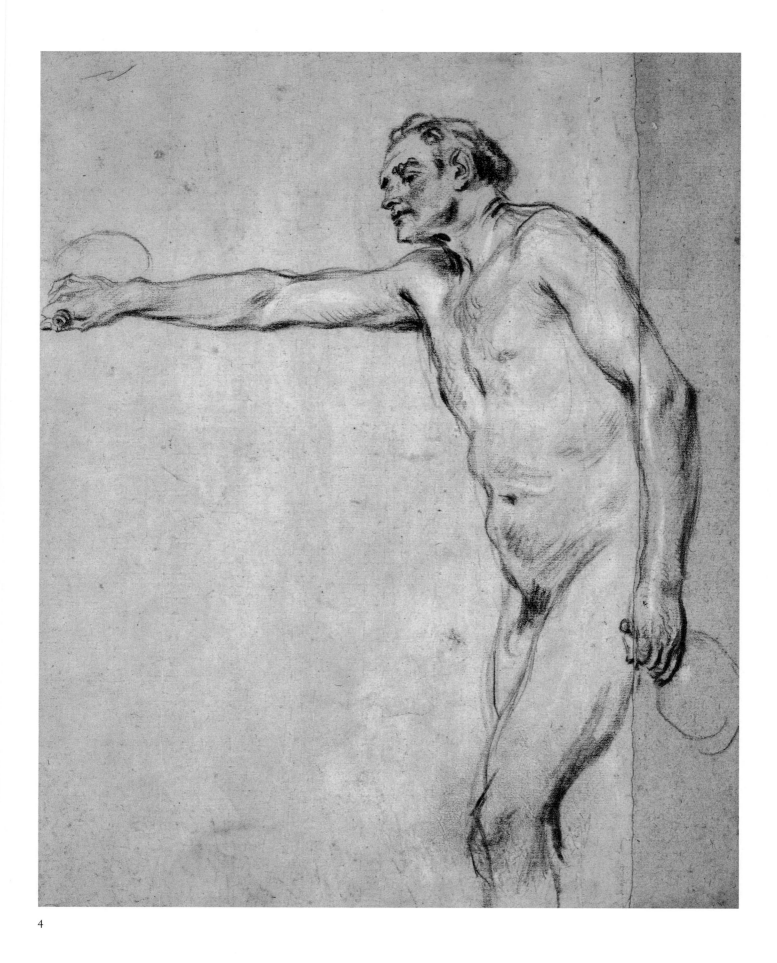

4

PROVENANCE: Jean-Antoine Vassal de Saint-Hubert; his sale, Paris, March 23–April 17, 1779, part of lot 94, p. 25; Félix Harbord, London (according to Virch 1962); Mrs. H. D. Gronau, London; Walter C. Baker, New York, from 1958; bequeathed to The Metropolitan Museum of Art.

LITERATURE: *Drawings by Old Masters*, exh. cat., London, Royal Academy of Arts (London, 1953), p. 92, no. 394; Parker and Mathey 1957, vol. 1, p. 74, no. 518 (ill.); Rotterdam, Paris, and New York 1959, p. 69, no. 85 (ill. pl. 33); *Centennial Loan Exhibition: Drawings & Watercolors from Alumnae and Their Families,* exh. cat., Poughkeepsie, N.Y., Vassar College (Poughkeepsie, N.Y., 1961), no. 51 (ill.); Virch 1962, no. 73 (ill.); Douglas Cooper, ed., *Great Private Collections* (New York, 1963), pp. 35–36 (ill.); Cormack 1970, p. 28, no. 42 (ill. pl. 42); Posner 1984, pp. 80, and 283, n. 44; Grasselli and Rosenberg 1984, pp. 56, 60, 130–31, 134–35, 138, 189, 328; Bean and Turčić 1986, pp. 292–93, no. 329 (ill.); Grasselli 1987a, vol. 2, pp. 252, 254, 261, n. 180, fig. 301a; Grasselli 1987b, p. 96, n. 7; François Moureau, "L'Italie d'Antoine Watteau ou le rêve de l'artiste," *Dix-Huitième Siècle* 20 (1988), p. 450; Grasselli 1994a, p. 10, and 13, n. 9; Grasselli 1994b, p. 51; Rosenberg and Prat 1996, vol. 2, pp. 614–15, no. 373 (ill.).

1. Only one of the series, *Summer* (National Gallery of Art, Washington, D.C.), has survived. The painting *Spring* was destroyed by fire in 1966; only photographs survive. The others are known through engravings made for the *Recueil Jullienne* between 1729 and 1731. See Grasselli and Rosenberg 1984, pp. 325–28, under cat. 35.
2. Posner 1984 addresses this issue on pp. 76–107.
3. For illustrations of the painting and the study for Apollo, see Ananoff 1976, vol. 2, pp. 109, 111.

ANTOINE WATTEAU

Valenciennes 1684–1721 Nogent-sur-Marnes

5. *Italian Landscape with an Old Woman Holding a Spindle (after Domenico Campagnola)*

Red chalk on cream paper, 8⅛ x 12¹⁵⁄₁₆ in. (20.5 x 31.8 cm)

The Metropolitan Museum of Art, Bequest of Walter C. Baker, 1971 (1972.118.237)

Watteau tried two times, in 1709 and 1712, to win the Prix de Rome and travel to Italy. He never won and he never went. Rather, he was left to satisfy his desire to see the Italian countryside in the images of other artists and, in that endeavor, he was very fortunate indeed. Early in his career, probably owing to the good offices of the artist Charles de La Fosse, Watteau came to the attention of the wealthy patron Pierre Crozat. Crozat supported him, housed him, and allowed him access to his enormous art collection, which was rich in drawings by sixteenth-century Venetians—Titian, Veronese, and so forth—acquired during a buying trip in 1714–15, made by Crozat to Italy on behalf of the duc d'Orléans.[1] According to his biographers, Watteau made copies of many works in Crozat's collection when he lived at his house.[2] The comte de Caylus tells us that Watteau was charmed by the beautiful buildings, the lovely views, and the elegant and refined foliage of the trees in drawings by Titian and Campagnola which he discovered in Crozat's collection.

The present sheet is one of several such copies that have survived.[3] If Mariette is to be believed, there must have been many more. The Metropolitan Museum is fortunate to own not only the copy by Watteau but the original from which it was made, a drawing by Domenico Campagnola (1500–1564; fig. 5.1). Watteau began his career as a copyist, and what began as his bread and butter would become a lifetime habit. A survey of known copies suggests, not surprisingly, that he favored examples from the colorist tradition by Flemings (Rubens in particular) and Venetians. His own style in these copies is modified to emulate the manner of his models, although certain personal characteristics do appear.[4] This is unusual in eighteenth-century France,

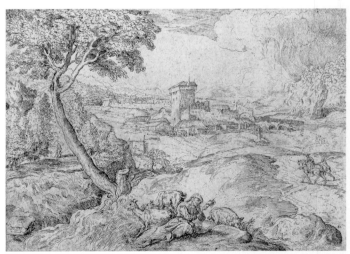

5.1. Domenico Campagnola (1500–1564), *Landscape with a Woman Spinning.* Pen and brown ink, 10 x 14⅝ in. (25.4 x 37.1 cm). The Metropolitan Museum of Art, Bequest of Walter C. Baker, 1971 (1972.118.243)

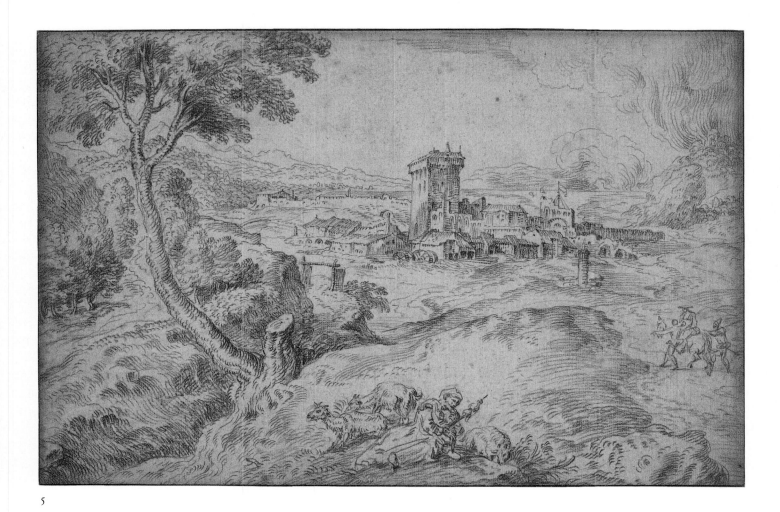

5

where most draftsmen developed their own style for making copies after the old masters, one that reproduced the image but not its manner. One thinks, for example, of Fragonard or Ango, each of whom retained a consistent copying style in their chalk copies no matter who the original artist. Watteau's technique in the copies after Campagnola, all of which are in red chalk, is by contrast based stylistically on the original, which accounts for the meticulous description—each hill, tree, and farmhouse limned with a continuous and careful stroke, laid often in closely spaced parallel lines reminiscent of an engraver's drawing. Watteau has, however, made several adjustments to the original,[5] and the red chalk is softer than the original's pen and ink.

As several scholars have suggested, it may be in the painted landscapes that we find the true impact of the Italian scenes copied from Venetian artists.[6] The softly lit pastoral backgrounds with a sequence of low hills, culminating in a mass of buildings, such as one finds in *La leçon d'amour* (Nationalmuseum, Stockholm) or *Amusements champêtres* (private collection, Paris), reflect this influence directly, based on drawings made by Watteau after Campagnola that are now in Besançon and Chicago.[7]

MTH

PROVENANCE: André de Hévesy; his sale, Sotheby's, London, April 25, 1951, lot 70 (bought in); [Mathias Komer, New York]; Walter C. Baker, New York; bequeathed to The Metropolitan Museum of Art.

LITERATURE: K[arl] T. Parker, "Sidelights on Watteau," *Old Master Drawings* 10, no. 37 (June 1935), p. 8 (ill. pl. 7); Parker and Mathey 1957, vol. 1, no. 439 (ill.); Virch 1962, no. 72 (ill.); *MMA Annual Report*, 1979–80, p. 27; Jacob Bean and Lawrence Turčić, *15th and 16th Century Italian Drawings in The Metropolitan Museum of Art* (New York, 1982), under no. 40 (ill.); Grasselli and Rosenberg 1984, p. 222; Helmut Börsch-Supan, *Watteau, 1684–1721: Führer zur Ausstellung im Schloss Charlottenburg*, exh. cat., Berlin, Schloss Charlottenburg (Berlin, [1985]), no. 43 (ill.); Bean and Turčić 1986, p. 298, no. 334; Haverkamp-Begemann and Logan 1988, pp. 147–48, no. 41 (ill.), entry by Paula Volent; Robert C. Cafritz, "Rococo Restoration of the Venetian Landscape and Watteau's Creation of the Fête Galante," in Robert C. Cafritz et al., *Places of Delight: The Pastoral Landscape*, exh. cat., Washington, D.C., National Gallery of Art (Washington, D.C., 1988), p. 180, n. 86; François Moureau, "L'Italie d'Antoine Watteau ou le rêve de l'artiste," *Dix-Huitième Siècle* 20 (1988), p. 450; Grasselli 1994b, p. 52; Martin Eidelberg, "Watteau's Italian Reveries," *Gazette des Beaux-Arts*, ser. 6, 126 (1995), pp. 114–15, and p. 134, nn. 34, 35; Rosenberg and Prat 1996, vol. 1, p. 546, no. 341.

1. Crozat's collection numbered some 19,000 drawings at the time of his death; see Margret Stuffmann, "Les tableaux de la collection de

Pierre Crozat: Historique et destinée d'un ensemble célèbre établis en partant d'un inventaire après décès inédit (1740)," *Gazette des Beaux-Arts,* ser. 6, 72 (1968), pp. 5–144; and Barbara Scott, "Pierre Crozat: A Maecenas of the Régence," *Apollo* 97, no. 131 (January 1973), pp. 11–19. The posthumous sale (April 10–May 13, 1741) was catalogued by Pierre-Jean Mariette, and included 113 landscape drawings attributed to Campagnola.

2. Mariette 1851–60, vol. 1, p. 294. Watteau was living at Crozat's house on the rue de Richelieu in 1717; see Grasselli and Rosenberg 1984, p. 23. See also Pierre Champion, *Notes critiques sur les vies anciennes d'Antoine Watteau* (Paris, 1921), p. 97.

3. On this subject, see Grasselli and Rosenberg 1984, pp. 220–21, under no. 139; and Haverkamp-Begemann and Logan 1988, pp. 147–48, under no. 41, entry by Paula Volent; and Martin Eidelberg, "Watteau's Italian Reveries," *Gazette des Beaux-Arts,* ser. 6, 126 (1995), p. 114, and p. 134, nn. 34, 35.

4. See, for example, *Le frère Simon, d'après Zuccaro,* now in the Museé Bonnat, Bayonne, in which Watteau mimics Zuccaro. The drawing by Zuccaro is in the École Nationale Supérieure des Beaux-Arts, Paris, and was probably in Crozat's collection (Rosenberg and Prat 1996, vol. 2, p. 702).

5. Grasselli and Rosenberg 1984, p. 221, under no. 139, detail these changes, and useful insights are added by Paula Volent in Haverkamp-Begemann and Logan 1988, under no. 41.

6. Graselli and Rosenberg 1984, pp. 220–21, under no. 139; Robert C. Cafritz, "Rococo Restoration of the Venetian Landscape and Watteau's Creation of the Fête Galante," in Robert C. Cafritz et al., *Places of Delight: The Pastoral Landscape,* exh. cat., Washington, D.C., National Gallery of Art (Washington, D.C., 1988), pp. 151–81; and Eidelberg, "Watteau's Italian Reveries," p. 114.

7. For the drawing in the Musée des Beaux-Arts, Besançon, and that in The Art Institute of Chicago, see Rosenberg and Prat 1996, vol. 2, p. 716, no. 430, and p. 720, no. 433, respectively. For Watteau's use of these sites in his paintings, see Eidelberg, "Watteau's Italian Reveries," pp. 124–30.

ANTOINE WATTEAU

Valenciennes 1684–1721 Nogent-sur-Marnes

6. Study of a Man's Head and Hands

Black and red chalk, 6⅝ x 9⁷⁄₁₆ in. (16.8 x 24 cm)

Private collection

Watteau's drawings often give the impression that he kept paper in his studio or on his person, sketching on it as needed, for different projects at different times. In the present example, Watteau seems to have drawn the delicate hand studies at one time, and come back later to use the same sheet for the study of the head.[1] There are other drawings that combine sketches drawn at different dates, for example the *Study Sheet with the Bust of a Woman, a Man Walking, and the Arms and Hands of an Oboe Player,* in the British Museum.[2]

Watteau drew all the time. He made sketches in the park, in friends' homes, at concerts that he attended. This has led scholars to look among the faces in his drawings and paintings for identifiable figures in Watteau's circle. Nonetheless, it is unlikely that the man in this drawing is Jean de Jullienne, as has previously been suggested.[3] Possibly he is the actor found in a drawing in the Musée Jacquemart-André, Paris, and in the painting *Comédiens françois* (fig. 6.1),

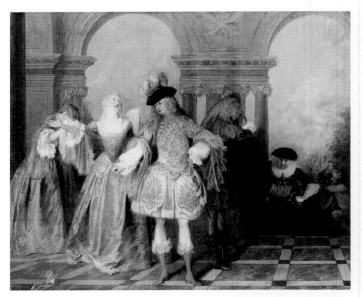

6.1. Antoine Watteau, *Comédiens françois,* ca. 1720–21. Oil on canvas, 22½ x 28¾ in. (57.2 x 73 cm). The Metropolitan Museum of Art, The Jules Bache Collection, 1949 (49.7.54)

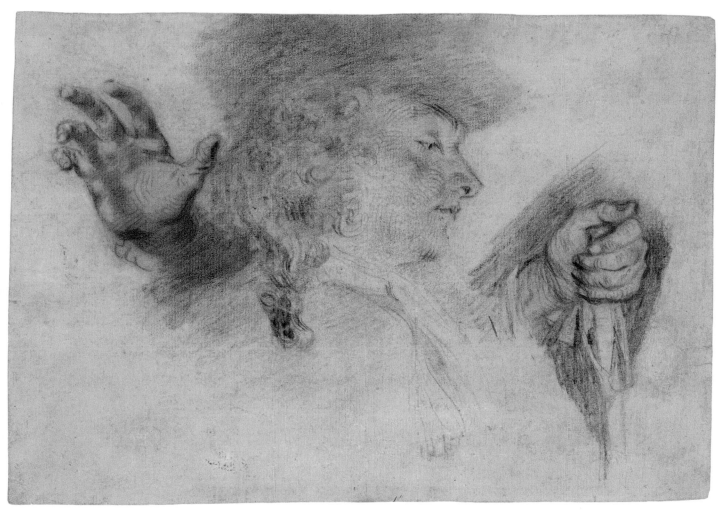

6

in the Metropolitan Museum.[4] Although the hands must surely have been drawn with a specific painting in mind, no corresponding figure has been found.　　　　MTH

PROVENANCE: Comtesse Martine Marie Pol de Béhague, Paris; her sale, Sotheby's, London, June 29, 1926, lot 123 (ill.); [Agnew's, London]; Louis Colville Gray Clarke, London; [Colnaghi, London]; Sir (then Lord) David Eccles, London, in 1957; Jean Davray, Paris, in 1963; Harry A. Brooks, New York, in 1968; [Knoedler, New York]; Norton Simon Foundation, Los Angeles, from 1970; [Artemis, London, 1976–77]; Eugene Victor Thaw, New York; private collection.

LITERATURE: Parker and Mathey 1957, vol. 2, no. 753 (ill.); Posner 1984, p. 291, n. 66; David W. Steadman and Carol M. Osborne, *18th Century Drawings from California Collections,* exh. cat., Claremont, Montgomery Art Gallery, Pomona College; Sacramento, E. B. Crocker Art Gallery (Claremont, Calif., 1976), no. 63 (ill.); Marianne Roland Michel, *Watteau: An Artist of the Eighteenth Century* (London, 1984), pp. 89–90; Grasselli and Rosenberg 1984, pp. 173–74, 439; Rosenberg and Prat 1996, vol. 2, pp. 1094–95, no. 640.

1. Rosenberg and Prat 1996, vol. 2, p. 1094, no. 640, date the head to about 1719, and the hands to a date "légèrement antérieure."

2. On this issue, see Grasselli and Rosenberg 1984, pp. 86–87, under no. 25.

3. Known portraits of Jullienne include one by Watteau himself (engraved by N.-H. Tardieu) used as the frontispiece to the first volume of prints after his work sponsored by Jullienne, and another by François de Troy in the Musée des Beaux-Arts, Valenciennes.

4. Parker and Mathey 1957, vol. 2, p. 383, under no. 940, suggest that the man represented in the Musée Jacquemart-André drawing (Rosenberg and Prat 1996, vol. 1, p. 243, no. 155 verso) and in the present sheet are one and the same and that "il ne serait pas impossible que ce fût Jullienne." They further draw analogies (no. 753) between the man in the New York drawing and the actor in *Comédiens français.* Grasselli and Rosenberg 1984 (under no. 97) support this identification and include a third representation, in the *Two Studies of a Man's Head and One of a Kneeling Woman,* in the Louvre. Both Posner (1984, p. 291, n. 66) and Rosenberg and Prat (1996, vol. 2, no. 640) reject the identification with Jullienne.

ANTOINE WATTEAU

Valenciennes 1684–1721 Nogent-sur-Marnes

7. *Seated Woman Turning Toward the Left, Holding a Fan*

Red, black, and white chalk on gray-brown paper, 9¼ x 5⅝ in.
(23.5 x 14.2 cm)

Private collection

Although it is common for scholars to speculate about how Watteau would have developed had he lived beyond the age of thirty-seven, it is hard to imagine his acquiring greater facility than that displayed in this sheet. Watteau neither invented *aux trois crayons* nor used it more frequently than other media; that his name has become inextricably linked to this medium is due in large measure to drawings such as this one, in which the handling of the three chalks is done with unparalleled subtlety and craft. Watteau took this technique, introduced to eighteenth-century French draftsmen by a number of earlier artists (Rubens and Charles de La Fosse among the most notable),[1] and honed it with an intuitive brilliance that far transcended the formulaic use of red for flesh, black for clothes and hair, and white for highlights. Many artists followed his lead in the use of colored chalks on neutral paper for figure studies, seeking to imbue even the most studied pose with the kind of spontaneous grace we see here. Artists such as Lancret, Le Moyne, and Boucher owe him a great debt.

The young woman in this sheet leans away, presumably from a suitor whom she rebuffs with her right hand. Although her head is still turned toward him, she no longer looks at him.

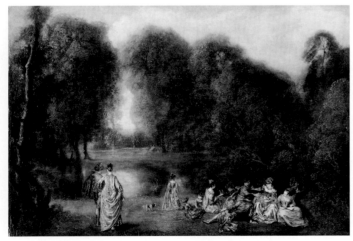

7.1. Antoine Watteau, *Assemblée dans un parc,* ca. 1716–17. Oil on panel, 12¾ x 18¼ in. (32.5 x 46.5 cm). Musée du Louvre, Paris

As she leans forward, the light catches her chest above the bodice and her skirt below the knees, as revealed by the shimmering white chalk. Watteau's figures are not men and women of action. Mostly they lean and turn and tilt. But in these subtle changes in carriage is a wealth of character and response, and in their placement on the page lies the story of their relationships. As Jean de Jullienne noted, "Each figure from the hand of this excellent man has a character that is so true and natural that all by itself it can hold and satisfy one's attention, seeming to have no need for a supporting composition on a greater subject."[2]

The figure in this drawing is related to figures in at least three paintings. She is found with virtually no change in *Assemblée dans un parc* (fig. 7.1), used again in *Les fêtes vénetiennes* (National Gallery of Scotland, Edinburgh), and substantially altered for *L'île enchantée* (private collection, Switzerland). Based on these relationships, Margaret Morgan Grasselli has plausibly dated this sheet to 1716–17.[3]

MTH

PROVENANCE: Camille Groult; his son Jean Groult; his son Pierre Bordeaux-Groult; [Artemis, London, 1977]; private collection, New York.

LITERATURE: Goncourt 1875, under no. 578; K[arl] T. Parker, *The Drawings of Antoine Watteau* (London, 1931), pp. 29, 31, 34; Parker and Mathey 1957, vol. 2, no. 547 (ill.); Jacques Mathey, *Antoine Watteau: Peintures réapparues, inconnues ou négligées par les historiens* (Paris, 1959), fig. 12; Grasselli and Rosenberg 1984, p. 147, under no. 77, p. 160, no. 85, p. 161, under no. 86, p. 167, under no. 92, p. 386, fig. 9, under no. 56, p. 394, fig. 4, under no. 60, p. 395; Helmut Börsch-Supan, *Watteau, 1684–1721,* exh. cat., Berlin, Schloss Charlottenburg (Berlin [1985]), no. 88 (ill.); Linda Nochlin, "Watteau: Some Questions of Interpretation," *Art in America* (January 1985), ill. p. 73; Grasselli 1987a, vol. 2, pp. 274, n. 57, 277, 283, 285, 287, n. 69, 288, no. 191, fig. 332; Marianne Roland Michel, "Watteau et les 'Figures de différents caractères,'" in *Watteau (1684–1721)*, edited by François Moureau and Margaret Morgan Grasselli (Paris and Geneva, 1987), p. 124 and n. 26; Pierre Rosenberg, "Des dessins de Watteau," in *Japan and Europe in Art History* (Tokyo, 1991), ill. on cover; Margaret Morgan Grasselli, "Eighteen Drawings by Antoine Watteau," *Master Drawings* 31, no. 2 (Summer 1993), p. 112, under no. 8; Rosenberg and Prat 1996, vol. 2, pp. 918–19, no. 543.

1. For the use of *aux trois crayons*, see Roland Michel 1987, pp. 28–38, and Grasselli 1987c.
2. Jean de Jullienne, *Les figures de différents caractères . . . par Antoine Watteau,* 2 vols. (Paris, [1726–28]), preface to vol. 1, n.p.
3. Grasselli and Rosenberg 1984, p. 160, no. 85.

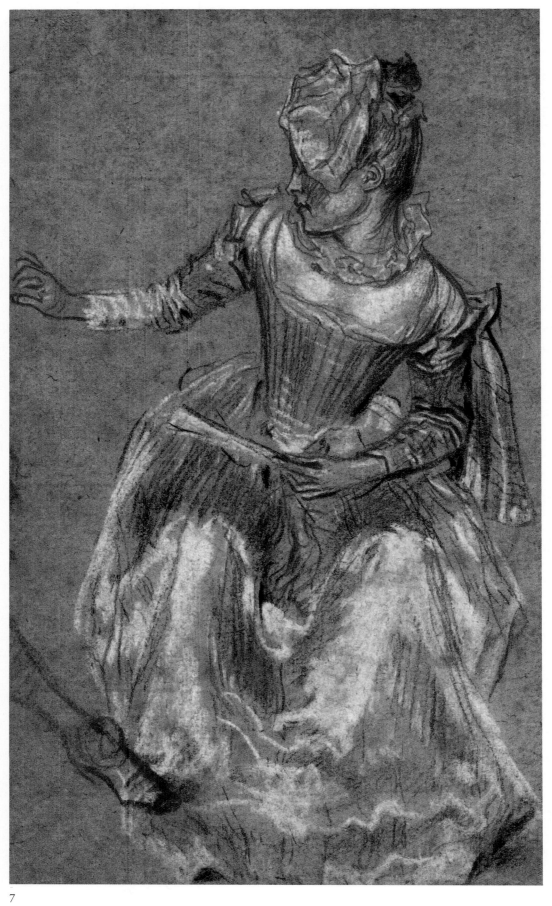

7

ANTOINE WATTEAU

Valenciennes 1684–1721 Nogent-sur-Marne

8. *Four Studies of the Head of a Woman*

Red, black, and white chalk on tan paper, 10⅛ x 9¼ in. (25.8 x 23.4 cm). Inscribed in graphite at lower right: *Watteau*

Private collection

Even when considered against the standards of Watteau's own drawn oeuvre, this drawing is a masterpiece, the unfettered inventiveness of its use of *aux trois crayons* and the rhythm and balance of its *mise-en-page* setting it apart.[1] Watteau's technique in this sheet is unusual, that of laying the white chalk highlighting on first, after applying a faint black chalk outline. Only then did he add the black and red chalks. The effect of this sequence is to allow the white chalk to remain pure, covering a broader expanse more evenly, and the colored chalks to maintain their crisp, strong accents. The tan of the paper becomes, to borrow Grasselli's apt description, a "fourth color."[2]

The four heads grace the page in a sustained flow. The *mise-en-page* is subtly linked to the logic of the technique, Watteau rotating the woman's pose around a fixed light source so that the position of the white sheen shifts as it glides over her face and chest. The sheet is closely related to a drawing in the British Museum (fig. 8.1), which makes use of the same model, her hair worn in the ribboned coif of the top two heads on the New York example. Grasselli has plausibly proposed that the two drawings were done the same day, the New York drawing being the second, and that the model changed her hat in the middle of the execution of the sheet.[3]

MTH

PROVENANCE: Camille Groult; his son Jean Groult; his son Pierre Bordeaux-Groult; New York, art market; private collection.

LITERATURE: Goncourt 1875, under nos. 461, 568, 594, 621, 769, and p. 366 for the counter-proof; Heinrich Leporini, "Watteau and His Circle," *The Burlington Magazine* 66, no. 384 (March 1935), p. 138 (?); Parker and Mathey 1957, vol. 2, no. 783 (ill.); J[acques] Mathey, *Antoine Watteau: Peintures réapparues, inconnues ou négligées par les historiens; identification par les dessins; chronologie* (Paris, 1959), p. 11; Jean Cailleux, "Four Artists in Search of the Same Nude Girl," *The Burlington Magazine* 108, no. 757 (April 1966), supplement no. 16, pp. i, and v, n. 5; Jacques Mathey, "'La comédienne': An Unpublished Watteau," *Connoisseur* 165, no. 664 (June 1967), p. 92; Cormack 1970, p. 32, under no. 63; Hulton 1980, p. 25, under no. 19; Marianne Roland Michel, *Watteau: Un artiste au XVIIIe siècle* (Paris, 1984), pp. 248, and 277, n. 24; Grasselli and Rosenberg 1984, p. 157, no. 83, p. 95, under no. 30, p. 150, under no. 77, p. 169, under no. 92, p. 177, under no. 100, p. 187, under no. 109, p. 374, fig. 6 (detail); Helmut Börsch-Supan, *Watteau 1684–1721: Führer zur Ausstellung im Schloss Charlottenburg*, exh. cat., Berlin, Schloss Charlottenburg (Berlin, [1985]), no. 80 (ill.); Grasselli 1987a, vol. 2, p. 299, no. 207, fig. 370; Grasselli 1987b, p. 96, n. 8; Marianne Roland Michel, "Watteau et les 'Figures de différents caractères,'" in *Watteau (1684–1721): Le peintre, son temps, et sa légende,* edited by François

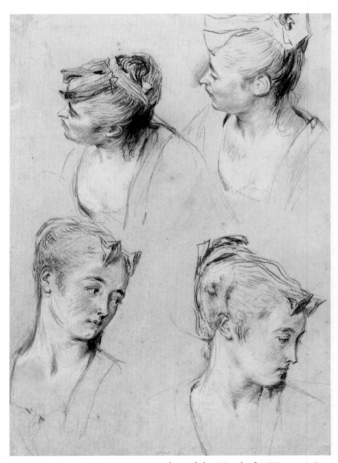

8.1. Antoine Watteau, *Five Studies of the Head of a Woman, One Lightly Sketched*. Red, black, and white chalk with red chalk wash, heightened with white gouache, 13 x 9⅜ in. (32.9 x 23.8 cm). British Museum, London

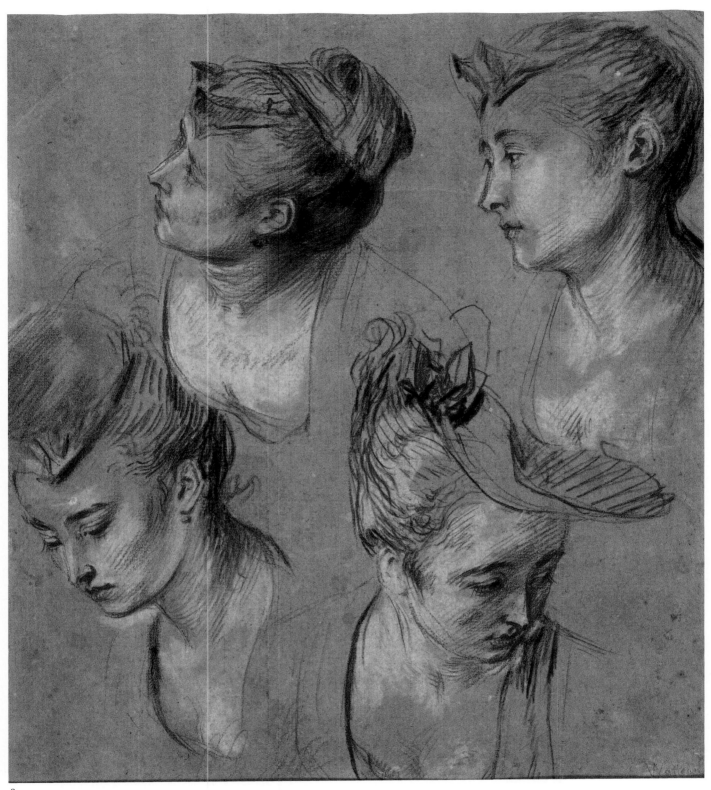

8

Moureau and Margaret Morgan Grasselli (Paris and Geneva, 1987), p. 120; John Ingamells, *The Wallace Collection: Catalogue of Pictures,* vol. 3, *French before 1815* (London, 1989), p. 353; Margaret Morgan Grasselli, "Eighteen Drawings by Antoine Watteau: A Chronological Study," *Master Drawings* 31, no. 2 (Summer 1993), p. 112, under no. 8; Rosenberg and Prat 1996, vol. 2, pp. 874–75, no. 520.

1. The "brilliant execution" of this sheet prompted Grasselli to date it to 1716–17, "when Watteau's powers were at their height." Grasselli and Rosenberg 1984, p. 157, under no. 83. Rosenberg and Prat concur (1996, vol. 2, p. 874, no. 520).

2. Grasselli and Rosenberg 1984, p. 150, under no. 78.

3. Grasselli and Rosenberg 1984, p. 157, under no. 83.

JEAN-BAPTISTE PATER

Valenciennes 1695–1736 Paris

9a. Standing Man (recto)
9b. Standing Woman (verso)

Red chalk, heightened with white, on blue paper, 11 x 6¼ in. (28 x 16 cm). Inscribed at lower right: *49*; on the verso: *491*

The Metropolitan Museum of Art, Purchase, David Tunick, Mr. and Mrs. Howard G. Lepow, and Stephen A. Geiger Gifts, and Bequest of Clifford A. Furst, by exchange, 1996 (1996.23)

Like his more illustrious master, Watteau, Pater was born in the northern town of Valenciennes, which had until 1678 been part of Flanders. He traveled to Paris as a young man and found steady income in churning out variations on the theme of the *fête galante,* meeting the demand that outlasted Watteau's brief career. If his work shares, on a superficial level, the pictorial vocabulary of his teacher, his temperament as a draftsman was completely his own. In contrast to Watteau's differentiated textures and sensitivity to underlying form, Pater's drawings cultivate the decorative potential of the chalk stroke, using a shorthand of short, jabbing marks and wiggly lines to exaggerate effects of vibration and shimmer. Like Watteau, he appears to have had little use for the compositional sketch. Pater's surviving drawings are almost invariably red chalk studies of single figures—drawings that were apparently retained and

reused, judging from the frequent recurrence of certain figures and poses in Pater's painted oeuvre. Presumably because of their shared subject matter, Pater's drawings have long been confused with those of his contemporary Nicolas Lancret, when, in fact, their styles are quite distinct. Scholarship of recent decades has begun to distinguish more reliably between these two oeuvres.[1]

The distinctive traits of Pater's draftsmanship can be appreciated in the Metropolitan's sheet, where brusque notations in red chalk become confluent with the creases and shadowy folds of the voluminous silks that often overwhelm in effect the stilted elegance of his figures. The use of blue paper, however, is unusual. Both recto and verso are anatomically bizarre, the woman with her floating head and bent-back left arm, the man with his odd proportions, from massive hips and thighs to almost nonexistent shoulders. In both cases, the figures correspond to generalized types in Watteau's oeuvre. The *Standing Woman,* her head tilted outward to engage the viewer while her male companion seeks unsuccessfully to gain her attention, is used by Pater in his *Fête galante* in Kenwood (fig. 9.2). Her compositional function, to negotiate between the viewer and the self-absorbed sociability of the larger

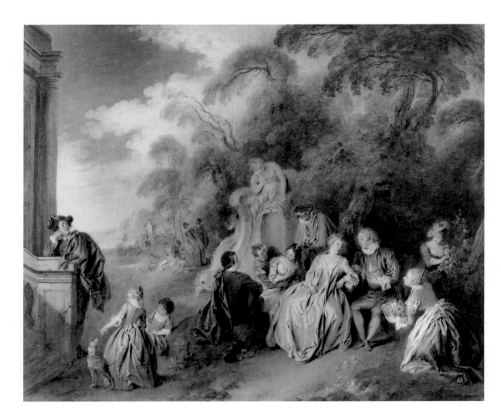

9.1. Jean-Baptiste Pater, *Love and Jest.* Oil on canvas, 28½ x 36 in. (72.4 x 14⅛ cm). Edythe C. Acquavella, New York

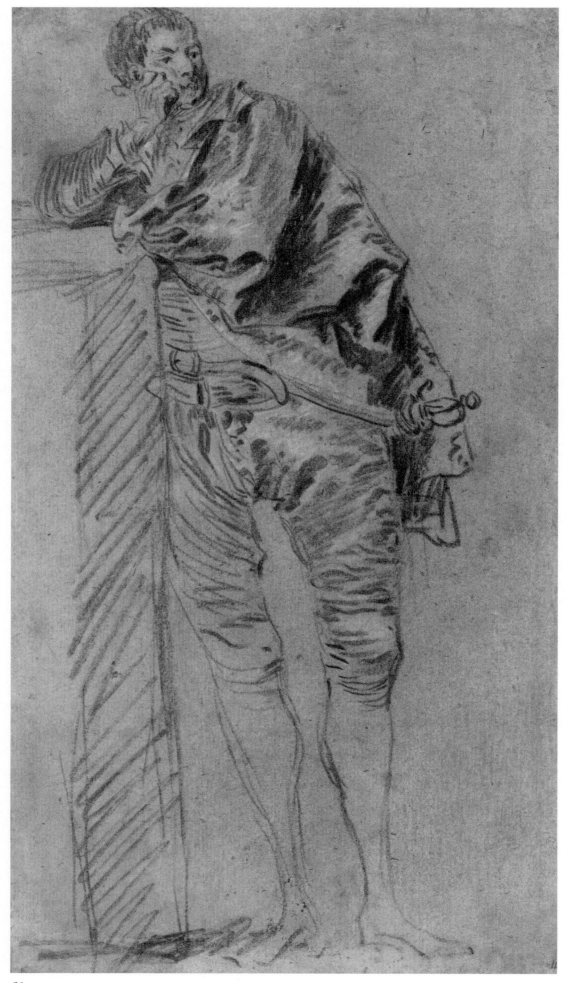

9a

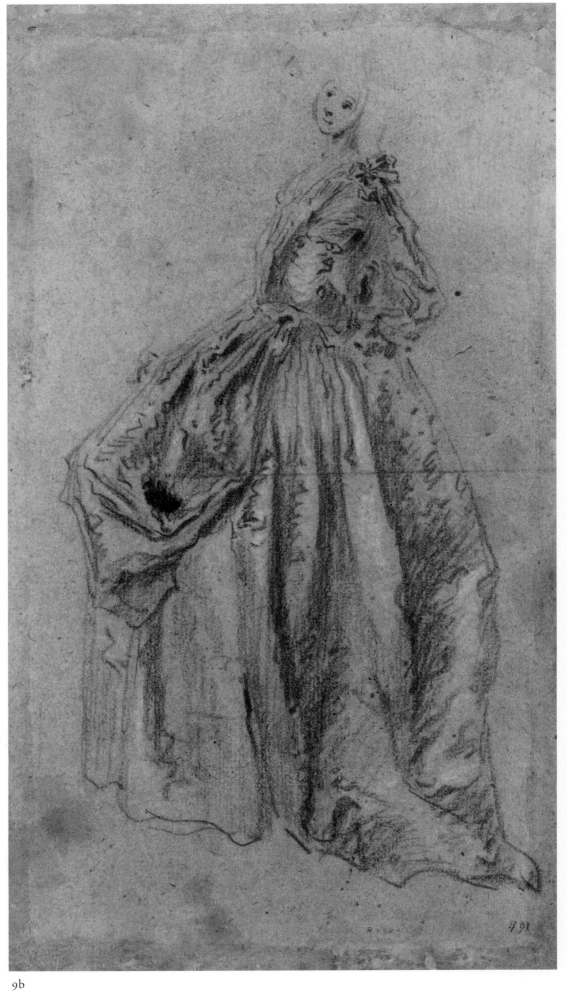

9b

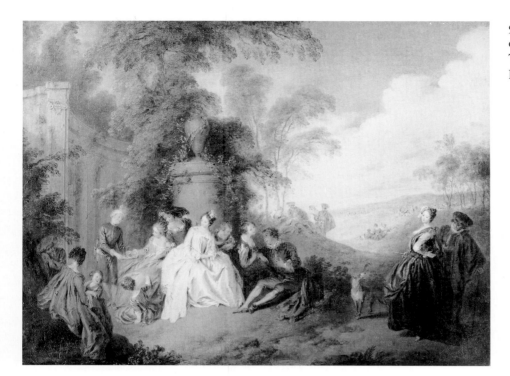

9.2. Jean-Baptiste Pater, *Fête galante.* Oil on canvas, 23¾ x 32¼ in. (59 x 82 cm). The Iveagh Bequest, Kenwood, English Heritage

gathering to the left, echoes that of her twin in Watteau's *The Conversation* (Toledo Museum of Art),[2] Pater's source for the figural group.

Precedents for the male figure include Watteau's *Italian Recreation,* in the Schloss Charlottenburg, Berlin.[3] He is used repeatedly in Pater's painted compositions, beginning perhaps with *Love and Jest* (fig. 9.1),[4] where he functions as a repoussoir figure and, by virtue of his physical isolation, as a foil for the easy social interchange of aristocrats at leisure—the canvas's central subject. While the painted incarnations of the leaning man may be characterized as bemused and detached, the Metropolitan's study stands out among Pater's graphic oeuvre for its interest in the figure's inner state. The raised eyebrow, the displaced flesh of his cheek as he leans heavily on his fisted right hand, and the pulling in of his cloak all convey a contemplative, even melancholic mood.

PS

PROVENANCE: Possibly in the collection of Camille Groult (1837–1908); sale, Hôtel Drouot, Paris, June 18, 1991, lot 46; [Galerie de Bayser, S.A., Paris]; purchased by The Metropolitan Museum of Art.

Unpublished.

1. See, for example, Grasselli 1986; and Rosenberg and Prat 1996, vol. 3.
2. Illustrated in Grasselli and Rosenberg 1984, p. 296, no. 23.
3. Illustrated in Grasselli and Rosenberg 1984, p. 342, no. 40. Other examples would be the etching *Standing Man Leaning on a Parapet,* retouched by Thomassin, included in the *Recueil Jullienne,* illustrated in Grasselli and Rosenberg 1984, p. 229, no. 1, and the drawing in Frankfurt for the standing man, thought to be a portrait of the painter Nicolas Vleughels, in *Les charmes de la vie* (Wallace Collection, London). For the latter, see Frankfurt am Main 1986, p. 95, no. 72.
4. Florence Ingersoll-Smouse lists the painting as in the collection of E. J. Berwind, New York, in 1928 (*Pater* [Paris, 1928], p. 38, no. 13, fig. 8). It was lent to *Masterpieces from Museums and Private Collections: Wildenstein Jubilee Loan Exhibition, 1901–1951,* exh. cat., New York, Wildenstein (New York, 1951), by Mrs. Sosthenes Behn, and was sold at Christie's, New York, May 31, 1979, lot 100, along with a pendant. Variations on the composition are illustrated on pp. 103, 104, 184, and 207 of Ingersoll-Smouse, *Pater.* The last mentioned appeared at auction in 1984 (Nouveau Drouot, Paris, June 6, 1984, lot 12). A version not included in Ingersoll-Smouse was sold at Christie's, London, November 30, 1979, lot 81. Finally, the same leaning figure appears at left in a somewhat altered composition in *Concert champêtre* (Metropolitan Museum of Art, 37.27).

A drawing for the central group in *Love and Jest* was in the Goncourt collection; see Launay 1991, pp. 410–11, no. 248 (as present location unknown). Interestingly, this drawing has little in common stylistically with the New York sheet, suggesting that they may have been executed at different times.

FRANÇOIS LE MOYNE

Paris 1688–1737 Paris

10. Studies of a Valet Pouring Wine

Red chalk on beige paper, 10⅛ x 6⅝ in. (25.6 x 16.7 cm)

The Metropolitan Museum of Art, Gift of Ann Payne Blumenthal, 1943 (43.163.22)

This drawing is a forcible reminder that Le Moyne was the contemporary of Watteau and Lancret and, indeed, Lancret's close friend. The stylish display of a single figure or group of figures in contemporary dress is the familiar territory of those masters of genre painting.[1] It is notable that Le Moyne, an artist who made his reputation as a history painter, was able to adopt this mode with such facility. We should not be surprised, however, as one hallmark of the painters of this time was their ability to switch from genre to genre,[2] and among Le Moyne's earliest efforts are landscape and genre paintings.[3]

In fact, the painting for which this drawing was made, the *Hunting Breakfast* of 1723, now in the Museu de Arte de São Paulo (fig. 10.1), reveals Le Moyne as not only capable of contemporary genre but in the forefront of its development

as an important part of the pictorial vocabulary of the Rococo.[4] The painting was made a mere three years after Watteau's *Halt of the Hunt* (Wallace Collection, London) and a decade or more before Carle Vanloo, Jean-François de Troy, and Lancret would produce their well-known variations on the theme of the hunt.

Le Moyne had a painstaking method of preparation, and it is not uncommon to see several drawn versions of a single figure in a painting. He did numerous studies for the *Hunting Breakfast,* all in red chalk, and at least two of them relate to the figure of the valet pouring wine found in the lower left foreground. In both drawings, this one in the Metropolitan Museum and another, formerly in a Paris private collection (fig. 10.2),[5] Le Moyne experimented with the pose of this important repoussoir figure, studying the direction of turn, the bend in the torso, and the position of the head. The Metropolitan drawing appears to be a first idea for the figure, Le Moyne being especially concerned with the pose, repeating it in a small sketchy figure at the left. The main figure exhibits Le Moyne's characteristic looping, often oval, strokes, and the head is very lightly drawn. In the

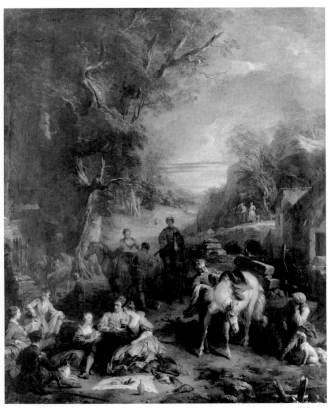

10.1. François Le Moyne, *The Hunting Breakfast*, 1723. Oil on canvas, 88 x 73 in. (223 x 185 cm). Museu de Arte de São Paulo

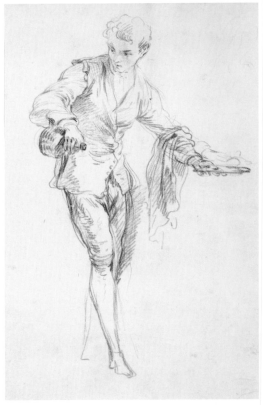

10.2. François Le Moyne, *Study of a Valet Pouring Wine*. Red chalk on buff paper, 9⅝ x 6½ in. (24.5 x 16.5 cm). Present location unknown

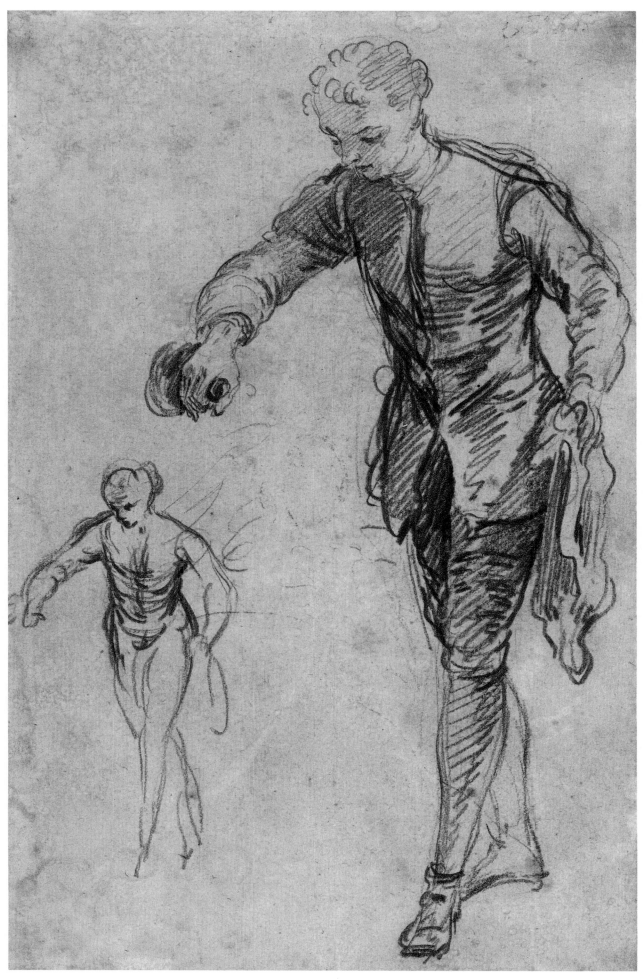

Paris drawing, he has arrived at the definitive solution. The figure, here turned to the left, its left arm extended toward the rest of the scene, now serves to lead the eye of the viewer *into* the painting. Le Moyne also slightly raised the head, allowing the valet in the painting to meet the gaze of the seated hunter, thus making for a livelier exchange.

<div align="right">MTH</div>

PROVENANCE: Léon Decloux; his collection sale, Hôtel Drouot, Paris, February 14–15, 1898, lot 167, ill. (as Watteau); George and Florence Blumenthal, New York; Ann Payne Blumenthal; given to The Metropolitan Museum of Art.

LITERATURE: Stella Rubinstein-Bloch, *Catalogue of the Collection of George and Florence Blumenthal,* vol. 5, *Paintings, Drawings, Sculptures, XVIIIth Century* (Paris, 1930), pl. XXIII (attributed to Watteau); Jacques Wilhelm, "François Le Moyne and Antoine Watteau," *The Art Quarterly* 14, no. 3 (Autumn 1951), pp. 223–24, and p. 219, fig. 6; Gillies and Ives 1972, no. 30 (ill. on cover); "Aus der Arbeit der Museen," *Pantheon* 30, no. 6 (November–December 1972), p. 513 (ill.); Rosenberg 1972, p. 176, under no. 79; Bjurström 1982, under no. 1054; Bordeaux 1984, pp. 89, 152, no. D55, fig. 183; Bean and Turčić 1986, p. 154, no. 166.

1. This drawing was in fact long attributed to Watteau. It was first recognized as the work of Le Moyne by Jacques Wilhelm, "François Le Moyne and Antoine Watteau," *The Art Quarterly* 14, no. 3 (Autumn 1951), pp. 216–30.
2. The "pseudo" Salon of 1725 was particularly indicative of this aspect of contemporary French painting; see Holmes 1991, pp. 40–41, and p. 148, n. 36.
3. Bordeaux devotes a chapter to these early works, and dates them to 1713–23; see Bordeaux 1984, pp. 52–59; see also Grasselli 1996, pp. 365–74.
4. Another version of this painting, in the Alte Pinakothek, Munich, is considered by Bordeaux (1984, p. 88) to be a studio copy.
5. Many of the drawings for this painting are listed in Bordeaux 1984, under nos. 51–56, pp. 151–52. The Paris drawing was on the art market in 1988, but its present location is unknown. Jacques Wilhelm, in "François Le Moyne and Antoine Watteau," p. 219, fig. 5, and pp. 223–24, identified a third drawing as belonging to this group, a drawing now in the Nationalmuseum, Stockholm, with a provenance that traces back to Tessin. Bordeaux includes it in his catalogue (1984, pp. 152–53, no. 56), but is not convinced of the attribution to Le Moyne (verbal communication, February 24, 1997). Unfortunately, the photographs of the Stockholm drawing and the Paris drawing were reversed in the Bordeaux catalogue. The correct order should be Stockholm, fig. 182, and Paris, fig. 184.

NICOLAS LANCRET

Paris 1690–1743 Paris

11. *Couple Seated on the Ground, Looking at a Songbook*

Black and white chalk on light brown paper, 9⅛ x 10¹⁵⁄₁₆ in. (24 x 27.8 cm)

Mrs. A. Alfred Taubman

A favorite at the court of Louis XV, Nicolas Lancret was a painter of genre scenes and *fêtes galantes.* As it was for his mentor, Watteau, chalk was his preferred medium, and he explored its full potential in the creation of mood and texture. His early drawing style was highly "worked up," lush and atmospheric, while his later usage was more spare, his line more angular. This drawing is a fine example of Lancret's ability to exploit the medium to tell a story. The lines used to describe the anxious young man fairly vibrate with tension, and are in noted contrast to those used to delineate the delicate grace of the girl, sketched with the lightest touch, her skirt a cloud of silky, luminous white.

Although once dated by the present author to early in the artist's career,[1] Grasselli and McCullagh are surely right in proposing a later date, about 1740, pointing out that the atmospheric use of white chalk masks the spare and angular strokes characteristic of Lancret's later manner.[2]

Lancret was a prolific draftsman. Ballot de Sovot, Lancret's friend, lawyer, and biographer, relates Lancret's drawing habits and Watteau's advice to his young protégé "to go sketching landscapes on the outskirts of Paris, then to draw some figures, and to combine them to form a painting of his own choice and imagination."[3] "All he saw on his walks," continued Ballot, "were potential models; and it often happened that he would abandon his friends and go off to some vantage point to draw, to capture the overall look of a group or a figure that appealed to him."[4] One can easily imagine this scenario in the creation of the Taubman sheet, which has a marvelous spontaneity, as if Lancret happened upon the young couple in a park, and quickly set them down.[5]

This unstudied quality is an illusion, for Lancret's work

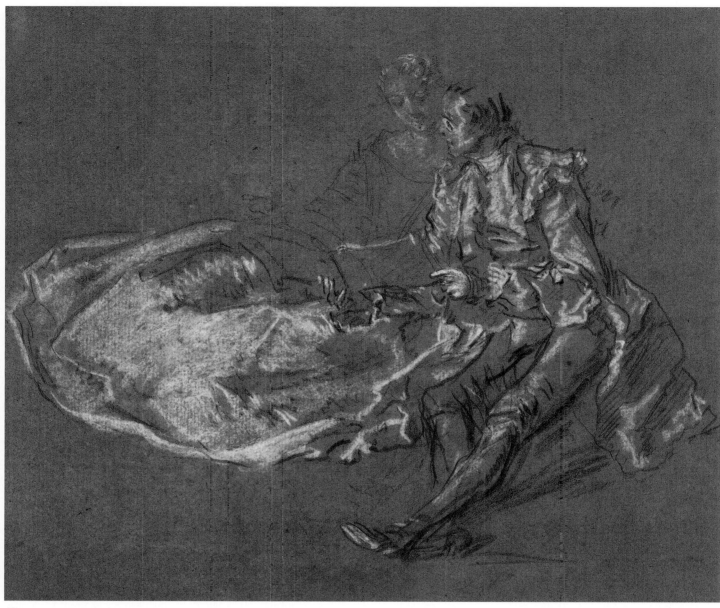

11

as much as it is for Watteau's; indeed, this couple owes much to the example of Watteau, in such drawings as *A Man Reclining and a Woman Seated on the Ground* (Armand Hammer Collection).[6] The majority of Lancret's drawings are figure studies, many of them preparatory to paintings,[7] and although this drawing is not a study for any known painting, people looking at songbooks are a regular occurrence in Lancret's paintings. Compositional studies in chalk are rare, though several oil sketches for complete compositions do survive.

MTH

PROVENANCE: O. LeMay; private collection, Switzerland; [William A. Schab Gallery, New York, 1987]; private collection, New York; sale, Sotheby's, New York, January 13, 1989; Mrs. A. Alfred Taubman.

LITERATURE: Holmes 1991, p. 114, no. 23, p. 115, pl. 28; Grasselli 1994b, p. 55; Margaret Morgan Grasselli and Suzanne Folds McCullagh, "Reviews: 'Nicolas Lancret 1690–1743,'" *Master Drawings* 32, no. 2 (Summer 1994), p. 171.

1. Holmes 1991, p. 114, no. 23.
2. Margaret Morgan Grasselli and Suzanne Folds McCullagh, "Reviews: 'Nicolas Lancret 1690–1743,'" *Master Drawings* 32, no. 2 (Summer 1994), p. 171.
3. See Ballot de Sovot, *Éloge de Lancret, peintre du roi,* edited by J. J. Guiffrey (Paris, n.d.), p. 18.
4. Ibid., p. 23.
5. Another drawing of a couple very close in style and subject to the present sheet was on the market in Paris in 1991 (see Galerie de la Scala, Paris, exh. cat., May 23–June 22, 1991, no. 41)
6. Illustrated in Grasselli and Rosenberg 1984, p. 151.
7. See "Lancret's Drawings," in Holmes 1991, pp. 106–9.

FRANÇOIS BOUCHER

Paris 1703–1770 Paris

12. *The Fortune Teller*

Pen and black ink, with brush and gray wash, watercolor, and gouache, over black chalk underdrawing, 6¾ x 11⅛ in. (17.2 x 28.2 cm)

The Metropolitan Museum of Art, Gift of Mrs. O'Donnell Hoover, 1960 (60.176.3)

This charming, previously unpublished sheet was originally classified with the Metropolitan Museum's anonymous sheets but is certainly a very early work by François Boucher.[1] In his youth more than in his maturity, Boucher liked to experiment with technique and color in his drawings, exhibiting in this example a precocious grasp of the watercolor medium. Unlike the amplitude and calm modeling of his later works, his early drawings are characterized by a sinuous linearity; figures are elongated, and nervous ink lines ripple and zigzag, describing their subjects in discontinuous outline.

Stylistically, the sheet can be connected to two drawings acquired by Carl Gustaf Tessin in the eighteenth century, probably directly from the artist's studio, and today in the Nationalmuseum, Stockholm.[2] Like the present sheet, they are executed in pen and black ink, with watercolor and gouache over graphite or black chalk. Of the two, it is the *Pastoral* (fig. 12.1) that provides the closer parallel. In addition to the quality of the ink line, they have in common the yellow-green color of the foliage, the touches of red highlighting the flesh tones, and the somewhat acidic pastels chosen for the clothing. Tessin, who knew the artist well, ascribed both the Stockholm watercolors to Boucher in his

manuscript inventories.[3] Discounting Tessin's entries, Per Bjurström saw the Stockholm watercolors as having "nothing in common" with Boucher's work, suggesting instead the hand of Marie-Jean Boucher, the artist's wife,[4] an opinion shared by neither Beverly Schreiber Jacoby[5] nor Alastair Laing,[6] or by the present author.

Both the Stockholm *Pastoral* and the present *Fortune Teller* are concerned with typical Boucher themes. In the Metropolitan's drawing, one can trace the continuity of the subject and its various transformations over a number of years, with the present sheet being the first instance. For Boucher, whose interest in rural life lay largely in its erotic possibilities, the subject of the fortune teller, with its interplay of naïveté and cunning, proved a versatile motif. In what is probably the second drawing in the sequence (fig. 12.2), the cast of characters is expanded.[7] The young woman having her fortune told is now set in the middle ground. The old crone, now with a baby on her back, has become the fortune teller, and the young boy stealing the girl's purse is now placed between the pair.[8] A seated girl with a basket of flowers, who is the object of attention of two young shepherds, recalls the girl in the New York drawing. In its best-known incarnation, the fortune teller group is employed as the central vignette in *La bohémienne* (fig. 12.3), one of Boucher's designs for the Beauvais tapestry series Les Fêtes Italiennes, which was woven beginning in 1736.[9] Here, the fortune teller is younger, the girl is seated, and the young pickpocket is omitted.

It is difficult to date the Museum's drawing with certainty. Most likely, it was made in the early 1730s, shortly after

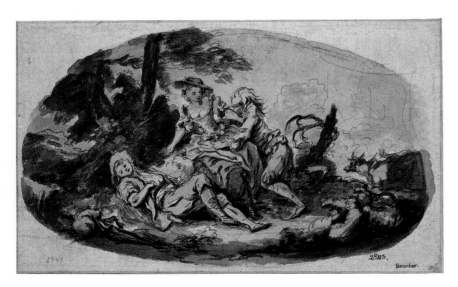

12.1. François Boucher, *Pastoral.* Pen and black ink, brush and gray wash, and watercolor over graphite, 6⅞ x 11¾ in. (17.5 x 29.8 cm). Nationalmuseum, Stockholm

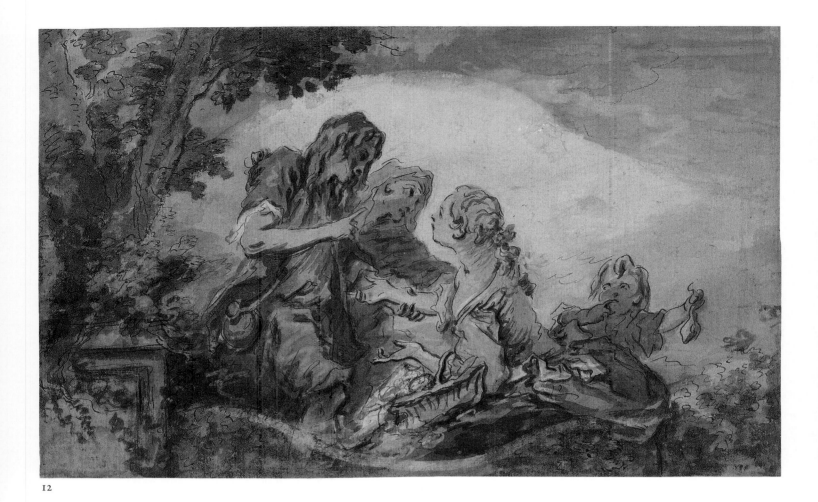

12

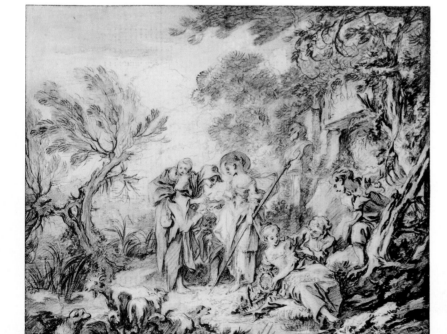

12.2. François Boucher, *La bonne aventure*. Pen and black ink, brush and gray wash, heightened with white, over black chalk, 10¾ x 12 in. (27.2 x 30.6 cm). Arnoldi-Livie, Munich (photo: G. U. E. von Voithenberg)

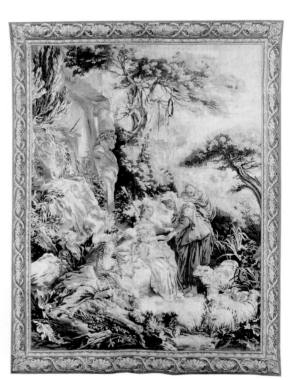

12.3. After François Boucher, *La bohémienne*. Wool and silk tapestry, from the Beauvais series Les Fêtes Italiennes, 1762. The Metropolitan Museum of Art, Gift of Ann Payne Robertson, 1964 (64.145.2)

Boucher's return from Italy, or perhaps in the late 1720s, before he left, as it contains no discernible Italianate elements and still shows Boucher somewhat under the sway of Flemish painting, an influence that would diminish over time.

P S

PROVENANCE: Kathleen O'Donnell Hoover, New York; given to The Metropolitan Museum of Art.

Unpublished.

1. This attribution has been confirmed on the basis of a photograph by Alastair Laing (letter, August 14, 1996), who also suggested comparing the sheet to the two watercolors in Stockholm.
2. Bjurström 1982, nos. 870–71.
3. The following were consulted: the manuscript list of the items Tessin brought back from his stay in Paris in 1739–42 (Kungliga Biblioteket Ms. S. 12), p. 44, and the manuscript catalogue drawn up by Tessin sometime between 1749 and 1755 (Nationalmuseum, Stockholm), p. 68, no. 102.
4. Since his 1982 catalogue, Bjurström has elaborated his views on Marie-Jeanne Boucher and the Stockholm drawings in an article, "Marie-Jeanne Boucher," *Konsthistorisk Tidskrift* 56, no. 1 (1987), pp. 38–41.
5. Jacoby reinstates the watercolors to Boucher in her dissertation and dates them to 1731–34. She also lists an untraced watercolor by Boucher, *Dinner in the Countryside,* which is mentioned by Pierre-Jean Mariette in a letter dated December 1, 1732. See Jacoby 1986, pp. 301–2.
6. Letter, August 14, 1996.
7. Pen and black ink, brush and gray wash, heightened with white, over black chalk, 28⅜ x 12 in. (72.2 x 30.6 cm). The drawing was with Galerie Arnoldi-Livie, Munich, in 1997.
8. In this version especially, Boucher recalls Watteau's *La diseuse d'aventure,* engraved by Laurent Cars, for which see Dacier, Hérold, and Vuaflart 1921–29, vol. 4, no. 30.
9. On the series, see Edith Appleton Standen, *European Post-Medieval Tapestries and Related Hangings in The Metropolitan Museum of Art,* vol. 2 (New York, 1985), pp. 507–18; Edith A. Standen, "Fêtes Italiennes: Beauvais Tapestries after Boucher in The Metropolitan Museum of Art," *Metropolitan Museum Journal* 12 (1977), pp. 107–30, and Regina Shoolman Slatkin, "The Fêtes Italiennes: Their Place in Boucher's Oeuvre," *Metropolitan Museum Journal* 12 (1977), pp. 130–39.

FRANÇOIS LE MOYNE

Paris 1688–1737 Paris

13. *Seated Draped Figure*

Black chalk, heightened with white, on blue paper, 12 x 9⅝ in. (30.5 x 24.6 cm)

The Metropolitan Museum of Art, Rogers Fund, 1963 (63.105)

François Le Moyne had the rare gift, so useful for a Rococo history painter, of creating figures at once monumental and graceful. That characteristic is much in evidence in this sheet, and in the ceiling for which it is a study. The *Apotheosis of Hercules,* made for the Salon d'Hercule at Versailles, the room connecting the royal apartments to the chapel, was Le Moyne's most important commission. Le Moyne began work as early as 1728 on this complex project[1] and labored over it for years, once even scraping out an entire section and repainting. When it was unveiled, on September 26, 1736, Louis XV immediately bestowed on Le Moyne the title *premier peintre du roi,* so long coveted by the artist. It remains one of the most important illusionistic ceiling paintings ever produced in France.

The preparation for the enterprise (the ceiling is 60 x 55 feet, and has 142 figures) was immense, involving composi-

tional *modelli* as well as numerous figure studies, mostly in Le Moyne's favorite black chalk heightened with white on blue paper.[2] The Metropolitan's drawing is a sketch for Valor, one of the four virtues associated with Hercules. Situated in the corners of the room, the virtues were identified in a 1736 publication on the iconography of the ceiling as Force, Constancy, Valor, and Justice.[3] Le Moyne derived his models from the 1677 Paris edition of Cesare Ripa's handbook of emblems.[4]

Le Moyne's soft chalk drapery study imparts to the figure its grace, while his masterly use of light and dark creates the requisite mass, crucial for a figure positioned to anchor a corner in a room of such size. Indeed, Le Moyne's program weights down the ceiling with an illusionistic sculptural scheme that runs along the entire cornice, and the figure for which our drawing is a study is realized in grisaille, a mock sculpture, on the ceiling. It is clearly no accident that the drawn draperies emerge from the page as if sculpted.

M T H

PROVENANCE: [Baderou]; purchased by The Metropolitan Museum of Art.

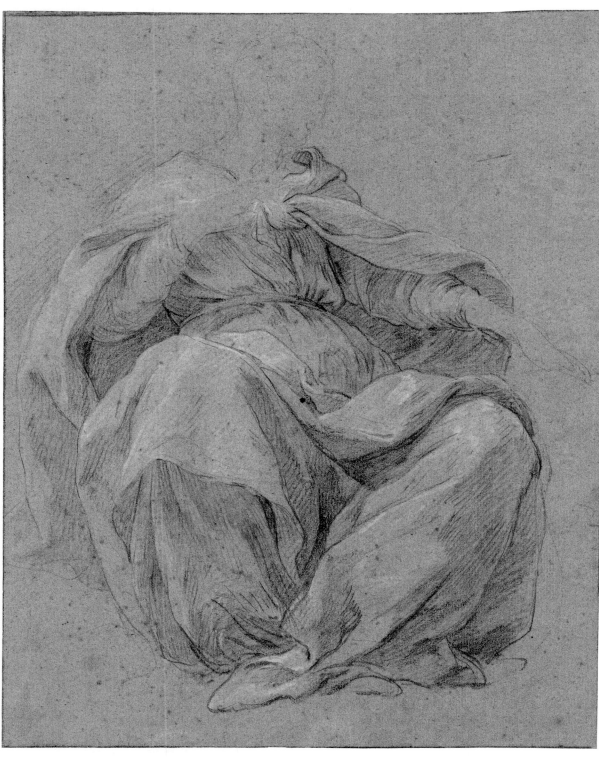

13

LITERATURE: *MMA Annual Report,* 1963–64, p. 62; Rosenberg 1972, p. 176, under no. 79; Bordeaux 1974, p. 313, fig. 21; Bordeaux 1984, pp. 125, 173, no. D156, fig. 283; Bean and Turčić 1986, p. 157, no. 168.

1. According to Nonnotte, in his *Vie de Monsieur Lemoyne,* cited in Bordeaux 1974, p. 304. This commission is discussed at length in Bordeaux 1974 and Bordeaux 1984, pp. 61–68, and pp. 123–25, no. 95.

2. Although Bordeaux (1984, p. 170) lists only 21 now known, he notes that there must be many more. Nonnotte, *Vie de Monsieur Lemoyne,* remarked on the great many preparatory drawings done by Le Moyne for this work (cited in Bordeaux 1984, p. 124). An exhibition on the Salon d'Hercule is currently being prepared by Xavier Salmon.

3. Reprinted in Bordeaux 1974, p. 314.

4. Cesare Ripa, *Iconologie, ou nouvelle explication de plusieurs images . . . ,* 2 vols. in 1 (Paris, 1677), pp. 42, 56, 73, 192. This source was identified by Jacob Bean and Lawrence Turčić (unpublished files, Metropolitan Museum of Art, Department of Drawings and Prints), who support the identification of the Metropolitan's sheet as Valor. Bordeaux identifies the figure as Force or Strength, but the presence of all four virtues in the *Iconologie* makes the identification as Valor certain.

FRANÇOIS LE MOYNE

Paris 1688–1737 Paris

14. Alexander and Porus

Brush and brown wash, heightened with white, over black chalk,
on blue paper, 12¼ x 17¼ in. (31.2 x 43.9 cm)

The Metropolitan Museum of Art, Rogers Fund, 1962 (62.238)

This drawing is a compositional sketch for the monumental history painting that Le Moyne was working on at the time of his death, a painting left unfinished on his easel when he stabbed himself with his sword on June 4, 1737, aged forty-nine.[1] In 1735, still at work on the Salon d'Hercule at Versailles (see no. 13), Le Moyne was commissioned to provide one of eight enormous paintings for the throne room of La Granja, the country palace near Segovia of Philip V of Spain.[2] The commission was designed to showcase the most famous artists in Europe at the time. Le Moyne was the only French artist so honored, the other commissions falling to Italian artists.[3] The commissions were coordinated by Filippo Juvarra, a Sicilian architect and decorator who determined the subjects, size, and format for the cycle. The canvases were to be approximately 8 by 11½ feet and échancré, the corners cut out in a crescent shape. The subjects, drawn from the life of Alexander the Great, represent kingly virtues, implying

Philip's possession of them in equal measure to Alexander. All the artists submitted complete compositional sketches of roughly the same size, and many of these have survived.[4]

Le Moyne was assigned the virtue of Clemency, and Juvarra suggested two appropriate scenes, Alexander and Timoclea and Alexander and the family of Darius (eventually provided by Trevisani).[5] However, Le Moyne himself wrote back to Juvarra that he preferred to take on the subject of Alexander's victory over Porus at Hydaspes, the moment when Alexander spares the life of his fallen enemy and restores his estates, though he notes that the representation will be more difficult because of the horses.[6] In January 1736, Le Moyne sent two compositional sketches along to Spain, together with a letter to Juvarra illuminating his method of monumental painting.[7]

In the meantime Juvarra died, and the marqués Scotti was asked to evaluate the sketches and report back to Patiño, the Spanish minister. In a letter dated February 6, 1736,

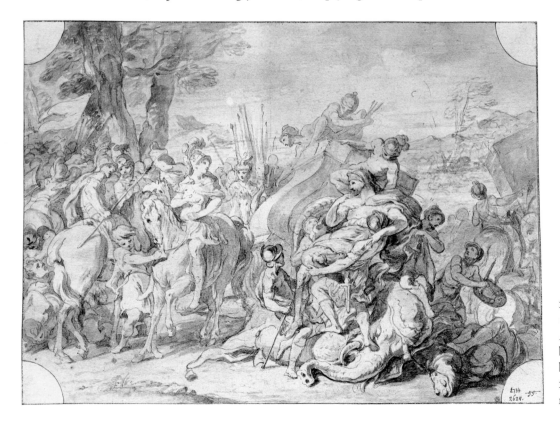

14.1. François Le Moyne, *Alexander Captures King Porus at the Battle of Hydaspes.* Pen and gray ink with brush and light brown wash over black chalk underdrawing, 12¼ x 17¼ in. (31.1 x 43.7 cm). Nationalmuseum, Stockholm

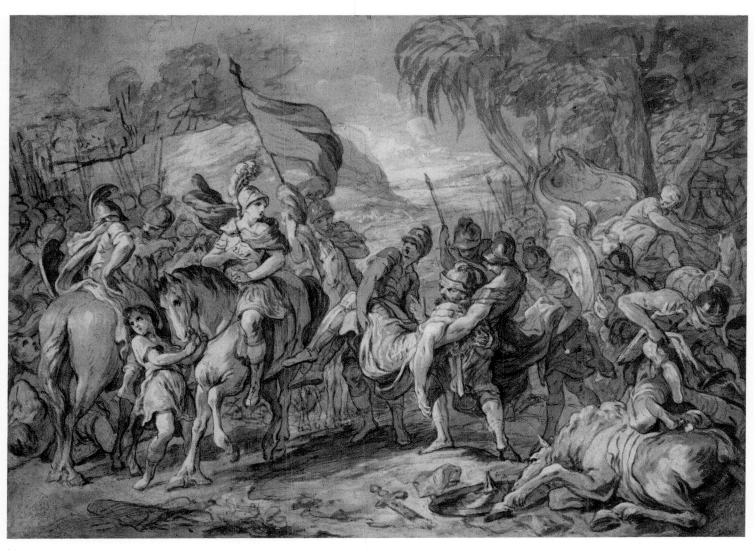

14

Scotti says that he finds them both good, and drawn with much brio. He notes the difficulty of assessing a painter's work without seeing a finished oil. After much discussion, he gets to the heart of the matter: "Returning to the Le Moyne . . . drawing no. 1 seems to me more picturesque and in better taste, while the other is more confused. And in a painting the dead elephant section would not work so well. . . . So for this reason, I prefer drawing no. 1."[8] Two sketches with this composition are known today, sketches that accord well with Scotti's description, the present sheet in the Metropolitan Museum, and another, today in the National-museum, Stockholm (fig. 14.1). The drawing Scotti refers to as drawing no. 2, the more confused composition featuring a dead elephant, would be the drawing in Stockholm; drawing no. 1, which Scotti prefers as more picturesque and in better taste, corresponds to the drawing in New York.[9]

The two drawings are similar; the differences are in the center and right side of each. In the Stockholm version, the composition is weighted down in the middle, with the supported figure of Porus still atop his elephant, now dead beneath him, the enormous saddle still in place. In the New York sheet two soldiers carry Porus, reducing his stature and creating a lighter composition. A chariot is driven away to the right. Le Moyne's composition here follows closely that created by Charles Le Brun (1619–1690) for his version of the story done for the *Triumphs of Alexander,* commissioned for Louis XIV. The series was engraved in Le Brun's lifetime by Gerard Edelinck. Le Moyne's composition reverses Le Brun's, indicating that the engraving was his main source. The central group of Porus slung between two soldiers is a virtual quotation from Le Brun, as is the mounted figure of Alexander. Although one might think that the New York version, more graceful and fluid than the Stockholm example, was a subsequent effort, it seems more likely, given its closeness to the Le Brun, that the New York version was the first. Carle Vanloo, who took over the commission on Le Moyne's death, knew both versions by Le Moyne, as well as the engraving after Le Brun. Elements of all these examples can be found in Vanloo's sketches and in the finished work.[10]

Philip V chose drawing no. 1, the one suggested by Scotti, here identified with the New York sheet,[11] and it was returned to Le Moyne on March 19, 1736, so that he could begin work on the painting.[12] He did not sign the contract until October 17, as he was still at work on the ceiling at Versailles. Immediately upon his death the following June, the Spanish court was notified.[13] The unfinished canvas on his easel was that for *Alexander and Porus.*

The subject of Alexander and Porus provides a fitting, if ironic, coda for Le Moyne, an artist haunted by the specter of the immensely successful Charles Le Brun. The duc de Luynes remarked, on hearing of Le Moyne's death, that the artist killed himself because he was not paid as much as Le Brun (in the capacity of *premier peintre du roi*).[14] Prior to Le Moyne's aborted attempt, the only artist to depict Alexander and Porus, and that too in the service of a king, was Le Brun.[15] Le Moyne, in choosing this subject, posed a direct challenge to the example of his mentor, perhaps hoping that the Spanish court would select the more original of his two offerings. MTH

PROVENANCE: Chabot; his sale of December 17, 1787, lot 130; Paignon-Dijonval; in 1792 to his heir, Charles-Gilbert vicomte Morel de Vindé; sold in 1816 to Samuel Woodburn, London; [Feist]; purchased by The Metropolitan Museum of Art.

LITERATURE: M. Bénard, *Cabinet de M. Paignon Dijonval . . .* (Paris, 1810), p. 139, no. 3251; J[ean] J[ules] Guiffrey, "Procès-verbal de suicide et inventaire . . . de François Le Moyne . . . ," *Nouvelles Archives de l'Art Français,* 1877, pp. 212–13; Anthony M. Clark, "Imperiali," *The Burlington Magazine* 106, no. 734 (May 1964), p. 233 (republished in Anthony Morris Clark, *Studies in Roman Eighteenth-Century Painting* [Washington, D.C.], 1981, pp. 88–89); London 1968, no. 427; Gillies and Ives 1972, no. 32; Rosenberg 1972, p. 176, no. 79; Rosenberg and Sahut 1977, p. 48, nos. 63–64; Yves Bottineau et al., *L'art européen à la cour d'Espagne au XVIIIe siècle,* exh. cat., Bordeaux, Galerie des Beaux-Arts; Paris, Grand-Palais; Madrid, Prado (Paris, 1979), p. 146, under no. 82; Bjurström 1982, under no. 1057; Bordeaux 1984, pp. 175–76, no. D171, fig. 298; Bean and Turčić 1986, pp. 158–59, no. 170.

1. Guiffrey, "Procés-verbal . . . ," as in literature, above, p. 204: "Une grand toile dessinée, représentant la défaite de Porus par Alexandre." The present location of this painting is unknown.
2. The letter of September 12, 1735, offering the commission to Le Moyne, was from Juvarra via José Patiño, the Spanish minister in charge of the project, to Fernando Triviño y Figueroa, an emissary of Spain to the French court. Triviño then relayed the offer to Le Moyne (Archives A.H. est 3993, San Ildefonso). Some of the correspondence related to the commission, including this letter, is published in Yves Bottineau, *L'art de cour dans l'Espagne de Philippe V, 1700–1746* (Bordeaux, [1961]), pp. 515–16, 549–50. Bottineau describes Triviño as an "homme d'affaires italien" (p. 515). His name also appears as Triniguo in some documents. The letter describing the commission, of October 2, 1735, is from Juvarra to Le Moyne (Archives A.G.P. San Ildefonso, C<u>e</u> 13552; published in F. García Fresca, "Documentos relativos al cuadro que debió pintar Francisco Le Moyne para el real sitio de San Ildefonso," *Revista de Archivos, Bibliotecas y Museos* 3 [1873], p. 222).
3. The paintings (excluding the Le Moyne, which was never completed), in very poor condition, are in the collection of the Patrimonio Nacional. Some are in the process of being restored,

and will be rehung at La Granja (letter from Juan Martínez, Área de Conservación del Patrimonio Nacional, April 30, 1997). Some confusion exists in the literature over the painters involved, but the list has firmed up in recent years: Le Moyne, Francesco Solimena, Sebastiano Conca, Francesco Trevisani, Agostino Masucci, G. B. Pittoni, Donato Creti, and Francesco Fernandi (called Imperiali), who replaced Domenico Parodi. See Teresa Fernandez Talaya, "Las pinturas encargadas por Juvarra para la Galería del Palacio de La Granja," *Reales Sitios* 31, no. 119 (1994), pp. 41, 42. For more on the commission, see Eugenio Battisti, "Juvarra a San Ildefonso," *Commentari* 9, no. 4 (October–December 1958), pp. 277–79.

4. See Anthony M. Clark, "Imperiali," *The Burlington Magazine* 106, no. 734 (May 1964), p. 233, n. 23; Federico Zeri, *Italian Paintings in the Walters Art Gallery,* 2 vols. (Baltimore, 1976), vol. 2, pp. 517–18, under no. 407 (entry by Placido Costanzi); and Yves Bottineau et al., *L'art européen à la cour d'Espagne au XVIIIe siècle,* no. 82, pp. 145–46, and no. 107, pp. 177–78.

5. Letter from Juvarra, October 2, 1735 (Archives A.G.P. San Ildefonso, C<u>e</u> 13552). See Fernandez Talaya, "Las pinturas encargadas," p. 44, and García Fresca, "Documentos relativos al cuadro que debió pintar Francisco Le Moyne," p. 222.

6. Letter of November 28, 1735. (Archives A.G.P. San Ildefonso, C<u>e</u> 13552). See Fernandez Talaya, "Las pinturas encargadas," p. 44, and García Fresca, "Documentos relativos al cuadro que debió pintar Francisco Le Moyne," p. 222.

7. Letter of January 18, 1736. See Pedro de Madrazo, *Viaje artístico de tres siglos por las colecciones de cuadros de los reyes de España . . .* (Barcelona, 1884), p. 207. See also Bottineau, *L'art de cour dans l'Espagne de Philippe V,* p. 516.

8. This letter is printed in full in Madrazo, *Viaje artístico de tres siglos,* pp. 205–6. See also Bottineau, *L'art de cour dans l'Espagne de Philippe V,* p. 516, and n. 225.

9. Jean-Luc Bordeaux (1984, p. 176), perhaps unaware of the Scotti correspondence, which he does not cite, says only that the Metropolitan Museum drawing, on account of its more Rococo composition, "might represent the approved final idea" (p. 176). Bean and Turčić (1986), like Bordeaux, conclude that "it is impossible to say whether the New York and Stockholm drawings were those sent to Spain, or which of them comes closest to the approved commission" (p. 159).

10. For Vanloo's examples, see Rosenberg and Sahut 1977, p. 48, nos. 63, 64, and Bottineau, *L'art européen à la cour d'Espagne,* pp. 145–46, no. 82.

11. Letter of February 29, 1736, signed by Chioga des Forges, which reads as follows: "Le roy d'Espagne a approuvé le dessin no. 1 et le [Le Moyne] prie d'avoir la bonté d'y mettre la main." It was found in Le Moyne's studio after his death. See Bordeaux 1984, p. 176.

12. See García Fresca "Documentos relativos al cuadro que debió pintar Francisco Le Moyne," p. 222. The Stockholm version was probably returned at the same time, as it was purchased in Paris by Count Tessin, appearing in his list of 1739.

13. Ibid.

14. Charles Philippe d'Albert, duc de Luynes, *Mémoires du duc de Luynes sur la cour de Louis XV (1735–1758),* 17 vols. (Paris, 1860–65), vol. 1, "Juin 1737," p. 260.

15. Donald Posner, "Charles LeBrun's 'Triumphs of Alexander,'" *The Art Bulletin* 41, no. 3 (September 1959), pp. 237–48, esp. p. 243, explains this introduction of the Porus subject by the production of Racine's *Alexandre le Grand,* in 1665, which is dedicated to the new Alexander, Louis XIV, and deals with the story of Alexander and Porus. The moment chosen by Le Brun comes from the final scene of the play, when Porus, asked by Alexander how he expects to be treated, replies, "En roi." Alexander answers, "Régnez toujours, Porus, je vous rends vos États." Juvarra selected the same moment for Le Moyne's depiction.

CHARLES-ANTOINE COYPEL

Paris 1694–1752 Paris

15. *Allegorical Figure of Painting*

Black chalk, stumped, heightened with red and white chalk, on blue paper. Lightly squared in black chalk, 14 x 12¼ in. (35.6 x 31 cm)

The Metropolitan Museum of Art, The Elisha Whittelsey Collection, The Elisha Whittelsey Fund, 1962 (62.19)

One would expect more than the rather small number of preparatory drawings that are known by Charles-Antoine Coypel, the heir to the Coypel dynasty of painters and to an academic tradition that revered drawing as the reasoned preparation for art in the grand style and the essential link to nature and the art of the past. A recent monograph on the artist lists a mere 111 drawings, most of them for engravings and most now lost.[1] These, and a small number of compositional and figure studies, are all we have from an artist who, by any comparison with his contemporary academic fellows, ought to have produced hundreds of sheets.[2] One clue to this mysterious dearth of material may lie in the complaint voiced by

15.1. Charles-Antoine Coypel, *La peinture réveillant le génie endormi*. Red, black, and white chalk on beige paper, 15¾ x 11⅜ in. (38.9 x 28.9 cm). Formerly collection Emile Wolf

Mariette in his *Abécédario* that Coypel "never really appreciated the necessity of studying from nature."[3] Later, engaged in cataloguing Coypel's estate, Mariette noted the presence in the studio of apparatus, stage sets, and mannequins designed to allow Coypel to formulate compositions without recourse to drawing from life.[4]

The Metropolitan's drawing is a preparatory sketch for an allegorical picture, dating from about 1730,[5] in which the figure of Painting, identifiable by her mahlstick and palette, appears above the bed of a sleeping figure of Genius, identifiable by the flame on his head, to waken him. The hand of Painting is extended in a gesture recognizable to all from Michelangelo's Sistine ceiling, there, as here, sending forth the spark of creation. The whole is framed in a window, rather like a stage set.[6] The complete composition is known also from a drawing formerly in the Emile Wolf collection, also *trois crayons* but on beige paper (fig. 15.1). In

that drawing, a canopied curtain is added to the window, further contributing to the impression of a staged scene. Our drawing focuses only on the figure of Painting. Her luminous form, moonlit by the white heightening on blue paper, floats gently down through lightly sketched clouds. Coypel's delicate and incisive handling of the *trois crayons* technique, especially in the face of the muse seen from above, and his adroit placement of the figure on the page would not be unworthy of Watteau.

Coypel spent many years torn between two ambitions—to be a history painter in the mold of his father and grandfather (a goal attained when he was appointed *premier peintre du roi* in 1747) or a writer, in particular, a playwright. These careers ran in tandem throughout his early working life, his struggle to choose between them often erupting into print or paint.[7] Eventually, probably in the 1730s, he decided to devote himself to painting and to allow his literary ambitions to languish. The Metropolitan's drawing was born of this still unresolved internal battle, Coypel imagining his dilemma solved by divine intervention, as it were. Judging from the ravishing beauty of his chosen muse, it would seem that painting had already gained the upper hand.

MTH

PROVENANCE: [Schatzki]; purchased by The Metropolitan Museum of Art.

LITERATURE: *MMA Annual Report*, 1961–62, p. 67 (as anonymous French eighteenth century); Rosenberg 1972, p. 150, under no. 36; Gillies and Ives 1972, no. 13; Oberhuber and Jacoby 1980, p. 96, under no. 28; Bean and Turčić 1986, p. 82, no. 84; Lefrançois 1994, p. 443, no. D54, and under nos. P115, p. 234, and D53, pp. 442–43.

1. Lefrançois 1994.
2. Coypel did produce several pastel portraits, but these are designed to mimic painting, and are grouped by Lefrançois with paintings in the catalogue.
3. Mariette 1851–60, vol. 2, p. 31.
4. [Pierre-Jean Mariette], *Catalogue des tableaux, desseins . . . du cabinet de feu M. Coypel* (Paris, 1753), for example, pp. 90–91, nos. 493, 494, 497.
5. The painting, now in a private American collection, is illustrated in color in Lefrançois 1994, p. 17, and catalogued, pp. 234–35, no. P115.
6. Oberhuber and Jacoby 1980, pp. 94–96, note that Coypel derived many of his compositions from set designs.
7. Coypel dealt with this issue in other works; see Lefrançois 1994, pp. 44, 140.

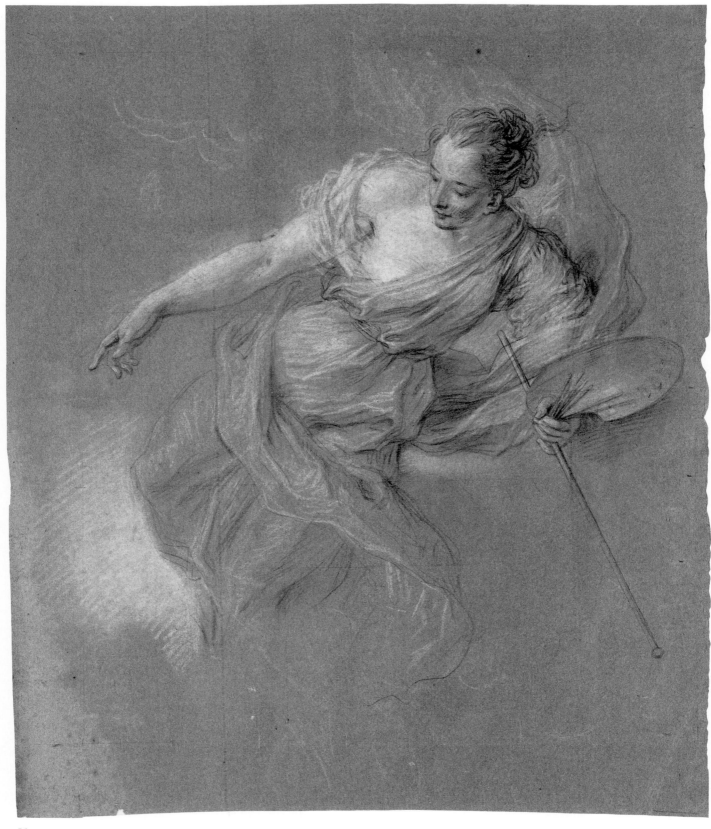

15

PIERRE-CHARLES TRÉMOLIÈRES

Cholet 1703–1739 Paris

16. A Zephyr

Red chalk, 8⅛ x 11⅜ in. (20.7 x 28.8 cm). Collection mark of Philippe de Chennevières at lower left (Lugt 2073)

Janet Mavec

The marquis de Chennevières, the nineteenth-century owner of this sheet, was a respected art historian and connoisseur whose collection of drawings numbered over four thousand sheets, including fine examples by many eighteenth-century draftsmen who had, by Chennevières's time, largely been forgotten. He described his holdings in twenty-two consecutive articles that appeared in the periodical *L'Artiste* between 1894 and 1897. Louis-Antoine Prat has connected this sheet with one ascribed to Trémolières by Chennevières in 1897.[1]

Over a relatively brief career, Trémolières's graphic manner underwent several transformations. The present sheet can be associated with his student years in Rome from 1728 to 1734. During this period he copied the Italian masters as expected, but it is to the draftsmanship of his near-contemporary and fellow pensionnaire, the sculptor Edme Bouchardon (1698–1762), that Trémolières owed the greatest debt. Although their styles differ considerably, that of Trémolières tending toward lightness and mannered grace, Bouchardon's toward solidity and classicism, a group of Trémolières's Roman sheets must be seen as either copies of or homages to the sculptor's confident and widely admired manner in red chalk.[2]

Trémolières's *Zephyr* makes undisguised reference to a series of personifications of the four winds by Bouchardon, all once owned by Mariette (presumably Bouchardon would have taken them on his return to Paris in 1732). The *East Wind* is today in the Metropolitan Museum,[3] the *South Wind* and the *West Wind* in the Staatliche Museen, Berlin.[4] The closest parallel, however, may be the untraced version of the *East Wind,* known through a counterproof in the Nationalmuseum, Stockholm (fig. 16.1).[5] Like Bouchardon's Winds, the Zephyr, similarly executed in red chalk, is depicted as a cloud-borne winged nude youth. Furthermore, the background hatching, the circular pattern of the clouds, and the emphasis on outline all support such a lineage. Trémolières's figures, however, never display the solidity of form more natural to a sculptor. Throughout, there is a suppleness, a less methodical hatching, a tremulous quality of line that set Trémolières's Bouchardon-style drawings apart from their models. PS

16.1. Edme Bouchardon (1698–1762), *The East Wind.* Red chalk counterproof. Nationalmuseum, Stockholm

PROVENANCE: Vaganay, Lyons; Philippe de Chennevières; his estate sale, Paris, April 4–7, 1900, p. 75, lot 486; [Zangrilli, Brady & Co., Ltd., New York]; Janet Mavec.

LITERATURE: Ph[ilippe] de Chennevières, "Une collection de dessins d'artistes français," *L'Artiste,* n.s., 13 (January 1897), p. 22; Cholet 1973, p. 114 (as location unknown).

1. See *French and English Drawings, 1700–1875,* exh. cat., New York, Zangrilli, Brady & Co., Ltd. (New York, 1986), no. 7. Chennevières's

16

description reads, "Un Zéphyr, sous la figure d'un jeune homme porté sur un nuage et volant vers la gauche: il souffle en retournant la tête vers la droite. A la sanguine. Acheté à Lyon chez Vaganay."

2. Trémolières's copies after Bouchardon include *L'age d'or* and *L'age d'argent* (Musée du Louvre, Paris, inv. 23 866 and 24 704), *L'étude* (Musée des Beaux-Arts, Orléans, inv. 1120), and *Nymphe surprise par des satyres* (École Nationale Supérieure des Beaux-Arts, Paris, inv. 1559). Others give every appearance of being copies, although no source has yet been identified. See, e.g., Cholet 1973, nos. 19–21; the Chicago drawing especially points to the existence of an untraced compositional study by Bouchardon that would have been prepara-

tory to an oval-format etching depicting the bath of Venus (?) etched by the comte de Caylus (Metropolitan Museum of Art, 50.514.2).

3. Bean and Turčić 1986, pp. 28–29, no. 14.

4. *Vom späten Mittelalter bis zu Jacques Louis David: Neuerworbene und neubestimmte Zeichnungen im Berliner Kupferstichkabinett,* exh. cat., Berlin, Staatliche Museen, Preussischer Kulturbesitz (Berlin, 1973), nos. 169, 170 (ill.).

5. First published under this attribution by Lawrence Turčić, "Exhibition Reviews: New York and Edinburgh, French Drawings from Stockholm," *The Burlington Magazine* 129, no. 1013 (August 1987), p. 561, fig. 106.

PIERRE-CHARLES TRÉMOLIÈRES

Cholet 1703–1739 Paris

17. *The Ascension of Christ* (recto)
Study for Saint Joseph (verso)

Black chalk and charcoal, stumped, heightened with white, on
gray-blue paper, 31⅞ x 18½ in. (81 x 47.1 cm). Inscribed in pen and
brown ink at lower left: *Vanloo* (recto); black and red chalk, charcoal,
stumped, heightened with white (verso), arched top

The Metropolitan Museum of Art, Harry G. Sperling Fund, 1985
(1985.102)

Even relative to the concentration of talent referred to
as the generation of 1700, high hopes were held for
the young painter Pierre-Charles Trémolières.
Protected by the comte de Caylus and esteemed by Nicolas
Vleughels, the director of the Académie de France in Rome,
Trémolières was widely heralded as the next great decorator,
heir to the mantle of Le Moyne, especially as his return to
the French capital coincided with the elder artist's suicide in
1737. Unfortunately, Trémolières suffered frequent illnesses
and died in 1739, at the age of thirty-six, only three years
after his return to Paris.

En route from Rome to Paris, he had stopped in Lyon for
eighteen months, during which time he accepted commis-
sions for a number of altarpieces. Both sides of the
Metropolitan's sheet can be associated with paintings for
churches in Lyon. The recto is a study for the *Ascension of
Christ* (fig. 17.1)[1] commissioned, with a pendant, the
Assumption of the Virgin, for Saint Bruno des Chartreux,
where both are still in situ. The large format of the sheet,
along with its atmospheric finish, suggests its role as a pre-
sentation drawing, done either in Lyon or sent from Paris
on approval (the painting is signed and dated 1737).

The attenuated elegance of Trémolières's style is fully
evident here in the rhythms of flowing drapery, the dramat-
ic, flickering light, and the elongated, mannered poses of
the figures. The feet of Christ and those of the airborne
angels taper, characteristically, to points. The painting retains
the principal figures of the drawing but discards many of
the subsidiary ones for a more focused composition, the
rearrangement of angels and onlookers motivated by a
desire to emphasize the diagonal compositional axis stretch-
ing from lower left to upper right.

The drawing on the verso, previously titled *Head of a
Bearded Man Looking Down*, appears to be a study for the
figure of Saint Joseph in the *Adoration of the Magi* (fig. 17.2),[2]

17.1. Pierre-Charles Trémolières, *The Ascension of Christ,* 1737.
Oil on canvas, 228¼ x 100⅜ in. (580 x 255 cm). Church of Saint-
Bruno des Chartreux, Lyon

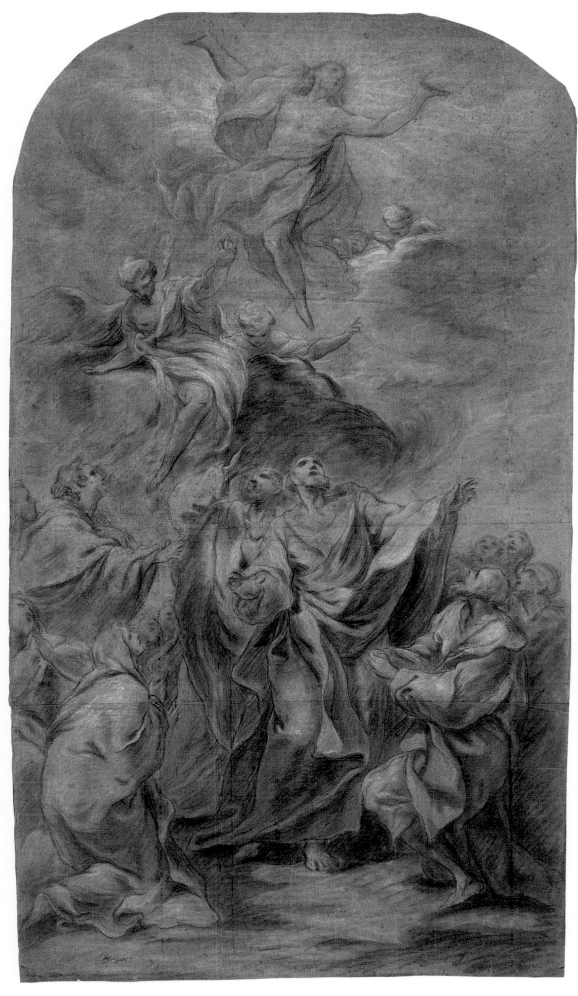

17a

17b

17.2. Pierre-Charles Trémolières, *Adoration of the Magi* (detail), 1736. Oil on canvas, 131½ x 108¼ in. (334 x 275 cm). Church of Sainte-Blandine, Lyon

one of three canvases executed by Trémolières for another church in Lyon, the Carmes Déchaussés, although the angle of the head is altered in the painting, which is dated 1736. Removed at the time of the Revolution, Trémolières's three paintings for that church are today in Sainte-Blandine, Lyon. PS

PROVENANCE: Sale, Sotheby's, Monte Carlo, December 8, 1984, lot 56; [Galerie Cailleux, Paris]; purchased by The Metropolitan Museum of Art.

LITERATURE: *MMA Annual Report*, 1984–85, p. 26; Bean and Turčić 1986, pp. 254–56, no. 288.

1. Cholet 1973, p. 69, no. 17.
2. Cholet 1973, p. 65, no. 9.

JEAN-BAPTISTE OUDRY

Paris 1686–1755 Beauvais

18. *Hyena Attacked by Two Dogs*

Pen and brown ink with brush and brown and gray wash, 6⅛ x 8⅜ in. (15.5 x 21.2 cm). Signed in pen and ink at lower right: *Oudry*

Private collection

Oudry began his career as an artist in the studio of his father, Jacques Oudry, a painter and art dealer, and then studied for a short period with Michel Serre. His principal teacher, however, was Nicolas de Largillierre (1656–1746), the portraitist with whom he studied from 1707 to 1712 and who left a lasting impression on Oudry's art and art theory. The earliest known works by Oudry are in fact portraits that imitate Largillierre's opulent style; he appears to have done landscapes from a very early date as well. He is best known, however, for his still-life and animal works. He was *agréé* by the Académie in 1717, and *reçu* as a history painter in 1719. He became a painter to the Beauvais tapestry works in 1726, and its director in 1734. One of Oudry's most notable achievements was the *Royal Hunts,* a tapestry series based on the hunts of Louis XV, commissioned by the Gobelins manufactories in 1733, where he was appointed director in 1748.

This unusually broad range of artistic endeavor is reflected in Oudry's draftsmanship, and the three drawings in this exhibition give some small hint of the variety therein. The *Still Life with Fish and Parrot* (no. 19) is an autograph replica of a painting done twenty years earlier; the landscape (no. 21) was drawn *en plein air* as an independent sketch, and the present drawing is a finished preparatory study for a painting, a relative rarity in Oudry's oeuvre. The painting in the Staatliches Museum Schwerin (fig. 18.1) is connected to three known drawings, one in the Louvre (fig. 18.2), one in the Witt Collection of the Courtauld Institute, and this one in a private collection, the only preparatory study of the three. The other two drawings are replicas of the painting made at a later date by Oudry himself.[1]

The New York drawing is vigorous, wiry, and energetic. The hair on the agitated hyena stands up along the back, a bit of observed reality familiar to anyone who has ever seen

18.1. Jean-Baptiste Oudry, *Hyena Attacked by Two Dogs,* 1739. Oil on canvas, 51⅛ x 76¾ in. (129.7 x 195 cm). Staatliches Museum Schwerin

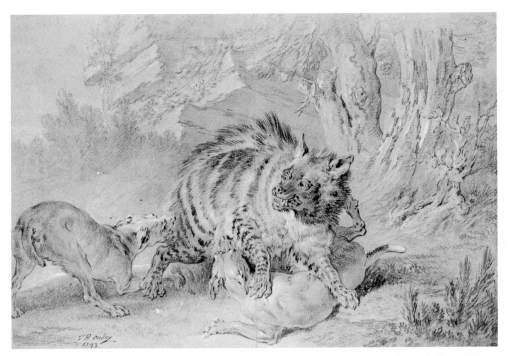

18.2. Jean-Baptiste Oudry, *Hyena Attacked by Two Dogs,* 1743. Black and white chalk on blue paper, 12⅝ x 18 in. (32 x 45.8 cm). Musée du Louvre, Paris

a threatened dog. After centering the drawing on the hyena, Oudry ran out of room for the hind leg of one of the dogs and dropped down to sketch it below, an adjustment that adds to the spontaneous quality of the image. The Louvre drawing and the drawing in the Witt Collection, which is its close replica, in contrast, are finished and highly polished, a refinement that renders them somewhat static.

MTH

PROVENANCE: Private collection.

LITERATURE: Opperman 1966, pp. 395–96; Opperman 1977, vol. 1, pp. 425–26, P191, vol. 2, pp. 735–36, D602; Claus Virch, *The Artist and the Animal: A Loan Exhibition for the Benefit of the Animal Medical Center,* exh. cat., New York, M. Knoedler and Co. (New York, 1968), no. 49 (ill.).

1. See Opperman 1966, pp. 395–96.

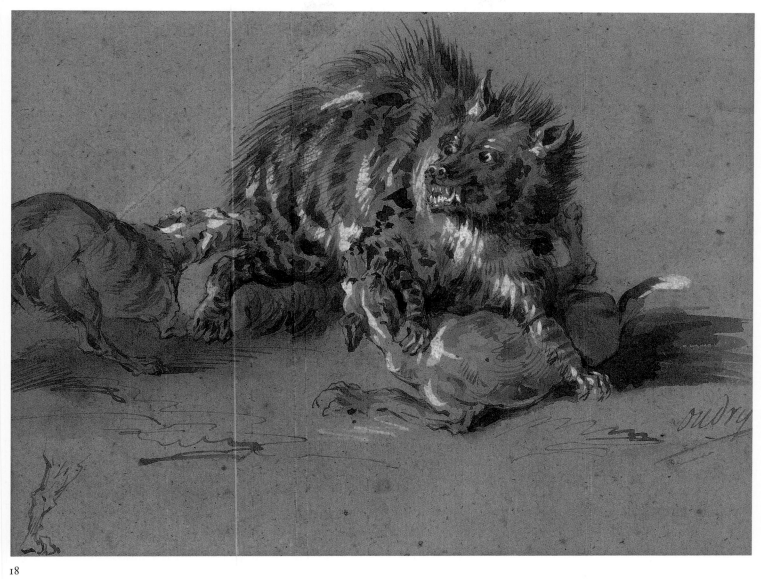

18

JEAN-BAPTISTE OUDRY

Paris 1686–1755 Beauvais

19. Still Life with Fish and Parrot

Black and white chalk on blue paper, 12⅛ x 16⅜ in. (30.7 x 41.6 cm).
Collectors' mark of Jules and Edmond de Goncourt (Lugt 1089) at
bottom left; collector's mark of Alfred Beurdeley (Lugt 421) at bottom
right. Inscribed and dated in pen and brown ink at lower right, on a
rock: *Oudry 1740*

Cooper-Hewitt, National Design Museum, Smithsonian Institution,
Museum Purchase through Friends of the Museum Fund (1938-66-1)

This well-known tour de force by Oudry, once owned
by the famous connoisseurs of eighteenth-century
art Jules and Edmond de Goncourt, reminds us that
the eighteenth century produced more than one master of
still life. It also reveals much about Oudry's methods.

Oudry was a highly prolific draftsman, his surviving oeu-
vre numbering in the thousands; he seems also to have held
a special regard for his work in this medium. According to a
contemporary biographer, the abbé Gougenot, "In a way he
was more attached to his drawings than to his paintings. He
grouped them in portfolios of more than fifty pieces, of such
variety that their owner would have an example of all the
genres he had practiced. He considered them as an estate that
he accumulated for the benefit of his family; very few of
them were to be had during his lifetime."[1] Indeed, not one of
his drawings appeared in a public sale until after his death.

This drawing, together with its pendant, also at the
Cooper-Hewitt (fig. 19.1), perfectly exemplifies the artist's
love of drawing. Throughout his career, Oudry produced
the expected preparatory studies for paintings, but he also
created scores of drawings intended as finished works of art
and copies of his own work, both painted and drawn. This
was his habit from his earliest days.[2] Hal Opperman has
suggested that Oudry maintained a kind of Musée Oudry
in his studio, both as a record for himself and as an entice-
ment to patrons,[3] and the finished copies were perhaps part
of that display. The Cooper-Hewitt drawings are replicas of
paintings made some twenty years earlier than the date on
the drawings.[4]

Between 1719 and 1721, Oudry traveled to the port city of
Dieppe, expressly for the purpose of studying freshly caught
marine life,[5] showing the same persistent enthusiasm for
plein air naturalism that would later take him to the gardens
of Arcueil. Among the many paintings he produced at
Dieppe were two, now lost, that were exhibited in the 1724

Salon de la Jeunesse and the Salon of 1725, and amply
described at the time in the *Mercure de France.*[6] The paint-
ings were still in Oudry's studio in 1739, where they were
seen, happily for us, by Oudry's great patron the prince of
Mecklembourg-Schwerin, who sketched the painting from
which the Metropolitan's drawing derives.[7]

Both compositions represent an artfully arranged heap of
marine creatures watched over by a parrot.[8] The present
sheet shows them piled high and hung in a triangle in front
of a crumbling parapet overlooking the sea; the pendant has
nautical staffage, a mast, a barrel, and a masterfully drawn
net. The tension between nature and artifice that character-
izes the *genre pittoresque* is beautifully realized. The use of
black and white chalk on blue paper was favored by Oudry,
and it perfectly suits the subject here, the blue creating the
water and the white highlights simulating the shimmer of
the glistening scales. One can easily believe, with Opperman
and with Faré and Faré, that the paintings were seen by
Chardin, who was in turn inspired by them to produce *The
Skate* (Musée du Louvre, Paris), of 1728.[9]

MTH

PROVENANCE: Count Antoine-François Andréossy (collection
formed between 1783 and his death in 1828); his estate sale, Hôtel
Drouot, Paris, April 13–16, 1864, lot 807 (with its pendant); Edmond
and Jules de Goncourt (Lugt 1089); their sale, Hôtel Drouot, Paris,
February 15–17, 1897, lot 218 (sold to Beurdeley, with its pendant);
Alfred Beurdeley (Lugt 421); his sale, Galerie Georges Petit, Paris,
March 13–15, 1905, lot 184 (to Ducrey); F. Dreyfus, Paris, 1924; Sarah
Cooper Hewitt; sale of Erskine Hewitt, Parke-Bernet, New York,
October 18–22, 1938, lot 559 (with its pendant); Cooper-Hewitt,
National Design Museum, Smithsonian Institution.

LITERATURE: Edmond de Goncourt, *La maison d'un artiste*, 2 vols.,
new ed. (Paris, 1881), vol. 1, p. 130; Locquin 1912, no. 572, p. 109;
Jean Vergnet-Ruiz, "Oudry, 1686 à 1755," in Dimier 1928–30, vol. 2,
p. 180, no. D121; *The Eighteenth Century Art of France and England*,
exh. cat., Montreal, Musée des Beaux-Arts (Montreal, 1950), no. 89;
Algy S. Noad, "Les Anglais Rococo: The Georgian French," *Art News*
49, no. 3 (May 1950), p. 35 (ill.), and pp. 58–59; Richard P. Wunder,
*Extravagant Drawings of the Eighteenth Century from the Collection of
The Cooper Union Museum* (New York, 1962), p. 102, no. 53 (ill.);
Jean Vallery-Radot, *French Drawings from the Fifteenth Century
through Géricault*, Drawings of the Masters (New York, [1964]),
pl. 40; Claude-Gérard Marcus, "Jean-Baptiste Oudry (1686–1755),
peintre de poissons," *Art et Curiosité*, n.s., no. 14 (October–December
1965), pp. 5–7; Opperman 1966, p. 394, and pl. 23; *Old Master

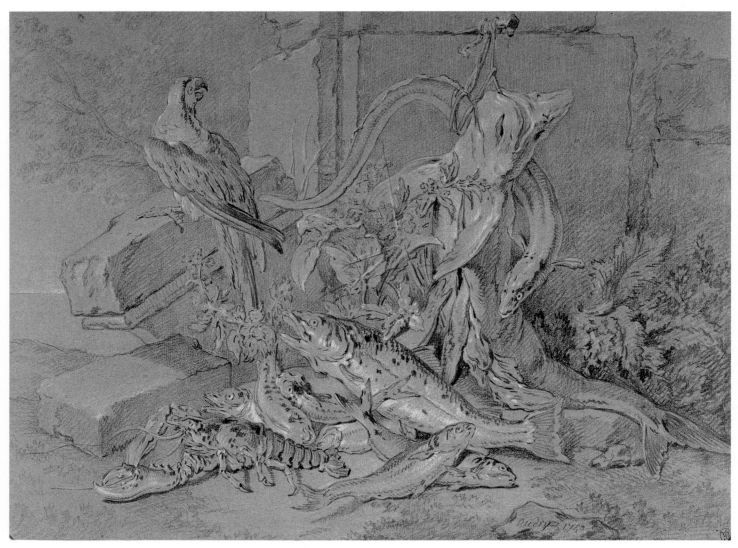

19

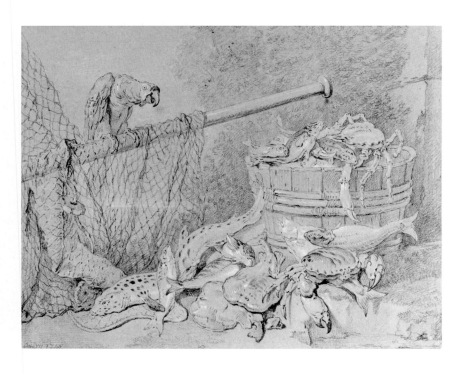

19.1. Jean-Baptiste Oudry, *Still Life with Fish and Parrot,* 1740. Black and white chalk on blue paper, 12⅛ x 16 in. (30.8 x 40.8 cm). Cooper-Hewitt, National Design Museum, Smithsonian Institution

Drawings, exh. cat., Newark Museum (Newark, [1960]), no. 44; Gillies and Ives 1972, no. 38; Rosenberg 1972, cited under no. 100; Colin Eisler, *The Seeing Hand: A Treasury of Great Master Drawings* (New York, 1975), pl. 5, after p. 215; Faré and Faré 1976, p. 116; Opperman 1977, vol. 1, pp. 60, 150, vol. 2, p. 829, no. D975, fig. 102; Opperman 1982, p. 90, no. 35; Opperman 1983, p. 53, fig. 22; Roland Michel 1987, p. 27, and p. 172, fig. 195; Launay 1991, pp. 400–401, no. 235, fig. 243.

1. Abbé Louis Gougenot, *Vie de M. Oudry* (1761), reprinted in Dussieux 1854, p. 380.
2. Oudry produced a record book, dating to about 1714, that includes sketches of all his paintings and projected paintings of that time. What remains of the book is in the Musée du Louvre, Département des Arts Graphiques.
3. Opperman 1983, p. 5.
4. Opperman (1982, p. 90) asserts that the dates written on the drawings, though not in Oudry's hand, are nonetheless correct.
5. Gougenot (Dussieux 1854, p. 377) notes that Oudry visited Dieppe ten times "pour y peindre des poissons dans leur fraîcheur."
6. They are described as "peints à Dieppe d'après nature." See *Mercure de France*, June 1724, p. 1389; *Mercure de France*, September 1725, vol. 2, pp. 2253–72. See also Georges Wildenstein, *Le salon de 1725* (Paris, 1924), p. 45.
7. Opperman made the identification of the Cooper-Hewitt sheets as replicas of the earlier paintings; see Opperman 1966, p. 394, and p. 407, no. 44. For the sketch by the prince, see Opperman 1977, vol. 1, p. 529, P448, and vol. 2, p. 1097, fig. 249.
8. The description of this bird in the Salon of 1725 *livret* identifies it as a "Perroquet ou Haras Bleu," and the one in the pendant as "beau Hara, couleur de feu."
9. Opperman 1982, p. 90, under no. 35; and Faré and Faré 1976, p. 116.

JACQUES-ANDRÉ PORTAIL

Brest 1695–1759 Versailles

20. *Flowers in a Silver Vase, Fruit in the Foreground*

Watercolor and black chalk, 13⅝ x 11 in. (34.6 x 27.8 cm)

The Metropolitan Museum of Art, Bequest of George Blumenthal, 1941 (41.190.119)

Still life was an ideal genre in which to display virtuosic and controlled technique. Often working in miniature, Portail produced, in addition to still lifes, landscapes, genre sketches, and portraits of great delicacy that were coveted by important collectors of his own and the next century.[1] The marquis de Marigny owned no fewer than seventy-six examples.[2] This drawing well exemplifies Portail's manner—each flower, leaf, and fruit rendered with exquisite refinement, their velvety softness in sensuous contrast to the opulent reflection of the silver vase. Baron Grimm noted correctly that in a flower piece by Portail, "Only the scent is absent."[3] Other known still-life drawings by Portail share the control of the Metropolitan's drawing, bringing Portail's precision to bear on a wide range of objects—rabbits, birds, and so forth—sometimes in compositions far more elaborate.[4]

In the greater simplicity and focus of the Metropolitan's drawing lies much of its appeal. Portail has muted the background to a near seamless join of parapet and wall, the matte ground serving only to support the still life. This has the effect, surely intended, of allowing each carefully crafted petal to vibrate with light and virtually jump off the sheet. Portail's work in still life is in striking contrast to the most famous eighteenth-century master of the genre, Jean Siméon Chardin (1699–1779). Chardin's still life does not depend for its effect, as does Portail's, on a detailed copying of nature. Rather, his painterly technique evokes texture, light, and shade. And it is the Chardin that lets off a vaporous scent.

One wonders whether it was Portail's early training as an architect and engineer that imbued his style with its preternatural precision. His painstaking approach to still life continued a tradition long favored in France, and one that he knew well. In 1744, for example, he copied, or had copied, the works of Blain de Fontenay (1653–1715) for the apartments of the dauphine at Fontainebleau.[5] His imagery and subject matter also suggest the influence of seventeenth-century Dutch art, for example the Leiden school. Gerard Dou (1613–1675) was one of the most favored artists in eighteenth-century France, and the enamel-like perfection

20

of his genre and still-life pictures would have had a strong appeal for Portail. Dou's paintings were well represented in Paris collections, and two of them entered the royal collection in the first two years of Portail's tenure as *garde des tableaux du roi,* a post he obtained in 1740.[6]

<div align="right">MTH</div>

PROVENANCE: Marius Paulme (Lugt 1910); Paulme sale, Galerie Georges Petit, Paris, May 13–15, 1929, lot 198, pl. 133; [Germain Seligmann]; George Blumenthal; bequeathed to The Metropolitan Museum of Art.

LITERATURE: Margaretta Salinger, "Early Flower Paintings," *The Metropolitan Museum of Art Bulletin* 8, no. 9 (May 1950), p. 260 (ill. p. 261); Faré and Faré 1976, p. 20 (ill.); Bean and Turčić 1986, p. 223, no. 251; Salmon 1996, p. 22, no. 54.

1. For Portail's life and works, see Salmon 1996.
2. Marius Paulme, in the catalogue of his sale in 1929, identifies this drawing with one owned by the marquis de Marigny. Jacob Bean concurs with this identification (Bean and Turčić 1986, p. 223, no. 251). Although the size is roughly correct, the Metropolitan's drawing cannot be the drawing described, as it shows neither tulips nor pear.
3. Maurice Tourneux, ed., *Correspondance littéraire, philosophique et critique par Grimm, Diderot, Raynal, Meister, etc.,* 16 vols. (Paris, 1877–82), vol. 11, p. 465.
4. See, for example, Salmon 1996, fig. 53. One wonders whether there are not more examples of Portail's still-life art to be found. For example, in the Hôtel Drouot, Paris, sale of March 18, 1987, lot 106 (ill.), a watercolor and black chalk still life of flowers ascribed to Anne Vallayer-Coster bears a striking resemblance to similar work by Portail.
5. Faré and Faré 1976, p. 20.
6. For these, see Arnauld Brejon de Lavergnée, Jacques Foucart, and Nicole Reynaud, *Catalogue sommaire illustré des peintures du Musée du Louvre,* vol. 1, *Écoles flamande et hollandaise* (Paris, 1979), p. 48, inv. 1218, 1219.

JEAN-BAPTISTE OUDRY

Paris 1686–1755 Beauvais

21. *View in the Gardens of Arcueil*

Charcoal, stumped, black chalk heightened with white, on blue-green paper, 12⅜ x 20⅝ in. (31.3 x 52.3 cm). Signed and dated in pen and brown ink at lower left: *JB Oudry 1744*

The Metropolitan Museum of Art, Rogers Fund, 1910 (10.45.28)

The estate and gardens of the prince de Guise at Arcueil near Paris, already running to seed in the 1740s and demolished in 1752, attracted many eighteenth-century artists, drawn there by the captivating blend of artifice and unchecked nature.[1] Their drawings, like the Natoire in this exhibition (no. 22), are beguiling, atmospheric, and decorative. None, however, share the vision of Oudry, who lived nearby from 1742. Oudry's Arcueil, seen in a group of some fifty sheets, most of them black chalk with white heightening on blue paper,[2] has a quiet stillness unlike the drawings of his compatriots. In contrast to Natoire, Oudry eliminated the extraneous from these scenes, concentrating on light and shade, effects of chiaroscuro. Only rarely are people present in Oudry's Arcueil, and there is little sense of the anecdotal. Such an omission, common in sketches, is unusual in drawings of such finish. As Bacou points out,

Arcueil was to Oudry what the Villa d'Este in Tivoli would be to Fragonard and Robert in the 1760s, and the focus and intensity of each drawing is riveting.[3]

The site of the Metropolitan's drawing was a favorite with Oudry, who drew it from various vantages at least four times. It was a spot in the garden where two flights of stairs, one curved and one straight, ascended toward each other at right angles, meeting on a landing with trellised pavilions, and then ascended again. The Metropolitan's drawing includes the bottom of both stairs, the pedestal and curving bottom step of one just visible to the left, while the bottom step of the straight stair, as well as the unobstructed flow of light down the stairs onto the grass below, occupies the middle ground. The rise of that stair is lightly indicated by a diagonal line in the foliage. An allée connects the two. A recent acquisition by the Musée de l'Île-de-France, Sceaux,

21

dated 1744, is drawn from the other end of the allée, in front of the straight stair, the artist looking down the allée toward the curving stair, only the bright sun on the grass indicating its presence.[4] Oudry drew complete frontal views of both stairs, the straight stair in a drawing at Sceaux (fig. 21.1) and the curved stair in a drawing in the Louvre (fig. 22.1).[5] The Natoire in this exhibition shows the same stair. For Natoire, the pattern of the steps is a decorative element, and a focus of human activity. Oudry ignores both these aspects. His interest in the multitiered stair is in what the man-made structure does to the light of the garden. In his drawing light floods down the steps, unchecked by trees, often obliterating the pattern of the steps themselves. MTH

21.1. Jean-Baptiste Oudry, *Vue d'un escalier de face dans un parc,* ca. 1744. Black chalk with white heightening, stumping, on blue paper, 12 x 20¼ in. (30.4 x 51.5 cm). Musée de l'Île-de-France, Sceaux

PROVENANCE: William Young Otley (?) [per inscription on back of mount]; Rimmel (?) [per inscription on back of mount]; purchased by The Metropolitan Museum of Art.

LITERATURE: Michael Benisovich, "The French Drawings of the Metropolitan Museum," *The Burlington Magazine* 82, no. 480 (March 1943), p. 73; Bean 1964, no. 57 (ill.); Opperman 1977, vol. 2, pp. 850–51, no. D1052; Opperman 1982, pp. 242–43, no. 137 (ill.); Bean and Turčić 1986, p. 199, no. 222.

1. They included François Boucher, Jacques-André Portail, Jacques-Nicolas Julliard, and Charles-Joseph Natoire. For discussions of

Arcueil as a subject, see Roseline Bacou, *French Landscape Drawings and Sketches of the Eighteenth Century,* exh. cat., London, British Museum (London, 1977), p. 30, no. 27. See also J.-F. Méjanès, "A Spontaneous Feeling for Nature: French Eighteenth-Century Landscape Drawings," *Apollo* 104, no. 177 (November 1976), pp. 396–404.

2. Opperman (in Opperman 1982, pp. 232f, and nos. 129–38) proposes that Oudry made as many as one hundred. He dates them to 1744–47. See also Denison 1993, p. 94, no. 40.

3. Bacou, *French Landscape Drawings and Sketches of the Eighteenth Century,* p. 30.

4. See *Jardins en Île-de-France: Dessins d'Oudry à Carmontelle, collection du cabinet des dessins du Musée de l'Île-de-France,* exh. cat., Musée de l'Île-de-France, Château de Sceaux (Sceaux, 1992), pp. 70–71, no. 30.

5. For the drawing in the Louvre, see Musée du Louvre 1907– , vol. 12, p. 156, no. 281 (ill. p. 152), *Escalier entre des massifs d'arbres;* for the drawing at Sceaux, *Jardins en Île-de-France: Dessins d'Oudry à Carmontelle,* pp. 72–73, no. 31.

For the layout of the gardens and eighteenth-century maps, see André Desguine, *L'oeuvre de J.-B. Oudry sur le parc et les jardins d'Arcueil* (Paris, 1950). See also Opperman 1982, p. 244, under no. 138.

CHARLES-JOSEPH NATOIRE

Nîmes 1700–1777 Castel Gandolfo

22. *View in the Gardens of Arcueil*

Pen and brown ink, brush and brown wash, and blue gouache over black chalk and stump, heightened with white, 9⅛ x 12¹¹⁄₁₆ in. (23.2 x 32.2 cm). Signature and date in pen and brown ink partially visible at lower left: [*C Natoire . . . 47* (?)]. Inscribed at lower right in pen and brown ink: *arcueil,* with brown ink framing lines

Private collection

From the letters he exchanged with the *surintendant des bâtîments,* we know that Nicolas Vleughels, as director of the Académie de France in Rome, encouraged the pensionnaires to go into the Roman countryside and make sketches after nature.[1] While there is every likelihood that Natoire's lifelong interest in landscape was born during these years, no landscape drawings have been securely documented to his first Italian period.[2] Instead, the earliest known landscape studies by Natoire's hand are those made in the park at Arcueil, outside Paris, between 1747 and 1751. Of the fourteen views of Arcueil sold as a lot in Natoire's posthumous sale, only a handful are traced today.[3] As a group, they bear all the hallmarks of his mature style, the close observation of nature imbued with a timeless lyricism and cool luminosity.

The steady traffic of draftsmen to the estate of the prince de Guise at Arcueil is widely credited to the example of Jean-Baptiste Oudry, who began to work there about 1744 (see no. 21). The garden architecture, marked by elaborate structures of wood and metal trelliswork connected by a series of terraces and stone stairs, was already crumbling and overgrown by the 1740s and would be destroyed not long after. It was precisely this state of picturesque decay that appealed to the eighteenth-century aesthetic, deriving, in part, from a familiarity with Italianate scenes of ruins where

22.1. Jean-Baptiste Oudry, *Escalier entre des massifs d'arbres,* 1744. Black chalk, heightened with white, on faded blue paper, 12¾ x 18⅝ in. (32.5 x 47.2 cm). Musée du Louvre, Paris

the fecundity of nature inevitably triumphs over the ephemeral achievements of mankind. In contrast to the remarkable absence of human presence in many of Oudry's highly finished sheets, Natoire consistently enlivened his scenes with a changing cast of pastoral types, their decorative function reinforced by their occasionally unfinished or transparent state.

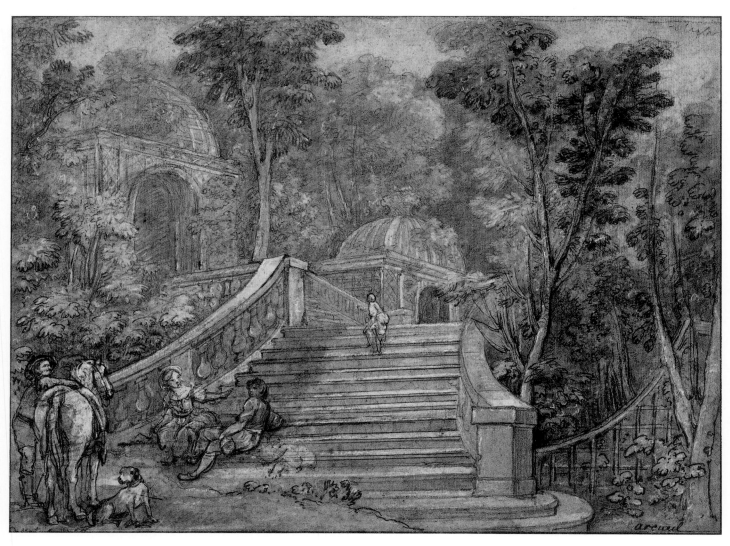

22

It has already been pointed out that the wide curving stair depicted by Natoire also appears in a longer view by Oudry in the Louvre (fig. 22.1).[4] What has not been observed is that the lower right newel is the same one that functions as a repoussoir on the left side of the Metropolitan's Oudry. The curved trellis, the tree with the low, forked branch, and the bush at its base all correspond. Although the dates on the sheets suggest they were done three years apart, one can imagine the two artists stood on the same spot, facing at slightly different angles. Comparing the present sheet to the Louvre view from farther back, one notices corresponding nicks and cracks in the stonework, all supporting the notion that, despite stylistic differences, the two artists shared a fidelity to observed reality. The only major difference is in the articulation of the two pavilions built of trelliswork visible on the upper terrace of both views. Oudry's truncated structures sprout fanciful domed roofs in Natoire's drawing.

Excepting the unlikely possibility of major repairs in the intervening three years, it seems more probable that Natoire embellished than that Oudry suppressed.

PS

PROVENANCE: Probably in the group of fourteen views of Arcueil grouped as lot 287 in Natoire's estate sale, Paris, December 14, 1778, p. 38; anonymous sale, Christie's, London, March 12, 1948, lot 35, ill. (as Robert); sold to Houthakker; P. de Boer, Amsterdam, in 1974; Stichting Collectie P. en N. de Boer sale, Christie's, London, July 4, 1995, lot 86; [W. M. Brady & Co., Inc., New York]; private collection.

LITERATURE: *Franse tekenkunst van de 18de eeuw uit nederlandse verzamelingen,* exh. cat., Amsterdam, Rijksprentenkabinet, Rijksmuseum ([Amsterdam, 1974]), pp. 69–70 (ill. p. 151); J.-F. Méjanès, "A Spontaneous Feeling for Nature: French Eighteenth-Century Landscape Drawings," *Apollo* 104, no. 177 (November 1976), p. 404, n. 5; Duclaux 1991, p. 27, no. 24 (ill.).

1. Bernard Hercenberg, *Nicolas Vleughels: Peintre et directeur de l'Académie de France à Rome, 1668–1737* (Paris, 1975), pp. 18–19, 22.

2. Duclaux 1991, p. 7.

3. Charles Natoire estate sale, Paris, December 14, 1778, p. 38, lot 287. An anecdotal scene of figures and animals on a landing, dated 1746, was acquired by the Art Gallery of Ontario in 1987 (inv. 87/35). A sheet depicting a lion-flanked fountain, to which Natoire has added a group of female bathers, was with Paul Prouté, S.A., in 1991 (see their fall catalogue, *Dessins, estampes anciens du XVe au XVIIIe siècle* [Paris, 1991], p. 20, no. 26). *Stairway at Arcueil with Figures and Peacocks at Midday* came up at auction at Christie's, London, July 2, 1996, lot 235 (bought in). Finally, an untraced sheet, *L'aqueduc d'Arcueil,* dated 1747, is recorded in the second Masson sale, Hôtel Drouot, Paris, December 6, 1923, p. 29, lot 92. The first three can be compared to drawings of the same areas of the park by Oudry; see Opperman 1982, pp. 242–44, figs. 136, 137a, 138.

4. Stichting Collectie P. en N. de Boer sale, Christie's, London, July 4, 1995, lot 86.

FRANÇOIS BOUCHER

Paris 1703–1770 Paris

23. *Les charmes de la vie champêtre*

Black chalk, 10½ x 12⅝ in. (26.6 x 32 cm). Inscribed in graphite at lower right: *F Boucher.* Jean Masson's collector's mark (Lugt 1494a) at lower left

Private collection

Just as Watteau invented the genre of the *fête galante,* Boucher would become known for his Rococo formulation of the pastoral, in which idealized landscapes are the setting for romantic idylls featuring protagonists of ambiguous social stature: although they seem to play at peasant pursuits, their silken dress offers only the slightest suggestion of rustic attire, and their generously exposed flesh, always milky white, is unmarked by labor. Diderot's disparaging remark about Boucher—"that man is capable of everything—except the truth"[1]—reflects both the nature of Boucher's achievement and the mixed reaction it engendered later in the century.

This fresh and energetic study in black chalk suggests that it was Boucher's *première pensée* for the painting *Les charmes de la vie champêtre* (fig. 23.1), which was probably at the château de Versailles in the later eighteenth century and is today in the Louvre, although no documentation for its early provenance survives.[2] Once the compositional scheme was indicated on paper in rapid black chalk notations, Boucher turned not to nature but to his own cache of drawn studies to produce the final painted version. The types of trees and the architecture visible in the distance in the painting evoke an Italianate landscape based both on his own experience and on secondary sources. The pose of the seated man echoes that of a similar figure in *La collation,* one of Boucher's designs for the Beauvais tapestry series Les Fêtes Italiennes,[3] for which there is a sanguine sketch,[4] as does, more loosely, that of the blond woman opposite him. For this figure, Boucher must have reused the study in the Nationalmuseum, Stockholm, which has long been catalogued as by Natoire.[5] The pose of the goat to the right also recurs in Boucher's oeuvre.[6]

The most significant adjustment made from the New York *première pensée* to the painting in the Louvre has to do with the grouping of the three figures. In the chalk study, the shepherd seated on the ground propositions the seated shepherdess whose left arm he clasps at both the elbow and the hand. The second woman, who stands behind them and is only partially visible, leans forward in a protective manner. In the painting it is no longer clear to whom the man is making his advances; it is the dark-haired girl, now brought forward and inserted between the other two, who pulls back, coyly resisting his urgent entreaties with a wagging finger.[7] Such sexual tensions and ambiguities are a recurring theme in Boucher's pastoral and mythological scenes.

Like many of Boucher's compositions, this "scene of country life" was disseminated in other media.[8] A vertical version of the painting was engraved by Jean Daullé in 1757.[9]

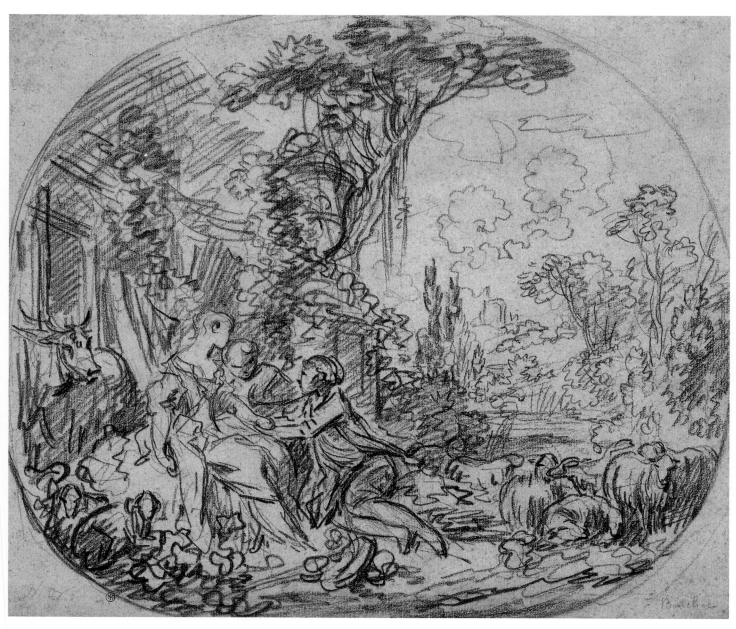

23

23.1. François Boucher, *Les charmes de la vie champêtre*. Oil on canvas, 39⅜ x 57½ in. (100 x 146 cm). Musée du Louvre, Paris

Interestingly, it seems to have been the present sheet, rather than the finished painting, that provided the model for François Antoine Aveline's engraving (fig. 23.2), published in 1742, which placed the scene within an ornamental surround.[10] At the time it was sold with the Masson collection in 1923 and until 1967, the present sheet had as a pendant an oval black chalk sketch of two couples playing on a see-saw (fig. 23.3),[11] although no painting of this subject has come to light.

P S

PROVENANCE: Jean Masson, Paris; his sale, Paris, May 7–8, 1923, lot 20; bought (with its pendant, lot 19) by James Schwob d'Héricourt; (per Ananoff, with Mme Schwob d'Héricourt in 1966); [Paul Prouté, S.A., Paris, in 1967]; [Jean-Pierre Selz, Paris]; private collection.

LITERATURE: Pierre de Nolhac, *Exposition François Boucher (1703–1770)*, exh. cat., Paris, Hôtel de Jean Charpentier (Paris, [1932]), p. 28, no. 65; Hermann Voss, "Boucher's Early Development: Addenda," *The Burlington Magazine* 96, no. 616 (July 1954), p. 209 (ill. p. 208); Ananoff 1966, vol. 1, p. 77, no. 218; Ananoff 1976, vol. 1, p. 268, no. 147/1 (ill. p. 266); *François Boucher, gravures et dessins provenant du Cabinet des Dessins et de la collection Edmond de Rothschild au Musée du Louvre*, exh. cat., Paris, Musée du Louvre (Paris, 1971), p. 53, under no. 25; Jean-Richard 1978, pp. 77–78, under no. 197.

1. "Cet homme a tout—excepté la vérité" is quoted from Diderot's 1761 *Salon* and translated by Alastair Laing in "Boucher: The Search for an Idiom," in New York, Detroit, and Paris 1986, p. 56.
2. According to Alastair Laing (letter, January 1, 1998), the early provenance of this painting provided in Ananoff 1976 (vol. 1, p. 266, no. 147) cannot be documented. There is no evidence to support the claim either that it was commissioned in 1737 or that

23.3. François Boucher, *La bascule*. Black chalk, 10¾ x 12⅝ in. (27.2 x 32 cm). Present location unknown

Les présents du berger was originally its pendant. Furthermore, the canvas may have been cut down from an upright rectangular format, rather than filled in from an oval shape.
3. See Ananoff 1976, vol. 1, p. 261, no. 135. The tapestry series is studied in Edith Appleton Standen, *European Post-Medieval Tapestries and Related Hangings in The Metropolitan Museum of Art*, vol. 2 (New York, 1985), pp. 507–18; Edith A. Standen, "Fêtes Italiennes: Beauvais Tapestries after Boucher in The Metropolitan Museum of Art," *Metropolitan Museum Journal* 12 (1977), pp. 107–30, and Regina Shoolman Slatkin, "The Fêtes Italiennes: Their Place in Boucher's Oeuvre," *Metropolitan Museum Journal* 12 (1977), pp. 130–39.

4. The sanguine study for the seated man is in the Musée du Louvre, Paris (inv. MI559). Presumably made for the *Collation,* it may have been reused for *Les charmes de la vie champêtre.* The drawing is illustrated in Ananoff 1976, vol. 2, p. 262, fig. 475.

5. Alastair Laing recognized the sheet as by Boucher and annotated the mount. The drawing is illustrated in Bjurström 1982, no. 1072 (as Natoire).

6. A drawing of a goat in black and white chalk may have been the source for several of these. See Slatkin 1973, p. 78, no. 60.

7. *La fontaine de l'amour,* a lost work known from a print (see Ananoff 1976, vol. 1, p. 269, no. 149), includes another reprise of this group, this time with both versions of the woman in the center, increasing the number of figures to four.

8. For an adaptation on a Vincennes porcelain plate, see Gisela Zick, "D'après Boucher: Die 'Vallée de Montmorency' und die europäische Porzellanplastik," *Keramos,* no. 29 (July 1965), p. 39, fig. 42.

9. Jean-Richard 1978, pp. 165–68, no. 571. It is unclear whether Daullé based his print on the king's version (which would later be cut down), or on another version, now lost. Aside from the added areas at top and bottom, the internal proportions, especially in the architectural elements, are different, although these differences may just be liberties taken by the printmaker. Voss reproduces a vertical version of the composition with Messrs. J. Böhler, Munich (Hermann Voss, "Boucher's Early Development—Addenda," *The Burlington Magazine* 96, no. 616 [July 1954], p. 207, fig. 21), but the correspondence is not specific in this case either.

10. Jean-Richard 1978, pp. 77–78, no. 197.

11. This drawing was engraved by Gabriel Huquier as the pendant to the print by Aveline (fig. 23.2), which is based on the New York drawing; see Jean-Richard 1978, p. 276, no. 1124.

CHARLES-JOSEPH NATOIRE

Nîmes 1700–1777 Castel Gandolfo

24. *Rinaldo and Armida*

Pen and brown ink and brush and brown wash over black chalk, heightened with white, on blue paper, 10⁷⁄₁₆ x 10¹¹⁄₁₆ in. (26.5 x 27.1 cm). Signed bottom center in pen and brown ink: *C. natoire*; collector's mark of L. D. Lempereur (Lugt 1740) at lower right

Mr. and Mrs. Felix Rohatyn

The love story of the Christian knight Rinaldo and the pagan enchantress Armida provided the most often illustrated episodes of *Gerusalemme liberata* (1581), Torquato Tasso's epic poem about the Christian crusade to liberate Jerusalem from the Saracens in 1099. While the triumph of moral duty over physical temptation was Tasso's theme, French artists of the eighteenth century preferred to depict the moment of voluptuous enchantment over the inevitable leave-taking. As Alastair Laing has suggested, the popularity of the subject in French Rococo art may be due as much to the success of the opera *Armide* by Jean-Baptiste Lully, which between its first production in 1686 and 1761 was revived eight times, including stagings in 1746 and 1747.[1]

Natoire's treatment of the subject in the Rohatyn drawing distills the story to its essential components. Rinaldo sits in the magical garden, his weapons at his feet, gazing spell-bound into the sorceress's eyes. The mirror, symbol of Armida's magical powers, is held aloft by an airborne putto, while other putti play at the couple's feet. The arrival on the scene of Rinaldo's comrades-in-arms, Carlo and Ubaldo, partly visible in the bushes to the right, will set into motion Rinaldo's departure from the garden and return to knightly duties. This is accomplished, in the poem, by Carlo and Ubaldo's holding up Rinaldo's reflective shield, so that he can see how love has rendered him weak and powerless. A conventional attribute of the scene, the shield is absent in Natoire's compact composition. Also atypical is the fact that, judging from their hand gestures, Rinaldo and Armida appear to be conversing.

The function and dating of the sheet present some questions. Presumably, it was made as part of a larger commission for a decorative scheme, although no related painting

24.1. Charles-Joseph Natoire, *Rinaldo and Armida*. Black chalk, brush and gray and brown wash, heightened with white on gray-blue paper, 9¾ x 14 in. (24.7 x 35.7 cm). Musée du Louvre, Paris

survives,[2] and it may have formed a pair with the *Bacchus and Ariadne* in the Lempereur sale of 1773. The quatrefoil outline drawn in black chalk suggests that it was a design for a *trumeau,* to be hung over a mirror.

It is also possible that the Rohatyn sheet is an early idea for Natoire's more fully realized treatment of the subject in the Louvre (fig. 24.1), part of a group of five drawings (three in Paris, one in Lille, and one in Frankfurt) illustrating scenes from *Gerusalemme liberata,* also unconnected to any known paintings.[3] The Paris version, in a more horizontal shaped surround, incorporates more of the traditional pictorial elements: Rinaldo's shield and helmet, the chains of flowers with which Armida binds Rinaldo, and the curving architectural backdrop that represents Armida's palace. In this more elaborate treatment, one feels strongly the precedents of Domenichino and Boucher,[4] both of whose paintings of Rinaldo and Armida would have been known to Natoire. In the simplified presentation of the New York sheet, however, where the lovers gaze adoringly into each other's eyes, Natoire extracts from his literary source the universal theme of love's enchantment.[5]

The dating of the group to which the Louvre sheet belongs is a matter of debate. It has generally been assumed that Natoire's decorative projects must date from between his return to Paris in 1730 and his return to Rome in 1751.[6] Running counter to this theory, one of the Louvre Tasso drawings is annotated "Natoire f. Rome 1755." Sophie Raux has suggested that Natoire received a decorative commission before leaving Paris and continued to work on the designs over many years; she dates the group to about 1750–55.[7] It is

curious, however, that such a large commission would find no mention in the extensive *Correspondance des directeurs* from this period. Until more information comes to light, the New York *Rinaldo and Armida* should be dated to the late 1740s–early 1750s.

P S

PROVENANCE: L. D. Lempereur sale, Paris, May 24, 1773, part of lot 574 ("deux, idem, l'un représente Bacchus & Arianne, l'autre, Renaud & Armide"); private collection, Munich; [Colnaghi, New York]; Mr. and Mrs. Felix Rohatyn.

LITERATURE: Charlotte von Prybram-Gladona, *Unbekannte Zeichnungen alter Meister aus europäischem Privatbesitz* (Munich, 1969), p. 24, no. 26 (ill.); Musée du Louvre 1907– , vol. 12, p. 36, under no. 54.

1. See New York and Paris 1986, pp. 160–62 (entry by Alastair Laing).

2. Ferdinand Boyer lists a painting of the subject signed and dated 1768 (*Catalogue raisonné de l'oeuvre de Charles Natoire* [Paris, 1949], p. 56, no. 175), but the present drawing would seem to date stylistically to an earlier period.

3. The series is discussed most recently in Raux 1995, pp. 146–47, under no. 52.

4. Both paintings are in the Musée du Louvre, Paris: Domenichino (inv. 798); Boucher (inv. 2720).

5. Duclaux points out that the pose of the couple in the Rohatyn sheet echoes in reverse that of the couple to the left in the Louvre *Triomphe de l'amour.* See Musée du Louvre 1907– , vol. 12, p. 31, no. 42.

6. See Musée du Louvre 1907– , vol. 12, p. 31 (under no. 42); and Lise Duclaux, "Natoire dessinateur," in Troyes, Nîmes, and Rome 1977, p. 21.

7. Raux 1995, p. 147.

C. natoire

24

JEAN-MARC NATTIER

Paris 1685–1766 Paris

25. Self-Portrait

Black chalk with touches of white chalk, on brown paper, 16⅛ x
9⅝ in. (41 x 24.5 cm)

The Metropolitan Museum of Art, Purchase, Karen B. Cohen Gift
in honor of Jacob Bean, 1987 (1987.197.1)

This drawing was made in preparation for a painting,
now in the Musée National de Versailles, of the artist
and his family (fig. 25.1). Seated at the harpsichord is
Nattier's wife, Marie-Madeleine de la Roche. The four chil-
dren (Nattier had eight) are probably Marie-Catherine
Pauline, Charlotte Claudine, Madeleine Sophie, and
Nicolas, who holds the pencil box. The painting was begun
in 1730; it was not completed until 1762.[1] In the interim,
Nattier suffered the loss of his wife (in 1740) and the young
Nicolas (in 1754) who, barely twenty, drowned in the Tiber.
It has been speculated that these bereavements account for
Nattier's delay in completing the canvas, and indeed, X-ray
examination reveals many changes, hesitations, and addi-
tions.[2] Also under the painting, its orientation perpendicu-
lar to the visible composition, is a portrait of a man in a large
wig, identified by Xavier Salmon as Nattier himself.[3] It is
thus possible to track the transformation of the canvas from
its initial incarnation as a self-portrait to the more poignant
representation of the artist with his loved ones.

In the earlier version, visible in the X-ray, one sees a man
facing front, in full wig and elegant clothes. In the drawing,
Nattier reinterprets his own character. In work clothes, his
palette prominent, his eyes focused to the right, probably on
his easel, Nattier emphasizes his professional identity.
Perhaps the idea was to set his family in his studio, posed for
a group portrait, in the manner of Velázquez's *Las meninas.*
Still working on the same sheet, however, Nattier apparently
changed his mind, arriving at the conception that appears
in the finished work. In the upper right corner of the draw-
ing, one sees a hand cupping a chin, the gesture Nattier ulti-
mately opted for in the Versailles painting. In changing the
hand, he changed his role. No longer an elegant solitary
gentleman or an active artist, he portrays himself finally as
a thoughtful, much older man. This small change is indica-
tive of the larger shift of intention that takes place in the
painting, which has become both family portrait and
memento mori. In the painting the figure of Nattier is iso-
lated, his palette reduced in importance, his work clothes
replaced by a dressing gown more appropriate to a family
gathering. He looks out to include the viewer in his
thoughts; the other two family members who look out at the
viewer are both dead by this time, their youth eternally pre-
served. The candles on the harpsichord have been snuffed
out. The drawing, done as part of the process of replacing
one self-image with another, represents both Nattier's image
of himself as an artist and, in the upper right corner, the face
Nattier ultimately chose to include in the finished work, a
pensive man touched by age and sorrow.

MTH

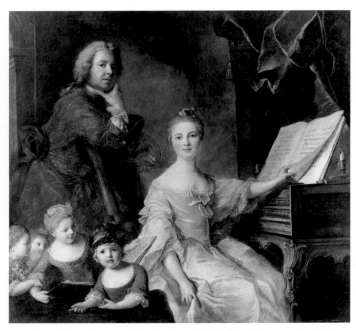

25.1. Jean-Marc Nattier, *The Artist with His Family,* 1730–62. Oil on
canvas, 58¾ x 65 in. (149 x 165 cm). Musée National de Versailles

PROVENANCE: [Colnaghi, New York]; purchased by The Metro-
politan Museum of Art.

LITERATURE: Lawrence Turčić, "New York: Four Exhibitions of
Drawings," *The Burlington Magazine* 129, no. 1014 (September 1987),
p. 622; Salmon 1997, pp. 5–6 (ill. p. 3).

25

1. The harpsichord bears the following inscription, probably by a family member: "Tableau de lattelier de M. Jean-Marc Nattier, trésorier de L'Académie Royale de Peinture et de Sculpture commencé en 1730 et fini par Le dit S. En 1762." The painting was exhibited at the Salon of 1763, no. 16.

2. See X[avier] S[almon], "L'artista i la Seva família, 1762," *Versailles: Retrats d'una societat (segles XVII–XIX),* exh. cat., Barcelona Centre Cultural de la Fundació "la Caixa" (Barcelona, 1993), pp. 113–15 (English summary, pp. 207–8).

3. Ibid., p. 208.

CHARLES-ANTOINE COYPEL

Paris 1694–1752 Paris

26. *Portrait of an Abbé (Self-Portrait?)*

Black chalk, stumped, heightened with white, on gray-blue paper, 13⅛ x 10⅞ in. (33.4 x 27.5 cm), folded

Alan Wintermute and Colin Bailey

This forthright and naturalistic image has been described as a self-portrait,[1] and the face of the model certainly bears a strong resemblance to known images of Coypel (for example, fig. 26.1). It is not surprising that someone of theatrical bent himself (see no. 15) and who produced the memorable portrait of Jélyotte in costume in the Louvre would have chosen to portray himself in costume.[2] Role portraits, based on mythological, allegorical, or theatrical characters, were routine by the time this portrait was made, about 1740. What is unexpected is the role indicated by the clothing, that of an abbé, a man of the church. By the eighteenth century, it is true, the position of abbé, or abbot, was only nominally clerical, having become largely an honorary title that allowed the younger sons of the aristocracy an income. Nevertheless, it was an unusual role for the sitter of a self-portrait to assume, and one would be hard pressed to cite another example. The presentation of the figure, too, raises doubts about the identification, so straightforward and at ease does the figure inhabit his role, as if it were his day-to-day guise.

While the face in the drawing resembles Coypel's (the almond-shaped eyes, uniform brows, and long thin nose, known from other self-portraits), many of his portraits of other men include the same features.[3] It might be the portrait of an actual abbé, and indeed Coypel did two portraits of abbés in precisely this manner, half-length in an oval frame. In one of these, that of Jean-Antoine de Maroulle, abbé de Maroulle (1674–1726; fig. 26.2), the sitter holds a portfolio in much the same way that our sitter holds a book, with the same graceful, attenuated fingers. Coypel's other

26.1. Charles-Antoine Coypel, *Self-Portrait,* 1734. Pastel, 38⅝ x 31½ in. (98 x 80 cm). The J. Paul Getty Museum, Los Angeles

26

26.2. Henri-Simon Thomassin (1687–1741), engraving after Charles-Antoine Coypel, *Portrait of Jean-Antoine de Maroulle.* Bibliothèque Nationale, Paris

26.3. Nicolas Tardieu (1674–1749), engraving after Charles-Antoine Coypel, *Charles d'Orléans, abbé de Rothelin.* Bibliothèque Nationale, Paris

known portrait of an abbé, the portrait of Charles d'Orléans, abbé de Rothelin (1691–1744; fig. 26.3), closely resembles the man in the Wintermute/Bailey drawing, with the same almond eyes gazing directly out at the viewer, straight brows, long nose, determined chin, and unpowdered hair.[4] He lacks only the book. The present sheet would appear to be a study for another engraving of this type, and not a costume piece. Perhaps Coypel, preparing a series of abbé portraits such as those found in the engravings, even used himself as a model. MTH

PROVENANCE: Sale, Sotheby's, New York, January 9, 1996, lot 38; Alan Wintermute and Colin Bailey.

Unpublished.

1. In Sotheby's, New York, sale catalogue of January 9, 1996, lot 38.
2. See Compin and Roquebert 1986, vol. 3, p. 172 (ill.).
3. See Lefrançois 1994, pp. 90, 110, 136–40.
4. The painted version of this portrait, signed and dated 1742, was on the art market in 1998 (see Christie's, New York, May 22, 1998, lot 124, pp. 138–39).

MAURICE-QUENTIN DE LA TOUR

Saint-Quentin 1704–1788 Saint-Quentin

27. Portrait of Mlle Dangeville

Colored chalks, stumped, on light blue paper, 11¼ x 9⅛ in. (28.7 x 23.2 cm)

The Pierpont Morgan Library, Purchased on the von Bulow Fund (1981.12)

La Tour frequented the theaters of Paris and found among the female performers vivacious and charismatic subjects for his pastel portraits. His thirty-year liaison with the singer and actress Marie Fel (1713–1794) would also have drawn him into theatrical circles, explaining the number of actresses who sat for him. The subject of the present sheet, Marie-Anne Botot (1714–1796), called Mlle Dangeville, was a celebrated actress of the Comédie Française from 1730 until her retirement in 1763. Known for the range of roles she played and for her lively persona, Dangeville is praised in Bachaumont's *Mémoires secrets,* published in 1780: "You alone are ageless, inimitable *Dangeville!* Always fresh, always new. Each time one sees you, it is as if for the first time."[1]

While La Tour made at least three sketches of Mlle Dangeville, no finished pastel is recorded. In his *préparations,* quick sketches made from life, one sees the struggle to capture not just the physiognomy but also the fleeting expression, an essence rather than a projection. Such objectives, acknowledged in contemporary Salon criticism,[2] are apparent in the candor and suppressed amusement of the Morgan Library's sketch.

Unfortunately, many of La Tour's *préparations* come down to us without inscriptions. The identity of the sitter in the present sheet was debated in 1908[3] and again in the 1920s,[4] but has been accepted since then on the basis of its resemblance to a group of portraits of the actress in various media, including a signed, dated, and inscribed portrait bust by Jean-Baptiste Defernex in the Museum of Fine Arts, Boston (fig. 27.1), and a pastel sketch by La Tour once owned by the Goncourt brothers and now in the Louvre (fig. 27.2) inscribed on the verso, on what appears to be an eighteenth-century label, "Mlle Dangeville."[5] Closely related to the Louvre *Dangeville* is a pastel study in the Musée Antoine Lécuyer de Saint-Quentin.[6] *Préparations* were central to La Tour's method, not only as studies, but also to be cut out and pasted onto larger sheets to create finished portraits, as can be seen in the full-length seated portrait *Gabriel Bernard de Rieux,* in the J. Paul Getty Museum, Los Angeles,[7] with the artist working up the rest of the composition around these convincingly lifelike heads.

PS

27.1. Jean-Baptiste Defernex (1729–1783), *Portrait Bust of Marie-Anne Botot d'Angeville,* 1752. Terracotta, height 14³⁄₁₆ in. (36 cm). Museum of Fine Arts, Boston, Forsythe Wickes Collection

27.2. Maurice-Quentin de La Tour, *Mlle Dangeville.* Pastel, 12¼ x 8¼ in. (31.1 x 20.9 cm). Musée du Louvre, Paris

PROVENANCE: J. Auguste Carrier, Paris; his sale, Paris, May 5, 1875, lot 9 (per Gabriel Henriot, 1927); Mme Becq de Fouquières, Paris, in 1908; David David-Weill, Neuilly, by 1912; [Wildenstein]; purchased in 1941 by Mrs. Byron Foy, New York; Thelma Chrysler Foy estate sale, Parke-Bernet Galleries, Inc., New York, May 23, 1959, lot 634; private collection, New York; [E.V. Thaw and Co., Inc., New York]; The Pierpont Morgan Library.

LITERATURE: Leon Roger-Miles, *Cent pastels par Boucher, Rosalba Carriera, Chardin . . . ,* exh. cat., Paris, Galerie Georges Petit (Paris, 1908), p. 22 (ill. opp. p. 22); Jean Guiffrey, "L'exposition des cent pastels," *Monatshefte für Kunstwissenschaft* 1, no. 7/8 (1908), pp. 639–40; Maurice Tourneux, "L'exposition des cent pastels," *Gazette des Beaux-Arts,* ser. 3, 40 (1908), p. 9; Émile Dacier, *Les préparations de M.-Q. de La Tour, conservées dans les musées et les collections particulières* ([Paris, 1912]), n.p. (ill.), as "Portrait de femme," in the David Weill collection; Gabriel Henriot, "La Collection David Weill," *L'Amour de l'Art* 6, no. 1 (January 1925), p. 11, pl. XXI; Émile Dacier and P. Ratouis de Limay, *Exposition de pastels français du XVIIe et du XVIIIe siècle,* exh. cat., Paris, Hôtel Jean Charpentier (Paris, 1927), p. 42, no. 61; Émile Dacier and P. Ratouis de Limay, *Pastels français des XVIIe et XVIIIe siècles, études et notices* (Paris and Brussels, 1927), pp. 59–60, pl. XXVIII (as sitter unknown); Gabriel Henriot, *Collection David Weill,* vol. 2, *Pastels, aquarelles, gouaches, tableaux modernes* (Paris, 1927), pp. 29–30 (ill.); Albert Besnard and Georges Wildenstein, *La Tour: La vie et l'oeuvre de l'artiste* (Paris, 1928), p. 138, no. 92, pl. LXXII, fig. 127; *French XVIII Century Pastels, Water Colors and Drawings from the David-Weill Collection,* exh. cat., New York, Wildenstein ([New York, 1938]), no. 7, n.p.; Adrian Bury, *Maurice-Quentin de La Tour, The Greatest Pastel Portraitist* (London, Edinburgh, Oslo, 1971), p. opp. pl. 34; Charles Ryskamp, ed., *Twentieth Report to the Fellows of The Pierpont Morgan Library, 1981–1983* (New York, 1984), p. 270; Cara D. Denison, *French Drawings 1550–1825,* exh. cat., New York, The Pierpont Morgan Library (New York, 1984), no. 53, n.p.; Denison 1993, p. 128, no. 56 (ill. p. 129); Denison 1995, p. 22, no. 7 (ill. p. 28); Moscow and Saint Petersburg 1998, pp. 122–23, no. 55 (ill.).

1. Louis Petit de Bachaumont, *Mémoires secrets . . . ,* vol. 1 (London, 1780), p. 31.
2. See, for example, La Font de Saint-Yenne, *Sentimens sur quelques ouvrages de peinture, sculpture et gravure, écrits à un particulier en province,* quoted in Albert Besnard and Georges Wildenstein, *La Tour: La vie et l'oeuvre de l'artiste* (Paris, 1928), p. 56.
3. Jean Guiffrey proposed the sitter's identity as Mme de Mondonville; see "L'exposition des cent pastels," *Monatshefte für Kunstwissenschaft* 1, no. 7/8 (1908), pp. 639–40.
4. See Émile Dacier and P. Ratouis de Limay, *Pastels français des XVIIe et XVIIIe siècles, études et notices* (Paris and Brussels, 1927), pp. 59–60 (as sitter unknown); and Gabriel Henriot, *Collection David Weill,* vol. 2, *Pastels, aquarelles, gouaches, tableaux modernes* (Paris, 1927), pp. 29–30 (as Mlle Dangeville).
5. The arguments in support of the identification were put forward by Henriot, *Collection David Weill,* vol. 2, *Pastels, aquarelles, gouaches, tableaux modernes,* pp. 29–30.

Other portrayals that have been claimed to depict Dangeville include a marble bust by Monnot exhibited at the Salon of 1771; a marble bust by Jean-Baptiste Lemoyne in the Comédie Française, Paris; a painting by Jean-Baptiste Pater, known through an engraving by Le Bas (the last two reproduced in Émile Dacier, *Le musée de la Comédie-Française,* Paris [1905], opp. p. 60); and a pastel by Louis Vigée (reproduced in Jean Monval, *La Comédie-Française* [Paris, 1931], p. 43).
6. See Christine Debrie, *Maurice-Quentin de La Tour: "Peintre de portraits au pastel," 1704–1788, au Musée Antoine Lécuyer de Saint-Quentin* (Saint-Quentin, 1991), p. 105 (ill.).
7. Denise Allen, in *Masterpieces of the J. Paul Getty Museum: Paintings* (Los Angeles, 1997), pp. 82–83, no. 45 (ill.).

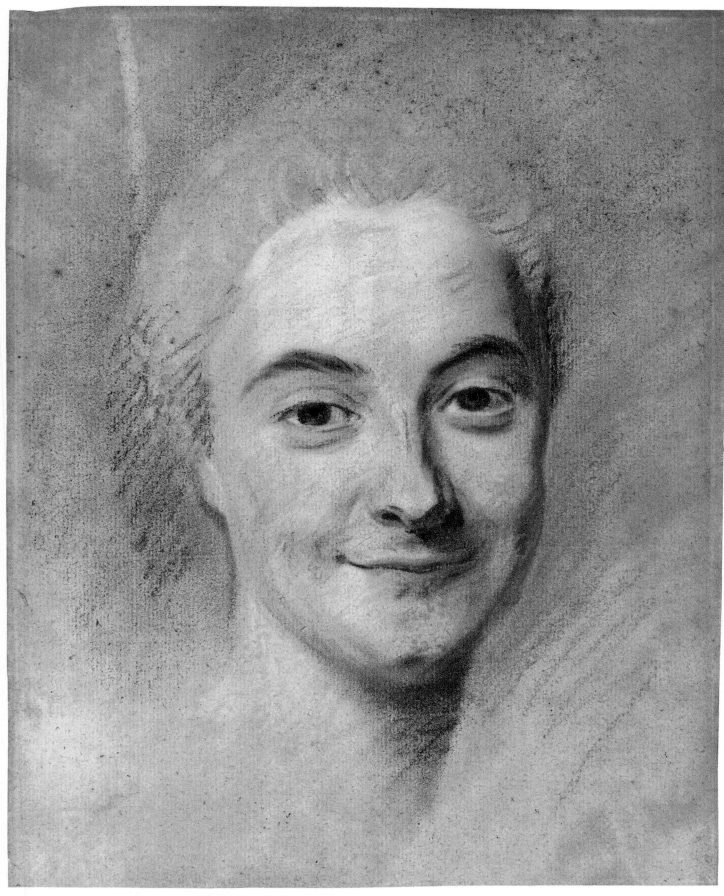

27

CARLE VANLOO

Nice 1705–1765 Paris

28. Portrait of a Seated Woman

Black chalk, heightened with white, on blue paper, 18⅜6 x 12¹³⁄₁₆ in.
(46.4 x 32.6 cm). Signed and dated at lower left, in pen and brown ink:
Carle Vanloo 1743; collector's mark of Jean Masson (Lugt supplement
1494a) at lower right

The Pierpont Morgan Library, Purchased on the von Bulow Fund
(1982.4)

Aside from the evidence of the drawings themselves,
we know nothing of the genesis of Carle Vanloo's
magnificent series of large portrait drawings dated
1743. Scholars have suggested that it may have been either a
specific commission or a response to a sudden need to raise
cash.[1] Done in black chalk, heightened with white, and
worked up to the edges of the sheet, the drawings depict
their subjects—men, women, and children—in comfort-
able domestic interiors, usually seated at a table with an
everyday prop—holding a tobacco box, knitting, and so
forth—with a disarming air of familiarity and immediacy.

Only seven sheets in the series were known to the orga-
nizers of the Vanloo exhibition in 1977.[2] In the 1980s, five
more came to light.[3] There are now, by this author's count,
twelve known compositions,[4] of which three are still
untraced and known only from photographs.[5] Of the twelve
sheets, plausible identifications of the sitters have been put
forward for five—the three acquired by the Louvre in 1981
and the two with Didier Aaron—based on early inscrip-
tions on their versos or frames. The idea voiced in earlier lit-
erature of a commission linking the sheets as a single
project[6] now seems less likely, given the identification of the
sitters of the Louvre and Didier Aaron groups as from
apparently unrelated families.

While portraiture, with its low rank in the academic hier-
archy of genres, was never more than an occasional side pur-
suit for Vanloo, his skills in this area were considerable.
Without knowing the identity of the sitter in the present
sheet, we can guess quite a bit about her. She sits stiffly in a
straight-backed chair, seemingly a visitor to, not an inhabi-
tant of, the salon densely hung with framed pictures.
Perhaps unaccustomed to direct scrutiny, she toys nervous-
ly with the handkerchief in her lap, her only accessory, her
proper, matronly demeanor enlivened by the faintest twin-
kle of the eye. From her imperfect grace comes the appeal-
ing naturalism of the sheet. And while the treatment of the

figure gives the impression of being objective and unem-
bellished, the technique is lush and free. Black chalk is used
both lightly and with an emphatic, velvety vigor. A gener-
ous use of white heightening gives to the figure's face and
clothes a pearly luster. PS

PROVENANCE: Jean Masson (Lugt supp. 1494a); his sale, Galerie
Georges Petit, Paris, May 7–8, 1923, lot 232 (ill.); bought by Sibillat;
sale, Casablanca, March 25, 1966, lot 32 (no catalogue) (per Rosen-
berg and Sahut 1977, p. 138); private collection, Cormeilles-en-Parisis;
André Meyer, New York; his sale, Sotheby Parke Bernet, New York,
October 22, 1980, lot 6 (ill.); [Richard J. Collins, Inc., New York];
[E. V. Thaw and Co., New York]; The Pierpont Morgan Library.

LITERATURE: Rosenberg 1972, pp. 216–17, under no. 141; Rosenberg
and Sahut 1977, p. 138, no. 409; Charles Ryskamp, ed., *Twentieth
Report to the Fellows of The Pierpont Morgan Library, 1981–1983*
(New York, 1984), pp. 272–73; Cara D. Denison, *French Drawings,
1550–1825,* exh. cat., New York, The Pierpont Morgan Library
(New York, 1984), no. 55; Denison 1993, p. 132, no. 58 (ill. p. 133);
Denison 1995, pp. 24–25, no. 8 (ill.); Moscow and Saint Petersburg
1998, pp. 126–27, no. 57 (ill.).

1. When Vanloo won the Prix de Rome in 1724, depleted coffers pre-
 vented the crown from underwriting his trip, as was the custom.
 Louis Réau describes Vanloo raising the necessary funds himself with
 a series of drawn portraits. See Louis Réau, "Carle Vanloo
 (1705–1765)," *Archives de l'Art Français* 19 (1938), p. 17. With the
 closely paced arrival of his second and third sons in the years 1743
 and 1744, Vanloo may again have needed additional funds. See
 Rosenberg and Sahut 1977, p. 21.
2. In addition to this sheet and a portrait of a seated man (with a differ-
 ent provenance) also in the Morgan Library (inv. 1971.11), Sahut lists
 a seated man in the Société Historique et Litteraire Polonaise, Paris, a
 seated man in the Nelson-Atkins Museum of Art, Kansas City, and
 two untraced drawings of seated women, both formerly in the
 Goncourt collection. In the section on lost drawings, she lists a sev-
 enth sheet of a seated man as no. 483. See Rosenberg and Sahut 1977,
 pp. 136–38, 153, nos. 404–9, 483.
3. Three drawings representing members of the Berthelin family
 entered the Louvre in 1981 (see Paris 1984a, pp. 54–55, nos. 80–81).
 A pair representing Jacques Aubert, a musician, and his wife, Marie
 Lecat, appeared at auction in 1988 (Hôtel Drouot, Paris, May 18,
 1988, lots 63–64) and are now with Didier Aaron, Paris.
4. Replicas or copies seem to exist for two of the compositions (the
 Morgan Library man and the Kansas City sheet); see Rosenberg and
 Sahut 1977, p. 137, under no. 406, and Launay 1991, p. 488, under
 no. 352.
5. See Launay 1991, pp. 487–90, nos. 351, 353, and 354. Domenique
 Cordellier expresses doubts that no. 353, the *Portrait d'homme assis,*

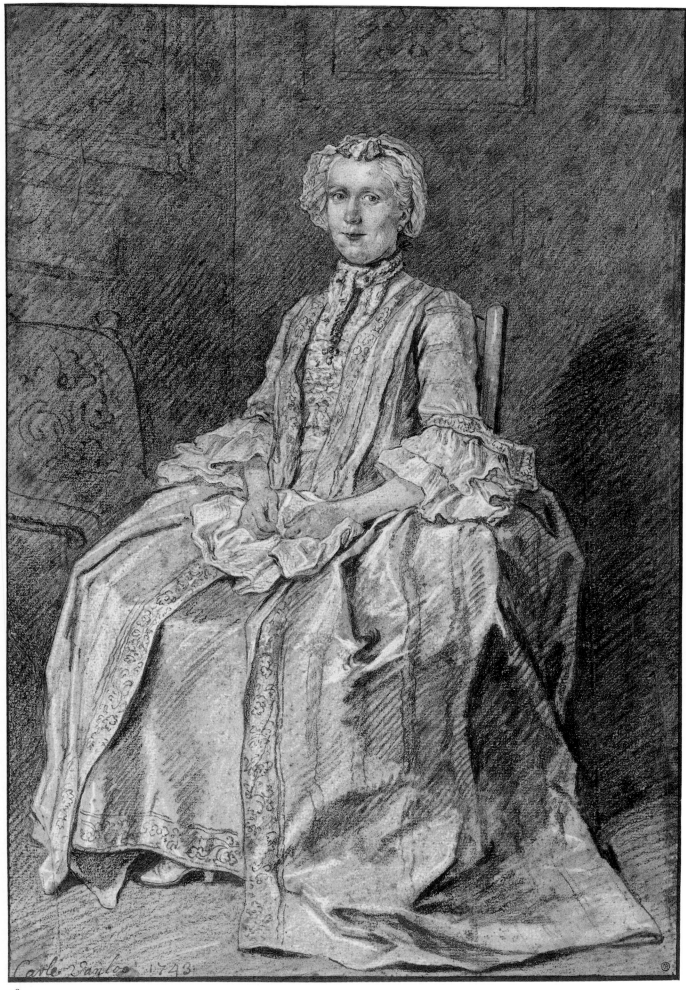

28

une tabatière dans la main gauche, should be considered part of the series; see Paris 1984a, p. 55, under nos. 80–81. Cordellier places in the same category a drawing of a *femme lisant,* sold as attributed to

Carle Vanloo in 1978 (Hôtel Drouot, Paris, June 14–15, 1978, lot 10). This drawing is not illustrated in the auction catalogue.

6. Rosenberg 1972, p. 216.

CARLE VANLOO

Nice 1705–1765 Paris

29. *Piety*

Pen and brown ink with white, pink, blue, and green gouache, diameter 9⅞ in. (25 cm)

Alan Wintermute and Colin Bailey

This gouache study was recognized as the work of Carle Vanloo by its present owners, who acquired it in 1994 at auction where it appeared under the designation "French school, eighteenth century." Marie-Catherine Sahut published a related design now in Dijon (fig. 29.1) in 1977 that she linked to a lost group of four round overdoors depicting allegorical figures of virtues commissioned by Christian VI, king of Denmark.[1] The two remaining studies are untraced.

The Danish court was one of many foreign courts in the eighteenth century that sought the services of French artists in the decoration of royal residences. During the reign of Christian VI (1730–46) hundreds of paintings were commissioned from French painters for the palace of Christiansborg, which was unfortunately gutted by fire in 1794. Joachim Wasserschlebe, a secretary to the Danish embassy in Paris, was given the task of allocating the commissions, a task made more difficult by the king's insistence that depictions of nudity were unacceptable. It also occurred to the king that asking for copies rather than original works might keep costs down. Nevertheless, despite these restrictions and suggestions, by 1741 Wasserschlebe had ready for shipment to Copenhagen nearly 140 paintings by leading French artists, most of them overdoors and *trumeaux de cheminées* often in preformed sets by individual artists, which would provide coherent ensembles for each room.[2]

That Wasserschlebe may have been more sophisticated in his artistic tastes than his employer emerges in his correspondence. In a letter of 1751 he offers his opinion of Vanloo: "Carle Vanloo has made some admirable things. He is a great painter and, because of his skills as a colorist, is regarded as the first painter of the modern school. But he needs space and grave, heroic subjects. His genius does not accommodate jest and is hardly suited to light or graceful subjects."[3] From the evidence of the Dijon and New York gouaches, the lost set of overdoors would certainly have accorded with Wasserschlebe's characterization. Dignified, fully draped, and well drawn, neither figure could be called light or gay. Nevertheless, the palette of *Piety,* even in the gouache, is refined and delicately balanced, with salmony pinks and

29.1. Carle Vanloo, *La générosité.* Pen and brown ink, blue, white, pink, and brown gouache, diameter 10¼ in. (26.1 cm). Musée Magnin, Dijon

29

mossy greens, a scheme carried over from the figure to the still life of fruit spilling out from the cornucopia.

The subjects of the four overdoors are given in a 1765 inventory of Christiansborg as conjugal fidelity, equality, generosity, and piety,[4] though back in France there was already confusion over the precise subjects of the gouaches. In his eulogy of Vanloo, written in 1765, Vanloo's fellow painter and biographer Michel-François Dandré-Bardon mentions the paintings sent to Denmark: "Quatre Vertus.

On croit que ce sont la Justice, la Magnanimité, la Prudence & la Valeur."[5] Conflicting accounts notwithstanding, the present image displays all the conventional attributes associated with the personification of piety: flame on head, upturned horn of plenty (representing charity), left hand on heart, and wings. It is not clear from the published sources who was responsible for the choice of these particular virtues. They are not the three theological virtues or the four cardinal virtues, nor are they particularly princely virtues. Rather,

they appear to have been chosen from a broader group of moral, secular virtues that gained wide currency in the pictorial arts in the Renaissance and the Baroque period.

<div align="right">PS</div>

PROVENANCE: Jean-Denis Lempereur sale, Paris, May 24–June 28, 1773, lot 520 (sold with *La foi conjugale*); purchased at the sale by Joullain, Paris; Paignon-Dijonval; in 1792 to his heir, Charles-Gilbert vicomte Morel de Vindé; sold in 1816 to Samuel Woodburn, London; sale, Sotheby's, New York, January 12, 1994, lot 74 (as *An Allegorical Figure of Abundance*, French School, 18th century); purchased by Alan Wintermute and Colin Bailey.

LITERATURE: M. Bénard, *Cabinet de M. Paignon Dijonval: État détaillé et raisonné des dessins et estampes* (Paris, 1810), p. 145, no. 3429 (with *La foi conjugale*); Rosenberg and Sahut 1977, p. 150, no. 467 (as lost).

1. Rosenberg and Sahut 1977, pp. 104, 115, nos. 280–83, 333.
2. Louis Réau, *Histoire de l'expansion de l'art français,* vol. 2, pt. 2, *Pays scandinaves, Angleterre, Amérique du Nord* (Paris, 1931), pp. 24–25.
3. Selections from Wasserschlebe's letters, held at the Kongelige Bibliothek in Copenhagen, were published by Mario Krohn, *Frankrigs og Danmarks kunstneriske forbindelse i det 18. aarhundrede,* 2 vols. (Copenhagen, 1922).
4. Ibid, vol. 2, p. 81
5. M[ichel]-F[rançois] Dandré-Bardon, *Vie de Carle Vanloo* (Paris, 1765), reprint (Geneva, 1973), p. 201.

CHARLES PARROCEL

Paris 1688–1752 Paris

30. Scene of Military Life: A General Giving Orders

Red chalk; the frame is drawn in red chalk over a preliminary sketch in graphite, 18⅜ x 13⅞ in. (46.7 x 35.2 cm). Signed and dated in pen and brown ink at lower right: *charle Parrocel. f. 1744*

The Metropolitan Museum of Art, Rogers Fund, 1963 (63.3)

30.1. Charles Parrocel, *Conseil de guerre avec un général entouré de plusieurs officiers,* 1744. Oil on canvas, 61⅞ x 54¾ in. (157 x 139 cm). Musée National de Versailles

Charles Parrocel's idiosyncratic and distinct drawing style is well matched to his usual subject matter, hunts and battles. Parrocel came from a long line of men who made the military both their life and the subject of their art. He himself joined the cavalry briefly in his youth. He studied painting with his father, Joseph, a painter of battles and a student of Jacques Bourguignon (1621–1676). Parrocel's chalk drawings are very forceful, typically done with speed and springy, energetic strokes, forthright handling, and schematic shading. The draftsman and illustrator Charles-Nicolas Cochin pointed out in his 1760 lecture to the Académie on Parrocel's life that drawing suited Parrocel better than painting, which was too slow for him.[1]

The drawing in this exhibition represents Parrocel at his energetic best, his vigorous chalk handling lending the scene force and brio. Parrocel was particularly known for his virtuoso drawing of horses, and the three shown here are fanned out to display three different views.[2] Even the frame, drawn in imitation of its destination in *boiserie,* curves and vaults with energy.

Charle Parrocel f. 1744.

30

Fortunately for Parrocel, Louis XV shared his enthusiasms, and Parrocel was repeatedly hired by the crown to provide decorations for royal residences, among them Versailles, Choisy, and Fontainebleau.[3] The Metropolitan's drawing is a study for such a decoration, one of two ordered in 1744 for the *appartement du dauphin* at Versailles in preparation for the dauphin's first marriage, in February 1745, to Marie-Thérèse of Spain (fig. 30.1),[4] and described by the architect Ange-Jacques Gabriel in a payment memo of 1745.[5] There are various revisions between the painting and the drawing. In the drawing the orders are shown in the general's hands; in the painting they are on the ground. There are other revisions as well, especially in the background and in the costume. Xavier Salmon suggests that the costumes in the drawings are imaginary, based loosely on seventeenth-century examples. In the paintings, Parrocel made the costumes conform to contemporary military dress.[6]

The paintings are unlikely to reflect the taste of the dauphin, who lived in awe of his father's vigorous life-style. It is true that he is represented in armor in both an equestrian portrait by Parrocel and a portrait by Nattier, which shows the battle of Fontenoy at which he was present.[7] But when the dauphin himself commissioned several works for his rooms after his marriage, none were martial in character.[8] And in fact, he lived in the bedroom with the Parrocel decorations for only one year, moving to a suite decorated with, among other things, mythologies by Jean-Baptiste Marie Pierre (1714–1789) and Oudry's *La ferme,* of 1750 (Musée du Louvre, Paris). Perhaps the king was trying in his way to encourage in his son more valorous pursuits. Or perhaps the martial themes were simply considered appropriate decoration for a room occupied by the heir to the throne.

The drawing for the other painting, together with the present sheet in the eighteenth-century Lempereur sale, has not been located.[9] MTH

PROVENANCE: Jean-Denis Lempereur (Lugt 1740); Lempereur sale, Paris, May 24, 1773, and following days, part of lot 652, "Deux compositions à la sanguine, pour des dessus de portes de l'appartement de Monsieur le Dauphin à Versailles"; Henri Delacroix (his mark, an interlaced HD, not in Lugt); sale, collection H.D., Palais Galliera, Paris, March 31, 1962, lot 62, pl. XXIII; [Charles Slatkin and Co.]; purchased by The Metropolitan Museum of Art.

LITERATURE: *MMA Annual Report,* 1962–63, p. 63; Alexandre Ananoff, "Les cent 'petits maîtres' qu'il faut connaître," *Connaissance des Arts,* no. 149 (July 1964), p. 55 (ill.), as in a private collection; Pierre Rosenberg and Antoine Schnapper, *Choix de dessins anciens,* exh. cat., Bibliothèque Municipale de Rouen ([Rouen], 1970), under no. 39, p. 84; Gillies and Ives 1972, no. 40; Rosenberg 1972, p. 192, under no. 105; Bean and Turčić 1986, pp. 205–6, no. 229 (ill.).

1. Reprinted in Dussieux 1854, p. 422.
2. Rosenberg and Schnapper note a horse and rider very similar to those in the present sheet in a drawing in the Bibliothèque Municipale de Rouen, and they date that drawing to about 1744 on the basis of that resemblance. See Pierre Rosenberg and Antoine Schnapper, *Choix de dessins anciens,* exh. cat., Bibliothèque Municipale de Rouen ([Rouen], 1970), p. 84, no. 39.
3. For this aspect of Parrocel's career, see Xavier Salmon, *Versailles: Les chasses exotiques de Louis XV* (Paris, 1995), pp. 44–50, 86–93, 148–59.
4. See Claire Constans, *Musée National du Château de Versailles: Les peintures,* 3 vols. (Paris, 1995), vol. 2, p. 701, nos. 3945 and 3946 (after the Metropolitan drawing; ill.).
5. "Représentant un général à cheval qui vien de recevoir par un courrier des avis de plusiurs officiers et autres troupes, le deuxième des hussards qui passent à cheval par un camp et dans le fond de la cavalerie en marche. . . ." Archives, Versailles, O 1813 fol. 154. The author wishes to thank Xavier Salmon of the Musée National des Châteaux de Versailles et de Trianon for bringing this document to her attention. See Fernand Engerand, *Inventaire des tableaux commandés et achetés par la direction des Bâtiments du Roi (1709–1782)* (Paris, 1901), pp. 379–80.
6. Verbal communication, April 29, 1997.
7. The original of this portrait is lost, although copies exist: see Pierre de Nolhac, *J.-M. Nattier, peintre de la cour de Louis XV* (Paris, 1905), pp. 74–76.
8. For the paintings that the dauphin commissioned, see Pierre Verlet, *Versailles* (Paris, 1961), pp. 480–81; and Pierre de Nolhac, *Le Chateau de Versailles sous Louis XV* (Paris, 1898), pp. 136–49.
9. A pen-and-ink with gray wash drawing closely resembling the composition of the pendant painting, which shows the group in front of the auberge but not the hussars riding by, was on the market in 1989; see Hôtel Drouot, Paris, April 24, 1989, lot 141.

CARLE VANLOO

Nice 1705–1765 Paris

31. La conversation espagnole

Pen and brown ink, brush and brown wash, over black chalk, 10 x 8¾ in. (25.5 x 22.3 cm). Collectors' mark of Jules and Edmond de Goncourt (Lugt 1089) at lower right

The Metropolitan Museum of Art, Harry G. Sperling Fund, 1983 (1983.299)

From the time he took the first *médaille du dessin* in 1723 at age eighteen, Vanloo was considered by his contemporaries to be one of the greatest draftsmen of the French school.[1] Given the renown of his drawings, it is surprising that more have not come to light, a situation that led Pierre Rosenberg to lament that the catalogue of drawings produced in conjunction with the 1977 exhibition of his work was no more than "a rough outline, a starting point for the reconstitution of an oeuvre that must have been vast and among the finest of the century."[2] Still, from what has survived, one can offer the tentative suggestion that Vanloo's choice of graphic medium was dictated, for the most part, by the function of the sheet. *Académies* and designs for prints were typically in sanguine, figure studies and portraits in black chalk, stump, and white heightening, and *premières pensées* for compositions in pen-and-ink and wash. These last, including the present sheet, lack the soft-focus precision of Vanloo's chalk drawings (see no. 28), but achieve instead an unstudied elegance of line. In the Metropolitan's sheet, delicate curves echo one another in an upturned chin, the sway of a dog's back, the sweep of a stone archway. Crinkly lines convey the volume of the historicizing costume, and parallel vertical lines indicate shadow without obscuring the architectural detail.

This drawing is the *première pensée* for one of Vanloo's most acclaimed paintings, *La conversation espagnole* (fig. 31.1), executed in 1754 for Mme Geoffrin, whose artistic and literary salons were weekly events in Paris, and was sold in 1771 to Catherine II of Russia.[3] The painting is of a type popularized by Vanloo that straddles the line between portraiture and genre and makes elaborate use of exotic costume. According to Grimm, author of the privately circulated *Correspondance littéraire,* the subject was not only dictated by Mme Geoffrin, but the painting was executed "sous ses yeux." He goes on to describe the subject as a widowed Flemish countess looking up from her music upon the arrival of her lover.[4] The marquis de Ségur, writing in 1897,

considered the female protagonist to be a portrait of Mme Geoffrin's daughter, the marquise de la Ferté-Imbault. This identification is difficult to confirm, however, as the marquise had in 1754 already been widowed seventeen years and her only daughter, Charlotte-Thérèse, had died at the age of thirteen, several years before Vanloo's painting, which shows a girl closer to eight years old. In the pendant to the painting, *La lecture espagnole*, also commissioned by Mme Geoffrin, Vanloo is thought to have used his wife's features for the figure of the woman embroidering.[5]

In the alterations made between the Metropolitan's drawing and the final painting, one can follow Vanloo's compositional process. Of the nine figures in the drawing, only the four most essential were retained. While the lovers gaze fixedly at each other, the young girl stares frankly out at the viewer. The female musician and the white dog both not only look but physically bend toward the center, which results in a scene of uncluttered balance. The drawing, with its larger cast of characters, is both more busy and more festive, down to details of architecture and outdoor statuary. The costumes, which are also altered considerably from drawing to painting, suggest in their slashed sleeves and elaborate, high ruffs a generalized vocabulary of late-sixteenth–early-seventeenth-century style associated with the period of Rubens and Van Dyck. The term *espagnole*, much used in the eighteenth century, referred not so much to contemporary Spain as to a historicizing style evocative of the Low Countries when they were under Spanish rule. Temporal and physical distance, as twin elements of exoticism, were often capriciously and charmingly commingled in Vanloo's work.

PS

PROVENANCE: Émile Norblin; his sale, Hôtel Drouot, Paris, March 16–17, 1860, *Supplément,* no. 16; D.-G. d'Arozarena; his sale, Hôtel Drouot, Paris, May 29, 1861, lot 92; acquired by Edmond and Jules de Goncourt (Lugt 1089); Goncourt sale, Hôtel Drouot, Paris, February 15–17, 1897, lot 332; acquired by de Jonghe; [Galerie Cailleux, Paris]; purchased by The Metropolitan Museum of Art.

LITERATURE: "Mouvement des arts et de la curiosité: Vente de dessins anciens," *Gazette des Beaux-Arts* 6 (1860), p. 58; *Dessins de maîtres anciens,* exh. cat., Paris, École des Beaux-Arts (Paris, 1879), no. 535; Ph[ilippe] de Chennevières, "Les dessins de maîtres anciens exposés à l'École des Beaux-Arts," *Gazette des Beaux-Arts,* ser. 2, 20 (1879), pt. 4, p. 200; reprinted as [Philippe] de Chennevières, *Les*

31

31.1. Carle Vanloo, *La conversation espagnole,* 1754. Oil on canvas, 64⅝ x 50⅞ in. (164 x 129 cm). The State Hermitage Museum, Saint Petersburg

dessins de maîtres anciens exposés à l'École des Beaux-Arts en 1879 (Paris, 1880), p. 102; Edmond de Goncourt, *La maison d'un artiste,* 2 vols., new ed. (Paris, 1881), vol. 1, p. 169; *Catalogue de l'exposition de l'art français sous Louis XIV et sous Louis XV,* exh. cat., Paris, Maison Quantin (Paris, 1888), no. 53 (per Marianne Roland Michel); Louis Réau, "Carle Vanloo (1705–1765)," *Archives de l'Art Français,* n.s., 19 (1938), p. 82, no. 31; Rosenberg and Sahut 1977, p. 75, under no. 147; *MMA Annual Report,* 1983–84, p. 24; *MMA Notable Acquisitions,* 1983–84, p. 71 (ill.); Bean and Turčić 1986, p. 261, no. 293 (ill.); Inna S. Nemilova, *The Hermitage, Catalogue of Western European Painting: French Painting, Eighteenth Century* (Moscow and Florence, 1986), p. 355, under no. 269; Launay 1991, pp. 87, 93, 491, no. 357 (ill.).

1. See M[ichel]–F[rançois] Dandré-Bardon, *Vie de Carle Vanloo* (Paris, 1765), reprint (Geneva, 1973), pp. 9–10.
2. Rosenberg and Sahut 1977, p. 15.
3. See Inna S. Nemilova, *The Hermitage, Catalogue of Western European Painting: French Painting, Eighteenth Century* (Moscow and Florence, 1986), pp. 355–56, no. 269.
4. Maurice Tourneux, *Correspondance littéraire, philosophique et critique par Grimm, Diderot, Raynal, Meister, etc.* . . . , vol. 2 (Paris, 1877–82), pp. 410–11.
5. A pen study for this composition is recorded in the sale of the collection of the artist's son; see Rosenberg and Sahut 1977, p. 154, no. 491.

CARLE VANLOO

Nice 1705–1765 Paris

32. *The Sacrifice of Iphigenia*

Pen and brown ink, brush and brown, blue, red, and pale yellow wash, heightened with white, over traces of black chalk, on brownwashed paper, 29⅝ x 36¾ in. (75.2 x 93.4 cm). Signed in pen and brown ink at lower left: *Carle Vanloo.* The sheet consists of fourteen pieces of cream-colored paper mounted on a paper support.

The Metropolitan Museum of Art, Rogers Fund, 1953 (53.121)

This sheet is a study for the large painting *The Sacrifice of Iphigenia* (fig. 32.1), commissioned from Vanloo in 1755 by Frederick the Great, king of Prussia, for the marble room at the Neues Palais at Potsdam. Vanloo's contract called for payment in three installments, the second due when the painting was roughly sketched out (*ébauché*),[1]

implying a specific function for the present drawing, which was perhaps sent to Potsdam for approval and to mark completion of this stage of the work.[2] Either at his patron's behest or on his own initiative—it is not recorded—Vanloo substantially reworked the composition in the painting. Comparing the drawn and painted versions, it is not at all clear that these revisions were ultimately of benefit. With the exception of the airborne Diana, the entire composition, including background elements, has been reversed. The positions of Iphigenia and the high priest, Calchas, have been altered, rendering the former less graceful and the latter less virile. The explanation for this seemingly needless campaign of change may lie in Vanloo's fear of appearing

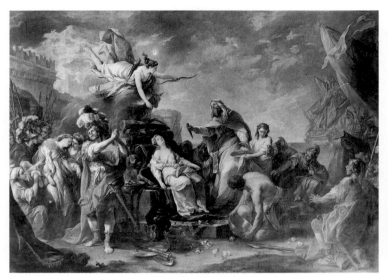

32.1. Carle Vanloo, *The Sacrifice of Iphigenia,* 1757. Oil on canvas, 167¾ x 244 in. (426 x 613 cm). Neues Palais, Potsdam

32.2. Gabriel-François Doyen (1726–1806), *The Sacrifice of Iphigenia,* 1749. Oil on canvas, 71 x 74½ in. (155 x 189 cm). Private collection, France (photo: Bruce C. Jones)

derivative, for the composition of the drawing is indebted to an early work by Vanloo's precocious student Gabriel-François Doyen (1726–1806), which appeared at auction in 1988 (fig. 32.2).[3] In his drawing, Vanloo has successfully rethought the central triad of Diana, Iphigenia, and deer, but the supporting figures rely heavily on Doyen's painting, as does the motif of the large crescent moon and the background vessels and tents.

The challenging subject of Iphigenia was a popular one among aspiring history painters: examples are known or recorded by Charles de La Fosse,[4] François Le Moyne,[5] Jean-François de Troy,[6] and Charles-Antoine Coypel,[7] among others. Moreover, Iphigenia was only one of a number of innocent young maidens whose imminent or closely averted deaths inspired pictorial tribute during this period. One thinks of Doyen's *Death of Virginia* (Pinacoteca, Parma), exhibited in the artist's studio in 1758, and Fragonard's *Corésus and Callirhoë* (see fig. 57.1), exhibited in the Salon of 1765. On the surface, the appeal of such subjects lay in the *frisson* of contemplating the exposed, pearly white flesh of the innocent victim, motionless beneath the glinting blade of her executioner's knife. Furthermore, one can read in Iphigenia and similar subjects a monarchic message in the valorization of kingly sacrifice for the good of the nation.

Yet more than these other stoic maidens, the subject of Iphigenia was encumbered with a burden of precedent stretching back to antiquity. Nor was the interest in Iphigenia's representation limited to France. H. Fullenwider

has described Vanloo's painting as playing a pivotal role in the contemporary critical debate that pitted Johann Joachim Winckelmann's admiration of Greek decorum against Charles Le Brun's theory of the depiction of the passions, still taught at the Académie.[8] These theoretical discussions often invoked a lost painting of the Sacrifice of Iphigenia by Timanthes of Kythnos (ca. 406 B.C.), in which the face of Agamemnon was veiled to spare the viewer the unprincely sight of a noble visage distorted by extreme emotion. Thus the unveiled face of Vanloo's Agamemnon, specified in the wording of the contract,[9] was considered by many critics the most notable feature of the composition.[10]

It is surprising for a commission of this size and importance that more preparatory drawings have not come to light.[11] Dandré-Bardon, in his 1765 biography of Vanloo, stated, "He never picked up his brushes until he had exhausted the possibilities of chalk; then he would fix with color all the traces of the chalk."[12] Vanloo's reputation among his contemporaries as one of the great draftsmen of his time finds confirmation in the Metropolitan's *Iphigenia.* Standing out against the lightly sketched background elements, the volumetric figures are rendered in confident ink line and modeling, their impressive range of emotional response masterfully conveyed in both pose and expression. The vigor of Vanloo's grand manner is softened by a few delicate touches: the ice blue wash on the drapery behind Iphigenia, the pearly luster of her drooping figure, and the radiance of Diana enveloped in transparent moonlight.

P S

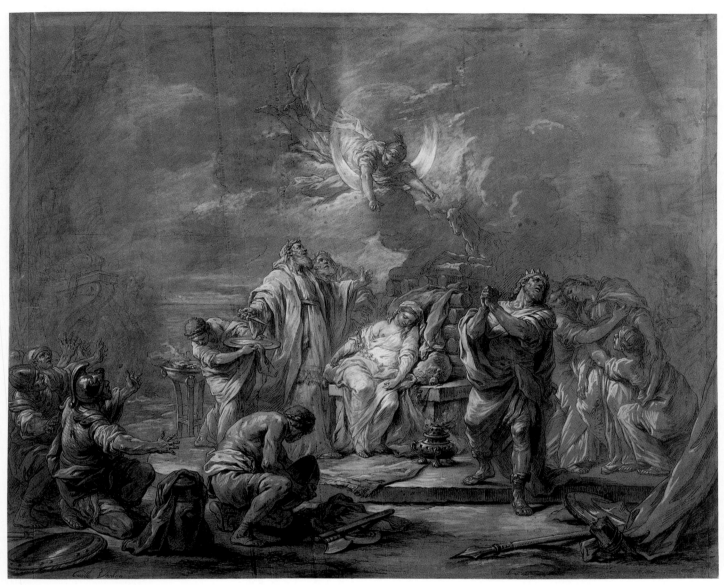

32

PROVENANCE: Christine Vanloo, the artist's widow; presumably in her posthumous sale, Paris, April 30, 1785; Chariot sale, Paris, January 28, 1788, lot 121; [Clifford Duits]; purchased by The Metropolitan Museum of Art.

LITERATURE: *MMA Annual Report*, 1953, p. 23; Francis H. Dowley, "Carle Van Loo's 'Sacrifice of Iphigenia,'" *Master Drawings* 5, no. 1 (1967), pp. 42–47, pl. 32; London 1968, p. 96, no. 449, fig. 153; Gillies and Ives 1972, no. 33; Rosenberg 1972, p. 217, under no. 141; Rosenberg and Sahut 1977, pp. 15, 123, no. 363; James David Draper and Joan R. Mertens, *Treasures from The Metropolitan Museum of Art, New York: Memories and Revivals of the Classical Spirit*, exh. cat., Athens, National Pinakothiki, Alexander Soutzos Museum (Athens, 1979), no. 56 (ill.); *From Watteau to David: A Century of French Art*, exh. cat., New York, Christophe P. Janet/Maurice Segoura (New York, 1982), p. 34, under no. 9, fig. 11; Bean and Turčić 1986, p. 262, no. 295 (ill.); Rosenberg 1988, p. 216, fig. 10, under no. 104.

1. The contract is reprinted in Paul Seidel, *Les collections d'oeuvres d'art français du XVIIIe siècle appartenant à sa majesté l'empereur d'Allemagne, roi de Prusse* (Berlin and Leipzig, 1900), pp. 108–9.
2. The argument is presented in Francis H. Dowley, "Carle Van Loo's 'Sacrifice of Iphigenia,'" *Master Drawings* 5, no. 1 (1967), p. 42.
3. Sale, Ader Picard Tajan, Paris, June 28, 1988, lot 31. The connection to Vanloo's composition was pointed out by Christophe Janet in *From Watteau to David: A Century of French Art*, exh. cat., New York, Christophe P. Janet/Maurice Segoura (New York, 1982), p. 34. The Doyen was exhibited at Versailles in 1750.
4. Margret Stuffmann, "Charles de La Fosse et sa position dans la peinture française à la fin du XVIIe siècle," *Gazette des Beaux-Arts*, ser. 6, 64 (1964), pp. 39–41, fig. 4.
5. Marandel 1975, p. 59, no. 58.
6. Illustrated in Bailey 1992, p. 221, fig. 3.
7. Coypel's design is known from a tapestry; see Lefrançois 1994, pp. 228–31, no. P112 (tapestry ill. p. 229).

8. H. Fullenwider, "'The Sacrifice of Iphigenia' in French and German Art Criticism, 1755–1757," *Zeitschrift für Kunstgeschichte* 52, no. 4 (1989), pp. 539–49.

9. Published in Seidel, *Les collections d'oeuvres d'art français du XVIIIe siècle*, pp. 107–8.

10. A black chalk drawing in the Musée des Beaux-Arts, Quimper, apparently made after the painting, may indicate that a print of the isolated figure of Agamemnon was contemplated; see Roseline Bacou, "Quimper: Dessins du Musée des Beaux-Arts," *Revue de l'Art*, no. 14 (1971), p. 103, fig. 6.

11. In addition to the present study and the black chalk study of Agamemnon mentioned above, there is an untraced oil sketch of similar dimensions to the present sheet, described in the November 28, 1781 catalogue of the Jean-Baptiste Le Prince estate sale as a "belle esquisse avancée, et richement ornée de figures." The catalogue is reprinted in Jules Hédou, *Jean Le Prince et son oeuvre* (Paris, 1879), p. 313 (128); reprinted as *Jean-Baptiste Le Prince, 1734–1781* (Amsterdam, 1970).

12. M[ichel]-F[rançois] Dandré-Bardon, *Vie de Carle Vanloo* (Paris, 1765), reprint (Geneva, 1973), p. 50.

JEAN RESTOUT

Rouen 1692–1768 Paris

33. *Funeral of François Duplessis de Mornay*

Black chalk, traces of stumping, heightened with white chalk, on beige paper, 13 x 15¾ in. (33.1 x 40 cm)

The Metropolitan Museum of Art, Harry G. Sperling Fund, 1993 (1993.200)

The rhythmic solemnity and ritual pomp of a funeral cortege are powerfully evoked in this compositional drawing by Jean Restout, an artist whose singular vision formed an important link between the passion of Counter-Reformation Baroque painting and the moral authority of Neoclassicism. Another, more finished, version exists (fig. 33.1), certainly done after the present sheet.[1] The presence of invalids in the crowd has led one scholar to suggest a link to the Jansenists.[2] Restout did several works related to this controversial reform movement,[3] and as such commissions were undertaken with a measure of risk, scholars have assumed an association on the part of Restout.[4] But although the scene does represent a religious sect, it is that of the Capuchins, a reform arm of the Franciscan order. They are identifiable by their tonsure, their long, hermitlike beards, and their short mantle with hood (*capuch*), all adopted as emblematic of the austerity of the mendicant order. The bare feet as well are common among members of such orders.

Two details suggest the identity of the dead monk. The funeral procession, a large and stately one, includes bishops (identifiable by their miters), implying a measure of status for the deceased. More telling, perhaps, is the face of the dead monk which, alone among the Capuchins present, has

no beard. A beardless Capuchin bishop was indeed buried in Paris in 1741, the approximate date of Restout's composition. He was François Duplessis de Mornay, the third bishop of Québec, and he was buried from the Capuchin convent on the rue Saint-Honoré.[5]

No documents survive to indicate a commission for a painting, whether from the Capuchin convent or from another institution, and the building visible in this drawing is not the facade of Notre-Dame de la Paix, the church of the convent, demolished in 1802. It does, however, resemble other Baroque religious buildings on the rue Saint-Honoré, such as

33.1. Jean Restout, *Funeral of François Duplessis de Mornay*. Black chalk heightened with white on beige paper, 15⅜ x 15⅝ in. (39 x 39.7 cm). Hessisches Landesmuseum, Darmstadt

33

the street facade of the Convent of the Feuillants, demolished in 1804.[6] Perhaps Restout had no specific facade in mind, but was simply trying to evoke the procession on the rue Saint-Honoré. Nonetheless, it seems certain that the funeral of Bishop Duplessis de Mornay is the subject of this drawing.

Restout's characteristic style, built around an austere formal vocabulary and highly focused dramatic compositions, is very evident here. The elongated figures, their attenuation accentuated by the tapers, are played off against the stark rhythm of the march and the purposeful repetition of the cassocks. The sketchy angular black line, describing mass and chiaroscuro more than detail, is typical of Restout's compositional drawings. In the Metropolitan's version, the central group is most clearly defined, while the background buildings and other figures are more lightly indicated. The

Darmstadt version describes the background, penitents, and bishops more distinctly, but omits the woman in the lower right holding a bowl. In both, the poignant detail of the dead monk's bare feet is emphasized.[7]

MTH

PROVENANCE: [Galerie Cailleux, Paris]; purchased by The Metropolitan Museum of Art.

LITERATURE: Roland Michel 1991, no. 22.

1. Pierre Rosenberg and Antoine Schnapper, "Some New Restout Drawings," *Master Drawings* 15, no. 2 (Summer 1977), p. 167. The present drawing was unknown to the authors at the time of publication.
2. Christine Gouzi, who is completing doctoral research on Restout at the Sorbonne, letter of June 30, 1997.

3. See A. Gazier, "Jean Restout et les 'miracles' du Diacre Pâris (1737)," *Revue de l'Art Chrétien* 62 (1912), pp. 118–19; and Pierre Rosenberg and Antoine Schnapper, *Jean Restout (1692–1768)*, exh. cat., Musée des Beaux-Arts de Rouen ([Rouen], 1970), p. 9, and pp. 44–45, under no. 8.

4. See Goodman 1995a, pp. 75–78.

5. Friar Regis Armstrong, O.F.M. Cap., Vicar Provincial, Capuchin Friars, White Plains, New York, and Friar Servus Gieben, O.F.M. Cap., Director, Museo Francescano, Istituto Storico dei Cappuccini, Rome, kindly assisted in making this identification.

There are three engraved portraits of de Mornay without beard in the collection of the Museo Francescano, Rome (letter from Servus Gieben, O.F.M. Cap., September 30, 1997).

See also Jean Mauzaize, "Le couvent des capuchins de la rue Saint-Honoré: Étude topographique et historique," 5 vols. (Paris, 1971), unpublished ms. in the library of the Istituto Storico.

6. See Jacques Hillairet, *Dictionnaire historique des rues de Paris,* 2 vols., 8th ed. (Paris, [1985]), vol. 2, under Saint-Honoré, pp. 428–29, nos. 229–51.

7. The composition is similar to the grand procession Restout formulated for another, later commission, known today only from a drawing in Stuttgart. See Pierre Rosenberg and Heinrich Geissler, "Un nouveau groupe de dessins de Jean Restout (1692–1768) au Musée de Stuttgart," *Jahrbuch der Staatlichen Kunstsammlungen in Baden-Württemberg* 17 (1980), p. 149 (ill.), and p. 153, n. 31.

JACQUES DUMONT, CALLED LE ROMAIN

Paris 1701–1781 Paris

34. *The Sacrifice of Manoah*

Red chalk, 11⅜ x 14½ in. (28.9 x 36.8 cm). Inscribed in pen and brown ink at lower left: *L. de Silvestre fecit.;* in pencil at lower right: *L de Silvestre fecit*

The Metropolitan Museum of Art, Purchase, David L. Klein Jr. Memorial Foundation Inc. Gift, 1982 (1982.173)

Following the inscriptions, this drawing was acquired and published as a work by Louis de Silvestre (1675–1760), who did in fact make a painting of this subject in 1732.[1] The style of the sheet, however, is undeniably that of Jacques Dumont le Romain.[2] The Metropolitan's drawing fits into a stylistically consistent group of sheets in red chalk,[3] of which the closest parallel is a drawing acquired by Jeffrey E. Horvitz in 1995 (fig. 34.1). Indeed, as Christine Giviskos was the first to point out, the two must relate to a commission Dumont received in 1752 for a set of seven paintings depicting the story of Samson to serve as models for the Gobelins manufactory.[4] Neither the paintings nor the tapestries seem to have been executed, but the New York and Horvitz sheets demonstrate that Dumont had at least begun the project. The Metropolitan's sheet depicts the first episode, in which Manoah and his wife sacrifice a goat, following the instructions of the angel who has foretold the birth of Samson (Judges 13:15–20). The Horvitz sheet represents Samson meeting the Philistine woman in Timnah (Judges 14:1). Perhaps a scene of Samson killing the lion preceded it.

Quite distinctive in both sheets is Dumont's vigorous yet extremely precise handling of the red chalk. Objects are shaded in parallel lines of varying direction and intensity. The way these lines fade or deepen in tandem to suggest the three-dimensionality of objects is reminiscent of printmaking techniques, in which Dumont had clearly been trained. In fact, in a family that produced a long line of sculptors, Dumont was the only artist who worked in two dimensions.

P S

PROVENANCE: [Seiferheld, in 1968]; Christian Humann; his sale, Sotheby Parke-Bernet, New York, June 12, 1982, lot 33 (as Louis de Silvestre); purchased by The Metropolitan Museum of Art.

LITERATURE: *MMA Annual Report*, 1982–83, p. 23; Bean and Turčić 1986, p. 249, no. 283 (ill., as Louis de Silvestre).

34

34.1. Jacques Dumont le Romain, *Samson Meeting the Philistine Woman in Timnah*. Red chalk, 10¾ x 15¼ in. (27.2 x 38.7 cm). Fogg Art Museum, Harvard University Art Museums, Loan from the Collection of Jeffrey E. Horvitz

1. The painting is in the Gemäldegalerie Alte Meister, Dresden; see Harald Marx, *Die Gemälde des Louis de Silvestre* (Dresden, 1975), p. 51, no. 1 (ill.). However, the composition of the Metropolitan drawing is quite different from that of the painting. Silvestre's red chalk study for the Dresden painting is in the École Nationale Supérieure des Beaux-Arts, Paris, *donation* Polakovitz (PM 883).

2. The attribution to Dumont was confirmed by Pierre Rosenberg (verbal communication, January 28, 1997) and, based on a photograph, by Chantal Mauduit (letter, April 7, 1997), who is preparing a catalogue raisonné on the artist.

3. A *Birth of the Virgin* was sold in Berlin (Bassenge, November 29, 1996, lot 5590).

4. Dimier 1928–30, vol. 2, p. 233.

EDME BOUCHARDON

Chaumont-en-Bassigny 1698–1762 Paris

35. *Rhea Outwitting Saturn*

Red chalk, 13¹⁄₁₆ x 10⅜ in. (33.2 x 26.4 cm)

Private collection

Edme Bouchardon's lifelong dedication to drawing is unmatched among eighteenth-century sculptors. Not only did drawing play a critical role in the genesis of his sculptural projects, but he pursued it for a range of other purposes as well. Several collections of Bouchardon's *académies* and vase designs were published by Gabriel Huquier. More surprising, for a sculptor later to be heralded for his classicism, were his Chardinesque *Études prises dans le bas peuple, ou les cris de Paris,* engraved by the amateur print-maker the comte de Caylus. It is also significant that for the Salon of 1737, the first in which he participated, Bouchardon included among his entries six highly finished red-chalk compositional drawings for history subjects.

That his reputation rested as much on his draftsmanship as on his sculptural output is clearly expressed in the writings of his contemporaries. Charles-Nicolas Cochin declared Bouchardon not only "le plus grand sculpteur," but also "le meilleur dessinateur de son siècle."[1] His drawings were widely sought after—both during and after his lifetime—in France and abroad. They appear in the estate sales of his fellow artists, among them François Boucher, Jean-François de Troy, and Jean-Baptiste Deshays;[2] over 120 were in the collection of Charles-Joseph Natoire alone.[3] The famed collector Pierre-Jean Mariette, who owned over five hundred sheets by Bouchardon, describes in his *Abécédario* entry how the drawings remaining in the sculptor's possession at his death were fetching prices equivalent to their weight in gold.[4]

Almost invariably in red chalk, Bouchardon's drawings nonetheless display a wide range of techniques corresponding, as Gerold Weber has suggested, less to a chronological point in Bouchardon's career than to the role the sheet played in the design process.[5] Atypical in their spontaneity of handling and relatively rare in number are the *premières pensées,* Bouchardon's first ideas for sculptural projects, among which the present sheet should be counted. Although executed with authority and vigor, *Rhea Outwitting Saturn* shows undisguised traces of the artist's thought process. Visible pentimenti reveal where the poses have been adjusted (Rhea's head and arm, Saturn's right foot). Unlike the controlled, continuous outline associated with his more highly finished designs, Bouchardon here gives inspiration free rein, continually lifting and putting down the chalk, often going over the same area several times, producing an energetic and vibrating effect.

Characteristic of Bouchardon's style is the design's subjugation of a Baroque vocabulary to a classical sense of balance, decorum, and idealization. As their hands grasp opposite ends of the wrapped bundle, the protagonists' forearms mirror and cross one another, echoing the larger diagonals of their bodies. The diagonal thrust of Saturn's wing is similarly counterbalanced by the draped form of the hidden Jupiter on the left.

The story, taken from Ovid's *Fasti* (4:197–214),[6] describes how Saturn, having heard an oracle's prophecy that he would be ousted by his own son, devours his offspring just after birth. Rhea, Saturn's wife, desiring that a child live, eventually outwits him, substituting a stone wrapped in swaddling clothes for the infant Jupiter, whom she spirits away to a Cretan mountaintop to be nurtured by the goat Amalthaea.[7] While the subject of Saturn devouring his offspring was occasionally depicted by Baroque artists, the moment of Rhea's deception is more rarely seen.[8] The existence of a *première pensée* unconnected to a completed project is commonplace in Bouchardon's oeuvre. While one cannot rule out the possibility that such sheets were intended to offer ideas to prospective patrons, one senses that it was more out of pure enjoyment of the process of conceptualization through draftsmanship that Bouchardon produced *Rhea Outwitting Saturn.*

P S

PROVENANCE: Paignon-Dijonval; in 1792 to his heir, Charles-Gilbert vicomte Morel de Vindé; sold in 1816 to Samuel Woodburn, London; sale, Christie's, London, July 2, 1985, lot 100; [Hazlitt, Gooden & Fox, Ltd., London]; private collection.

LITERATURE: M. Bénard, *Cabinet de M. Paignon Dijonval: État détaillé et raisonné des dessins et estampes* (Paris, 1810), p. 141, no. 3305.

35

PROVENANCE: Sale, Sotheby's, New York, January 13, 1988, lot 112; [Patrick Perrin, Paris]; Mr. and Mrs. Patrick A. Gerschel, New York.

LITERATURE: Olivier Aaron, *Jean-Baptiste Marie Pierre 1714–1789*, Cahiers du Dessin Français, no. 9 (Paris, [1993]), p. 16, no. 37 (ill.).

1. Recent publications by Olivier Aaron have begun to address this gap in the literature; see "Pierre: Premier peintre du roi," *L'Estampille, l'Objet d'Art*, no. 292 (June 1995), pp. 42–50, and *Jean-Baptiste Marie Pierre 1714–1789*, Cahiers du Dessin Français, no. 9 (Paris, [1993]). Aaron is also preparing a catalogue raisonné.

2. Jacques Wilhelm, "'L'apothéose de Psyché': Une esquisse égarée de Jean-Baptiste Pierre pour le plafond du salon de la duchesse d'Orléans au Palais-Royal," *Bulletin de la Société de l'Histoire de l'Art Français*, 1991, pp. 165–72.

3. The head is visible in the middle detail reproduced on p. 50 in Jean-Louis Gaillemin, "Perspectives baroques," *Connaissance des Arts*, no. 503 (February 1994), pp. 48–55.

JEAN-BAPTISTE MARIE PIERRE

Paris 1714–1789 Paris

37. *Cybele Prevents Turnus from Setting Fire to the Trojan Fleet by Transforming the Ships into Sea Goddesses*

Pen and brown ink, brush and brown wash, heightened with white, over black chalk, on beige paper, vertical crease at center, 14⅞ x 18⅝ in. (37.9 x 47.2 cm)

The Metropolitan Museum of Art, Harry G. Sperling Fund, 1981 (1981.219)

Virgil's *Aeneid* had rarely been a subject for decorative cycles in French buildings before Antoine Coypel's paintings for the Galerie d'Énée at the Palais Royal in the first decade of the eighteenth century. The choice of the classic epic tale as the pictorial program for this important space in the primary residence of the d'Orléans family, second in line to the French throne, was motivated by its association with princely valor and triumph.[1] Pierre's large and highly finished drawing of a scene from the same story may well relate to his close ties with the d'Orléans family. He had been made *premier peintre* to the duc d'Orléans in 1752 and undoubtedly would have had frequent opportunity to gaze upon Coypel's composition of the same subject, known today from an engraving by Nicolas Dauphin de Beauvais (fig. 37.1).[2]

The subject of Cybele transforming the Trojan fleet into sea goddesses gave Coypel ample excuse for the display of female flesh; indeed, the figure of Turnus is omitted altogether. The combination of dramatic action and female nudity must have appealed to Pierre as well, although clearly he had reread his Virgil, as his depiction corresponds much more closely to the text.[3] In the Metropolitan's sheet, Turnus, brandishing two torches, rushes forward on the shore at left, intending to set fire to the Trojan fleet. Cybele, identified by her crown of city walls and her lion-drawn chariot, blocks his way, as the ships are transformed into sea nymphs. Pierre's only departure from established pictorial iconography is in giving graphic form to Virgil's description of the sea nymphs' swimming "like dolphins" by the addition in the foreground of a dolphin, or dolphin-shaped wave.

PS

PROVENANCE: Philippe de Chennevières (Lugt 2073); his sale, Hôtel Drouot, Paris, April 4–7, 1900, part of lot 403; [Didier Aaron, Paris]; purchased by The Metropolitan Museum of Art.

LITERATURE: Ph[ilippe] de Chennevières, "Une collection de dessins d'artistes français," *L'Artiste*, n.s., 8 (March 1897), pt. 9, p. 180; *MMA Annual Report*, 1981–1982, p. 22; *MMA Notable Acquisitions*, 1981–1982, p. 43 (ill.); Olivier Aaron, *Dessins insolites du XVIIIe français* (Paris, 1985), pp. 80, 114, no. 79 (ill.); Bean and Turčić 1986, p. 219, no. 246; Olivier Aaron, *Jean-Baptiste Marie Pierre 1714–1789*, Cahiers du Dessin Français, no. 9 (Paris, [1993]), p. 17, no. 45 (ill.).

1. Scott 1995, pp. 193–200.

2. For the commission as a whole, see Antoine Schnapper, "Antoine Coypel: La Galerie d'Énée au Palais Royal," *Revue de l'Art*, no. 5 (1969), p. 35, and Garnier 1989, pp. 151–55.

3. Virgil, *Aeneid*, 9: 107–22.

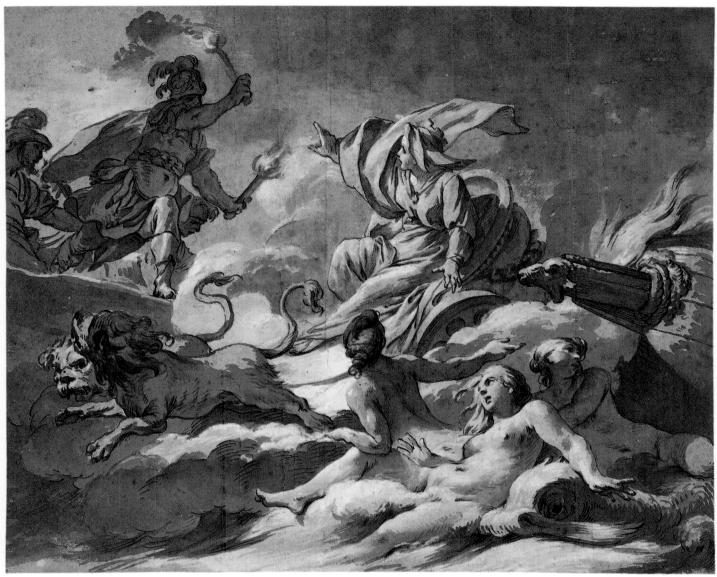

37

37.1. Nicolas Dauphin de Beauvais (ca. 1687–1763), engraving after Antoine Coypel, *Ite, deae pelagi*. Bibliothèque Nationale, Paris

ÉTIENNE JEAURAT
Vermenton 1699–1789 Versailles

38. Study of Two Women for "Le déménagement du peintre"

Black chalk, heightened with white, on gray paper, 8½ x 13⅜ in. (21.5 x 34 cm)

The Metropolitan Museum of Art, Purchase, Bequest of Helen Hay Whitney, by exchange, 1995 (1995.185)

Compared with the elegant social interactions represented by Antoine Watteau, François Boucher, and Jean-François de Troy, the scenes of urban life created by Étienne Jeaurat display a gritty realism, a bawdy sense of humor, and a theatrical, stagelike approach to composition and narrative.[1] For this reason, his genre scenes have often been compared with those of William Hogarth (1697–1764), whose work was becoming known in France through engravings by the mid-1740s. *Le déménagement du peintre* (fig. 38.1), the painting for which the Metropolitan's sheet is a study, for example, bears a compositional resemblance to plate 4 of Hogarth's *A Rake's Progress* (fig. 38.2); in the print one finds the same density of jeering onlookers, down to the yapping dog, and the steeply receding perspective of the buildings behind.

Possible ties with Hogarth notwithstanding, the primary impetus for Jeaurat's urban street dramas may well have been more literary than visual. Jeaurat was a member of the Société du Bout de Banc, a literary society presided over by the comedic actress Jeanne-Françoise Quinaut that included the writers Alexis Piron, Charles Collé, Jean-Joseph Vadé, Charles-François Panard, and the amateur Anne-Claude-Philippe de Tubières, comte de Caylus, all of whom, to some degree, took inspiration from the life, language, and mores of the working classes. Vadé, for example, invented the *genre poissard*, salacious stories centering on the raunchy language and behavior of Parisian street vendors. In his review of the Salon of 1763, Diderot called Jeaurat the "Vadé de la peinture," conceding, despite some otherwise disparaging remarks, that "c'est la vérité dans ce genre."[2]

Jeaurat's work in this vein—five scenes in a private collection and two canvases in the Musée Carnavalet, Paris[3]—may have been executed over a short period of time, judging from the surviving figure studies, which exhibit a high degree of uniformity in dimension, medium, and technique. Figures, seen alone or in small groups, are sketched, seemingly from life, in a brittle, crinkly, black chalk line.

They are given volume by gentle parallel hatching over an entire plane of the figure's clothing, with highlights from the lit side picked out in white heightening. Often, small adjustments of pose are made between the sketch and the finished painting.

While the two women in the Metropolitan's drawing are studies for the same painting, they are placed on the sheet without regard to their relative position in the final composition. The Goncourt brothers owned three drawings of this type: a sketch for the boy pulling the handcart; a genre study of a man and a woman dancing for a painting in a private collection; and a sheet they considered a study for the painting *Enlèvement des filles de joie* (Musée Carnavalet, Paris).[4] The last is lost today, but was probably similar to *Two Women Wearing Capes, with Studies of a Third* (Fogg Art Museum, Harvard University, Cambridge).[5] Also relating to the private collection pictures is a drawing of pea shellers seated around a table, in the Pushkin Museum, Moscow,[6] and a study of three men talking, which was sold at auction in 1987.[7] P S

PROVENANCE: Sale, Christie's, New York, January 11, 1989, lot 138 (as attributed to Jeaurat); [Patrick Perrin, Paris, in 1989]; sale Ader Tajan, Paris, March 31, 1993, lot 106; [Yvonne Tan Bunzl, London]; purchased by The Metropolitan Museum of Art.

Unpublished.

1. There are few studies of the artist. See Xavier Salmon, "Un carton inédit d'Étienne Jeaurat pour la tenture des 'Fêtes de village,'" *Bulletin de la Société de l'Histoire de l'Art Français*, 1995, pp. 187–96; Paul Wescher, "Étienne Jeaurat and the French Eighteenth-Century 'Genre de Moeurs,'" *The Art Quarterly* 32, no. 2 (Summer 1969), pp. 153–65; Sylvain Puychevrier, "La famille Jeaurat à Vermenton: Le peintre Étienne Jeaurat," *Annuaire historique du département de l'Yonne: Recueil de documents authentiques destinés à former la statistique départementale* 27, ser. 2, vol. 3 (1863), pp. 159–88.
2. Paris 1984b, pp. 280–81.
3. The group of five are reproduced in London 1968, pl. LXXIX, figs. 223–27. For the Carnavalet pair, see *Cinquante ans de mécénat: Dons*

38

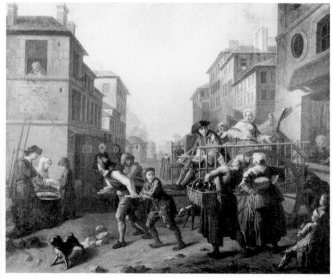

38.1. Étienne Jeaurat, *Le déménagement du peintre,* ca. 1755. Oil on canvas, 20¼ x 24¾ in. (51.4 x 62.9 cm). Private collection, England

38.2. William Hogarth (1697–1764), *A Rake's Progress* (pl. 4). Etching and engraving. The Metropolitan Museum of Art, Gift of Sarah Lazarus, 1891 (91.1.86)

de la Société des Amis de Carnavalet et de ses membres, exh. cat., Paris, Musée Carnavalet (Paris, 1981), pp. 38–39.

4. See Launay 1991, pp. 335–36, nos. 147, 148 (as present location unknown), 149. At the time they were mistakenly attributed to Edme Jeaurat (1688–1738), the engraver, elder brother, and teacher of Étienne.

5. Black and white chalk on blue paper, 9 x 11¼ in. (23 x 28.5 cm), Gift of Belinda L. Randall from the John Witt Randall Collection (inv. 1898.24). Both the Fogg and the Goncourt drawings came from the Damery collection (L.2862), although the old mount on the Cambridge sheet bore an attribution to Henri Watelet and was reattributed to Jeaurat only in 1969 (per Miriam Stewart, letter, September 16, 1996).

6. See *Le dessin français des XVIe–XVIIIe siècles: La collection du Musée des Beaux-Arts Pouchkine à Moscou* (Moscow, 1977), no. 67.

7. Hôtel Drouot, Paris, December 16, 1987, lot 11.

CHARLES-JOSEPH NATOIRE

Nîmes 1700–1777 Castel Gandolfo

39. *The Harvest of Silenus*

Red, white, and touches of black chalk, pen and brown ink, brush and brown wash, heightened with white, on beige paper, 7¼ x 10⅛ in. (18.3 x 25.7 cm)

The Metropolitan Museum of Art, The Elisha Whittelsey Collection, The Elisha Whittelsey Fund, 1996 (1996.568)

On August 29, 1759, Charles-Joseph Natoire, then the director of the Académie de France in Rome, wrote to the marquis de Marigny, the *surintendant des Bâtiments* in Paris: "I have the honor of presenting to you this small painting which I mentioned in the last post. I was inspired in my idea for it by a young man, fifteen years old, who goes around Rome, a butcher's son, who seems to have been made for the sole purpose of representing a young Silenus. *After having first drawn it* [emphasis added] I created this small work which could be titled 'The Harvest of Silenus.' It seemed to me to be susceptible to certain lighting effects favorable for painting. I am hoping that you will find it passable and deserving of a place in your cabinet."[1] Marigny wrote back on October 4: "I have received, Monsieur, your letter of August 29 and the small painting representing a Harvest of Silenus, which you had told me about several days earlier. Please accept my thanks. Your work is always marked by the talent and learning of your art."[2] The catalogue of Marigny's estate sale in 1782 records a small canvas, "A bacchanal comprising seven figures. The young Bacchus is seated near a vat filled with grapes; a nude man in a vat squeezes a bunch of grapes on his head."[3]

While the painting is untraced, the preparatory drawing Natoire refers to in his letter must be the present sheet.[4] Apparently he kept the study, for he made another version in watercolor five years later (fig. 39.1).[5] Natoire often made several versions of his own drawings, sometimes separated by months or years, typically opting for a different medium and technique but leaving the composition unchanged. In his later years this practice accelerated. In these late copies his earlier conviction and delicacy of rendering are frequently replaced by a decorative use of watercolor.[6]

Bacchanals were a favorite theme of Natoire's throughout his career. The unconventional iconography of the Metropolitan's sheet—in which Silenus is shown as a young man, in a paternal role with the young Bacchus—must have been improvised to provide a role for Natoire's source of inspiration: the teenage son of a local butcher. Nonetheless, it recalls in many of its details the painting *The Triumph of*

39.1. Charles-Joseph Natoire, *The Harvest of Silenus*, 1764. Pen and brown ink over black chalk and watercolor, 7¾ x 10½ in. (19.8 x 26.8 cm). Musée Atger, Montpellier

39

Bacchus (Musée du Louvre, Paris), which he submitted to the 1747 *concours*. In contrast to Carle Vanloo's painting, *The Drunkenness of Silenus* (Musée des Beaux-Arts, Nancy),[7] made for the same competition, Natoire does not use the drunken, overweight character as an excuse for an essay in Rubensian color and naturalism, but sees the stories of classical antiquity as harmoniously linked to the beauties of the pastoral landscape—strewn with antiquities, suffused with golden light, and inspired by the artist's love of the Roman campagna.

P S

PROVENANCE: Christie's, London, July 2, 1996, lot 236 (as "The Education of Bacchus"); [Katrin Bellinger Kunsthandel, Munich]; purchased by The Metropolitan Museum of Art.

Unpublished.

1. Montaiglon and Guiffrey 1887–1912, vol. II, p. 302. Lise Duclaux includes this mention in her biographical chronology, although the month of the letter is mistakenly given as November; see Duclaux 1991, p. 19.
2. Montaiglon and Guiffrey 1887–1912, vol. II, pp. 310–11.
3. The marquis de Ménars estate sale, Paris, March 18–April 6, 1782, p. 20, lot 61. The dimensions are given as: "17 pouc. sur 13 de haut."
4. The ratio of height to width in the lost painting is very close to that of the drawing. An eighth figure, a semiobscured putto, may have either been left out of the final painting or missed in the auctioneer's count. The drawing was catalogued by Christie's in 1996 as an "Education of Bacchus" and connected to an untraced shaped overdoor of that subject exhibited at the 1745 Salon.
5. See Yvonne Vidal, *Dessins du Musée Atger conservés à la Bibliothèque de la Faculté de Médecine de Montpellier*, exh. cat., Paris, Musée du Louvre (Paris, 1974), p. 24, no. 32.
6. This aspect of Natoire's draftsmanship is discussed in Roland Michel 1987, p. 38.
7. See Rosenberg and Sahut 1977, p. 65, no. 107.

JEAN-ROBERT ANGO

Active Rome 1759–70; died after January 16, 1773

40. "A Stucco Angel from the Nave Vault, Church of the Gesù, Rome," from the album "Drawings after Ornament and Architecture"

Red chalk, 5⅝ x 8⅜ in. (14.3 x 21.4 cm), mounted to a larger sheet with multiple framing lines, then inset into a secondary sleeve mount

Cooper-Hewitt, National Design Museum, Smithsonian Institution, Gift of Mr. Noah Butkin, 1977-110-4 (9)

Jean-Robert Ango is an artist about whom we know very little, and whose very existence was doubted earlier in the century. His career has now been reconstructed from scant evidence by Marianne Roland Michel and Pierre Rosenberg.[1] Although he worked outside the official channels of patronage, he appears to have been integrated into the French artistic community in Rome and to have received many commissions from French collectors. An attack of apoplexy in 1772 left him unable to work and reduced to begging. In 1761 Ango visited Naples in the company of Fragonard, presumably to make sketches for the abbé de Saint-Non's *Recueil de griffonnis, de vuës, paysages, fragments antiques et sujets historiques*, published in 1773, and apparently exchanged drawings and counterproofs with Hubert Robert.[2] It would also appear that Ango was a painter, although no paintings by his hand have been identified to date. Julien de Parme refers to him in correspondence as a painter,[3] and the supplement to the bailli de Breteuil's sale catalogue lists and describes four canvases by his hand.[4]

Although the details of Ango's life remain shadowy and incomplete, his legacy of chalk copy drawings, numbering well into the hundreds, allows us to retrace his steps as he labored to record the art and sculptural decoration of Rome's great palaces and churches. Rather than the learning process of a student, this vast body of copies evinces an encyclopedist's urge to describe and record. Indeed, much of Ango's oeuvre may have been made on commission for just such a purpose. Twenty-seven of Ango's copies were translated into etchings and aquatints by the abbé de Saint-Non as part of his *Recueil de griffonnis* project, and the bailli de Breteuil commissioned Ango to make what was essentially an illustrated catalogue of his paintings collection in 1770.[5]

The present album belongs to a group of four at the Cooper-Hewitt, long attributed to Fragonard before Alexandre Ananoff published them as by Ango in 1965.[6] As a group they may represent a similar documentary venture, although the fragmentary nature of the copies—which typically focus on a detail of a larger whole—reveals a more selective aesthetic, perhaps absorbed by Ango during his involvement with the *Griffonnis* project. Coming, as Roland Michel pointed out in 1981, from the collection of the bailli de Breteuil, the albums together include 151 drawings of details, mostly single figures, taken from Rome's great monuments. Jacques-Laure Le Tonnelier de Breteuil (1725–1785), the bailli de Breteuil, was ambassador of the Order of the Knights of Malta to the Holy See as well as a devoted collector and patron of the arts. Ango is documented as working for him in 1760 and identified in 1770 by the title *dessinateur de M. le bailly de Breteuil* in the inscription of the album of drawings he made after paintings in Breteuil's collection.[7]

Ango's distinctive handling of red chalk seems to have changed little over his career, although the group still held by the Breteuil family, which must be late works, tends to be more accomplished.[8] The Cooper-Hewitt drawings represent Ango's characteristic style, in which outlines are worked over repeatedly with a heavy hand, resulting in a tremulous quality. Lively lines describe swirling effects of Baroque drapery and ornamental design, but there is little

40.1. Ercole Antonio Raggi (1624–1686), after a design by Giovanni Battista Gaulli (1639–1709), *Angel.* Stucco. From the nave vault of the Church of Il Gesù, Rome

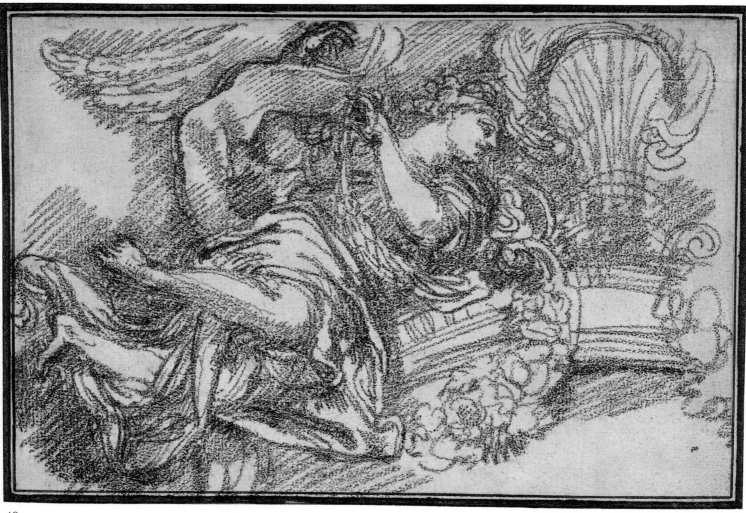

40

interest in facial features or anatomical nuance. More prominent are broad areas of even hatching that suggest an atmospheric context.

Phyllis Dearborn Massar, whose research has identified the sources for many of the sheets in the Cooper-Hewitt albums, has noted that the present sheet is after a stucco angel on the ceiling of the Church of Il Gesù in Rome, the central fresco of which depicts the Triumph of the Name of Jesus.[9] The decoration of the nave vault of this important Jesuit church was supervised by Giovanni Battista Gaulli, called Baciccio (1639–1709), between 1676 and 1679.[10] The playful blurring of illusionistic and real space fostered a close collaboration between Baciccio and his stucco workers. In this case, the stucco angel (fig. 40.1) seems to have been the work of Ercole Antonio Raggi, working from a drawing by Baciccio. Again, one can make the point, as with *The Flaying of Saint Bartholomew* by Vincent (no. 67), that while the

teachings of the Académie may have emphasized the instructive value of classical antiquity and the high Renaissance, French artists of the later eighteenth century were more likely to take their inspiration from the Italian Baroque which, with its emphasis on movement and luminosity, was much closer to the Rococo sensibility. P S

PROVENANCE: Jacques-Laure Le Tonnelier, bailli de Breteuil; his estate sale, Paris, January 16, 1786, and following days, lot 93 ("Quatre volumes de Dessins par Angot, d'après Michel-Ange & autres"); Ernest Hébert (per 1965 sale catalogue); George Hoentschel; Marius Paulme; sold to the Honorable Irwin Laughlin, Washington, D.C., in 1926; Mrs. Hubert Chanler, New York; sold, Sotheby's, London, June 10, 1959, lot 18 (as Fragonard), to S. and R. Rosenberg; sale, Sotheby's, London, May 21, 1963, lot 130 (as Fragonard); sale, Palais Galliera, Paris, March 30, 1965, lot 1 (as Ango); [Shepherd Gallery, New York]; Noah L. Butkin, Cleveland, Ohio; given by him to the Cooper-Hewitt, National Design Museum, Smithsonian Institution.

LITERATURE [for the group as a whole]: Alexandre Ananoff, "Les paysages d'Ango," *Bulletin de la Société de l'Histoire de l'Art Français,* 1965, p. 164, n. 1; Marianne Roland Michel, "Un peintre français nommé Ango . . . ," *The Burlington Magazine* 123, no. 945 (December 1981), supplement no. 40, p. iii, nn. 14, 18; James David Draper, "Ango after Michelangelo," *The Burlington Magazine* 139, no. 1131 (June 1997), pp. 398–400.

1. Marianne Roland Michel, "Un peintre français nommé Ango . . . ," *The Burlington Magazine* 123, no. 945 (December 1981), supplement no. 40, pp. ii–viii; and Pierre Rosenberg, "La fin d'Ango," *The Burlington Magazine* 124, no. 949 (April 1982), pp. 236–39.
2. A counterproof is a drawing made by placing a blank sheet of moistened paper on top of a chalk drawing and running the two sheets through a press. This creates a pale mirror image on the second sheet.
 For an example of an album of drawings and counterproofs assembled by Robert containing works by Ango, see the entry on the album sold at Christie's, New York, January 10, 1996, lot 216.

3. Roland Michel, "Un peintre français nommé Ango . . . ," p. ii.
4. Le bailli de Breteuil estate sale, Paris, January 16, 1786, and following days, "supplement," lots 42–45.
5. Raoul Ergmann, "La collection inédite du bailli de Breteuil," *Connaissance des Arts,* no. 413–14 (July–August 1986), pp. 70–75; Yavchitz-Koehler 1987; and *Un grand collectionneur sous Louis XV: Le cabinet de Jacques-Laure de Breteuil, bailli de l'ordre de Malte, 1723–1785,* exh. cat., Château de Breteuil ([Breteuil, 1986]).
6. Alexandre Ananoff, "Les paysages d'Ango," *Bulletin de la Société de l'Histoire de l'Art Français,* 1965, p. 163.
7. Ergmann, "La collection inédite du bailli de Breteuil," p. 70.
8. A selection from this group is illustrated in Yavchitz-Koehler 1987.
9. Conversation, October 29, 1997. Massar's article on the Cooper-Hewitt albums, "Drawings by Jean-Robert Ango after Paintings and Sculpture in Rome," is forthcoming in *Master Drawings,* vol. 37, no. 1.
10. Robert Enggass, *The Painting of Baciccio, Giovanni Battista Gaulli, 1639–1709* (University Park, Pa., 1964), pp. 135–40, fig. 67.

HUBERT ROBERT

Paris 1733–1808 Paris

41. Draftsman in the Oratory of Sant' Andrea, San Gregorio al Celio

Red chalk, 12¹⁵⁄₁₆ x 17⅝ in. (32.9 x 44.8 cm). Dated in lower left corner in red chalk: *1763*

The Pierpont Morgan Library, Gift of Mr. and Mrs. Eugene Victor Thaw (1981.74)

Although he was not officially a pensionnaire, Robert often accompanied the Académie students on their sketching expeditions, as is documented here. In the Morgan Library sheet, we see one of Robert's compatriots hard at work in the Oratory of Sant' Andrea (fig. 41.1),[1] copying a fresco by Domenichino, *The Flagellation of Saint Andrew* (1609); all that is visible are the legs of the executioner in the right foreground. To best study the painting, the artist has positioned himself just so, creating a precarious perch of chairs and kneelers, sitting on one chair and resting his feet on another. The tricorne hat at his left suggests the presence of another artist, since this man's head is already covered by a knitted cap; it forms a triangular accent in the center of the composition. An easel rests against the holy water font. The complex play of triangles and diagonals reveals a carefully arranged composition. As the artist intently studies the painting, a dog peers through an open door into the street outside (there is often a playful and irreverent side to Robert's depictions of churches), and bright sunshine streams into the dark cool space of the church.

Another drawing by Robert of the oratory showing three artists is known through reproduction only (fig. 41.2).[2] Victor Carlson has pointed out that the draftsman seated directly on the kneelers is Robert himself (which suggests that he is the owner of the tricorne hat),[3] and that the two drawings must have been done about the same time, as the easel is placed in exactly the same spot in both. In this view the entire composition of the Domenichino is visible, but Robert faces the opposite side of the room, copying the fresco of *Saint Andrew Led to Martyrdom* (1609), by Guido Reni.

Although works by such luminaries as Domenichino and Reni were held up as models to the young pensionaires, appreciation of these particular works was heightened by the awareness, widespread by the 1760s, of their deteriorating state of preservation. Copying in this case thus took on an added urgency. Robert had a particular interest in the decay of civilization's material accomplishments. Usually documenting Greek and Roman remains, he focuses here on the Baroque.

MTH

41

41.1. Oratory of Sant' Andrea, Church of San Gregorio al Celio, Rome (photo: Instituto Centrale per il Catalogo e la Documentazione)

41.2. Hubert Robert, *Draftsmen in the Oratory of Sant' Andrea.* Red chalk, 14⅛ x 19¾ in. (36 x 50 cm). Present location unknown

PROVENANCE: M. Le Vicomte Beuret; his sale, Galerie Georges Petit, Paris, November 25, 1924, lot 19; Charles Férault (Lugt supp. 2793a); Mrs. W. H. Crocker; [Frank Perls Gallery, Beverly Hills, California]; Eugene Victor Thaw, New York; The Pierpont Morgan Library.

LITERATURE: *Le gaulois artistique,* May 12, 1928, p. 189; Felice Stampfle and Cara D. Denison, *Drawings from the Collection of Mr. and Mrs. Eugene V. Thaw,* exh. cat., New York, The Pierpont Morgan Library; The Cleveland Museum of Art; The Art Institute of Chicago; Ottawa, The National Gallery of Canada (New York, 1975), pp. 48–49, no. 37 (ill.); Carlson 1978, no. 13 (ill.); Beverly Schreiber Jacoby, *French Master Drawings,* exh. cat., pp. 52–53, New York, Didier Aaron, Inc.

(New York, 1984), no. 7; Charles Ryskamp, ed., *Twentieth Report to the Fellows of The Pierpont Morgan Library, 1981–1983* (New York, 1984), p. 294; Roland Michel 1987, p. 76, no. 65 (ill.); Rome 1990, no. 117 (ill.); New York and Montreal 1993, p. 172, no. 94 (ill.).

1. For the oratory and its decoration, see Richard E. Spear, *Domenichino,* 2 vols. (New Haven and London, 1982), text vol., pp. 155–57, no. 33, plates vol., nos. 58–60.
2. This drawing was included in the Paul Bureau collection sale, Galerie Georges Petit, Paris, May 20, 1927, no. 13 (ill.); its present location is unknown.
3. Carlson 1978, p. 52, no. 13.

JEAN-HONORÉ FRAGONARD

Grasse 1732–1806 Paris

42. *Saint Celestine V Renouncing the Papacy, after Mattia Preti*

Black chalk over a black chalk counterproof , $7^{11}/_{16}$ x $7^{5}/_{8}$ in. (19.5 x 19.3 cm). Inscribed in pen and gray ink at lower left: *Naples / Eglise de St. Pierre / de Calabrese*; at lower right, in black chalk, in reverse: *de Calabrese*

The Metropolitan Museum of Art, Gift of Dr. and Mrs. John C. Weber, 1987 (1987.239)

Just before their three-week return journey to Paris from Rome, the abbé de Saint-Non sent Fragonard and Ango (see no. 40) to Naples in March 1761 to make copies in the churches and at the Capodimonte after the old masters.[1] The excursion represents the first time Saint-Non employed Fragonard as a recording copyist.[2] Among the many copies that Fragonard drew in Naples are several after paintings from the nave ceiling of San Pietro a Maiella by Mattia Preti (1613–1699), called the Cavaliere Calabrese. The ceiling, one of Preti's most celebrated Neapolitan commissions, is formed of several separate canvases depicting scenes from the lives of Saint Catherine and Saint Celestine V, set into elaborate stucco frames in a variety of shapes—rectangles, tondi, ovals, and so forth (fig. 42.1 and figs. 43.1, 43.2).[3] Fragonard made at least five

42.1. Mattia Preti (1613–1699), *Saint Celestine V Renouncing the Papacy,* ca. 1656–60. Oil on canvas. Church of San Pietro a Maiella, Naples (photo: Soprintendenza alle gallerie)

42

copies after sections of the ceiling, including the *Saint Celestine V Renouncing the Papacy* (fig. 42.2), *The Mystic Marriage of Saint Catherine* (fig. 43.3), and *Saint Catherine Touched by Divine Love* (fig. 43.4), all now in the Norton Simon Museum, Pasadena, together with a number of others from the commission.[4] Saint-Non used four of Fragonard's copies from San Pietro a Maiella to make etchings for his *Recueil de griffonnis*.[5]

The broadly hatched black chalk drawings are largely faithful records of their models, with a few minor changes. (Fragonard reoriented the head of the angel on the steps in the *Saint Celestine,* for example, so that he no longer looks at the viewer.) These changes are characteristic of Fragonard as a copyist; he often altered details without subverting the overall sense of the original. Black chalk was Fragonard's favorite medium for making copies during this first Italian sojourn,

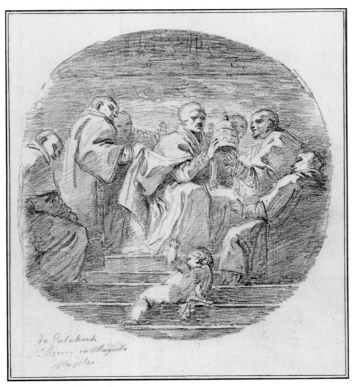

42.2. Jean-Honoré Fragonard, after Mattia Preti, *Saint Celestine V Renouncing the Papacy*, 1761. Black chalk, 17¾ x 13 in. (45.1 x 33 cm). The Norton Simon Foundation, Pasadena

the Metropolitan's drawing, Fragonard has used black chalk to rework his own counterproof. Comparison with his copy drawing in Pasadena (fig. 42.2) indicates that he obliterated the suggestion of the background wall and the chair on which the figure at the right is seated. In the Preti, the background is roof and sky. One wonders if Fragonard made the counterproofs as a record for his own use.

<div align="right">MTH</div>

PROVENANCE: Sale, Hôtel Drouot, Paris, November 13, 1986, lot 52 (ill.); [Galerie Cailleux, Paris]; given to The Metropolitan Museum of Art.

LITERATURE: Rosenberg and Brejon de Lavergnée 1986, p. 344, under no. 38; Lamers 1995, p. 87, under n. 56.

1. See Lamers 1995, pp. 24, 65.
2. See "The Return to France of Fragonard and the Abbé de Saint-Non," in Rosenberg 1988, pp. 118–20.
3. For illustrations of the ceiling, see Claudia Refice Taschetta, *Mattia Preti: Contributi alla conoscenza del Cavalier Calabrese* (Brindisi, n.d.), p. 66, figs. 48–56.
4. See Lamers 1995, pp. 287–301; Rosenberg and Brejon de Lavergnée 1986, p. 344, under nos. 34–38; and Ananoff 1961–70, vol. 4, nos. 2581–85, pp. 198–200.
5. The Fragonard copies after Preti in the *Recueil de griffonis . . .* were *Saint Catherine Touched by Divine Love* and *The Mystic Marriage* and two roundels, *The Martyrdom* and *The Apotheosis* (plates 9, 16, and 17), from the section "Fragment des peintures et des tableaux les plus interessans de l'Italie, 2 ème suite . . . Naples."

and nearly all the known copies for Saint-Non (some three hundred were made) are in this medium. The assertive use of chalk, dense hatching around the figures, and dark chiaroscuro made them ideal to counterproof, as most of them were. In

NICOLAS-BERNARD LÉPICIÉ

Paris 1735–1784 Paris

43. *The Mystic Marriage of Saint Catherine*; *Saint Celestine V Renouncing the Papacy*; *Saint Catherine Touched by Divine Love*

Pen and ink, brush and gray wash over black chalk underdrawing, 8 5/16 x 14 1/16 in. (21.1 x 35.7 cm)

The Metropolitan Museum of Art, Van Day Truex Fund, 1986 (1986.302.1)

Twenty years after he sponsored Fragonard's trip to Naples, the abbé de Saint-Non began to have some of the copies made on the 1761 trip, together with new material he was gathering (see no. 66), engraved by professional printmakers to be included in his *Voyage pittoresque . . . de Naples et de Sicile* (published in four volumes, 1781–86).

As part of this process he engaged Lépicié (who, ironically, never went to Italy himself), the son of a well-known engraver, to copy the copies in 1780.[1] The present drawing is such a copy of a copy, of three scenes from Mattia Preti's ceiling of San Pietro a Maiella (see no. 42). One might ask why Saint-Non required this service. There are two answers, one having to do with the legibility of the copy for reproduction, the other with taste.

Lépicié had never seen the original Preti paintings (see figs. 42.1, 43.1, and 43.2), so he could not add to the verisimilitude of the detail (unlike Saint-Non's other copyist on the project, Charles-Nicolas Cochin). Indeed, his drawing is faithful to Fragonard's copies (figs. 42.2, 43.3, and 43.4), which depart from Preti's originals in several small details. The changes introduced by Lépicié are not in detail but in style, his copies

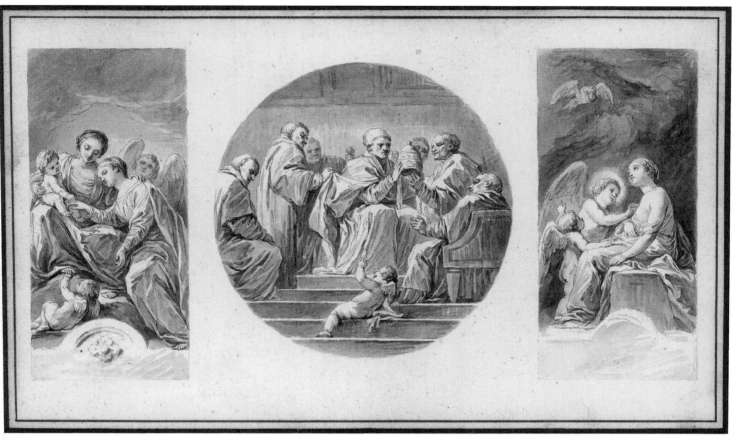

43

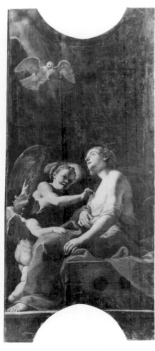

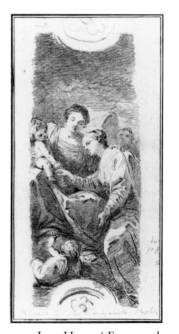

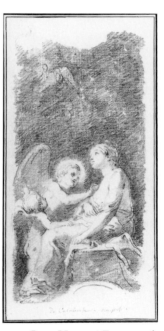

43.1. Mattia Preti (1613–1699), *The Mystic Marriage of Saint Catherine*, ca. 1656–60. Oil on canvas. Church of San Pietro a Maiella, Naples (photo: Soprintendenza alle gallerie)

43.2. Mattia Preti (1613–1699), *Saint Catherine Touched by Divine Love*, ca. 1656–60. Oil on canvas. Church of San Pietro a Maiella, Naples (photo: Soprintendenza alle gallerie)

43.3. Jean-Honoré Fragonard (1732–1806), *The Mystic Marriage of Saint Catherine*, 1761. Black chalk, 17¾ x 13 in. (45.1 x 33 cm). The Norton Simon Foundation, Pasadena

43.4. Jean-Honoré Fragonard (1732–1806), *Saint Catherine Touched by Divine Love*, 1761. Black chalk, 17¾ x 13 in. (45.1 x 33 cm). The Norton Simon Foundation, Pasadena

being more legible, more tightly executed. Saint-Non himself cited his reasons for bringing Cochin and Lépicié to the project, noting that although Fragonard's drawings were "spirited," they were not finished enough, so that the participation of Cochin and Lépicié would be most helpful to the engravers.[2] Philip Conisbee ascribes Lépicié's alterations to the changing taste of the times, away from the vigorous Baroque of Fragonard's original copies: "If we ever wondered how Fragonard's spirited draftsmanship was rendered into the much more precise engraved forms of the archaeological and antiquarian *Voyage pittoresque*, [it is the copies made] . . . by the engraver Nicolas-Bernard Lépicié, after Fragonard drawings, . . . [that] tame his spirit down for the more classical demands of the 1780's."[3]

Saint-Non's project was ultimately scaled back because of lack of funds and these three scenes were not used. Other scenes from the ceiling, copied by Fragonard, do, however, appear: *The Beheading of Saint Catherine of Alexandria* and *The Body of the Martyred Saint Catherine Carried by Angels*.[4] Although no intermediary copies have come to light,[5] one would surmise that these too were drawn by Lépicié.

MTH

PROVENANCE: Anonymous sale, Paris, May 4–5, 1843, lot 113; [Galerie Cailleux, Paris]; purchased by The Metropolitan Museum of Art.

LITERATURE: Philippe Gaston-Dreyfus, *Catalogue raisonné de l'oeuvre peint et dessiné de Nicolas Bernard Lépicié (1735–1784)* (Paris, 1923), nos. 332–34, p. 104; Roland Michel 1968, no. 38, n.p.; Roland Michel 1986, p. 168 (ill. p. 165); Rosenberg and Brejon de Lavergnée 1986, p. 344, under nos. 34, 35, 38; Lamers 1995, p. 87, n. 56.

1. Several such copies of copies were made by Lépicié for this project. Also in the Metropolitan Museum is the *Six Drawings after Solimena and Ribera* (1986.302.2), for which see Roland Michel 1986, no. 37 (ill.); and another, also deriving from compositions by Solimena and Ribera, was on the market at Christie's, Monaco, June 20, 1992, no. 236 (ill.). All the known examples follow the same format of including two or three copies on one sheet.

2. Jean Claude Richard de Saint-Non, *Voyage pittoresque, ou, description des royaumes de Naples et de Sicile*, 4 vols. (Paris, 1781–86), "Explication sommaire," vol. 1, pt. 1, p. 1.

3. Philip Conisbee, "London and Paris: French Artists at Home and Abroad," *The Burlington Magazine* 128, no. 1000 (July 1986), p. 533.

4. Saint-Non, *Voyage pittoresque*, vol. 1, pt. 1, pl. 66, and p. 117. See also Lamers 1995, pp. 297–98, under no. 306 (a, b, and c).

5. There is, however, a tantalizing reference in the catalogue of the Paignon-Dijonval collection (cited in Lamers 1995, p. 87, under n. 56), nos. 4056–66: "Recueil de Dessins, Faits pour le Voyage de Naples et de Sicile publié par M. de St.-Non . . . no. 4061: Cochin et Lépiciér. Quatre d. [Dessins] d'après des tableaux des maîtres célèbres d'Italie, représentant le martyre d'une sainte; la même portée au ciel par des Anges; un repos en Egypte; et le Christ au tombeau; ils sont d'après le Calabrois, Schidone et le Poussin: à la pierre noire sur papier blanc; ils sont collés sur deux feuilles, et portent de h. 8 po. sur 6 po."

CHARLES-JOSEPH NATOIRE

Nîmes 1700–1777 Castel Gandolfo

44. *The Fountain of the Water Organ at the Villa d'Este, Tivoli*

Pen and brown ink, brush and brown and gray wash, watercolor, heightened with white, over black and red chalk, 12⅜ x 18¾ in. (31.4 x 47.5 cm). Inscribed, dated, and signed in pen and brown ink at lower right: *villa d'est en Tyvoly / aprille 1760. / C.N.*

The Metropolitan Museum of Art, Rogers Fund, 1965 (65.65)

After two highly productive decades in the French capital, creating decorative cycles for private hôtels, large-scale illusionistic church interiors, and designs for tapestry, Natoire was awarded the post of director of the Académie de France in Rome. While a prestigious appointment, it meant he would spend the last twenty-six years of his life in Italy, with relatively few opportunities to gain commissions for paintings. As a result, much of his energy was

44.1. Jean-Honoré Fragonard (1732–1806), *The Gardens and Terraces of the Villa d'Este at the Foot of the Fountain of the Organ*, ca. 1760. Red chalk, 14 x 19¼ in. (35.6 x 49 cm). Musée des Beaux-Arts, Besançon

44

redirected to drawing: copies after other artists (a lifelong practice for Natoire), copies after his own earlier drawings, and a great number of ambitious independent landscape drawings. Typically, these last would be of a fairly large format, executed in his distinctive technique of pen and brown ink, wash, and watercolor, over black and red chalk, heightened with white. The types of views that he chose were fairly consistent as well—not pure landscape, but vistas that combined architecture, antiquities, and garden sculpture with picturesque overgrown foliage and local pastoral types tending children, tending animals, making music.

Natoire's regular letters to the marquis de Marigny during this period make frequent mention of his expeditions into the Roman campagna and the drawings that he made there. Natoire's encouragement of *plein-air* sketching influenced a generation of students—an agenda no doubt fostered in part by directives from Paris suggesting that students with skills less than perfectly suited to history painting might pursue the genre of landscape, where the talent pool in the capital was considered lacking.[1] The Villa d'Este, in nearby Tivoli, was a favorite destination. Built in the sixteenth

century for Ippolito d'Este and his son, Ludovico, the villa had fallen into disrepair by the eighteenth century, when it was the property of the duke of Modena, Francesco III d'Este, son-in-law of the duc d'Orléans. Renowned for their antique statuary and inventive fountain designs, the gardens were arranged down a steep hillside and provided a great range of viewpoints and subjects.

The present sheet shows the Fountain of the Water Organ framed by two trees, with its water flowing beneath a balustrade and falling in a cascade. Designed by two Frenchmen, Luc LeClerc and Claude Venard,[2] the Water Organ was a novel feat of hydraulic engineering in which the movement of water forced air into the pipes of an organ, producing sound. The apse of the Chiesa della Carità stands to the right. The scene was recorded by a number of eighteenth-century artists,[3] including Natoire's student Fragonard, whose view, now at the Musée des Beaux-Arts, Besançon, was made from the foot of the fountain (fig. 44.1), and shows the organ in shadow, nearly engulfed by an abundance of lush foliage.

The accuracy of the foreground elements in Natoire's

drawing is difficult to confirm. The two vases flanking the path to the left do not correspond to any visible object in other drawings or prints of the garden. Nor do any other sources indicate the presence of a statue of a spouting lion in this particular spot, though similar statues appear in some of Fragonard's scenes inspired by Tivoli.[4]

Although Natoire occasionally gave his Roman landscape drawings as gifts (they appear in the Mariette and Marigny sales), he still had over 160 in his possession at the time of his death. Of the twelve views of Tivoli described in the catalogue of his sale, the present location of only a handful has been traced.[5] As a group, the Italian landscapes are unified by their exquisite sensitivity to coloristic effect and the fall of light. Natoire's easy inventiveness within his figural repertoire is complemented by the supple, calligraphic ink line used on the figures and other foreground elements. The scenes are marred only by an occasional awkwardness in perspective, as in the present sheet, where the path ascending to the right was, according to engraved plans, at right angles both to the balustraded terrace above and to the path at the left.[6]

P S

PROVENANCE: Sale, Sotheby's, London, March 25, 1965, lot 125; purchased by The Metropolitan Museum of Art.

LITERATURE: *MMA Report*, 1965–66, p. 75; Berckenhagen 1970, p. 240, under no. 3007; Dayton 1971, no. 10 (ill.); Gillies and Ives 1972, no. 35; Rosenberg 1972, p. 187, under no. 99; Storrs 1973, no. 63, fig. 18; Andrea Busiri Vici, "Paesistica romana di Charles Natoire," *Antichità Viva* 15, no. 2 (March–April 1976), pp. 40–41, fig. 17; *Artists in Rome in the 18th Century: Drawings and Prints*, exh. cat., Metropolitan Museum of Art (New York, 1978), n.p. [14]; Bean and Turčić 1986, p. 189, no. 208 (ill.); Jennifer Montagu, "Quand un musée s'expose," *Connaissance des Arts*, no. 416 (October 1986), pp. 88–89 (ill.); Rosenberg 1988, p. 114, under no. 35; Alan Wintermute, ed., *Claude to Corot: The Development of Landscape Painting in France*, exh. cat., New York, Colnaghi (New York, 1990), pp. 182–84, no. 33 (ill.; entry by Eunice Williams).

1. Marigny's letter to Natoire on July 10, 1752, is quoted in Christian Michel, *Charles-Nicolas Cochin et l'art des lumières* (Rome, 1993), pp. 508–9.
2. See David R. Coffin, *The Villa d'Este at Tivoli*, Princeton Monographs in Art and Archaeology, 34 (Princeton, 1960), pp. 17–19.
3. For a red-chalk drawing attributed to Pierre-Adrien Pâris (1745–1819), see Rosenberg 1988, p. 114, fig. 5, under no. 35.
4. See his *Interior of a Park: The Gardens of the Villa d'Este* in the Thaw collection, Denison 1993, p. 164, no. 73.
5. A view of the Fountain of Pomona and the Avenue of the Hundred Fountains is in the Kunstbibliothek, Berlin, and a view of the Fountain of Rome was recently given to the Metropolitan Museum (no. 45).
6. Coffin, *The Villa d'Este at Tivoli*, fig. 1.

CHARLES-JOSEPH NATOIRE

Nîmes 1700–1777 Castel Gandolfo

45. *The Fountain of Rome at the Villa d'Este, Tivoli*

Pen and brown ink, brush and brown and gray wash, watercolor, heightened with white, over black and red chalk, on faded blue paper, 11⅞ x 18¾ in. (30.2 x 47.6 cm). Inscribed, dated, and signed in black ink along the lower margin: *villa Dest magio 1765. C.N.*

The Metropolitan Museum of Art, Anonymous gift in honor of a curator, 1996 (1996.506)

Given to the Metropolitan Museum in 1996, this view of the Villa d'Este was made five years after *The Fountain of the Water Organ* (no. 44) and depicts a less frequently sketched part of the garden, the Fountain of Rome, designed in the 1560s by Pirro Ligorio, archaeologist to the cardinal of Ferrara. One of the most important fountains in the garden, the Fountain of Rome depicted the relationship between Tivoli and Rome in a complex arrangement of landscape, architecture, and allegorical forms. A waterfall representing the cascade at Tivoli merged with a larger waterflow to represent the Tiber, which then flowed before a podium upon which were arranged various symbols and representations of the eternal city.

Rather than the inclusive, straight-on view recorded in engraved views (fig. 45.1), Natoire positioned himself atop the podium with his back to the curved row of architectural facades depicting the seven hills of Rome (this part of the fountain collapsed in 1850).[1] The central statue, the personification of Rome, is seen in profile silhouetted against the small cascade. To accommodate this vantage point, which set the figural and sculptural elements against the dramatic backdrop of the sunlit villa, Natoire rotated by 180 degrees the sculpture of Romulus and Remus suckled by a wolf and gave the wolf a gentler pose.[2] The beginning of the Lane of the Hundred Fountains and the structure built to house the unfinished Fountain of Flora can both be seen in the middle ground to the left. Here, to a greater degree

45

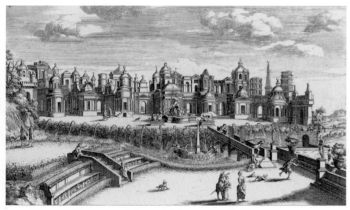

45.1. Giovanni Francesco Venturini (1650–1710), "Fontana e prospetto di Roma antica . . ." Etching and engraving, in *Le fontane di Roma*, 1691, part 4, no. 15. The Metropolitan Museum of Art, Gift of D. W. Langton, transferred from the Library (1991.1073.145)

than usual, Natoire has used figural groups to interact with and echo the sculptural groups. The guitar player who shares the pedestal with Romulus and Remus appears to serenade the female personification of Rome, while the figures seated at the foot of her pedestal look to her for a response. A nursing mother and another woman either feeding or milking a pair of goats echo the nursing wolf in stone.

What may be the same drawing, or at least a close variant, is described in some detail in the nineteenth-century collection of Jules and Edmond de Goncourt: "View of the Villa d'Este. In the foreground a kneeling woman giving a drink to the goat, and on the pedestal, where a she-wolf is suckling Romulus and Remus, a man playing the guitar."[3] However, the fact that the Goncourt brothers recorded the inscription on their drawing as "1766" while the Metropolitan's sheet seems to read "1765" leaves open the possibility that another version may have existed.

P S

PROVENANCE: Possibly in the Jules and Edmond de Goncourt sale, Hôtel Drouot, Paris, February 16, 1897, lot 205; possibly acquired by the comtesse de Péthion; possibly in her estate sale, Paris, May 14–17, 1902, lot 7; sale, Hôtel Drouot, Paris, May 10, 1916, lot 82 bis; acquired by Annette Dreux, Louveciennes, France; by descent to a private collection, New York; given to The Metropolitan Museum of Art.

Unpublished.

1. David R. Coffin, *The Villa d'Este at Tivoli* (Princeton, 1960), pp. 24–26, 122.
2. Both sculptures were carved by the Flemish sculptor Pierre de la Motte; see Coffin, *The Villa d'Este at Tivoli*, pp. 26–27.
3. Quoted in Launay 1991, p. 388, no. 219.

HUBERT ROBERT

Paris 1733–1808 Paris

46. View in an Italian Garden

Red chalk, 10½ x 14¼ in. (26.7 x 36.2 cm)

The Pierpont Morgan Library (I, 290)

Robert and Fragonard developed similar manners of red-chalk landscape drawing during their years in Italy—their response to the Italian light and to Natoire's encouragement of the pensionnaires at the Académie de France in Rome to draw *en plein air*. Their views of Italy often share energetic saw-tooth lines for foliage and dense parallel hatching in the shadows, the deep red chalk contrasting with the white paper and the paper often reserved to mimic brilliant sunlight. Although much research has been done to distinguish their hands, the fact remains that the two artists produced a group of drawings, often of the same sites, that are remarkably similar.[1]

The Morgan Library drawing, though undated, was surely done when Robert was in Italy, perhaps in 1763–64. The scene appears suffused with bright light. The entire composition is determined by vibrating lines, from the dense saw-toothed tangle of foliage in the left foreground to the sweep of the stairs and the checkerboard trellis boxing in the right middle ground, taking the viewer's eye to the fountain above. The swaying figure of the laundress is the ideal counterpoint to the angularity of stairs and trellis. Laundresses are frequent inhabitants of scenes by Robert, who seemed to enjoy the contrast between the luxury and cultivated society implied by the presence of the fountain and the use of such a fountain for purposes of mundane practicality. The garden represented in this sheet has not been identified. While reminiscent of a group of drawings and paintings by Robert inspired by the *giardino secreto* at the Palazzo Farnese at Caprarola[2] and of the Fountain of the Dragon at the Villa d'Este, which Robert also visited and drew, neither of these villa gardens matches the Morgan Library sheet exactly.

Further complicating matters, the fountain visible in the niche on the second level is a fountain formed of three nymphs holding aloft a basin. This sculpture (fig. 46.1), a small Roman marble now in the Louvre, had been at the Villa Borghese since 1609, and seventeenth-century inventories describe it as a fountain. In the eighteenth century it was inside the villa, first in the Stanza del Moro, then in the Stanze dal Sole.[3] The sculpture was used by Robert in at least one other composition, a painting of a fountain in a temple (fig. 46.2).[4]

The drawing must be viewed as a *capriccio*, a fantasy based on elements from several sources, in this instance gardens admired by Robert in or near Rome and a sculpted group from the Villa Borghese with which he was intimately familiar. Indeed, the combining of real elements from different venues in an imagined scene is a commonplace in Robert's oeuvre.[5]

A counterproof taken from this drawing is in Besançon.[6]

MTH

PROVENANCE: William Mayor (Lugt 2799); Charles Fairfax Murray; from whom purchased in 1910 by J. Pierpont Morgan; The Pierpont Morgan Library.

LITERATURE: C[harles] Fairfax Murray, *J. Pierpont Morgan Collection of Drawings by the Old Masters formed by C. Fairfax Murray*, 4 vols. (London, 1905–12), 1290 (ill.); *Pierpont Morgan Treasures*, exh. cat., Hartford, Conn., Wadsworth Atheneum ([Hartford, Conn., 1960]), no. 86; *French Masters, Rococo to Romanticism*, exh. cat., Los Angeles, The UCLA Art Galleries ([Los Angeles], 1961), no. 51; Denison 1993, p. 168, no. 75 (ill. p. 169); Moscow and Saint Petersburg 1998, pp. 162–63, no. 74 (ill.).

1. See Jean-Pierre Cuzin and Pierre Rosenberg, "Fragonard e Hubert Robert: Un percorso romano," in Rome 1990, pp. 21–30; see also Williams 1978, p. 20.

2. See Carlson 1978, pp. 66–67, no. 20; and Victor Carlson, "Hubert Robert at Caprarola: Two Drawings in American Collections," *Apollo* 87, no. 72 (February 1968), pp. 118–23.

 The similarity of the Morgan sheet to the renditions of Caprarola has caused some confusion in the literature. The painted variant of the Morgan Library composition referred to in Denison 1993, p. 168, under no. 75, records an actual view at Caprarola.

3. See Katrin Kalveram, *Die Antikensammlung des Kardinals Scipione Borghese* (Worms am Rhein, 1995), pp. 215–17, no. 103: *Drei Nymphen, die eine Vase tragen*.

4. See Georges Bernier, *Hubert Robert: The Pleasure of Ruins*, exh. cat., New York, Wildenstein (New York, 1988), p. 86 (ill. p. 41).

5. This aspect of Robert's art is discussed by Carlson, in "Hubert Robert at Caprarola: Two Drawings in American Collections," esp. pp. 118–22.

6. See M. L. Cornillot, ed., *Inventaire général des dessins des musées de Provence* [vol. 1], *Collection Pierre-Adrien Pâris: Besançon* (Paris, 1957), no. 143 (ill.); *Fontaine dans une villa italienne*.

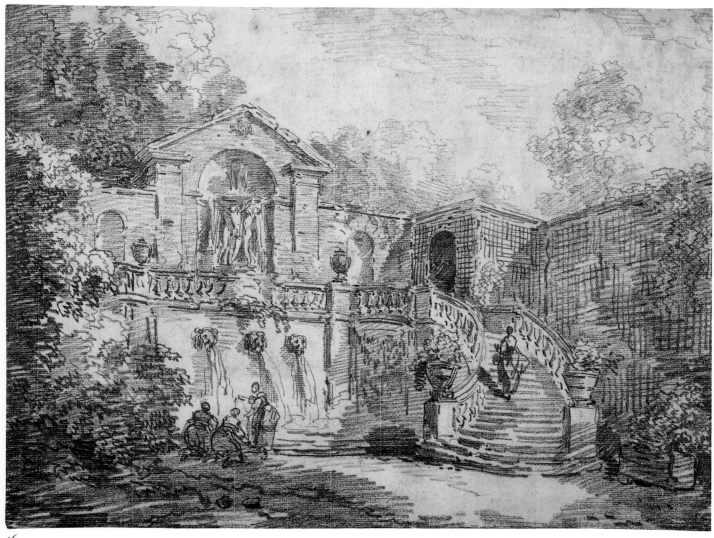

46

46.1. Roman, *Three Nymphs Supporting a Vase*. Marble, height 28½ in. (75 cm). Musée du Louvre, Paris

46.2. Hubert Robert, *Fountain in a Temple*, ca. 1800. Oil on canvas, 44 x 57 in. (112 x 145 cm). Private collection

JEAN-HONORÉ FRAGONARD

Grasse 1732–1806 Paris

47. Virgin and Child with Angels

Black chalk, 10¼ x 7⁷⁄₁₆ in. (26 x 18.7 cm). Inscribed in black chalk at bottom center: *fragonard 1780*

Roberta J. M. Olson and Alexander B. V. Johnson

This previously unpublished sheet looks back to some of Fragonard's earliest themes. This practice, of returning again and again to favorite subjects, has added to the difficulty of dating Fragonard's drawings, especially those of his maturity, for which so little documentation exists. Many of these enduring themes can be traced to the period that Fragonard spent as an apprentice in the early 1750s in the studio of Boucher, where he copied not only the master's work[1] but also, following Boucher's example, paintings by Dutch artists of the seventeenth century. During this time Fragonard made painted copies after three works by Rembrandt in the collection of baron Crozat de Thiers and later bought by Catherine the Great. It was *The Holy Family with Angels*, today in the Hermitage, that most captured his imagination.[2] In addition to the first copy, in which he faithfully transcribed Rembrandt's composition, Fragonard made several smaller horizontal variants that excerpt the mother and child group,[3] giving the subject an air of secular domesticity, as has often been observed.[4]

Fragonard's decision, made about 1767, not to pursue the official path of a history painter, was a defining moment in his career. Nonetheless, he continued to treat religious subjects for private patrons. His compositions for the Adoration of the Shepherds, the Education of the Virgin, the Visitation, and the Rest on the Flight into Egypt are all known through a number of variants,[5] attesting to their popularity. Dating probably to the mid-1770s, these moving scenes are imbued with the stylistic lessons of the Italian Baroque, his appreciation of which he recorded, in the case of his first trip, in the numerous black chalk copies made in churches throughout Italy for the abbé de Saint-Non.

The present sheet, while certainly autograph, is puzzling as to date. The debate hinges on the authenticity of the inscription, "Fragonard 1780."[6] Accepting the 1780 date, the sheet would fit thematically with Fragonard's treatment of biblical subjects in the 1770s and 1780s. The carefully hatched black chalk medium would, however, be unusual for this period, when Fragonard more typically prepared and recorded his religious compositions with wash drawings. On the other hand, guided by style, one would be tempted to associate the sheet with the first Italian trip. Considered against the spectrum of this group, the present drawing would stand among the most highly worked and nuanced of the Italian-period black chalks. Nevertheless, the confirmation of such a thesis awaits the identification of the Italian original that was Fragonard's source.

Throughout his career, Fragonard moved easily between subjects of rustic "happy families" and the traditional Christian iconography from which they derive. Here the sleeping Christ child, his halo clearly visible, is shown with his bare arm casually extended, a premonition of the Crucifixion. Mary is shown spinning. And one of the angels, in a charming anecdotal detail, hushes the other, not to wake the sleeping child. PS

PROVENANCE: Private collection, Paris; [David and Constance Yates, New York]; Roberta J. M. Olson and Alexander B. V. Johnson.

Unpublished.

1. Rosenberg 1988, p. 34.
2. Illustrated in Colin Eisler, *Paintings in the Hermitage* (New York, 1990), p. 193.
3. Daniel Wildenstein, *L'opera completa di Fragonard*, Classici dell'Arte, 62 (Milan, 1972), nos. 7–10, p. 86.
4. For example, Pierre Rosenberg and Marion C. Stewart, *French Paintings, 1500–1825, The Fine Arts Museums of San Francisco* (San Francisco, 1987), pp. 168–70.
5. See Rosenberg 1988, pp. 467–80.
6. Pierre Rosenberg believes the inscription is not by Fragonard's hand, and dates the sheet twenty years earlier, to ca. 1760–61 (verbal communication, March 12, 1998).

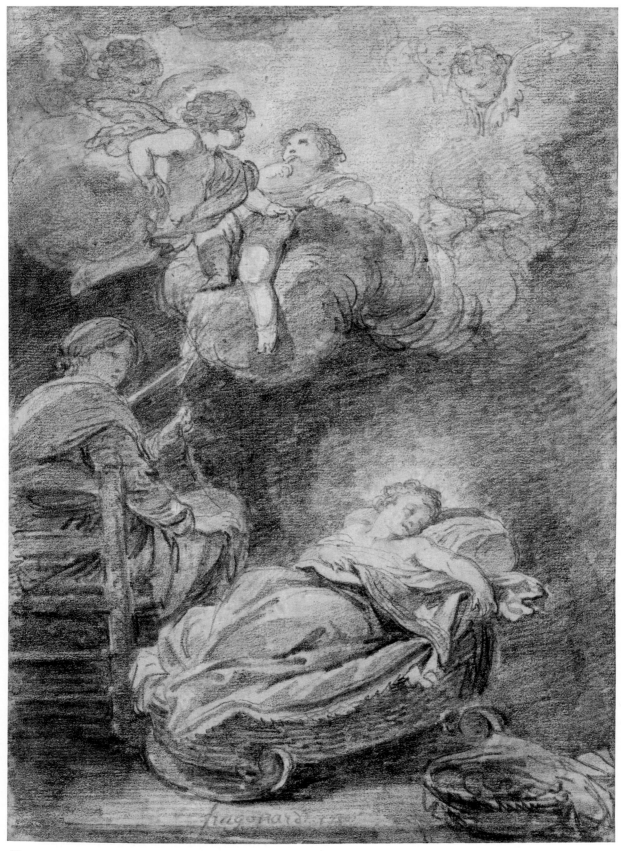

47

JEAN-HONORÉ FRAGONARD

Grasse 1732–1806 Paris

48a. La servante justifiée (2.6)

Black chalk, 7¹³⁄₁₆ x 5⅜ in. (19.7 x 13.6 cm)

48b. L'anneau d'Hans Carvel (2.12)

Black chalk, 7⅞ x 5⁷⁄₁₆ in. (20.1 x 13.8 cm)

48c. Les troqueurs (4.3)

Black chalk, 7¹⁵⁄₁₆ x 5⅜ in. (20.1 x 13.6 cm)

Private collection

First penned in the late seventeenth century, Jean de La Fontaine's amusing and salacious *Contes et nouvelles en vers* found appreciative audiences in eighteenth-century France. About 1740, Nicolas de Larmessin published a suite of prints after the *Contes* with compositions by Lancret, Pater, Eisen, Boucher, Le Clerc, Le Mesle, Lorrain, and Vleughels. An edition illustrated by Charles-Nicolas Cochin appeared in 1743. And the edition known as "des fermiers généraux," with illustrations after Charles Eisen, followed in 1762. No artist, however, was more suited to evoking the light-hearted ribaldry of La Fontaine's stories than Fragonard.

The three sheets included here are from a group of forty-two black chalk sketches generally considered the earliest surviving compositional studies for the project.[1] The sheets from the New York series were counterproofed, with the resulting counterproofs then reworked by the artist in pen and ink and brown wash. Fifty-seven of these reworked counterproofs are in the collection of the Musée du Petit Palais, Paris,[2] and several other groups have been put forward as later variations on the same compositions.[3]

The genesis and function of Fragonard's La Fontaine drawings have long occupied art historians.[4] An edition of the *Contes* published in 1795 by Pierre Didot the elder included prints after sixteen of the compositions, although this fell far short of the "eighty, mostly after Fragonard" that Didot had announced earlier, despite the fact that the drawings doubtless predate the project.[5] Further clouding the known history of the drawings is the tradition, thought to have originated with the artist's descendants, that the black chalk drawings were made on one of Fragonard's Italian trips. Authors from Roger Portalis to Alexandre Ananoff have chosen to interpret this as indicating Fragonard's second trip of 1773–74,[6] though more recently Anne Schroder has called attention to an announcement in the September 1796 *Mercure* that describes the drawings as done in Rome "dans toute la chaleur de la jeunesse."[7] Neither, in fact, may be true. Scholars have approached the problem anew in recent decades, this time giving weight to stylistic analysis and the evidence of watermarks, resulting in a general consensus that the black chalk drawings and the reworked counterproofs all date from the 1760s. Nevertheless, the issue was resurrected in 1992 by José-Luis Los Llanos, who redated both series to the 1770s based on a formal similarity between one of Fragonard's compositions and a drawing by the Swiss artist Henry Fuseli, whom Fragonard could have encountered in Rome in 1774.[8] This theory was soundly rejected by both Bailey and Schroder in their reviews of the 1992–93 exhibition.[9]

Whether or not Fragonard's drawings were originally intended as designs for engravers, he certainly had before him earlier illustrated editions of La Fontaine; in several cases he made direct use of compositions by Eisen, themselves often adaptations of Cochin's illustrations, made two decades earlier. Fragonard's approach was much looser; only occasionally did he take one of the Cochin/Eisen compositions as a starting point. In the drawing for *L'anneau d'Hans Carvel*, for example, he may have been looking at Eisen's illustration not for the corresponding passage, but for *La Joconde*.[10]

Leaving aside issues of sources, dating, and commission, one can appreciate Fragonard's La Fontaine illustrations as part of a unified and appealing vision in which human

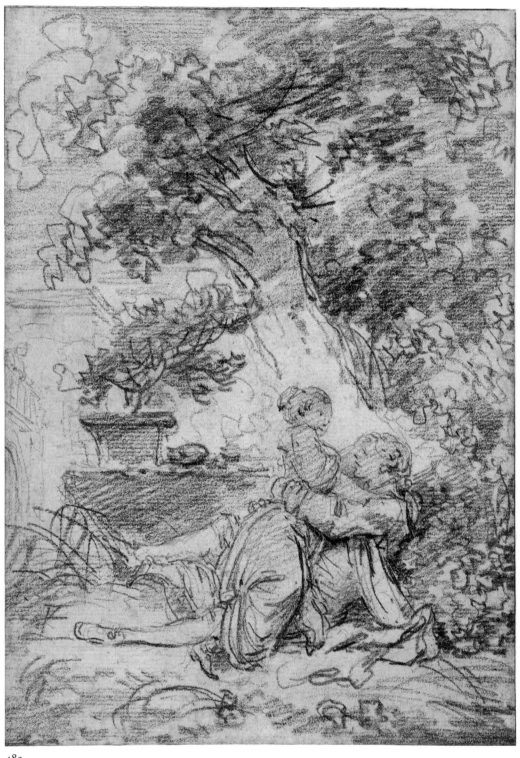

48a

foibles and desires are affectionately depicted. Figures act out their roles not against backgrounds, but **as** integral components of a fertile and harmonious world of bursting foliage, sheltering vines, and billowing clouds and bedsheets. Human impulse is not judged, but smiled upon. Moreover, the graphic means are of a piece with the sentiments expressed; far from the frozen detail one expects of small-scale book illustration, Fragonard's compositions are unified by speed and dexterity. Notational bursts of inspiration,

tactile pleasure, and spontaneity become the visual equivalent of La Fontaine's light-hearted and licentious tales.

PS

PROVENANCE: Traditionally considered to have stayed in the artist's family until the mid-nineteenth century; Hippolyte Walferdin; his collection sale, Paris, April 12–16, 1880, lot 227; acquired at the sale by Étienne-François Haro, Feuillet de Conches; sold in 1888, Roger Portalis; Lord Carnarvon, London; [Édouard Rahir, Paris, 1912]; private collection.

48b

LITERATURE: The series as a whole has an extensive bibliography, which is given in Paris 1992, p. 200.

1. Anne Schroder points out that a smaller, less detailed black chalk drawing (*Belphégor*) formerly with the Galerie Cailleux, Paris, lends weight to the theory that the present group may have been preceded by rougher sketches made on Fragonard's first Italian trip. See Anne L. Schroder, "Reviews: 'Fragonard et le dessin français au XVIIIe siècle dans les collections du Petit Palais,'" *Master Drawings* 34, no. 4 (Winter 1996), p. 433.

2. Paris 1992, pp. 191–275.

3. See Marianne Roland Michel, "Fragonard: Illustrator of the 'Contes' of La Fontaine," *The Burlington Magazine* 112, no. 811 (October 1970), supplement no. 25, pp. i–vi; Williams 1978, pp. 134–35; Paris 1992, pp. 192–93; Colin B. Bailey, "Book Reviews: 'Fragonard et le dessin français au XVIIIe siècle dans les collections du Petit Palais,'" *The Burlington Magazine* 135, no. 1088 (November 1993), pp. 771–72; and Schroder, "Reviews: 'Fragonard et le dessin français,'" pp. 430–35.

48c

4. In addition to the studies cited in notes 2 and 3, Fragonard's La Fontaine drawings were the subject of a dissertation by Anne Layton Schroder, "Fragonard's Drawings Illustrating the *Contes et nouvelles* of La Fontaine: The Role of the Artist in Eighteenth-Century French Book Illustration" (Ph.D diss., University of North Carolina, Chapel Hill, 1992).

5. Emmanuelle Brugerolles and Geneviève Deblock, "Un dessin de Jean Honoré Fragonard pour les *Contes* de La Fontaine conservé a l'École des Beaux-Arts," *Gazette des Beaux-Arts*, ser. 6, 112 (1988),

pp. 269–71; Schroder, "Reviews: 'Fragonard et le dessin français,'" p. 432.

6. The material is summarized in Paris 1992, p. 193.

7. Schroder, "Reviews: 'Fragonard et le dessin français,'" p. 432.

8. Paris 1992, pp. 198–99.

9. Bailey, "Book Reviews: 'Fragonard et le dessin français,'" p. 772; Schroder, "Reviews: 'Fragonard et le dessin français,'" p. 433.

10. Jean de La Fontaine, *Contes et nouvelles en vers* (Paris, 1762), I, opp. p. 6.

JEAN-BAPTISTE GREUZE

Tournus 1725–1805 Paris

49. Head of a Girl with Eyes Downcast (Study for "L'accordée de village")

Black and red chalks, brush and gray wash, over graphite underdrawing, 15%₁₆ x 11¹³⁄₁₆ in. (39.5 x 30.1 cm)

Private collection

The path of Jean-Baptiste Greuze was not that of the traditional academician. Born to a roofer in Tournus and first trained as an artist by Charles Grandon (1691–1762) in Lyon, he arrived in Paris about 1750, already convinced of his abilities and steadfastly—some would say arrogantly—refusing to submit to the system of training and competition required of the ordinary petitioner.[1] If he did not embrace the traditional system of training, however, he accepted the academic system of the hierarchy of genres, that structure whereby history painting was the pinnacle of aspiration and achievement. This conviction led Greuze to explore two directions in his narrative scenes. While he produced a number of traditional religious and history themes, he also created contemporary genre scenes of a scale, compositional complexity, and emotional tone usually reserved for grand history painting.[2]

L'accordée de village (fig. 49.1), one of Greuze's most famous works and a great success when exhibited at the Salon of 1761, was first bought by Mme de Pompadour's powerful brother, the marquis de Marigny, and then by Louis XVI.[3] The contemporary descriptions, especially those by Diderot and the abbé Joseph de la Porte, praised in particular the truthful expression of emotion, and singled out each character as perfectly emblematic of specific emotional moments. Greuze made more than a dozen preparatory drawings for *L'accordée de village*,[4] including three drawings for the bride: one full-length study now in the Musée Vivant-Denon, Chalon-sur-Saône,[5] one mentioned in Mariette's estate sale,[6] and this study for her head. Here, he examines the tilt of the head and the lowering of her shoulder to make sympathetic space for her sad sister. Her modest and grave expression is more reticent than that of her painted counterpart; nor are there flowers on her bodice. Both faces, however, evince the slight ambivalence noticed by Salon viewers.[7] MTH

PROVENANCE: Saint Petersburg, Academy of Fine Arts (Lugt Supp. 2699a); Leningrad, Hermitage; sale, Boerner, Leipzig, April 29, 1931,

49.1. Jean-Baptiste Greuze, *L'accordée de village*, 1761. Oil on canvas, 36¼ x 46⅛ in. (92 x 117 cm). Musée du Louvre, Paris

lot 105, sold to Mincieux; sale, Geneva, June 15, 1960, lot 204; [Charles Slatkin Gallery, New York]; Louis Silver, Chicago; private collection.

LITERATURE: François Monod and Louis Hautecoeur, *Les dessins de Greuze conservés à l'Académie des Beaux-Arts de Saint-Petersbourg* (Paris, 1922), no. 103, pl. XL; Munhall 1976, p. 82, no. 32 (ill.).

1. See Munhall 1976, "Summary Biography," pp. 18–26, and Thomas E. Crow, *Painters and Public Life in Eighteenth-Century Paris* (New Haven, 1983), pp. 134–74.
2. See Munhall 1976, p. 12, and Edgar Munhall, "The Variety of Genres in the Work of Greuze, 1725–1805," *Porticus, Journal of the Memorial Art Gallery of the University of Rochester* 10/11 (1987–88), pp. 21–29.
3. On the popularity, importance, and interpretation of the painting, see Munhall 1976, pp. 84–86, no. 34; Richard Rand, "Civil and Natural Contract in Greuze's 'L'accordée de village,'" *Gazette des Beaux-Arts*, ser. 6, 127 (1996), pp. 221–34; and Emma Barker, "Painting and Reform in Eighteenth-Century France: Greuze's 'L'accordée de village,'" *Oxford Art Journal* 20, no. 2 (1997), pp. 42–52.
4. See Munhall 1976, pp. 85–86, under no. 34.
5. For which, see *Musée de Chalon-sur-Saône, Musée Vivant-Denon:*

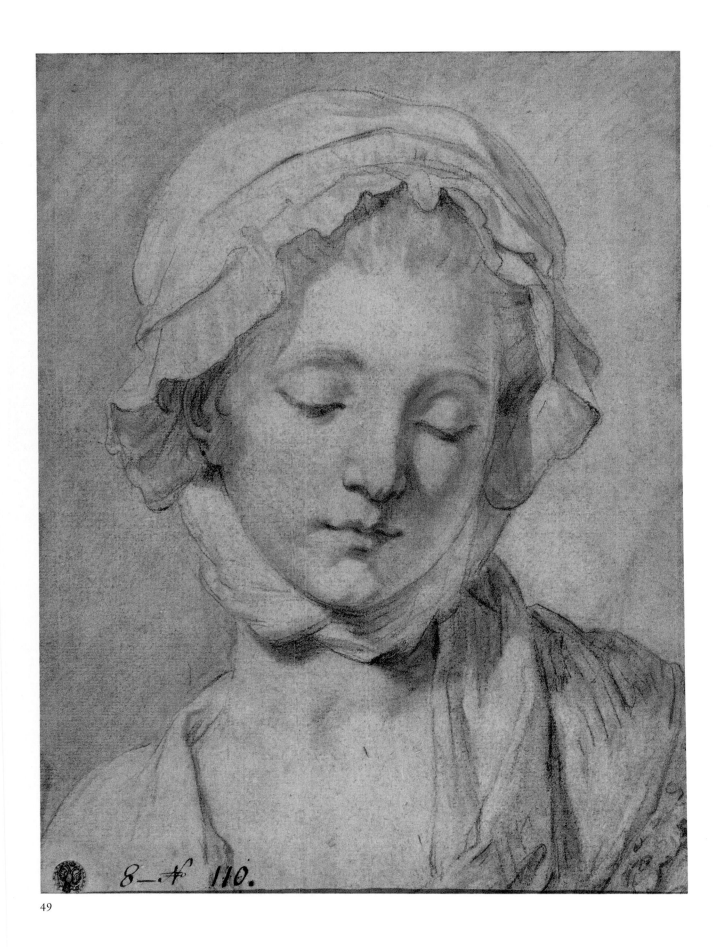

49

Catalogue de la section des Beaux-Arts, peintures, dessins, sculptures, introduction by L. Armand-Calliat (Chalon-sur-Saône, 1963), p. 80, no. 256, pl. xxiii.

6. Pierre-Jean Mariette estate sale, Paris, 1775, lot 1163.
7. In addition to abbé de la Porte, see also Diderot and Baron Grimm in Seznec and Adhémar 1973–83, vol. 1, p. 145.

LOUIS-CLAUDE VASSÉ

Paris 1716–1772 Paris

50. Venus Teaching Cupid to Use His Bow

Red chalk; framing lines in pen and black ink, 15⅜ x 9¾ in. (39.1 x 24.6 cm)

The Metropolitan Museum of Art, Harry G. Sperling Fund, 1982 (1982.94.2)

Louis-Claude Vassé came from a family of sculptor-decorators. His father was employed by the renowned architect Robert de Cotte (1656–1735), and was responsible for, among other projects, the decoration of the Galerie Dorée in the Hôtel de Toulouse, Paris (now the Banque de France). Vassé studied with his father initially, and then became the favorite student of Edme Bouchardon, who considered him a prodigy. He won the first prize for sculpture at the Académie in 1739, and went to Rome as a pensionnaire in 1740, remaining there until 1744. Back in Paris, he won the admiration of Anne-Claude-Philippe de Tubières, the comte de Caylus, who became his patron and protector; the machinations of Vassé and Caylus on behalf of Vassé's career, often at the expense of other artists, earned Vassé the enmity of the artistic community, and ultimately damaged his reputation.[1]

The Metropolitan's drawing is a record made by Vassé of one of his own sculptures in marble (fig. 50.1). It was ordered in 1749 by the Bâtiments du Roi, under the leadership of Lenormant de Tournehem, for an unspecified purpose, and remained in Vassé's atelier for some years. In 1771 it was given to Mme du Barry by Louis XV, and installed at Louveciennes. The sculpture was moved several times and suffered the loss of Venus's right hand and left foot, as well as Cupid's left forearm. It was restored in 1918.[2]

Why Vassé left the bow out of his record drawing is a mystery. One wonders if the bow and arrow were added only when the piece was about to leave the studio, more than a decade after it was begun, and thus not a part of Vassé's record, made soon after the sculpture was completed.

This sheet is characteristic of Vassé's record drawings in both medium and style. It was his practice to make his preparatory drawings in wash and pen and ink, and then his record of the finished sculpture in red chalk. The use of a lush red chalk eliminates the sense of coldness one might find in the sculptures themselves. Vassé further enhanced the warmth of the drawing by emphasizing the tilt of

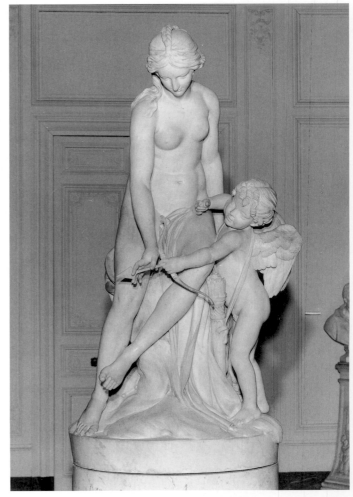

50.1. Louis-Claude Vassé, *Venus instruisant l'amour à tirer de l'arc*, 1755–60. Marble, height 75⅜ in. (191.5 cm). Musée National des Châteaux de Versailles et de Trianon

Cupid's chubby face, to take full advantage of the soft roundness of his cheek. As in all the known record drawings by Vassé, the dense hatching of the background creates a three-dimensional effect, allowing the sculpted group to emerge from the page.

MTH

114

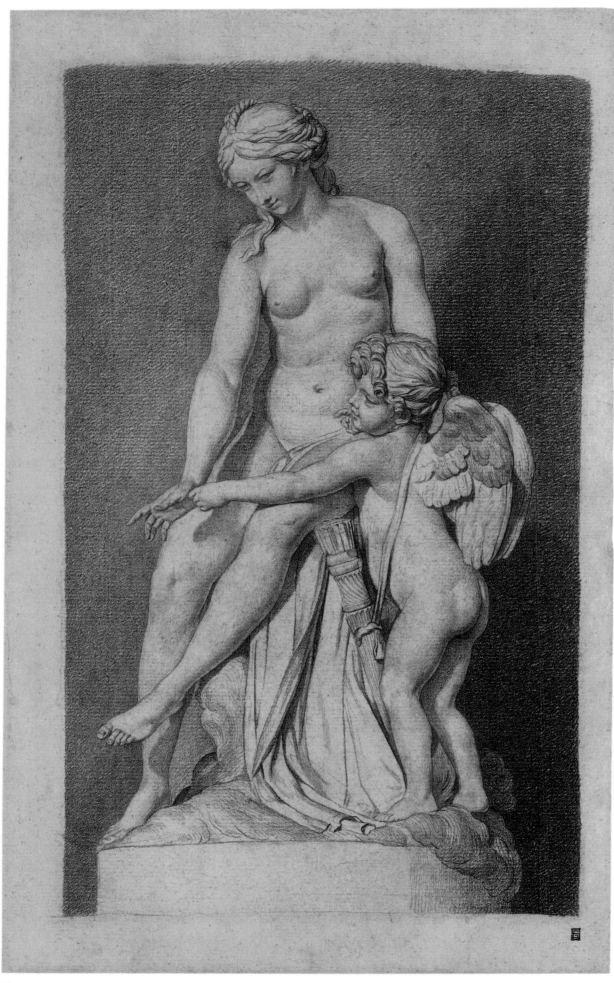

PROVENANCE: Germain Seligman (his mark, an interlaced GS, not in Lugt); Christian Humann; his sale, Sotheby Parke Bernet, New York, April 30, 1982, lot 67; purchased by The Metropolitan Museum of Art.

LITERATURE: *MMA Annual Report,* 1981–82, p. 23; Bean and Turčić 1986, p. 269 (ill.).

1. For his life and career, see Louis Réau, "Un sculpteur oublié du

XVIIIe siècle: Louis-Claude Vassé (1716–1772)," *Gazette des Beaux-Arts,* ser. 6, 4 (1930), pp. 31–56; and Bernard Black, *Vassé's "Bambinelli": The Child Portraits of an 18th-Century French Sculptor* (London, 1994), pp. 12–24.

2. The history of the statue is detailed in Gaston Brière, "Sculptures françaises des XVIIe et XVIIIe siècles nouvellement exposées au Musée de Versailles," *Bulletin de la Société de l'Histoire de l'Art Français,* 1923, pp. 71–72.

GABRIEL DE SAINT-AUBIN

Paris 1724–1780 Paris

51. *Germain-Augustin and Rose de Saint-Aubin, Drawn by Their Uncle*

Brush and gray wash, over black chalk and graphite, 7⅛ x 4¾ in. (18.2 x 12.2 cm). Inscribed very faintly in graphite at top center in the artist's hand: *augustin de St aubin 1766 janvier* [?]; along bottom edge: *G. de St aubin et Rose de St aubin dessinés par leur oncle gabriel*

The Metropolitan Museum of Art, Bequest of Walter C. Baker, 1971 (1972.118.233)

A highly prolific draftsman, Saint-Aubin was described as never being without a pencil in hand.[1] His older brother, Charles-Germain, listed some four to five thousand unfinished drawings in his studio after his death.[2] Approximately one thousand of his drawings survive, and they form an incomparable view of many aspects of eighteenth-century Parisian life. Among the most well known are the tiny marginal sketches of exhibited works in the Salon *livrets*.

Although portraits form a relatively small percentage of Saint-Aubin's enormous output, those we have, both drawn and etched, are very affecting, with an emotional transparency and engaging blend of genre and portrait. The sitters were often participants in the world of art and theater or members of his large family. Germain-Augustin and Rose were the two children of Charles-Germain. Germain-Augustin was born in 1758, and Catherine-Noëlle, called Rose, in 1755. Their mother died giving birth in 1759, and they were raised by their father's sister, Catherine, in their father's house. Charles-Germain lived near Gabriel, and his home formed a nexus for the family. Rose is shown here with a hurdy-gurdy, an instrument popular with children in the eighteenth century.

Saint-Aubin's secure control of the medium is clearly evident in this double portrait in which he uses the paper for the children's skin, and carefully fills in the background. He employed the profile format, newly popular in France after the mid-century emergence of Neoclassicism, for many portraits of children and young people, including one dating to about the same time of the young Anne Vallayer-Coster.[3]

MTH

PROVENANCE: Ransonnette; Ransonnette sale, Paris, February 21–23, 1878, lot 20; Hippolyte Destailleur; Destailleur sale, Paris, May 26–27, 1893, lot 112, 2; Destailleur sale, Paris, May 19–23, 1896, lot 852; J. Bouillon (according to Dacier); Walter Burns (according to Schiff sale catalogue); Mortimer L. Schiff; his sale, Christie's, London, June 24, 1938, lot 51; [Wildenstein & Co., Inc., New York]; Walter C. Baker; bequeathed to The Metropolitan Museum of Art.

LITERATURE: Goncourt 1880–82, vol. 1, pp. 426–27; Dacier 1929–31, vol. 1, p. 84, vol. 2, p. 44, no. 238; Virch 1962, no. 77 (ill.); *MMA Annual Report,* 1979–80, p. 27; Bean and Turčić 1986, p. 242, no. 274 (ill.); McCullagh 1996, p. 129 (ill.).

1. In the February 13, 1780, announcement of his death, in *Mémoires secrets,* Dacier 1929–31, vol. 1, p. 151.
2. Many of the details of Gabriel de Saint-Aubin's life come to us from Charles-Germain de Saint-Aubin, whose *Livre des Saint-Aubin* is excerpted in Dacier 1929–31, vol. 1, pp. 14–15. See also pp. 22–23.
3. See Middletown and Baltimore 1975, no. 45 (ill. p. 91).

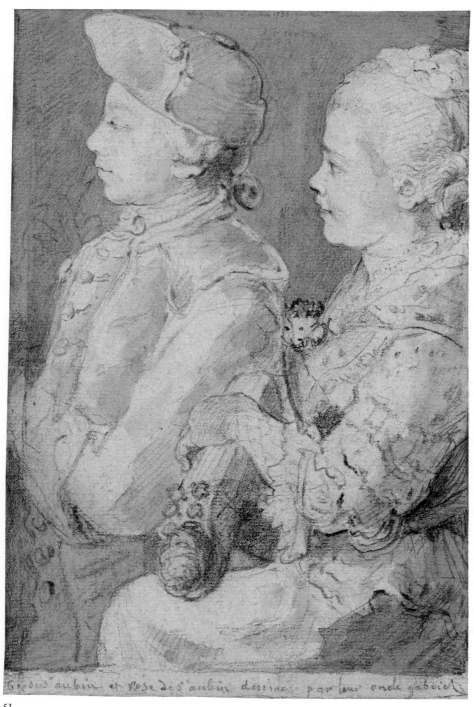

51

FRANÇOIS BOUCHER

Paris 1703–1770 Paris

52. *The Adoration of the Shepherds*

Oil paint over black chalk underdrawing, on paper, mounted on canvas, 16¼ x 11 in. (41.2 x 28 cm). Partial collector's mark of Damery (Lugt 2862) at the lower right; collector's mark of Jules and Edmond de Goncourt (Lugt 1089) at bottom center

The Metropolitan Museum of Art, Purchase, David T. Schiff Gift, and Rogers and Harris Brisbane Dick Funds, 1997 (1997.95)

Oil sketches, in *grisaille* (black and white), in *camaïeu* (colored monochrome), or in full color, as here, were frequent components of Boucher's working process in the preparation of major commissions. Students at the École des Élèves Protégés were instructed in the use of compositional studies in oil, and the eighteenth century saw many accomplished practitioners of the technique. Characterized by lithe, elegant figures, a lush handling of the medium, and a preference for compositions based on the arabesque, Boucher's in particular transcended their practical function, to become quintessential expressions of the Rococo idiom. Here, in the rustic subject of the Adoration of the Shepherds, Flemish painting and the oil sketches of Giovanni Benedetto Castiglione (1616–1670) are recalled, but in Boucher's hand the subject takes on a lightness and delicacy that separates it from such sources.

Known for graceful mythologies and charming scenes of rustic genre, Boucher produced relatively few religious paintings for a history painter of his standing. The Goncourt brothers, who once owned the Metropolitan's sketch, considered it the *maquette*, or model, for the painting *La lumière du monde*, today in the Musée des Beaux-Arts, Lyon (fig. 52.1), commissioned just before 1750 by Mme de Pompadour for her château at Bellevue.[1] In fact, Boucher treated the subject of the Adoration in a number of drawings and sketches that have been grouped together in the literature as part of the preparatory process for the Bellevue painting, although none (with the exception of the chalk studies for individual figures) is as close to the finished painting as the present sketch. More recently, Alastair Laing has made the alternative suggestion that some of Boucher's oil sketches of Adorations, including the present sheet[2] and one in blue *grisaille* that came on the market in 1991,[3] may postdate the Bellevue altarpiece by a decade or more. As is frequently the case in Boucher's oeuvre, his tendency to revisit certain subjects and to reuse figure studies complicates efforts to establish a chronology. If we accept that the Metropolitan's sketch dates from the 1760s, there is nonetheless a kinship between the two works that has less to do with particular figures and their placement than with a shared conception of palette and luminosity. Both compositions are organized around an intense golden light that falls diagonally from an opening in the clouds to the body of the Christ child and radiates outward, illuminating the faces of the onlookers. The palette to accommodate this scheme in the New York sketch is similar to that of the painting: from earthy browns and gold to dull lavender, icy turquoise, and the creamy rose of the baby's flesh, highlighted, as was Boucher's wont, in dabs of pure red.

PS

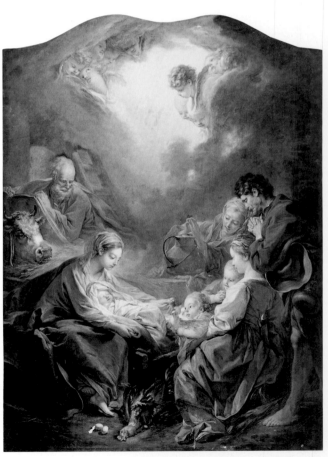

52.1. François Boucher, *La lumière du monde*, 1750. Oil on canvas, 69 x 51 in. (175 x 130 cm). Musée des Beaux-Arts, Lyon

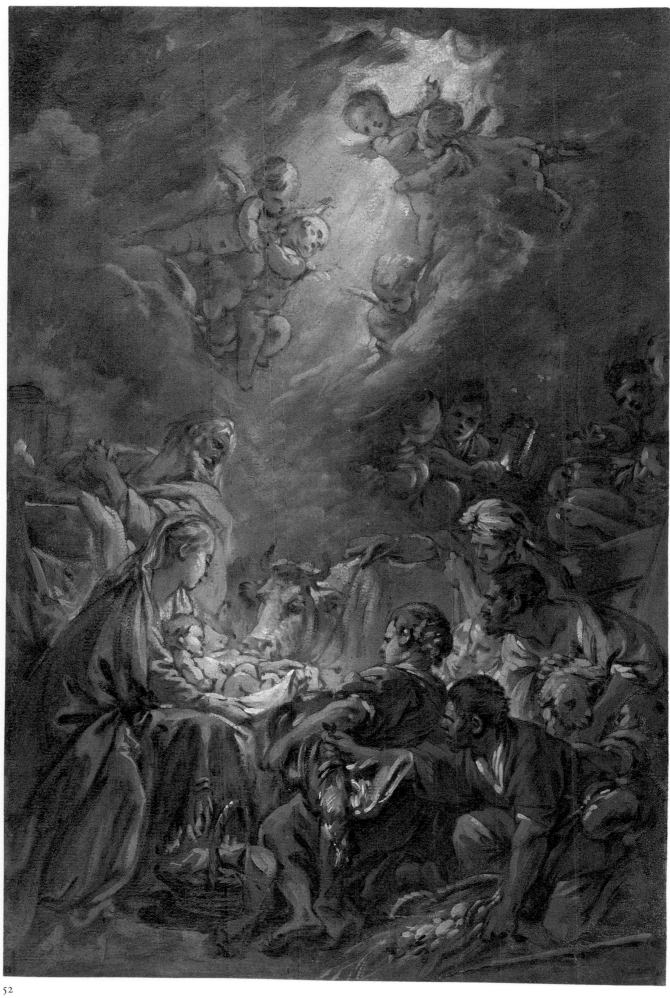

PROVENANCE: Chevalier de Damery (Lugt 2862); his sale, Paris, November 18–19, 1803, lot 2; M. Villenave; his estate sale, Paris, June 14–18, 1847 (auction postponed until February 1, 1848), lot 67; Edmond and Jules de Goncourt (Lugt 1089); their collection sale, Hôtel Drouot, Paris, February 15–17, 1897, lot 23; acquired at the sale by Étienne-François Haro (1827–1897); Baron Joseph Raphaël Vitta (1860–1942), Paris; his collection sale, Hôtel Drouot, Paris, June 27–28, 1924, lot 30; acquired by Léon-M. Lowenstein, Paris; his collection sale, Galerie Jean Charpentier, Paris, December 17, 1935, lot 17; acquired by M. Pape; Mme Carteron; [Wildenstein & Co., Inc., New York]; purchased by The Metropolitan Museum of Art.

LITERATURE: [Philippe] de Chennevières, *Les dessins de maîtres anciens,* exh. cat., Paris, École des Beaux-Arts (Paris, 1880), no. 518; Ph[ilippe] de Chennevières, "Les dessins de maîtres anciens exposés à l'École des Beaux-Arts," *Gazette des Beaux-Arts,* ser. 2, 20 (1879), p. 196; Goncourt 1880–82, vol. 1, p. 188; André Michel, *François Boucher: Catalogue raisonné de l'oeuvre peint et dessiné* (Paris, [1906]), p. 41, no. 748, p. 42, no. 757 (two entries seem to have been created for the same drawing); Edmond de Goncourt, *La maison d'un artiste,* 2 vols., new ed. (Paris, 1881), vol. 1, p. 54; Carlo Jeannerat, "L'adoration des bergers' de F. Boucher," *Bulletin de la Société de l'Histoire de l'Art Français,* 1932, pp. 81–82; Pierre de Nolhac, *Exposition François Boucher (1703–1770),* exh. cat., Paris, Hôtel Charpentier (Paris, 1932), p. 2, no. 2; *Exposition Goncourt,* exh. cat., Paris, Gazette des Beaux-Arts (Paris, 1933), p. 68, no. 174; Mario Roustan, *Exposition de l'art français au XVIIIe siècle: Catalogue,* exh. cat., Copenhagen, Palais de Charlottenborg (Copenhagen, 1935), no. 22; Slatkin 1973, p. 87, under no. 67; Ananoff 1976, vol. 2, p. 64, no. 362 (as grisaille), fig. 1064; Alexandre Ananoff, *L'opera completa di Boucher* (Milan, 1980), p. 117, no. 384 (as grisaille), ill. p. 116; *François Boucher: A Loan Exhibition for the Benefit of the New York Botanical Garden,* exh. cat., New York, Wildenstein (New York, 1980), p. 40, no. 19, fig. 19; Tokyo and Kumamoto 1982, p. 174, no. 44 (ill. p. 76); Sonia Dean, *Master Drawings from the Collection of the National Gallery of Victoria* (Melbourne, 1986), p. 90; Launay 1991, pp. 236–38, no. 27, also cited pp. 74, 84, 150 (in n. 116), 180, 207 (ill. p. 237); *MMA Recent Acquisitions,* 1996–97, p. 42 (entry by Perrin Stein).

1. The painting today in Lyon was first identified as the altarpiece painted for Bellevue by Carlo Jeannerat ("'L'adoration des bergers' de F. Boucher," *Bulletin de la Société de l'Histoire de l'Art Français,* 1932, pp. 81–82), although doubts have persisted in the literature; see Slatkin 1973, under no. 67, and Sonia Dean, *Master Drawings from the Collection of the National Gallery of Victoria* (Melbourne, 1986), p. 90. Jeannerat's thesis was accepted by Alastair Laing in 1986; see New York, Detroit, and Paris 1986, pp. 246–47.

2. Correspondence, October 4, 1997.

3. See his entry in *An Exhibition of Master Drawings,* exh. cat., New York and London, Colnaghi (London, 1991), no. 43.

JEAN-BAPTISTE DESHAYS

Rouen 1729–1765 Paris

53. *Phryne before the Areopagus*

Pen and brown ink, brush and brown wash, heightened with white, over black chalk and charcoal, on beige paper, 18⅝ x 23¾ in. (47.4 x 60.2 cm). Inscribed in pen and brown ink along lower edge right of center: *Deshays. f.*

The Metropolitan Museum of Art, Rogers Fund, 1961 (61.126)

This vivid sketch, its operatic grandeur so reminiscent of the Baroque, is the work of Jean-Baptiste Deshays, an artist now sadly remembered mainly for his unrealized potential. He died aged only thirty-five, and his early death devastated the hopes of the official art world. Deshays, a native of Rouen, had studied with Collin de Vermont, Restout, and Jouvenet before catching the eye of Boucher, who took him on as apprentice and, eventually, heir apparent. He won the Grand Prix in 1751, and on his return from the trip to Rome, married Boucher's eldest daughter. He was described by Diderot as the "sunrise of French painting."[1]

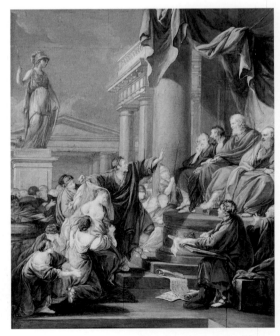

53.1. Pierre-Antoine Baudouin (1723–1769), *Phryne devant ses juges à Athènes.* Gouache on ivory and paper pasted on wood, 18¼ x 15 in. (46.4 x 38.2 cm). Musée du Louvre, Paris

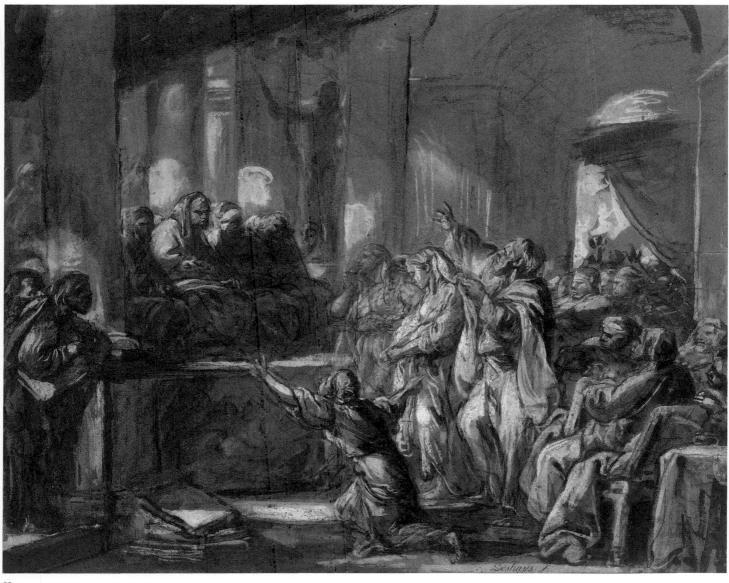

53

Deshays had a predilection for the sketch made with a brush as a preparation technique. The dynamic quality of the sketch accords well with his often dramatic subject matter, and he produced a great number relative to his overall output. They are, like this example, loose and energetic in their brushwork, yet with a fine sense of proportion and volume often absent in vigorous sketches; the strokes are frequently squared off, nearly cubic in shape. Boucher's example is especially apparent in the composition and figure style, as a comparison with that artist's *Christ and the Woman Taken in Adultery*, in the Metropolitan Museum, reveals.[2]

No painting is known from this sketch, and the subject has been a matter of some debate. The title used here refers to the story of Phryne, a courtesan who was defended before the Athenian court, or Areopagus, by the orator Hyperides, against a charge of impiety. Sensing that his arguments were not convincing the court, Hyperides drew back Phryne's

clothing to reveal her breast, and her beauty won the day.[3] This gesture is the identifying moment in the Phryne saga, and is clearly visible in the sketch. Hyperides points also to the statue of a god (Athena?), perhaps referring to the charge against Phryne.

The alternative subject would be Susannah before the Judges, a story with many of the same elements. Susannah, a beautiful Jewess, is seen at her bath by two Babylonian elders who then accost her. When she refuses their advances, they accuse her of adultery. The boy Daniel proves them liars and saves her life. A persuasive argument can be made for that subject as well,[4] mainly the presence of the expostulating boy, who would be Daniel, although the absence of the second elder is problematic. Ultimately, the drawing includes elements from both stories. One piece of external evidence that would support the identification of the scene as Phryne before the Areopagus is a rare version of this story by Pierre-Antoine

Baudouin (1723–1769), Boucher's other son-in-law, who depicted it in a miniature he submitted for his *morceau de réception* in 1763 (fig. 53.1).[5] It is similar to the Deshays treatment, and one may have inspired the other. MTH

PROVENANCE: Possibly in the Deshays estate sale, Paris, March 26, 1765, and following days, lot 12, "Phryné, courtisane d'Athènes, accusée d'impiété, et défendue par l'orateur Hypéride. Ce dessin capital, fait à la plume, au bistre rehaussé de blanc, est composé de plus de vingt figures dans le style des plus grands maîtres"; possibly in the collection of Randon de Boisset; possibly in the Randon de Boisset sale, Paris, February 27–March 25, 1777, lot 372, "Phrinée devant l'Aréopage" (dimensions described as same size as preceding drawings by Deshays in that sale, 15 x 20 *pouces*); possibly in the collection of Vassal de Saint-Hubert; possibly Vassal de Saint-Hubert sale, Paris, March 29–April 13, 1779, lot 150, "Phrinée devant l'Aréopage" (10 *pouces* 9 *lignes* x 22 *pouces*); sale, Hôtel Drouot, Paris, June 26, 1950, lot 52 (as *Tribunal jugeant une jeune femme*, 47.3 x 60.3 cm); [Duits]; purchased by The Metropolitan Museum of Art.

LITERATURE: Marc Sandoz, "Jean-Baptiste Deshays, peintre d'histoire (1721–1765)," *Bulletin de la Société de l'Histoire de l'Art Français*, 1958, p. 19; Jacob Bean, "The Drawings Collection," *The Metropolitan Museum of Art Bulletin* 20, no. 5 (January 1962), p. 170, fig. 15; *MMA Annual Report*, 1961–62, p. 67; Gillies and Ives 1972, no. 16; Sandoz 1977, p. 101, no. 136, pp. 102–3, no. 155, pl. IV (as "Suzanne devant ses juges"); Bean and Turčić 1986, p. 94, no. 97 (ill.).

1. Seznec and Adhémar 1975–83, vol. 1, p. 120.
2. See Bean and Turčić 1986, p. 44, no. 39 (ill.).
3. The story is related by various ancient authors, but is most fully given by the Pseudo-Plutarch. Just why exposing her breast would help her case is never explained. See *Plutarch's Moralia*, Loeb Classical Library (London, 1936), vol. 10, p. 443.
4. For support of the Susannah story, see Sandoz 1977, p. 103, no. 155B. Alastair Laing concurs (letter to Jacob Bean, November 11, 1987). Mssrs. Bean and Turčić were not convinced (letter of January 21, 1988).
5. See Pierrette Jean-Richard, *Inventaire des miniatures sur ivoire conservées au cabinet des dessins, Musée du Louvre et Musée d'Orsay* (Paris, 1994), p. 50, no. 47 (ill.).

JEAN-BAPTISTE LE PRINCE

Metz 1734–1781 Saint-Denis-du-Port

54. *A Farmyard with Peasants Drinking under a Pergola*

Brush and gray wash over black chalk, 16¾ x 14⅝ in. (42.5 x 37.2 cm)

The Phillips Family Collection

Although Le Prince's renown was largely based on the novelty of his Russian subject matter, it was his early training in Boucher's studio that determined his artistic disposition and predilection for the rustic pastoral. Just as Boucher had endowed subjects borrowed from Dutch seventeenth-century genre painting with Rococo sweetness and grace, Le Prince made the harshness of the Russian countryside palatable for the Parisian salon. Returning to Paris in 1762 from a five-year sojourn in Russia armed with cases of regional costumes and accessories as well as sketchbooks,[1] Le Prince spun out great numbers of *russeries*—paintings, drawings, and prints—for more than a decade, before returning to subjects based on his native land.[2] Le Prince's presentation of the Russian countryside as rural, backward, and quaint was not appreciated by Catherine the Great, who was continuing to enforce the campaign of Westernization begun earlier in the century by Peter the Great. Among Peter's pronouncements made in this pursuit, the wearing of beards was banned and it was decreed that French-style dress be worn in the capital.[3]

In his wash landscapes of the mid- to late 1760s, Le Prince typically relegated his Russian staffage—here, men drinking around a table and a young woman changing a small child—to subsidiary roles within larger compositions ordered by Rococo asymmetry and arabesque curves. These compositions are marked by airy expanses of sky, with the occasional sunny-day cloud described in the most delicate wash. Here, the irregular tree line is complemented by the graceful curves of the grapevines that hang from the arched pergola and the garlands that encircle the dovecote, all suggestive of the simultaneous subjugation and celebration of nature found in Rococo ornament.

Le Prince's facility with ink wash undoubtedly played a role in his contributions to the development of the aquatint technique in printmaking, in which areas of uneven ground are successively stopped out with varnish to create etched plates in imitation of ink-wash drawings.[4] Le Prince submitted twenty-nine of his tonal prints to the 1769 Salon.

PS

54

PROVENANCE: De Mesgrigny, Troyes (per label on back of frame); Comte du Parc, Château de Villebertin, near Troyes (per Baskett and Day); [Baskett and Day, London]; sale, Christie's, London, July 4, 1984, lot 112; The Phillips Family Collection.

Unpublished.

1. Many such items are detailed in the catalogue of Le Prince's estate sale held in Paris on November 28, 1781, lots 24, 35, 38, 39, 110, 111, 112. The catalogue is reprinted in Jules Hédou, *Jean Le Prince et son oeuvre* (Paris, 1879), pp. 297–313; reprinted as *Jean-Baptiste Le Prince 1734–1781* (Amsterdam, 1970).
2. For Le Prince's career, see Metz 1988; Kimerly Rorschach, *Drawings* by Jean-Baptiste Le Prince for the "Voyage en Sibérie," exh. cat., Philadelphia, Rosenbach Museum and Library; Pittsburgh, The Frick Art Museum; New York, The Frick Collection (Philadelphia, 1986); and Mary-Elizabeth Hellyer, "Recherches sur Jean-Baptiste Le Prince (1734–1781)" (Ph.D. diss., Université de Paris IV–Sorbonne, 1982).
3. See George E. Munro, "Politics, Sexuality, and Servility: The Debate between Catherine II and the Abbé Chappe d'Auteroche," in *Russia and the West in the Eighteenth Century*, edited by A. G. Cross, Study Group on Eighteenth-Century Russia, Proceedings of the 2nd International Conference, 1981 (Newtonville, Mass., 1983), pp. 124–34.
4. John Ittmann discusses Le Prince's experiments with aquatint in Baltimore, Boston, and Minneapolis 1984, p. 190.

JEAN-BAPTISTE LE PRINCE

Metz 1734–1781 Saint-Denis-du-Port

55. *Young Woman in an Oriental Costume*

Red chalk, 10¼ x 8⅞ in. (26 x 22.5 cm)

The Phillips Family Collection

55.1. Jean-Baptiste Le Prince, *La diseuse de bonne aventure*, 1767. Oil on canvas, 52¾ x 36⅞ in. (134 x 93 cm). Musée Départemental de l'Oise, Beauvais

Many of Le Prince's most accomplished drawings were made in preparation not for a painting but for a print. Adept at both etching and aquatint, Le Prince produced many series of prints after his own drawings, although there were other occasions, especially when a chalk-manner print was desired, when the services of a professional printmaker were employed. This drawing is one of a group etched in reverse by Gilles Demarteau (1722–1776).[1] Demarteau capitalized on the fashion for the recently developed technique of chalk-manner prints, forging a close working relationship with Boucher, who seems to have made chalk drawings specifically for reproduction by Demarteau and would logically have introduced his student into this lucrative arrangement. Drawings such as the Phillips sheet were likely made with such a venture in mind.

Le Prince's elegant proficiency in red chalk matches the accomplishments of Fragonard and Robert in this medium and is well suited to Demarteau's manner of reproduction. The young woman's facial features—widely spaced, heavy-lidded eyes and broad cheekbones—do not suggest a specific model, but rather a generic conception of Slavic physiognomy common to many of Le Prince's *russeries*. Close variants of this figure, in costume and pose, appear in

55

the painting *La diseuse de bonne aventure,* now at the Musée Départemental de l'Oise, Beauvais (fig. 55.1), and in the related tapestry panel woven at Beauvais as part of the *Jeux russiens.*[2] Details of the costume were surely inspired by a specific dress brought back from Russia by Le Prince (see no. 54), but, overall, ethnographic detail is tempered by Rococo ideals of beauty.

Le Prince's opulent renditions of exotic costume were harshly criticized by Diderot in 1767, the year the tapestry designs were exhibited: "If a Tartar, a Cossack, or a Russian saw this, he'd say to the artist, You've pillaged our wardrobes, but haven't a clue about our feelings." Diderot then addressed the artist directly: "If you understand only fabrics and their arrangement, then leave the Académie and become a salesgirl at the Trait Galant or a costume designer at the Opéra."[3] Such a judgment seems especially unjust in the case of the Phillips drawing, where Le Prince manipulates the medium of sanguine with great dexterity to describe not details of buttonholes or embroidery but the fall of various weights of material, bunched and loosely draped over the human form, articulated in ripples of sunlit fabric against shadowy folds. PS

PROVENANCE: Sale, Hôtel Drouot, Paris, May 25, 1962, lot 50 (ill. pl. 3); [Galerie Cailleux, Paris]; [Charles E. Slatkin Galleries, New York]; The Phillips Family Collection.

LITERATURE: Mary-Elizabeth Hellyer, "Recherches sur Jean-Baptiste Le Prince (1734–1781)" (Ph.D. diss., Université de Paris IV–Sorbonne, 1982), vol. 2, p. 220.

1. For the drawings related to Demarteau prints, see Mary-Elizabeth Hellyer, "Recherches sur Jean-Baptiste Le Prince (1734–1781)" (Ph.D. diss., Université de Paris IV–Sorbonne, 1982), vol. 2, pp. 212ff. The print after the present drawing is number 389 in the 1788 catalogue of Demarteau's prints; see Marcel Roux, *Inventaire du fonds français: Graveurs du XVIIIe siècle,* vol. 6 (Paris, 1949), p. 444, no. 389.
2. For both these works see Metz 1988, nos. 32–33, n.p.
3. Goodman 1995b, vol. 2, p. 182. Reading the complete text of Diderot's critique of Le Prince, it becomes clear that his complaints with the artist extended far beyond the formal issues of painting; see Perrin Stein, "Le Prince, Diderot, et le débat sur la Russie au temps des Lumières," *Revue de l'Art,* no. 112 (1996), pp. 16–27.

FRANÇOIS BOUCHER
Paris 1703–1770 Paris

56. *The Continence of Scipio*

Brown and black chalks, brush and brown wash, graphite and touches of white heightening, 16⅞ x 10⅝ in. (42.9 x 27 cm)

The Phillips Family Collection

Boucher developed four distinct solutions to his 1765 assignment on the theme of the Continence of Scipio, which concerned the Roman general who rejected the offer of a beautiful maiden as his prize on the defeat of Carthage, returning her unsullied to her intended. The theme was a popular one in the seventeenth and eighteenth centuries, exemplifying kingly virtue, restraint, and the proper uses of power. Boucher's painting, commissioned by Stanislaw II Augustus Poniatowski, the king of Poland (r. 1764–95), was to be one of four large arched canvases to decorate a room in the royal palace in Warsaw. The other artists commissioned were Joseph-Marie Vien (1716–1809), who was assigned Caesar Debarking at Cadiz before the Statue of Alexander; Louis Lagrenée (1725–1805), assigned the Head of Pompey Presented to Caesar; and Noël Hallé

(1711–1781), Silurius, Dying King of the Scythians, Surrounded by His Children.

The correspondence between Stanislaw and his emissary in Paris, Mme Geoffrin (see no. 31), to whom he entrusted negotiations and the choice of the artists, reveals an involved and demanding patron. Stanislaw chose the subjects, each a classical story selected to illustrate a moral precept. He wanted preliminary sketches from each artist which he intended to compare with drawings of the same subjects made by his favorite painter, Jean Pillement. It seems likely that Boucher's submission of four different designs was in response to continued dissatisfaction.[1] Eventually, the job was given over—on the recommendation of Boucher—to Vien, in 1768.

Boucher's four compositional drawings, one in the Detroit Institute of Arts (fig. 56.1), one in the Metropolitan Museum (fig. 56.2), one in the Musée des Beaux-Arts, Quimper (fig. 56.3), and this one in the Phillips Family Collection (listed here in the chronological order proposed by Victor Carlson), are all large fully realized drawings, each

56.1. François Boucher, *The Continence of Scipio*, 1765–67. Brown and red chalk, 19⅝ x 12 in. (49.7 x 30.4 cm). Detroit Institute of Arts, Founders' Society Purchase, Laura H. Murphy Fund

56.2. François Boucher, *The Continence of Scipio*, 1765–67. Brown chalk, brush and brown wash, 19⅛ x 11¼ in. (48.4 x 28.5 cm). The Metropolitan Museum of Art, Purchase, Joseph Pulitzer Bequest, 1966 (66.106)

a slightly different take on the same moment in the story.[2] Essentially a wedding scene, it depicts Scipio's return of the chaste girl to her betrothed. All four compositions are loosely based on a triangular plan, with Scipio's plumed helmet at the apex. In the Phillips and Detroit examples, Boucher used royal palms to frame the action. Although all four drawings employ brown chalk, a somewhat unusual choice but one favored by Boucher in the last decade of his life, they nonetheless vary in their technique.[3] Three use wash, one uses watercolor, one pen and ink, and one only chalk. The Phillips drawing is the most elaborate, combining two colors of chalk with two colors of wash, white highlights, and watercolor. The combining of media never results in murki-

ness in the assured hands of Boucher, nor is compositional clarity sacrificed. The swaggering strokes that define the palm fronds lend an air of jubilation to the happy occasion.

One is left to wonder whether Boucher's retirement from the commission was the result of sheer fatigue with the onerous process, or whether it represented an acknowledgment on the part of the aging master that the emerging Neoclassicism was a manner he could not, or had no wish to, adopt.

MTH

PROVENANCE: Possibly in the collection of M. G.**; his sale, Paris, May 30, 1873, lot 10 [?]; [Wildenstein & Co., Inc., New York]; The Phillips Family Collection.

56.3. François Boucher, *The Continence of Scipio*, 1765–67. Brown chalk, brush and brown and gray wash, heightened with white, with touches of pen and ink, 16 x 10¼ in. (40.5 x 25.9 cm). Musée des Beaux-Arts, Quimper

LITERATURE: André Michel, *François Boucher: Catalogue raisonné de l'oeuvre peint et dessiné* (Paris, [1906]), no. 875; Ananoff 1966, p. 258, no. 1011, fig. 165; Regina Shoolman Slatkin, "Reviews: Alexandre Ananoff, 'L'oeuvre dessiné de Boucher: Catalogue raisonné,'" *Master Drawings* 5, no. 1 (1967), p. 62; Roseline Bacou, "Quimper: Dessins du Musée des Beaux-Arts," *Revue de l'Art*, no. 14 (1971), p. 103, under no. 4; Rosenberg 1972, p. 137, under no. 13; Slatkin 1973, p. 118, no. 90 (ill.); *François Boucher: A Loan Exhibition for the Benefit of the New York Botanical Garden*, exh. cat., New York, Wildenstein (New York, 1980), no. 62 (fig. 61); Tokyo and Kumamoto 1982, p. 252, no. 119 (ill.); Bean and Turčić 1986, p. 43, under no. 38; *François Boucher: His Circle and Influence*, exh. cat., New York, Stair Sainty Matthiesen (New York, 1987), p. 79, no. 49 (ill.; entry by Alan Wintermute); Jacoby 1992, pp. 256, 259, and no. 2, pp. 279–80.

1. The commission is outlined and the correspondence published in Gaehtgens and Lugand 1988, pp. 180–82, under nos. 204–7. See also Seznec and Adhémar 1975–83, vol. 3, p. 87.
2. Victor Carlson, in Ellen Sharp et al., *Italian, French, English, and Spanish Drawings and Watercolors: Sixteenth through Eighteenth Centuries*, The Collections of the Detroit Institute of Arts (New York and Detroit, 1992), p. 22, under no. 92.
3. See Jacoby 1992.

JEAN-HONORÉ FRAGONARD

Grasse 1732–1806 Paris

57. Ancient Scene

Brush and gray, brown, red, yellow, and blue wash, over black chalk underdrawing, 13¼ x 17⁷⁄₁₆ in. (33.6 x 44.4 cm)

Private collection

This sketch, so reminiscent of Pietro da Cortona (1596–1669), Luca Giordano (1632–1705), and Fragonard's master, Carle Vanloo (see no. 32), is a powerful reminder of the path Fragonard intended to follow, that of a history painter. There is general consensus that the composition was created as a pendant to *Corésus and Callirhoë* (fig. 57.1), Fragonard's 1765 presentation piece to the Académie, both intended to be woven eventually at Gobelins.[1] The present drawing was evidently made as a record or presentation piece after the oil sketches in which Fragonard initially conceived the composition.[2]

On a stagelike platform reminiscent of that in the *Corésus* composition, Fragonard has placed the women, old and young, to one side, their garments flickering in the rising wind. A burst of light illuminates the central figure and the piece of paper she has just dropped. The left side of the drawing, composed solely of male figures, is cast in an ominous darkness, as Fragonard uses wash almost the color of coal.

The subject of this bold sketch has long been a matter of speculation. Neither of the two titles usually given, *Ancient Sacrifice* and *The Sacrifice to the Minotaur*, is wholly satisfactory.[3] A third possibility, recently suggested by Evelyn Harrison, is that the scene describes the moment when, in the vote to determine the patron god of the city that would later be Athens, the ballot is cast against Neptune in favor of Minerva (known in Greek as Athena), after which the god gives vent to his fury by flooding the city.[4] The story is the subject of the west pediment of the Parthenon, and many ancient sources can be found,[5] but only one, Saint Augustine's *City of God*, includes the crucial detail of the vote:

> Now this is the reason Varro gives for the city's being called Athens, a name that is certainly derived from Minerva, who is called Athena in Greek. When an olive tree had suddenly appeared there, and on another spot water had gushed forth, these portents alarmed the king, and he sent to Delphic Apollo to ask what the meaning of this was and what was to be done. Apollo answered that the olive signified Minerva and the spring Neptune, and that it rested with the citizens to decide from which of the two gods, whose symbols these were,

they preferred that the city should take its name. When Cecrops [the prehistoric king of Athens] received this oracle he called together all the citizens of both sexes—for at that time it was customary in that area that the women also should have a part in public deliberations—to take a vote. When therefore the multitude was consulted, the men voted for Neptune and the women for Minerva, and because the women were found to be one more, Minerva was victorious. Then Neptune in his wrath devastated the lands of the Athenians by great floods of sea-water.[6]

If Harrison's suggestion is accepted, the women to the right in Fragonard's sketch would be the female citizens of Athens. They cluster together, their garments torn by the wind of the oncoming storm, watching as their sister casts the deciding vote and brings on the destruction of the land. One is reminded that the sacrifice of Callirhoë, the subject for which this composition would have been a pendant, was intended to eradicate a plague on the same land. In the left foreground, a woman cries out to the gods for mercy. The tall cloaked man above her would be Cecrops, the ancient king who in some accounts served as the judge in the contest. Standing beside him, a herald trumpets Minerva's victory, and floating above, the harbinger of doom holds the trident of Neptune in one hand and a torch in the other. The statue of a seated figure on a pedestal visible at the upper left could be either Jupiter or Athena. This interpretation has Fragonard compressing Saint Augustine's narrative, conflating the casting of the final vote with the storm.

MTH

57.1. Jean-Honoré Fragonard, *Corésus and Callirhoë,* 1765. Oil on canvas, 122½ x 157½ in. (311 x 400 cm). Musée du Louvre, Paris

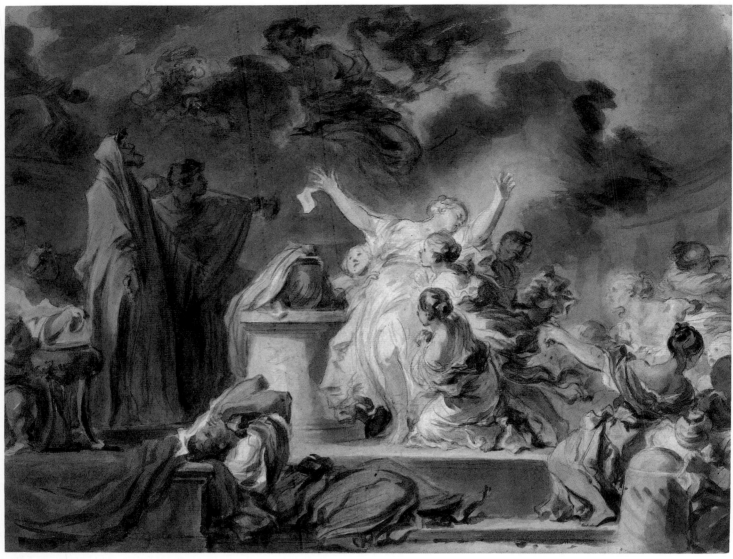

57

PROVENANCE: Godefroy; his sale, Paris, November 15, 1785, lot 98; Bruun-Neergard; his sale, Paris, August 29, 1814, lot 127; [Guyard, sale, Tours, November 26–28, 1824]; Jacques Doucet; his sale, Galerie Georges Petit, Paris, June 5, 1912, lot 16; E. M. Hodgkins; his sale, Galerie Georges Petit, Paris, April 30, 1914, lot 25; Seymour de Ricci; private collection.

LITERATURE: Goncourt 1880–82, vol. 2, p. 370; *Société de Reproduction des Dessins de Maîtres* 6 (1914), n.p.; Ananoff 1961–70, vol. 1, p. 173, no. 418; Williams 1978, pp. 66–67, no. 19 (ill.); Pierre Rosenberg and Udolpho van de Sandt, *Pierre Peyron 1744–1814* (Neuilly-sur-Seine, 1983), p. 81, under nos. 20–31; Rosenberg 1988, pp. 219–20, no. 107 (ill.).

1. The relationship of the two scenes was first suggested in Williams 1978, p. 66, under no. 19; see also Cuzin 1988, p. 89; Rosenberg 1988,

pp. 219–20, under no. 107.

2. Both oil sketches are illustrated in Cuzin 1988, p. 88.

3. For the history of the designation of the subject as the Sacrifice to the Minotaur, see Rosenberg 1988, p. 220, under no. 107. He accepts it, noting that "Fragonard made a habit of such inexactitudes." Eunice Williams casts some doubt (1978, p. 66, under no. 19).

4. Verbal communication, February 23, 1998. Professor Harrison cited the passage from Augustine.

5. Herodotus, *History*, 8.55; Virgil, *Georgics*, 1.12–18; Apollodorus, *The Library*, 3.77–81; Ovid, *Metamorphoses*, 6.72 fol.; and Pausanias, *Description of Greece*, 1.27 (2).

6. Saint Augustine, *The City of God against the Pagans*, Loeb Classical Library, 7 vols. (Cambridge, Mass., and London, 1957–72), vol. 5, chap. 9, pp. 391–93.

GABRIEL-FRANÇOIS DOYEN

Paris 1726–1806 Saint Petersburg

58. Allegory of Fishery: Neptune and Amphitrite

Charcoal, stumped, black chalk, heightened with white, 18⅞ x
14¾ in. (48 x 37.5 cm)

The Metropolitan Museum of Art, Purchase, Mr. and Mrs. David
T. Schiff Gift, 1981 (1981.286)

One year after the glowing reception of his neo-Baroque altarpiece *Le miracle des ardents* (Church of Saint Roch, Paris) at the 1767 Salon, Doyen was among a group of four artists commissioned to provide large canvases for the dining room of the Petit Trianon, the recently constructed pleasure house set in the gardens of Versailles. The subjects, as envisioned by Charles-Nicolas Cochin, who as secretary of the Académie oversaw royal commissions, were in keeping with the gustatory function of the room: Fishing (Doyen), the Hunt (Joseph-Marie Vien), the Harvest (Louis Lagrenée), and the Grape Harvest (Jean-Baptiste Marie Pierre, later passed to Noël Hallé).[1] Each subject would be represented by appropriate mythological deities providing the fruits of their realm to grateful human recipients. Doyen's assignment was to depict an allegory of fishery, "represented by Neptune and Amphitrite surrounded by nymphs and tritons presenting fish, shellfish, and other riches of their empire to the humans."[2] This emphasis on the beneficent nature of pagan deities is of particular interest given the setting and the pervasive analogy between Louis XIV and the sun god Apollo in the iconography of the palace and its grounds. While this metaphorical alliance between mythology and the monarchy had largely lapsed since Le Moyne's Salon d'Hercule,[3] one wonders whether the decorative mythologies were meant as comforting tableaux of a populace well provided for or, conversely, of a natural order wherein the land—that is, the peasantry—presented its bounty to the upper-class recipients who would dine in front of the paintings.[4]

Although it may strike us today as the most ravishing of the group, Doyen's canvas (fig. 58.1) met with disfavor not long after it was delivered to Versailles in 1773, most notably on the part of the new queen, Marie-Antoinette, who insisted that the artist supply a new version. Her impatience is evident in the letter written by the *surintendant des Bâtiments,* the comte d'Angiviller, to Doyen of August 21, 1774, which strongly suggested he waste no time in sending along a drawing of a new composition that would be more to the queen's taste.[5]

Marc Sandoz, in his reading of the surviving documents, assumed that the second version had been executed and was the painting today at Versailles, while the first—rejected—composition was lost.[6] With the discovery of an autograph drawing representing a different version of the subject (fig. 58.5), Martine Hérold recognized in 1989 that Doyen had in fact never supplied a replacement, although he had begun planning it in at least two drawings and a sketch.[7]

Since the publication of Sandoz's catalogue raisonné in 1975, which lists only the still-untraced sanguine study recorded in the Chennevières collection in the nineteenth century,[8] no fewer than four preparatory drawings for the first composition have come to light: two acquired by the Metropolitan Museum in 1981 (the present sheet and fig. 58.3), one in the Prat collection, Paris (fig. 58.4), and one reworked red-chalk counterproof in a French private collection (fig. 58.2).[9]

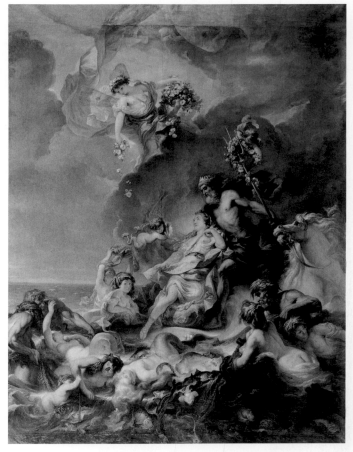

58.1. Gabriel-François Doyen, *The Triumph of Amphitrite, or Fishing,* ca. 1773. Oil on canvas, 114⅜ x 94⅞ in. (290 x 241 cm). Musée National des Châteaux de Versailles et de Trianon

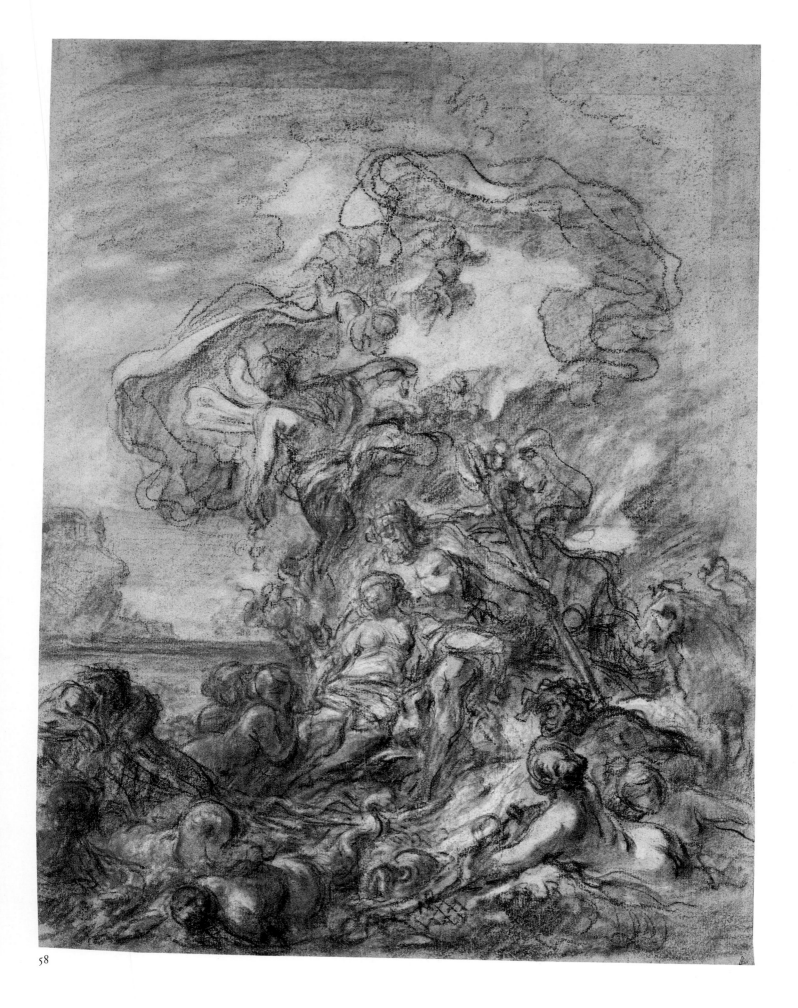

58

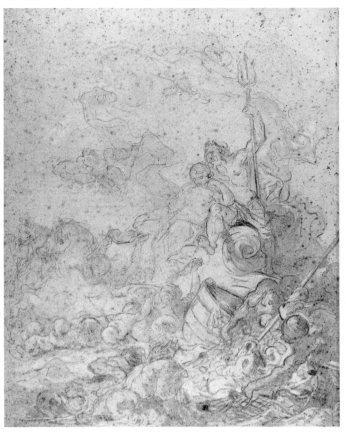

58.2. Gabriel-François Doyen, *Neptune and Amphitrite.* Red chalk counterproof, reworked with sanguine wash, 18¾ x 14⅞ in. (47.6 x 37.7 cm). Private collection, France (photo: Jean-Marc Manaï, Versailles)

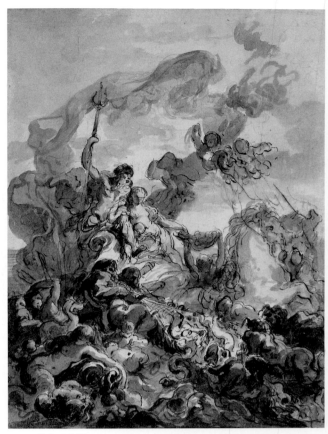

58.3. Gabriel-François Doyen, *Allegory of Fishery: Neptune and Amphitrite.* Pen and brown ink, brown wash, touches of white wash, over graphite, 11⅜ x 8½ in. (28.8 x 21.7 cm). The Metropolitan Museum of Art, Harry G. Sperling Fund, 1981 (1981.129)

As a group of composition studies, they exhibit an unusual range of technique and medium. The first among them would presumably have been the original from which the reworked counterproof was made. The composition of the counterproof, in reverse, is very close to the smaller of the two New York studies (fig. 58.3), in which the figures in the foreground are more elaborated. The exuberant pen work of the New York sheet and its boiling up of forms show Doyen's first idea as rooted in a Baroque conception of massing and movement. In the pen-and-ink study in the Prat collection (fig. 58.4), the protagonists are moved to the right (an idea perhaps suggested by the counterproof) and a winged figure strewing flowers from above has been added.[10] In the present sheet, the artist makes liberal use of charcoal and stumping for a vaporous effect. Refinements in the position of the airborne figure and the position of Neptune's trident bring the sheet closer to the painted composition.

Much speculation has been offered concerning the reasons behind Marie-Antoinette's displeasure with Doyen's canvas. Frequently cited is the increasingly tenuous position of the Baroque style in the climate of emerging Neoclassicism

(as reflected in the rejection of Fragonard's *Progress of Love* panels, now in the Frick Collection, by the comtesse Du Barry around the same time).[11] Also potentially objectionable was the display of female flesh in the form of nubile sea nymphs artfully arranged across the bottom of the canvas.[12] Another reason, perhaps overlooked in past discussions, is that Doyen's composition strayed from Cochin's iconographic program, which called specifically for tritons and nymphs to be shown presenting the edible riches of the sea to humans. The École Nationale Supérieure des Beaux-Arts sketch (fig. 58.5) suggests that Doyen intended to rectify all three "problems" in his second version. The voluptuous nymphs have been omitted and the entire setting has been transformed into a grotto, so that the focus of the composition becomes the tritons, shown hauling in their net and placing their catch in the baskets of the mortals who kneel on the rocky ledge; a clothed Amphitrite looks on calmly. In ironic contrast to the food shortages of the French populace, which would become a political thorn in the side of Marie-Antoinette, diners in the Petit Trianon gazed upon idyllic allegories of agricultural bounty. P S

58.4. Gabriel-François Doyen, *Neptune and Amphitrite*. Pen and brown ink, 7¾ x 7⅛ in. (19.6 x 18.1 cm). Louis-Antoine Prat Collection, Paris

58.5. Gabriel-François Doyen, *The Triumph of Amphitrite, or Fishing*. Black chalk with pen and brown ink, 9 x 7⅛ in. (23 x 18 cm). École Nationale Supérieure des Beaux-Arts, Paris, Donation Mathias Polakovits

PROVENANCE: Jacques Petit-Horry (his mark, JPH in a triangle, not in Lugt); [Baskett and Day, London]; purchased by The Metropolitan Museum of Art.

LITERATURE: Bean and Turčić 1986, p. 100, no. 104 (ill.); Lawrence Turčić, "Exhibition Reviews: Frankfurt am Main, French Drawings," *The Burlington Magazine* 129, no. 1008 (March 1987), p. 206; Rosenberg 1990, p. 141 (ill.); Rosenberg 1995, pp. 122–23, fig. 2.

1. Although Pierre had redirected his part of the commission to Hallé, he would eventually finish his canvas as a replacement for Hallé's, which was found unsatisfactory primarily because of lack of finish and then reworked in 1776. See Nicole Willk-Brocard, *Une dynastie, les Hallé: Daniel (1614–1675), Claude-Guy (1652–1736), Noël (1711–1781)* (Paris, 1995), pp. 155, 442–44. All five canvases were reunited at Versailles earlier in this century, although the Pierre is kept in storage because the room can accommodate only four pictures. See Claire Constans, *Musée National du Château de Versailles: Les peintures* (Paris, 1995), vol. 1, pp. 268, 450, 515, vol. 2, pp. 719, 931.

2. Marc Furcy-Raynaud, "Correspondance de M. de Marigny avec Coypel, Lépicié et Cochin," *Nouvelles Archives de l'Art Français,* ser. 3, 20 (1904), p. 139. Willk-Brocard identifies the program as allegories of the four seasons (Doyen–Spring; Lagrenée–Summer; Hallé–Autumn; Vien–Winter), although neither Cochin nor Marigny describes the subjects in such terms (*Une dynastie, les Hallé*, p. 155).

3. See Philippe Le Leyzour, "Myth and Enlightenment: On Mythology in the Eighteenth Century," in Bailey 1992, pp. 20–31.

4. Anxiety over the agricultural productivity of the peasantry manifested itself in a variety of forms around this time. For a modern interpretation of eighteenth-century workers, see Emma Barker, "Painting and Reform in Eighteenth-Century France: Greuze's 'L'accordée de village,'" *Oxford Art Journal* 20, no. 2, (1997), pp. 42–52.

5. Quoted in Paris 1989, p. 242 (entry by Martine Hérold).

6. Marc Sandoz, *Gabriel François Doyen, 1726–1806* (Paris, 1975), p. 43.

7. Pierre, after visiting Doyen's studio in July 1776, reports seeing an oil sketch for a replacement canvas that had been begun two years earlier and abandoned; see Marc Furcy-Raynaud, "Correspondance de M. d'Angiviller avec Pierre," *Nouvelles Archives de l'Art Français,* ser. 3, 21 (1905), p. 101.

 In addition to the École Nationale Supérieure des Beaux-Arts sketch, a larger red-chalk drawing, presumably corresponding to the second composition as well, is recorded in the collection of Philippe de Chennevières; see Paris 1989, pp. 242–44 (entry by Martine Hérold).

8. Sandoz, *Gabriel François Doyen*, pp. 42–44.

9. Xavier Salmon kindly brought this drawing to my attention. It was acquired by its present owners at a sale at Hôtel Meurice, Maître Roudmer, Paris (May 6, 1967, lot 172), as by Taraval. The fact that it is a counterproof implies, of course, that one more study remains to be found.

10. The sketch on the verso of the lower left quadrant of the composition, however, is very close to the painting and may well have been done after the Metropolitan's chalk sheet. It is reproduced in the entry for the Prat drawing in Rosenberg 1990, pp. 140–42.

11. See, for example, Sandoz, *Gabriel François Doyen*, p. 43, and Nathalie Volle, "Doyen, Gabriel-François," *The Dictionary of Art*, edited by Jane Turner, 34 vols. (London, 1996), vol. 9, pp. 208–9.

12. Pierre, in his letter to d'Angiviller of July 14, 1776, specifically describes Doyen's initial canvas as being considered "trop leste."

The letter is published in Furcy-Raynaud, "Correspondance de M. d'Angiviller avec Pierre," p. 101.

The poses of certain of the sea nymphs seem to echo those in François Boucher's *The Birth of Venus*, in the Nationalmuseum, Stockholm.

GABRIEL-FRANÇOIS DOYEN

Paris 1726–1806 Saint Petersburg

59. The Deliverance of Cybele, an Allegory of the Seasons

Pen and black ink, brush and brown wash, heightened with white gouache, over black chalk underdrawing, 25⅞ x 18¼ in. (65.6 x 46.4 cm). Collector's mark of Germain Seligman (not in Lugt) at bottom edge, left of center

Lansing and Iliana Moore Collection

From his first Salon, in 1759, where he exhibited the huge *Death of Virgina* (Pinacoteca, Parma), and was *agréé* and *reçu* by the Académie the same year, Doyen adhered to a policy of submitting only a few works, often just one painting, typically erudite and ambitious in scale, rather than risk diminishing his reputation by showing great numbers of minor efforts, as did some of his contemporaries. Not until 1773 did he put his first drawing on public view. The present sheet is undoubtedly no. 26 in the Salon *livret* of that year: "Cybele, Mother of the Gods, Representing the Earth with its Attributes." The title was followed, as was typical for Doyen's submissions, by a long

59.1. After Pierre Mignard (1612–1695), *L'hiver ou Cybèle implorant le retour du soleil*. Tenture de Saint-Cloud, Gobelins manufactory, 1692–93. Tapestry of silk wool and gold thread, 186⅝ x 242 in. (479 x 616 cm). Mobilier National, Paris

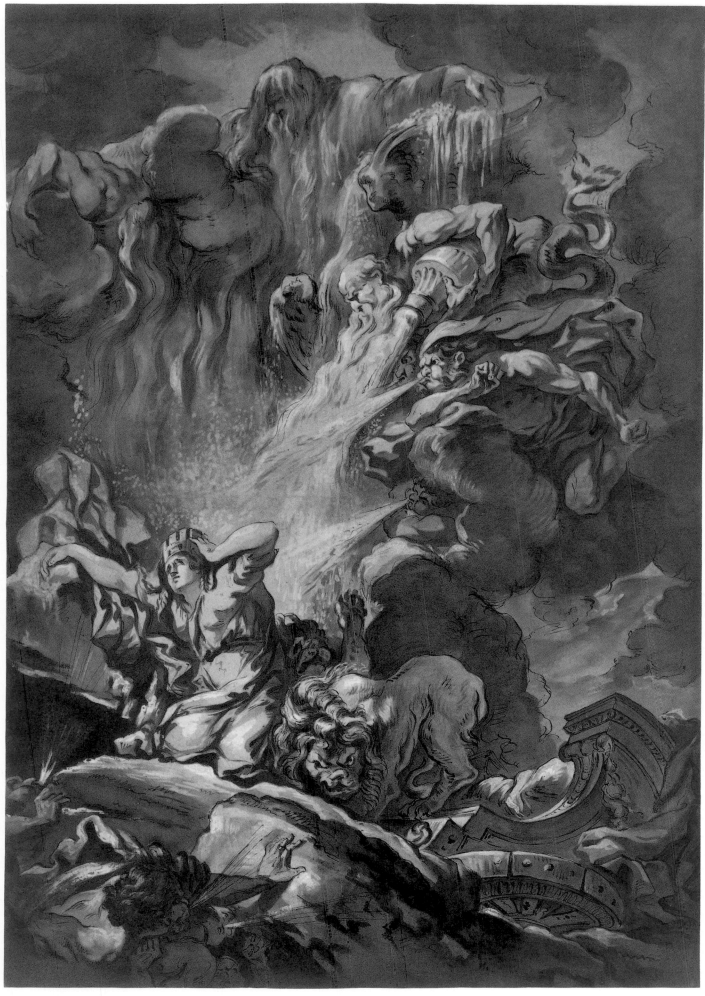

59.2. Gabriel-François Doyen, *Cybele Tormented by the Elements*, 1778. Pen and black and brown ink, brush and brown, ocher, and gray wash, heightened with white, 26 x 19⅜ in. (66 x 49.3 cm). Fogg Art Museum, Harvard University Art Museums, Loan from the Collection of Jeffrey E. Horvitz

59.3. Antoine Vestier (1740–1824), *Gabriel-François Doyen*, 1786 Oil on canvas, 50 x 37⅜ in. (127 x 95 cm). Musée du Louvre, Paris

explanation of the subject: "On an icy rock, the Winds gather all the frosts and attack the mother of the gods; her chariot is smashed; her lions, frightened, press in close to defend her; the subterranean winds, in combat with them, shake the rock upon which she has been tossed; at that instant, Jupiter Pluvius arrives with the children of the clouds to appease the Winds and deliver Cybele."[1]

Cybele, identified by her turreted crown and pair of lions, in addition to being the "mother of the gods, representing the earth" was also the goddess of fertility, vegetation, and mountains. Representations of Cybele often follow specific textual references from ancient literature. In Virgil's *Aeneid,* she comes to Aeneas's aid by transforming his fleet to nymphs (see no. 37),[2] although in the eighteenth century she is more often used in allegories. Doyen may have been aware of Pierre Mignard's *Cybele implorant le retour du soleil,* completed by 1678 for the Galerie d'Apollon at the château de Saint-Cloud, a residence of the d'Orléans family, and later woven as a tapestry at the Gobelins manufactory (fig. 59.1).[3] Indeed, Mignard's airborne figure of Saturn, in the

direction engraved by Jean-Baptiste Poilly, seems to find its echo in the muscular pose of the wind god at the right in the Doyen composition.

The dramatic sensory overload of the sheet, accomplished through Doyen's free and intuitive handling of ink and gouache, creates a convincing tempest of wind, water, ice, and frost that rains down upon the despairing figure of Cybele. François Lecarpentier, writing in 1821, described it as an allegory of winter. More precisely, it could be called an allegory of the seasons. Cybele and her lions are associated with heat, summer, and fertility, and thus with the season of growth. In Doyen's image they are rendered powerless, beset by the ice and frost of winter. It is the arrival of Jupiter Pluvius, the god of the rains, that signals the arrival of spring, "Cybele's deliverance." Yet the overall tenor of the sheet, with its zigzag composition, its intense Baroque theatricality, and its dark palette, and Cybele's truly besieged predicament exceed our expectations for either allegory or mythology and bring us closer to the moment of Fuseli or even Delacroix.

The possibility that Doyen's *Cybele* may have been conceived as a personalized, rather than a general, allegory was raised by Marc Sandoz in 1985.[4] The Salon *livret* describes the drawing as belonging to the duchesse de Choiseul and a study for a projected painting. Her husband, the duc de Choiseul, born into a noble Lorraine family of modest means, had made a dizzying climb through the ranks of the military and various diplomatic assignments, gaining the post of foreign minister in 1758 and with it the control of the Ministry of War and the Admiralty. His close ties to Mme de Pompadour, which had aided his ascent, were among the factors contributing to his fall from power following her death. He was dismissed from his offices and exiled to his country estate at Chanteloup by Louis XV in 1770, returning to Paris four years later, after the king's death.[5] The duchesse may have intended the *Cybele* as an allegory for the unjust (and, she hoped, temporary) banishment of her husband. In addition to her association with the earth and with agriculture, Cybele was considered a protectress in times of war, which may have provided a logical association with Choiseul's former position as foreign minister.

No painting of the subject by Doyen is known today. Presumably Choiseul's return from exile not long after the drawing was shown at the Salon (he had remained, throughout his four-year absence, a popular figure in the capital) put a halt to the commission. However, Doyen seems to have returned to the subject five years later, when he made a second version of the drawing, now at the Fogg Art Museum (fig. 59.2), introducing various small adjustments in the composition. While the two have approximately the same dimensions, the version in the Moore collection appears to have been trimmed a few inches along the left and bottom edges. That the projected painting was at least belatedly begun is suggested by a letter to the artist from the duchesse de Choiseul dated February 4, 1783, indicating that he had asked to borrow her "tableau,"[6] and by Antoine Vestier's portrait of Doyen (fig. 59.3). The painting, submitted to the Académie as his reception piece in 1786, shows the artist at work on a canvas upon which can clearly be made out the Moore version of the composition in outline.

P S

PROVENANCE: The duchesse de Choiseul, 1773; [possibly the drawing seized in 1793 from Billard, called Bélizard; the dimensions correspond to the present sheet, although the medium is described as sanguine]; d'Herbouville, prefect of Lyon and former student of Doyen, in 1821 (according to Lecarpentier); private collection, Paris, 1966; Germain Seligman, New York (his collection stamp, lower left, not in Lugt); private collection; Lansing and Iliana Moore collection.

LITERATURE: *Explication des peintures, sculptures et autres ouvrages de messieurs de l'Académie Royale* (Paris, 1773), p. 16, no. 26, reprinted in Jean-Jacques Guiffrey, ed., *Collection des livrets des anciennes expositions depuis 1673 jusqu'en 1800* (Paris, 1869–72); C[harles Jacques François] Lecarpentier, *Galerie des peintres célèbres* (Paris, 1821), vol. 2, pp. 267–68; Marc Sandoz, "Gabriel-François Doyen, peintre d'histoire (1726–1806)," *Bulletin de la Société de l'Histoire de l'Art Français*, 1959, pp. 85–86; Marc Sandoz, "Tableaux retrouvés de Jean-Baptiste Deshays, Gabriel Doyen et Louis Lagrenée (l'ainé)," *Bulletin de la Société de l'Histoire de l'Art Français*, 1967, pp. 113–16; Marc Sandoz, "The Drawings of Gabriel François Doyen (1726–1806)," *The Art Quarterly* 34, no. 2 (Summer 1971), pp. 153, 167 (ill. p. 160); Marc Sandoz, *Gabriel François Doyen, 1726–1806* (Paris, 1975), pp. 16, 45, no. 39b, (ill. pl. vi); Marc Sandoz, *Antoine-François Callet (1741–1823)* (Paris, 1985), pp. 23–24 (ill. p. 24).

1. *Explication des peintures, sculptures et autres ouvrages de messieurs de l'Académie Royale* (Paris, 1773), p. 16.
2. It is Antoine Coypel's version of this subject (fig. 37.1, p. 87) that provides the closest parallel to Doyen's sheet, with its atextual inclusion of wind gods by Cybele's side.
3. *Le tenture de la galerie de Saint-Cloud* was woven six times up until 1741. The original painting was destroyed in the nineteenth century; see Maurice Fenaille, *Etat général des tapisseries de la manufacture des Gobelins depuis son origine jusqu'à nos jours, 1600–1900*, 6 vols. in 5 (Paris, 1903–23), vol. 2, pp. 399–418. However, a drawing of the composition survives in the Louvre (inv. 31025; GM 9952).
4. Marc Sandoz, *Antoine-François Callet (1741–1823)* (Paris, 1985), p. 23.
5. See Barbara Scott, "The duc de Choiseul, a Minister in the Grand Manner," *Apollo* 97, no. 131 (January 1973), pp. 42–53.
6. Whether she uses the word "tableau" for the large painterly drawing or whether she also had a painted version is unclear. The letter, in the Archives Nationale, is quoted in Henri Stein, *Le peintre G. F. Doyen et l'origine du Musée des Monuments Français* (Paris, 1888), p. 16. Charles Jacques François Lecarpentier referred to multiple sketches not long after Doyen's death: "Il avait eu le projet de peindre un tableau représentant l'Hiver; c'eût été un de ses meilleurs ouvrages, à en juger par les différentes esquisses et surtout par un magnifique dessin au bistre"; see *Galerie des peintres célèbres* (Paris, 1821), vol. 2, p. 267.

ANTOINE-FRANÇOIS CALLET

Paris 1741–1823 Paris

60. Jupiter and Ceres

Brush and gray and black wash over black chalk, 10⅞ x 7⅞ in.
(27.5 x 20 cm)

The Metropolitan Museum of Art, Bequest of Harry G. Sperling,
1971 (1975.131.117)

A long with Vincent, Ménageot, and Berthélemy, Callet exhibited his *morceau d'agrément* at the Salon of 1777. His canvas must have been a late addition, for it is not mentioned in the official *livret,* although the talents of the young painter were heralded by critics who described the subject of the painting as Ceres, goddess of agriculture, seeking Jupiter's aid following the abduction of her daughter, Proserpine.[1] Callet's submission was praised for its Rubensian color and its Carraccesque draftsmanship. The continuer of Bachaumont wrote that Callet "is the one with the most soul and the most fire."[2] In its grandeur of conception and of scale, *Jupiter and Ceres* was considered by critics a stylistic departure. "[Callet] will be congratulated for having abandoned his *petite manière,*" wrote the author of one brochure.[3] Although the painting is lost today, one can form an idea of the composition from a tiny sketch made by Gabriel de Saint-Aubin in the margin of his 1777 Salon *livret*[4] and an oil sketch in the Musée des Beaux-Arts, Quimper (fig. 60.3), rediscovered by Brigitte Gallini in 1993.[5] In addition, two preparatory drawings are in the École Nationale Supérieure des Beaux-Arts, Paris: one, *donation* Gatteaux (fig. 60.1), and one, *donation* Mathias Polakovits (fig. 60.2).[6]

To this group of works can be added a brush and wash study in the Metropolitan Museum that, until now, was classed with the anonymous drawings.[7] Although the technique of the New York sheet is atypical for Callet, who tended to use black chalk and stumping, heightened with white,

60.1. Antoine-François Callet, *Jupiter and Venus* (?). Black chalk heightened with pastel, 12⅜ x 10⅝ in. (31.5 x 27 cm). École Nationale Supérieure des Beaux-Arts, Paris, Donation Gatteaux

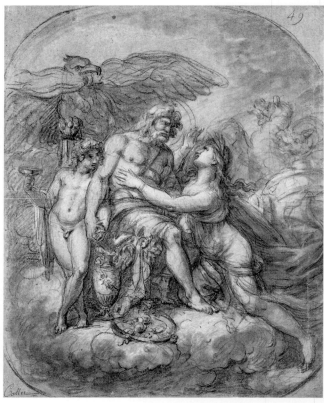

60.2. Antoine-François Callet, *Jupiter and Ceres.* Black chalk, stumping, heightened with white, 18 x 16⅞ in. (45.7 x 42.9 cm). École Nationale Supérieure des Beaux-Arts, Paris, Donation Mathias Polakovits

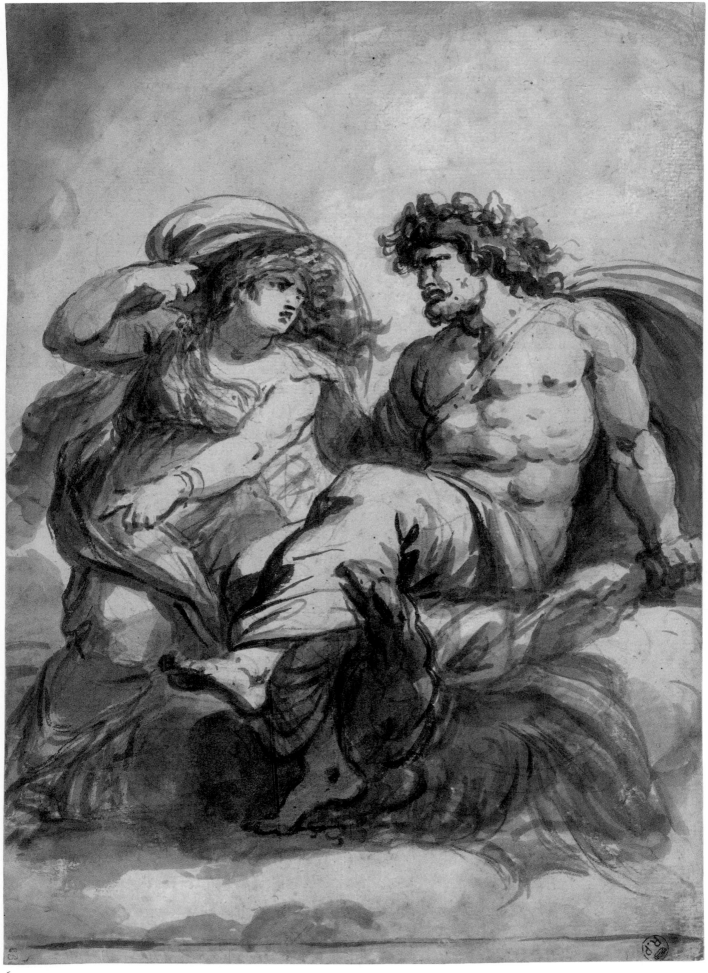

60

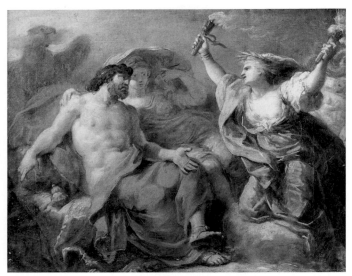

60.3. Antoine-François Callet, *Jupiter and Ceres*, ca. 1777. Oil on canvas, 12¼ x 16½ in. (31 x 42 cm). Musée des Beaux-Arts, Quimper

the positioning and treatment of the figures leave no doubt as to its place in the genesis of his *morceau d'agrément*. The chronological order of the drawings suggested by Gallini is entirely logical.[8] She proposes the *donation* Gatteaux sheet as the earliest, followed by the present sheet, which retains the relative positions of the protagonists, the eagle by Jupiter's feet, and the lightning bolt in his left hand. By the more highly worked-up *donation* Polakovits drawing, Ceres and Jupiter have swapped places, Ganymede is more prominently placed, assuming a homoerotic pose, and the eagle is shown in flight, thunderbolt in beak. The Polakovits composition, with its intertwined bodies and sexual tensions, must not have pleased Callet. In the Quimper oil sketch, the tenor of the subject is radically altered. Ganymede has departed, a supportive Juno appears at Jupiter's side, and the supple, feminine figure of Ceres becomes vengeance incarnate. Brandishing flaming torches with which she threatens to destroy the earth's crops, she lunges menacingly toward the calm, seated Jupiter. Unlike the languid poses of Ceres in the two Paris drawings, her depiction in the Metropolitan's sheet indicates that Callet had initially characterized her as enraged, a notion he returned to in the Quimper sketch.

What remains uncertain is whether the subject evolved along with the composition or was determined at the outset. The woman in the *donation* Gatteaux drawing has, understandably, been called both Venus and Thetis, while Philippe de Chennevières referred to the New York sheet in 1897 as "Venus Demanding Jupiter's Vengeance."[9] The corn (or wheat?) in the woman's hair in the Polakovits and Quimper versions—apparently present in the New York sheet as well—is considered an attribute of Ceres.[10] Judging from this attribute, it would appear that the Thetis of the Gatteaux sheet became Ceres only in the New York sheet. The Polakovits composition was an attempt to merge the attributes of Ceres and the pose of Thetis, an idea abandoned in the Quimper sketch, where the dramatic wrath of the Metropolitan Ceres is reinstated.

Also interesting are the appearances and disappearances of Ganymede in Callet's preparations. As Jupiter's lover/cupbearer, carried to Olympus by Jupiter's eagle, Ganymede plays no direct role in the story of Ceres, but may be included as a parallel to the abducted Proserpine. While the figure of Ganymede does not appear in the Metropolitan's drawing, an article by Chennevières, who owned the sheet in the nineteenth century, describes it as mounted together with a second treatment of the same subject in ink wash in which Juno and Ganymede are also present.[11] Chennevières also draws an insightful comparison between Callet's composition and Ingres's painting *Jupiter and Thetis*, now at Aix-en-Provence, suggesting that Ingres must have seen either a drawing or the painting by Callet.[12] This leads one to speculate whether Chennevières was aware of Callet's earlier rendition of the subject, given by Gatteaux to the École des Beaux-Arts in 1883, in which Ingres's striking contrast of Jupiter's massive, muscular bulk with Thetis's boneless languor is more precisely prefigured. Or perhaps the pose was carried over to the untraced pendant of the New York drawing.

PS

PROVENANCE: According to Chennevières, sold by Callet's son, Charles Callet, "poor painter who went mad"; to [Delaurier, Paris]; sold March 1862 to Philippe de Chennevières (Lugt 2073); his sale, Paris, April 4–7, 1900, p. 13, lot 58; Baron Roger Portalis (Lugt 2232); his estate sale, Paris, February 2–3, 1911, p. 6, lot 16 (lot included thirteen drawings by Callet: "études et compositions, la plupart relatives à la mythologie"); Harry G. Sperling; bequeathed to The Metropolitan Museum of Art (at the time of the bequest considered "attributed to Greuze" and later "French, anonymous").

LITERATURE: Ph[ilippe] de Chennevières, "Une collection de dessins d'artistes français, XX," *L'Artiste*, n.s., 14 (August 1897), pp. 106–7; Marc Sandoz, *Antoine-François Callet (1741–1823)* (Paris, 1985), p. 137 (cites "Vénus" drawing in Chennevières collection as untraced); Paris 1989, pp. 270–72 (under no. 114, entry by Brigitte Gallini, cites Chennevières drawing as untraced); Brigitte Gallini, "Autour du morceau d'agrément d'Antoine-François Callet (1741–1823): Élaboration d'une oeuvre et redécouverte d'une esquisse au musée de Quimper," *La Revue du Louvre et des Musées de France* 43, no. 2 (April 1993), p. 53 (cites Chennevières drawing as untraced).

1. The preceding Salon had included a large shaped canvas of the same subject by Louis-Jacques Durameau, commissioned as a ceiling for Versailles but also functioning as the artist's reception piece. Durameau's treatment was more elaborate, but also more conventional. See Marc Sandoz, *Louis-Jacques Durameau, 1733–1796* (Paris, 1980), pp. 96–97, no. 61 (ill.).

2. Louis Petit de Bachaumont, *Mémoires secrets . . .* , vol. 11 (Paris, 1777), letter dated September 9, 1777.

3. Anonymous, *La prêtresse, ou nouvelle manière de prédire ce qui est arrivé* (Rome and Paris, 1777), Deloynes Collection, Bibliothèque Nationale, vol. 10, no. 189, p. 21.

4. Illustrated in Brigitte Gallini, "Autour du morceau d'agrément d'Antoine-François Callet (1741–1823): Élaboration d'une oeuvre et redécouverte d'une esquisse au musée de Quimper," *La Revue du Louvre et des Musées de France* 43, no. 2 (April 1993), p. 54, fig. 1.

5. See Gallini, "Autour du morceau d'agrément d'Antoine-François Callet," pp. 52–57.

6. See Paris 1989, pp. 270–72, no. 114 (entry by Brigitte Gallini).

7. Gallini, who has recently completed a doctoral dissertation on Callet, confirmed the attribution of the Metropolitan's sheet from a photograph (correspondence, June 19, 1996), as did Pierre Rosenberg, who saw the original in 1997.

The sheet's nineteenth-century owner, Philippe de Chennevières, acquired the drawing with a group of works by Callet from a dealer who had bought them directly from the artist's son, but the identification was later lost, and the drawing came to the Museum in 1971 as "attributed to Greuze."

8. Correspondence, June 19, 1996.

9. Ph[ilippe] de Chennevières, "Une collection de dessins d'artistes français, XX," *L'Artiste*, n.s., 14 (August 1897), p. 106.

10. Themes of Ceres are further explored by Callet in his tapestry design *L'été* or the *Fêtes de Cérès* exhibited at the 1789 Salon, for which several drawings survive. See Teresa Sulerzyska, "'L'été' ou les 'Fêtes de Cérès': Un dessin d'Antoine-François Callet," *La Revue du Louvre et des Musées de France* 38, no. 5/6 (1988), pp. 409–12. In addition, two paintings of the Abduction of Proserpine are listed in eighteenth-century sales; see H. Mireur, *Dictionnaire des ventes d'art faites en France et à l'étranger pendant les XVIIIe et XIXe siècles* (Paris, 1911), vol. 2, p. 19.

11. Chennevières, "Une collection de dessins," p. 106. Another pair of Callet drawings, also from Chennevières's collection, were recently on the New York art market, still mounted together. See *Master Drawings 1996*, exh. cat., New York, Didier Aaron, Inc. (New York, 1996), no. 25.

12. Chennevières, "Une collection de dessins," pp. 106–7.

JEAN-JACQUES LAGRENÉE
Paris 1739–1821 Paris

61. *Telemachus and Mentor on the Island of Calypso*

Brush and brown wash over traces of black chalk, on cream paper, 16 13/16 x 22 in. (42.8 x 56.3 cm). Signed and dated in pen and brown ink at lower right: *J. J Lagrenée / 1776*
Mr. and Mrs. Patrick A. Gerschel

Jean-Jacques Lagrenée (Lagrenée *le jeune*) was a history painter and draftsman, and the younger brother of the well-known academician Louis (Lagrenée *l'aîne*). His studies at the École des Élèves Protégés were interrupted in 1760, when he accompanied his brother to Saint Petersburg, where the latter had been appointed director of the Academy. The two brothers returned to Paris in 1762, and Jean-Jacques finally got his trip to Rome three years later, a trip secured by his brother's influence. Although he had never won the Prix de Rome, he was permitted to stay at the Académie de France, then under the direction of

Natoire, and there he cultivated the lifelong love of classical art and subject matter that characterizes his work. Back in Paris by 1769, he exhibited frequently at the Salon, showing both paintings and drawings. His drawings were prized by eighteenth-century collectors.

Fénelon's 1699 adaptation of the tale of Telemachus, an often used source for eighteenth-century artists, is a coming-of-age story of a boy's search for his heroic father (Odysseus), the rescue of his mother (Penelope), his seduction by an alluring nymph (Calypso, who had earlier seduced his father), and his guidance by the voice of wisdom (Mentor/Minerva).[1] The subjects found in the tale were well suited to Lagrenée's transitional classicism, one that reflected the renewed interest in the stories of Greece and Rome but not yet the rigorous style of emerging Neoclassicism. His favorite story among the many available is the subject of the

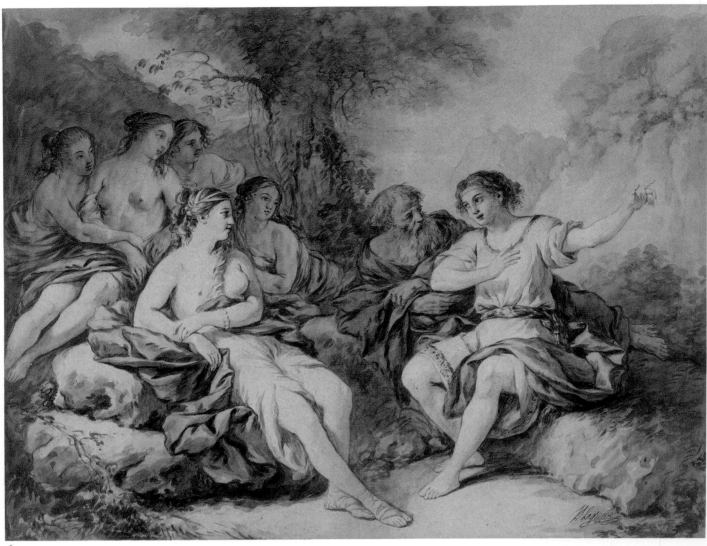

61

present drawing—the relating by Telemachus of his adventures to Calypso and her nymphs. He produced this particular theme, with few changes in composition, at least five times, beginning in 1775.[2] The first known example is a painting that dates from one year before the present drawing.[3] The drawings are so finished, and vary so little from the painting, that we can assume that they were made as repetitions of an established composition.

Lagrenée favored pen and ink and wash for compositional drawings; the ranging of figures across the picture plane in the manner seen here is characteristic of his work. This format was adopted also by Jacques-Louis David about the same time. The delicate touch, the graceful poses of the figures, and the opulent figure style, however, look back to an earlier age of French history painting, to the work of such artists as Le Moyne and Natoire. MTH

PROVENANCE: [Galerie Cailleux, Paris]; [Rosenberg and Stiebel, Inc., New York]; Mr. and Mrs. Patrick A. Gerschel.

LITERATURE: Marianne Roland Michel, *Les étapes de la création: Esquisses et dessins de Boucher à Isabey*, exh. cat., Paris, Galerie Cailleux (Paris, 1989), no. 44, n.p.

1. For this theme in eighteenth-century art, see Philippe Le Leyzour, "Myth and Enlightenment: On Mythology in the Eighteenth Century," p. 22, and Katie Scott, "D'un siècle à l'autre: History, Mythology, and Decoration in Early Eighteenth-Century Paris," pp. 46–47, both in Bailey 1992.
2. A close replica of the drawing in the present exhibition, slightly smaller and less red, was with the Galerie Cailleux, Paris, in 1997. Other compositions very close to the New York drawing are cited in Marc Sandoz, *Les Lagrenée. II. Jean-Jacques Lagrenée, 1739–1821* (Paris, 1988), p. 204, no. 74, and p. 206, no. 80.
3. The painting was with the Galerie Joseph Hahn, Paris, in 1982.

NICOLAS-BERNARD LÉPICIÉ

Paris 1735–1784 Paris

62. Seated Woman with a Cradle

Black chalk and stumping with some red and white chalks, on light brown paper, 13⅞ x 11 in. (35.2 x 27.9 cm). Signed in pen and brown ink at lower left. Blindstamp of François Renaud in bottom right corner (Lugt 1042)

The Pierpont Morgan Library, Gift of the Fellows (1961.11)

Born into a well-connected artistic family, Nicolas-Bernard Lépicié studied first with his father, Bernard Lépicié (1698–1775), engraver and *secrétaire histori-ographe* to the Académie Royale, and later with Carle Vanloo. In addition to enjoying a successful career as a painter of history and religious subjects, Lépicié regularly submitted genre subjects to the biannual Salons, especially in his later years. These efforts were warmly received for reasons that can still be appreciated today: treated with sympathy and naturalism, they manage to stop short of overt moralizing or sentimentality. From Lépicié's large corpus of surviving drawings (a group of 143 entered the Louvre in 1981), it is evident that he prepared these canvases with the same care that he brought to the higher genres. While the simple figure studies tend to be done in black and white chalk, many of the more finished composition and figure studies, such as the Morgan Library drawing, are rendered in Lépicié's distinctive adaptation of the *trois crayons* technique. Red chalk, sharpened to a fine tip, is used sparingly, while a considerable amount of black chalk stumping lends a sense of atmosphere and space to the precisely observed figures.

The *Seated Woman with a Cradle* is a study for the figures in the 1774 painting *La bonne mère* (fig. 62.1),[1] a celebration of a Rousseauean ideal of devoted motherhood that saw a burgeoning of interest among French painters in the 1770s. Given the affecting naturalism of both drawing and painting, one is surprised to find that the composition has a direct source in Noël Hallé's 1757 painting *A Savoyard*, known through an engraving made by Lépicié's mother, Renée-Elisabeth Marlié Lépicié (1714–1773; fig. 62.2).[2] One can also point to a similar precedent for the drawing of a seated old man holding a hat, formerly in a New York private collection, apparently conceived by Lépicié as a pendant to the Morgan Library sheet.[3]

Even for a relatively straightforward composition like *La bonne mère*, Lépicié made a number of preparatory studies. A smaller study in *trois crayons* for the same painting is recorded in an eighteenth-century sale.[4] A sketch of a baby's head in a sheet of studies sold at auction in 1988 may well be related to the present composition.[5] The head of the mother in the Morgan Library sheet appears to have been drawn from a live model as well, but the finished painting has more the air of a true genre image than that of a commissioned portrait in Savoyard costume, thus setting it apart from the majority of these types of images.[6] It is this sense of empathy rather than of maudlin sentiment or melodrama that distinguishes the work of Lépicié during this period, when the popularity of genre painting was growing and its uses were changing. PS

PROVENANCE: Anonymous sale, Paris, March 29–April 13, 1779, part of lot 205; Forrain collection, Annecy, in 1956; [Galerie Cailleux, Paris]; [Matthias Komor, New York]; The Pierpont Morgan Library.

LITERATURE: Philippe Gaston-Dreyfus and Florence Ingersoll-Smouse, "Notes et documents: Catalogue raisonné de l'oeuvre de Nicolas-Bernard Lépicié," *Bulletin de la Société de l'Histoire de l'Art Français*, 1922, p. 245, no. 403; reprinted as Philippe Gaston-Dreyfus, with the collaboration of Florence Ingersoll-Smouse, *Catalogue raisonné de l'oeuvre peint et dessiné de Nicolas-Bernard Lépicié (1735–1784)* (Paris, 1923), p. 117, no. 403; Frederick B. Adams, Jr., ed., *Eleventh Report to the Fellows of the Pierpont Morgan Library, 1961* (New York, 1961), pp. 95–96 (entry by Felice Stampfle); Alexandre Ananoff, "Les cent 'petits maîtres' qu'il faut connaître," *Connaissance des Arts*, no. 149 (July 1964), p. 52 (ill. p. 53); *The Pierpont Morgan Library: A Review of Acquisitions 1949–1968* (New York, 1969), p. 153; Rosenberg 1972, p. 178, under no. 82.

1. The painting (oil on wood, 42 x 32 cm) was sold in Paris, Palais Galliera, March 27, 1971, lot 18 (ill.).
2. See Nicole Willk-Brocard, *Une dynastie, les Hallé: Daniel (1614–1675), Claude-Guy (1652–1736), Noël (1711–1781)* (Paris, 1995), pp. 392–93, no. N69a. Lépicié adds a cat on a chair to the painted version of *La bonne mère*, echoing the dog in the Hallé. The composition of the Lépicié mirrors rather than repeats the Hallé as known from the print, although the print may have reversed the painting (now lost).
3. See Rosenberg 1972, pp. 177–78, no. 82; and Oberhuber and Jacoby 1980, p. 151, no. 55. The two drawings are of similar technique and dimensions, and seem to share a common provenance. For a similar

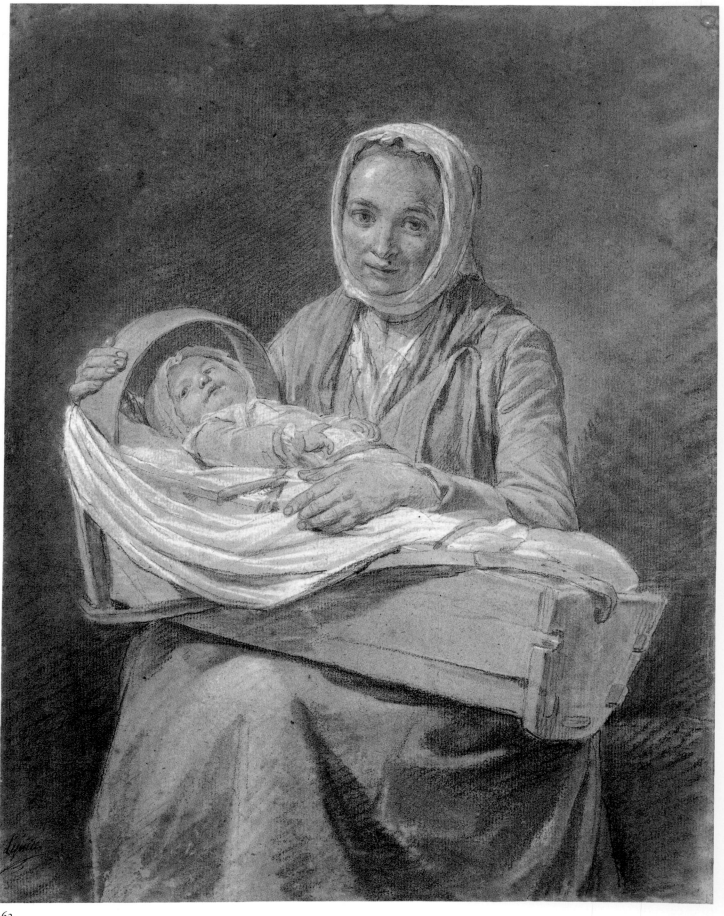

62

146

62.1. Nicolas-Bernard Lépicié, *La bonne mère*, 1774. Oil on panel, 16½ x 12⅝ in. (42 x 32 cm). Present location unknown

62.2. Renée Elisabeth Marlié Lépicié (1714–1773), etching after Noël Hallé (1711–1781), *La piémontaise*. 14½ x 10⅜ in. (36.9 x 26.5 cm). The Metropolitan Museum of Art, Rogers Fund, 1962 (62.602.835a)

composition by Noël Hallé, see Willk-Brocard, *Une dynastie, les Hallé*, p. 369, no. N26.

4. Paris, Vassal de Saint-Hubert sale, April 24, 1783, part of lot 173.
5. Christie's, London, April 19, 1988, lot 115.
6. A well-known example of this practice is François-Hubert Drouais's

The Count and the Chevalier de Choiseul as Savoyards, 1758, in The Frick Collection, New York (see Edgar Munhall, "Savoyards in French Eighteenth-Century Art," *Apollo* 87, no. 72 [February 1968], pp. 86–94). Willk-Brocard considers it likely that the lost Noël Hallé was also a *portrait déguisé*; see note 2 above.

ÉTIENNE AUBRY

Versailles 1745–1781 Versailles

63. *Study of a Gentleman*

Red chalk and brush and brown wash, 16⅝ x 10⅜ in. (42.1 x 26.3 cm)

Private collection

É tienne Aubry is best remembered today as a painter of tender scenes of family life, naturalistic and infused with sentiment. His subjects in this vein are indebted to Greuze, though without that painter's melodramatic presentation. The course his career followed was an atypical one. After training with Jacques Augustin de Silvestre

(1789–1809) and Joseph-Marie Vien, Aubry was *agréé* by the Académie as a portraitist in 1771, although genre subjects began to play an increasing role in his exhibited output beginning in 1775. Apparently he continued to harbor higher ambitions, and by 1777 had gained official sponsorship for a trip to Rome, where he would be lodged and trained as a history painter alongside the younger pensionnaires. The support of the Bâtiments du Roi for Aubry's "retraining" raises certain questions, especially in light of the official resistance to Greuze's attempt to elevate his own standing

63.1. Étienne Aubry, *Farewell to the Nurse*, 1777. Oil on canvas, 20⁷⁄₁₆ x 24¾ in. (51.9 x 62.8 cm). Sterling and Francine Clark Art Institute, Williamstown, Mass.

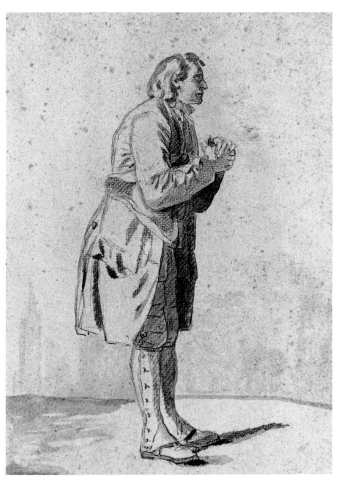

63.2. Here attributed to Étienne Aubry, *Study of a Man with Hands Clasped*. Red chalk, brush and brown wash, 15¾ x 10½ in. (40 x 26.8 cm). Musée des Beaux-Arts et de la Dentelle, Alençon

less than a decade before.[1] The correspondence reveals the personal dynamics to have been quite different in the case of Aubry, who was highly regarded by both d'Angiviller, the *surintendant des Bâtiments*, and his former teacher, Vien, director of the Académie de France in Rome.[2] The success of Aubry's bid to attain the status of history painter is difficult to gauge today as he died in 1781, less than a year after returning to Paris.

The *Study of a Gentleman* relates to one of Aubry's best-known genre paintings, *Farewell to the Nurse* (fig. 63.1), exhibited at the Salon just before Aubry's departure for Italy.[3] It is a charming rustic vignette with a didactic intent.[4] A well-dressed couple has arrived at a simple farm to retrieve their infant, who had been left, as was common practice, with a country wet-nurse. The Rousseauean message is conveyed in the teary parting glance of the infant, who turns away from his natural mother and reaches for his nurse. The present sheet is Aubry's study for the father, off to the side, who observes the scene in a pose of elegant reserve. In the painting, he is given a more youthful countenance and details of his hand, hairstyle, and hat are slightly altered. In the drawing, the pose was first quickly sketched in red chalk and then the fall of strong sunlight convincingly rendered by the careful application of light brown wash. A reworked counterproof, formerly attributed to Greuze, is in the Albertina, Vienna, and two compositional studies, one in wash, one in oil, remain untraced.[5] Aubry's study for the

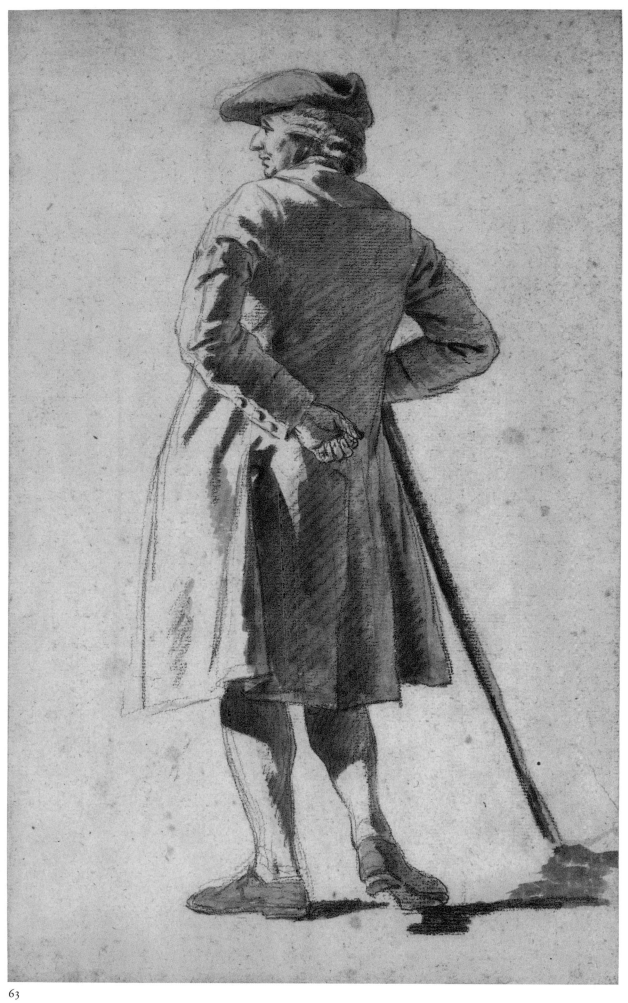

figure of the wet-nurse's husband (fig. 63.2), comparable in size and technique to the present sheet, was given by Philippe de Chennevières to the Musée des Beaux-Arts et de la Dentelle, Alençon, where it has long been catalogued as Lépicié.[6]

PS

PROVENANCE: Sale, Sotheby's, New York, January 10, 1995, lot 123; private collection.

Unpublished.

1. Curiously, rather than trying to distance himself from this failed model, Aubry chose as the subject for his first history canvas sent back from Rome and exhibited in the 1779 Salon *Le fils repentant de retour à la maison paternelle,* which owes an undisguised debt to Greuze.
2. References to the letters can be found in Caroline Fossey, "Étienne Aubry, peintre du roi, 1745–1781" (Ph.D. diss., Université de Paris I–Panthéon-Sorbonne, 1989), pp. 26–28.
3. A very close version of the painting in the Pushkin Museum, Moscow, has been published by that institution as the work exhibited in 1777, but Caroline Fossey in her study on the artist claims it to be an autograph replica of the Williamstown painting. See Fossey, "Étienne Aubry, peintre du roi," pp. 490–94.
4. The literature on the painting has recently been compiled in Richard Rand et al., *Intimate Encounters: Love and Domesticity in Eighteenth-Century France,* exh. cat., Hanover, N.H., Hood Museum of Art; The Toledo Museum of Art; Houston, The Museum of Fine Arts (Princeton, 1997), pp. 174–75, no. 37.
5. See Fossey, "Étienne Aubry, peintre du roi," nos. 107, 107a, and 108, pp. 485–89.
6. *Dessins du musée d'Alençon du XVIe au XIXe siècle,* exh. cat., Alençon, Musée des Beaux-Arts et de la Dentelle (Alençon, 1981), no. 44 (entry by Jean-François Méjanès).

PIERRE-ANTOINE DEMACHY

Paris 1723–1807 Paris

64. Demolition of the Old Vestibule of the Palais Royal

Gouache over traces of graphite, 9⅝ x 11¼ in. (24.4 x 28.6 cm)

The Metropolitan Museum of Art, Van Day Truex Fund, 1984 (1984.357)

Some artists suffered greatly at the hands of Diderot, whose mission of promoting his favorite artists often involved denigrating their rivals. In the case of Demachy, Diderot reversed his earlier praise of the artist when Hubert Robert returned from Rome and began to exhibit at the Salons, suggesting in 1767 that Chardin had "maliciously" hung their work side by side.[1] In fact, the differences between these two painters of ruins outweigh the similarities. A decade older than Robert, Demachy had experienced Italy only at second hand. He studied in Paris with the architect, stage designer, and painter Giovanni Niccolò Servandoni (1695–1766), and would have been aware of the work of Pannini and Piranesi through prints. Although his work is filled with formal parallels to the Italian tradition of ruins painting, Demachy does not focus on the crumbling remnants of ancient grandeur but rather on the changing urban fabric of the French capital, where ruins were a curious and temporary by-product of construction and modernization.

Like many of Demachy's urban views, the Metropolitan's gouache juxtaposes the destruction, accidental or intentional, of a structure from an earlier era in the foreground, with a glimpse of a classicizing facade, of more recent vintage and in good repair, beyond, as if the razing of the one unveils the other. The formula likely grew out of Demachy's exploration of the subject of the clearing of the space in front of the Louvre's east facade.[2] The subject of the gouache corresponds to a painting by Demachy exhibited at the 1767 Salon that depicted the demolition of the old vestibule of the Palais Royal following a fire in 1763, together with a pendant depicting the new vestibule built in its place.[3] The vestibule connected the *cour d'entrée* to the inner *cour d'honneur.* The identification of the subject is confirmed by comparing the niches and paired pilasters exposed by the demolition in the Metropolitan's drawing with the details of the corresponding area seen in the cross section included in Jacques-François Blondel's *Architecture française* (fig. 64.1).

More puzzling is the pale gray facade visible beyond the rubble, which corresponds neither to the facade of the west wing of the *cour d'honneur* in Blondel's cross section nor to its present-day appearance. Although Jacob Bean considered this motif an element of fantasy introduced by Demachy,[4] its function may have been more pointed. Demachy apparently had close ties with several practicing architects, including his teacher Servandoni, and he would,

64

64.1. "Élévation, coupe et profil des batimens du Palais Royal." Engraving, in Jacques-François Blondel, *Architecture française* III, 1754 (pl. 335, fig. 2). Musée Carnavalet, Paris

64.2. After Pierre Contant d'Ivry (1698–1777), "Élévation d'un palais," in *Oeuvres d'architecture de Contant d'Ivry,* Paris, 1769 (pl. 38). Avery Library, Columbia University, New York

the facade visible in the background of the Metropolitan's gouache. In other words, the facade beyond the rubble, previously considered imaginary, may in fact represent an unexecuted scheme of Contant's, and its inclusion by Demachy in his Salon-exhibited painting of the demolition, a public endorsement of his friend's plans and aspirations.

Should such a reading be correct, the differences between Demachy and his "rival," Robert, would appear even more profound. Rather than Robert's use of architectural ruins as an organic metaphor, a vehicle for the expression of melancholy themes of *vanitas,* Demachy contrasts the debris of a shoddy, poorly designed past with the enticing mirage of a grander, more desirable, and more permanent city as seen in the distant facades, glowing and ordered. The message is a celebration of new building and of the glories of modern architecture: once the debris of the past is cleared, the future monuments of French architecture will rise in their stead.

P S

on occasion, use his skills at architectural rendering to project from an architect's plans an image of the structure as it would appear integrated into the urban landscape. One could cite as examples his *Ruins of the Saint-Germain Fair after the Fire of 1762* (Musée Carnavalet, Paris),[5] which includes in the distance beyond the ruins a view of the Church of Saint-Sulpice as designed by Servandoni (but not as built), and the *Interior View of la Madeleine* (Musée Carnavalet, Paris),[6] which uses the plans of the architect Pierre Contant d'Ivry to project the appearance of the church before it was built. In the capacity of architect to the duc d'Orléans, Contant was also involved, in several distinct campaigns, with building projects at the Palais Royal between 1753 and 1779, including one lasting from 1764 to 1770 that was initiated by the construction of the new vestibule. Demachy collaborated with Contant in this project by contributing architectural paintings to the interior decoration of the *grand escalier.*[7]

Thus, it is not inconceivable that Demachy's picture, in juxtaposing reportage of the demolition with a skillfully projected building that does not correspond exactly to the existing building on that spot, reflects a conscious effort to promote the work of his friend and colleague Contant d'Ivry. A collection of seventy-one engravings published in 1796 after drawings by Contant included a design labeled "Élévation d'un palais" (fig. 64.2), which is not dissimilar to

PROVENANCE: R. Owen; [Tooth, London, 1951]; [W. Wheeler & Son Ltd.]; private collection, England; [Morton Morris, London]; purchased by The Metropolitan Museum of Art.

LITERATURE: *MMA Annual Report,* 1984–85, p. 26; Bean and Turčić 1986, pp. 91–92, no. 95 (ill.); *Le Palais Royal,* exh. cat., Paris, Musée Carnavalet (Paris, 1988), p. 138, under no. 148.

1. Goodman 1995b, vol. 2, p. 138.
2. See Marianne Roland Michel, "The Clearance of the Colonnade of the Louvre: A Study Arising from a Painting by de Machy," *The Burlington Magazine* 120, no. 906 (September 1978), supplement no. 36, pp. i–vi.
3. Both paintings were included as no. 58. From the Salon *livret,* it is not clear whether they were oil or gouache. The only other known surviving work of this subject is a drawing in pen and brown ink, brown wash, heightened with white, on ochre-washed paper, in the Musée Carnavalet, Paris (inv. D5197). The composition of the Carnavalet drawing is the reverse of the New York gouache; the details of architecture are identical, but there are differences in the figural groupings.
4. Bean and Turčić 1986, p. 92.
5. Bernard de Montgolfier and Pascal de La Vaissière de Lavergne, "Dessins parisiens du XVIIIe siècle," *Bulletin du Musée Carnavalet* 24, nos. 1–2 (1971), no. 66 (ill., p. 35).
6. M[ichel] G[allet], "Un modèle pour la Madeleine d'après le projet de Contant d'Ivry," *Bulletin du Musée Carnavalet* 18, no. 1 (June 1965), ill. p. 17.
7. Gabrielle Joudiou, "Constructions et projets de Contant d'Ivry à Paris," *Bulletin de la Société de l'Histoire de Paris et l'Île-de-France* 1, 1984–86, p. 97, and correspondence in the archives of the Department of Drawings and Prints, The Metropolitan Museum of Art.

65

CHARLES-LOUIS CLÉRISSEAU

Paris 1721–1820 Paris

65. *Architectural Fantasy*

Gouache, 16 x 22 in. (40.9 x 55.8 cm)

Mr. and Mrs. Robert E. Morrow

The fascination with Italian art and culture that characterized the first half of the eighteenth century spiraled to new heights with the discovery of Pompeii in 1748, propelling Neoclassicism to the fore as an artistic force to be reckoned with. Clérisseau's absorption with Italy did not end with the completion of his tenure as a pensionnaire at the Académie de France in Rome; he remained in Italy from 1749 until 1767, forming friendships with Giovanni-Battista Piranesi (1720–1778), Giovanni-Paolo Pannini (1691–1765), and Robert Adam (1728–1792), among others, artists whose passion for antiquity matched

65.1. Charles-Louis Clérisseau, *Architectural Fantasy.* Gouache, 16 x 22 in. (40.9 x 55.8 cm). Mr. and Mrs. Robert E. Morrow, New York

his own, and whose curiosity about the architectural remains of ancient cultures, and the recording of those remains, helped form the basis for Neoclassicism as it swept through France and England.[1]

Clérisseau's drawings of ruins were made both as souvenirs for travelers on the Grand Tour and as models for illustrations in archaeological treatises and travel guides. He traveled in the company of both Piranesi and Adam, and served as Adam's guide on the several expeditions they made from 1755 to 1757.[2] As both an architect and a painter, he was well situated to encourage a taste that he had helped to form, and indeed his influence was far-ranging, extending over geographical and cultural boundaries. Not only was he an architect to Catherine the Great but he served as a consultant to Thomas Jefferson on the architecture for the capitol at Richmond.

Clérisseau's drawings of ruins fall into roughly three categories: *vedute essata* (exact views), *vedute ideate* (real monuments in fictional settings), and, most common, *vedute di fantasia* (a combination of reality with fantasy). The present drawing and its pendant (fig. 65.1) are in the third category. Both feature a prominent historical monument: in the exhibited sheet, a close variant of the renowned Borghese Vase (Musée du Louvre, Paris), and in its pendant, an arch based loosely on the Arch of Titus (bearing a scaled-down copy of its inscription) surrounded by credible approximations of historically related architecture and decoration invented by Clérisseau himself. One can see, for example, in the exhibited drawing, close derivations of statues by Praxiteles, first-century A.D. Roman wall paintings, the Parthenon frieze, and the interior of the Pantheon. Clérisseau enlivened his scenes by a skillful use of color and chiaroscuro. Often, as here, he oriented such scenes at an angle, expanding the spacial complexity.

MTH

PROVENANCE: Private collection, France; [Didier Aaron, Inc.]; Mr. and Mrs. Robert E. Morrow.

Unpublished.

1. See Thomas J. McCormick, *Charles-Louis Clérisseau and the Genesis of Neo-Classicism* (New York, Cambridge, Mass., and London, 1990).
2. Robert Adam makes their relationship quite clear in correspondence with his brother James; see ibid., esp. p. 24.

LOUIS-JEAN DESPREZ

Auxerre 1743–1804 Stockholm

66. *View of Catania*

Pen and black ink and watercolor, 8¼ x 13⁷⁄₁₆ in. (20.8 x 34.1 cm)

Roberta J. M. Olson and Alexander B. V. Johnson

Louis-Jean Desprez, an architect with a talent for set design and an interest in classical antiquity fostered by early studies with Jean-François Blondel, was a logical choice to provide drawings for the abbé de Saint-Non's *Voyage pittoresque ou description des royaumes de Naples et de Sicile*, which appeared in four folio volumes between 1781 and 1786. Desprez arrived in Rome in 1777, after winning the Prix de Rome for architecture the year before. He left Rome in December of 1777, accompanied by Dominique-Vivant Denon, who would provide the text for the volume on Sicily, Claude-Louis Châtelet (ca. 1750–1795), and Jean-Augustin Renard (1744–1807), on a tour of southern Italy to do research and make drawings for the project. Desprez and Châtelet contributed the lion's share to the task, with 135 plates after Desprez drawings.[1] A large number of engravers were employed, thirty-six to reproduce Desprez's contributions alone.

Saint-Non's intention was not only to record monuments but to illustrate customs and the flavor of local life.[2] The text accompanying the plates often describes events, celebrations, and aspects of historical interest; indeed, the tour was planned to coincide with local festivals and pageants.[3] While Desprez may have been approached initially as an architect, it was his scenographic talents that prevailed. Far from being

66

dry schematic renditions, his scenes are alive with action, the small figures (so reminiscent of the work of Jacques Callot, which he must surely have known) expressive and energetic. Desprez was known to alter a view or to include additional local sites to achieve a more dramatic effect. Some of the scenes reflect events witnessed by Desprez, while others include imagined scenarios.

This view represents the piazza in front of the Duomo in Catania, a small town in Sicily that the artists visited in 1778.

The piazza was distinguished by a fountain, erected in 1736, with an ancient obelisk in the center borne by an elephant formed of lava from nearby Mount Etna. The piazza is viewed at an angle, so that we are given a posterior view of the elephant but the complete facade of the Duomo. Desprez's adept handling of pen and ink and watercolor gives an accurate impression of the bright Sicilian light as it obliterates architectural detail and of the clean blue Sicilian sky. Spectators have gathered on the roofs and balconies to

66.2. Louis-Jean Desprez, *The Piazza in Catania*. Pen and gray ink, 8 x 13⅞ in. (20.4 x 33.3 cm). Nationalmuseum, Stockholm

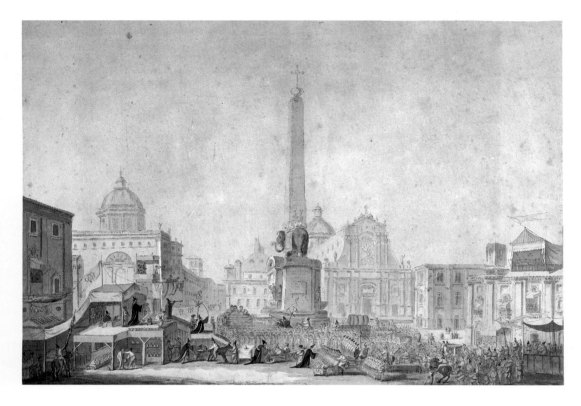

66.3. Louis-Jean Desprez, *View of Catania.* Pen and gray ink, brush and gray and brown wash, watercolor, 13⅛ x 19⅛ in. (33.5 x 48.5 cm). Institut Tessin, Centre Culturel Suédois, Paris

watch what one of the inscriptions describes as a carnival in Catania,[4] but the participants are too numerous, their actions too scandalous, to represent a real carnival in a small Italian town. The square is teeming with activity: a batallion of Polichinelli ranged in military formation, Il Dottore performing in a pavilion with acrobatic monkeys swinging above, and much else. One must assume that Desprez was familiar with such images as Watteau's *Qu'ai-je fait, assassins maudits?* (State Hermitage Museum, Saint Petersburg), which includes the same clyster-bearing soldiers strikingly similar to the mock-military barrage of soldiers visible in the foreground taking aim at a phalanx of doubled-over figures. In the engraving (fig. 66.1) the scene has been considerably edited (possibly after another drawing by Desprez, now lost, or by the engravers in France), leaving the piazza cleared of all but the main pavilion and a few vignettes in the foreground. The bawdy emetic dosing of the donkey remains, and has been moved forward. Other versions of this scene by Desprez are known. A preparatory drawing in pen and ink of the architecture alone is at the Nationalmuseum, Stockholm (fig. 66.2).[5] There is also a drawing at the Institut Tessin, Paris (fig. 66.3), very similar to the present sheet,

the main difference being that the piazza is viewed from slightly closer in, which cuts off the flag-bedecked building at the right.[6] The New York sheet is closer to the view depicted in the engraving, which includes the building but without the same festive embellishment.

MTH

PROVENANCE: Roberta J. M. Olson and Alexander B. V. Johnson.

Unpublished.

1. For this project and Desprez's contributions, see Lamers 1995, pp. 82–84; Nils G. Wollin, *Gravures originales de Desprez ou exécutées d'après ses dessins* (Malmö, 1933), pp. 22ff.; and Nils G. Wollin, *Desprez en Italie: Dessins topographiques et d'architecture, décors de théatre et compositions romantiques, exécutés 1777–1784* (Malmö, 1935), pp. 24ff.
2. See Lamers 1995, p. 33, and p. 57, n. 119.
3. Andrew Wilton and Ilaria Bignamini, eds., *Grand Tour: The Lure of Italy in the Eighteenth Century*, exh. cat., London, The Tate Gallery; Rome, Palazzo delle Esposizioni (London, 1996), p. 165.
4. Lamers 1995, p. 254, no. 249c.
5. Lamers 1995, p. 252, no. 249a.
6. Lamers 1995, p. 254, no. 249c. Yet another version, close to the present sheet but much less detailed, was with Didier Aaron, Inc., in 1998, and can be identified with Lamers 1995, p. 252, no. 249b.

FRANÇOIS-ANDRÉ VINCENT
Paris 1746–1816 Paris

67. The Flaying of Saint Bartholomew, after Mattia Preti

Brush and brown wash, over traces of graphite, 11⅝ x 11¾ in. (29.6 x 29.7 cm). Inscribed in brush and brown wash on sign attached to tree trunk: *BART . . . IX^t. nus*

The Metropolitan Museum of Art, Harry G. Sperling Fund, 1973 (1973.317.2)

Vincent's chameleon-like draftsmanship finds no match among his contemporaries. His ability to work in a host of disparate styles simultaneously, evident even in the work produced during his years as a pensionnaire, created a muddle for future art historians. Jean-Pierre Cuzin has labored for several decades to reconstitute his oeuvre, retrieving drawings lost under incorrect attributions to artists as diverse as Fragonard, David, Lagrenée, and Gericault.

Both the warm golden brown wash of the present sheet and the choice of a Baroque model reflect Vincent's encounter with Fragonard in 1773–74. This occurred during Vincent's period as a student at the Académie de France when the older artist visited Rome in the company of his patron, the wealthy financier Pierre-Jacques-Onésyme Bergeret de Grancourt (1715–1785). Apparently Vincent, in the spring of 1774, accompanied Bergeret's party to Naples,

where the two artists often sketched side by side[1] and where this copy was likely made. Several versions of Preti's *Martyrdom of Saint Bartholomew* are known today. The painting in the Currier Gallery of Art (fig. 67.1) hung in the eighteenth century in the house of Marchese Ferdinand van den Einden, a Flemish merchant resident in Naples,[2] and was presumably the one copied by Vincent.[3] While he was capable of extremely precise copies, Vincent is more interested here in Baroque effects of lighting and composition. Fragonard, who also made copies after Preti (fig. 67.2), may have directed Vincent to this painting, or such a taste may have already been fostered by Charles-Joseph Natoire, director of the Académie de France, whose continuing predilection for the Roman Baroque is seen in his late copy drawings.

In technique, however, the Metropolitan's drawing is wholly indebted to Fragonard, and in fact many of Vincent's unsigned wash drawings made in Rome have, until recently, borne attributions to Fragonard. With the benefit of hindsight, the wash techniques of the two artists are more easily distinguished. Next to Fragonard's unified, fluid handling, Vincent's application of wash is blocky, breaking the composition down into facets and planes. Here, Vincent's translation of Preti's image into bister wash heightens certain gruesome details: the knife of the executioner on the right is thrown into greater contrast, the face of the executioner on the left is rendered even more brutish, and the

67.1. Mattia Preti (1613–1699), *Martyrdom of Saint Bartholomew.* Oil on canvas, 75 x 76 in. (190.4 x 192.9 cm). The Currier Gallery of Art, Manchester, N. H.

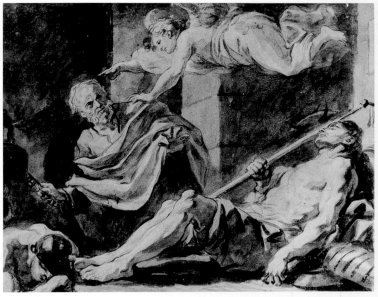

67.2. Jean-Honoré Fragonard (1732–1806), *The Deliverance of Saint Peter, after Mattia Preti.* Brush and brown wash, 11¼ x 14⅝ in. (28.5 x 37 cm). Musée d'Art et d'Histoire, Narbonne

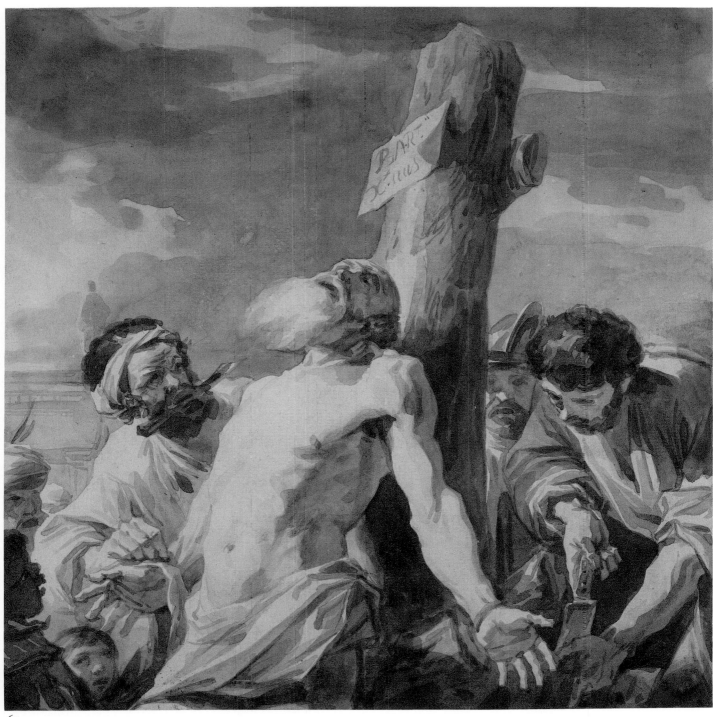

67

milky paleness of the saint's left forearm—mainly reserved paper—against the dark tree trunk is all the more shocking in its vulnerability.

PS

PROVENANCE: Anonymous sale, Paris, November 11, 1784, part of lot 165; [Jacques Petit-Horry]; purchased by The Metropolitan Museum of Art.

LITERATURE: *MMA Annual Report*, 1973–74, p. 37; Bean 1975, no. 58; Williams 1978, p. 172, no. 71 (ill.); Marc Sandoz, *Gabriel Briard (1725–1777)* (Paris, 1981), p. 86; Jean-Pierre Cuzin, "De Fragonard à Vincent," *Bulletin de la Société de l'Histoire de l'Art Français*, 1981, p. 118, fig. 32, pp. 119, 123–24, n. 64; Roland Michel 1987, pp. 80, 82, fig. 70; Jean-Pierre Cuzin, *François-André Vincent, 1746–1816*, Cahiers du Dessin Français, no. 4 (Paris, [1988]), p. 19, no. 21 (ill.).

1. See Jean-Pierre Cuzin, "De Fragonard à Vincent," *Bulletin de la Société de l'Histoire de l'Art Français*, 1981, pp. 107–13.
2. Clovis Whitfield and Jane Martineau, eds., *Painting in Naples 1606–1705, from Caravaggio to Giordano*, exh. cat., London, Royal Academy of Arts; Washington, D.C., National Gallery of Art (London, 1982), pp. 211–13.
3. A wash copy of Vincent's drawing is in the Musée Hyacinthe-Rigaud, Perpignan (inv. 840.2.26), and is inscribed *1776*.

FRANÇOIS-ANDRÉ VINCENT

Paris 1746–1816 Paris

68. View of the Gardens of the Villa Negroni

Black chalk heightened with white, on tan paper, 13⁷⁄₁₆ x 17⁷⁄₁₆ in.
(34.1 x 44.4 cm)

Private collection

The remarkable variety of drawn media and styles at which Vincent excelled has already been noted, and it is indeed hard to believe that his *Flaying of Saint Bartholomew* (no. 67), with its fluid wash and Baroque subject, is by the same hand as this crisply rendered landscape. The drawing's fresh immediacy is due in part to its excellent condition, but it is also a function of Vincent's skillful evocation of light and shade, his precisely descriptive strokes of chalk and use of reserved paper for foliage, and his artful placement of figures in modern dress, imparting a sense of the moment caught, very different from the artistic traditions evoked in the *Saint Bartholomew*. It was made in 1773,[1] during Vincent's stay as a pensionnaire at the Académie de France in Rome from 1771 to 1775.

The Villa Negroni was a favorite spot for the French students. Its cypress trees and antique statuary were well known, and drawings of the gardens by Robert, Drouais, and Berthélemy, to name only a few, have survived. Vincent made at least one other drawing of the villa, now in the Bibliothèque de Besançon.[2] Built by Pope Sixtus X (1520–1590) and in the possession of the Negroni family from 1696 until 1784, the villa was torn down in this century to make way for the Stazione Termini. The splendid caryatid in the foreground was one of two obtained by Sixtus X on their discovery by excavation in 1585–90. The two stood in the garden until 1784, when the English dealer Thomas Jenkins bought much of the sculpture, intending to sell to Charles Townley, the noted English collector. Jenkins was allowed to export only one of the sculptures, which is now in the British Museum. Its sister, the statue depicted in this sheet, remained in Italy, entering the collections of the Vatican Museums in 1803. It is now known as the Vatican Caryatid.[3]

MTH

PROVENANCE: [Jacques Foccart, Paris]; [W. M. Brady and Co., Inc., New York]; private collection.

Unpublished.

1. The drawing bears a signature, date, and inscription on the original backing: *intérieur de la Villa Negroni—dessiné à Rome par Vincent en 1773 / Vincent / n° 14.*
2. Album 453, vol. 1, no. 28. An engraving after this drawing was included in Charles Percier and Pierre-François-Léonard Fontaine, *Palais, maisons, et autres édifices modernes, dessinés à Rome* (Paris, [1798]).
3. For the history of the caryatids, see Andrew Wilton and Ilaria Bignamini, eds., *Grand Tour: The Lure of Italy in the Eighteenth Century*, exh. cat., London, The Tate Gallery; Rome, Palazzo delle Esposizioni (London, 1996), pp. 226–29, under nos. 174–77.

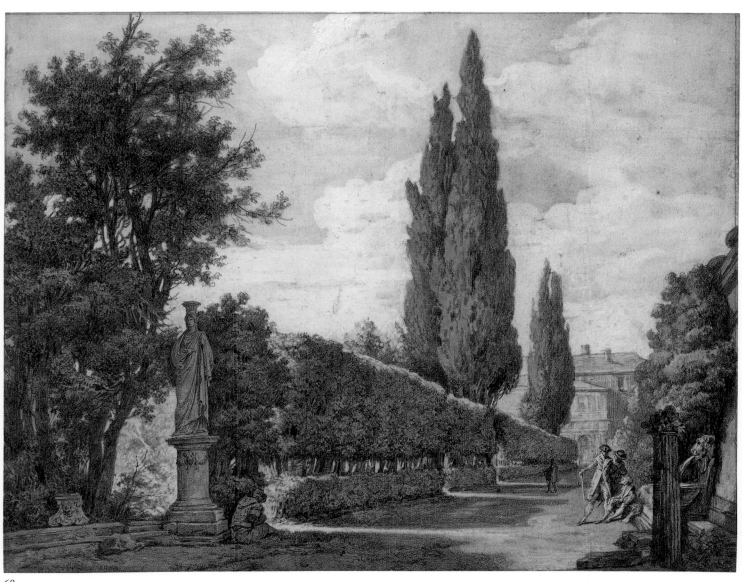

68

PHILIPPE-JACQUES DE LOUTHERBOURG

Strasbourg 1740–1812 Chiswick

69. Tom Jones Assisting Molly Seagrim in the Churchyard

Pen and brown ink, brush and brown wash, over black chalk underdrawing, diameter: 12¾ in. (32.5 cm). Signed and dated at left in pen and brown ink *P. I. de Loutherbourg / 1775*

Private collection

Prolific and versatile, Philippe-Jacques de Loutherbourg produced a highly disparate oeuvre that reflects the discontinuities of his unusual career.[1] Born the son of a miniature painter in Strasbourg, Loutherbourg was brought to the French capital in 1755 and studied with the history painter Carle Vanloo, the engraver Jean-Georges Wille (1715–1808), and the battle painter Francesco Casanova (1727–1802). He was accepted into the Académie Royale at an early age and contributed over eighty works to the Salon from 1763 to 1771. Despite his success Loutherbourg abandoned Paris for London in late 1771, perhaps to escape his strained marriage. In any case, he eventually remarried and lived out his days in England, readily adapting his talents to the new market. His pursuits expanded during this period to include—in addition to drawing and painting—theatrical production, stage design, alchemy, and faith healing.

Loutherbourg's works were widely engraved in both Paris and London, and drawings such as this one, illustrating one of the more bizarre scenes in Henry Fielding's novel *Tom Jones* (1749), were certainly made with the lucrative print market in mind.[2] The warm-hearted but low-born Molly Seagrim, pregnant by Jones, is taunted by parishioners while attending church services (book 4, chapter 8). A fight breaks out as she attempts to leave. Finding herself near a recently dug grave in the churchyard, she wards off her attackers with the only weapons at hand—human bones. Tom Jones then appears on the scene, coming to her defense with his horse whip. The format and size of the prints indicate that they were not book illustrations, but rather meant to be framed and hung on the wall. Loutherbourg depicted at least one other scene from the novel. *A Boxing Match* was exhibited at the Royal Academy in 1776[3] and engraved by the same team of engravers, with the title *Tom Jones and Mr. Western Combating with Blifil and Twackum*.[4] There may have been other drawings as well.[5]

Made in 1775, after four years in London, the churchyard drawing shows Loutherbourg well on his way to becoming an English artist. His early pastoral compositions, with rustic figures in repose in the style of seventeenth-century Dutch painters such as Nicolaes Berchem, had gradually given way while he was still in France to fashionable, terror-filled scenes of shipwrecks and *banditti* influenced by Claude-Joseph Vernet and Salvator Rosa. In England, with exposure both to the life of the theater and to the comic, satirical styles of Hogarth and Rowlandson, Loutherbourg introduced distinctly English motifs and scenes of contemporary drama into compositions that were still essentially Rococo in their aesthetic. In this example, the backdrop of the Gothic church and stormy sky, and the detail, at once grisly and comic, of human bones used as clubs suggest the influence of the English milieu, while Loutherbourg's French training can still be felt in the crisp elegance of the ink line and the nuanced application of wash.

PS

PROVENANCE: Christian Humann, New York; his sale, Sotheby Parke-Bernet, New York, April 30, 1982, lot 60; private collection.

LITERATURE: Eric M. Zafran, *The Rococo Age: French Masterpieces of the Eighteenth Century*, exh. cat., Atlanta, High Museum of Art (Atlanta, 1983), p. 160, no. 80 (ill. p. 151); Joseph Baillio, "French Rococo Painting: A Notable Exhibition in Atlanta," *Apollo* 119, no. 263 (January 1984), p. 23, fig. 15; Joseph Baillio, "La vie des arts: Atlanta, L'âge Rococo," *L'Oeil*, nos. 242–43 (January–February 1984), p. 90 (ill.); Olivier Aaron, *Dessins insolites du XVIIIe français* (Paris, 1985), pp. 51, 108, no. 41 (ill.).

1. The two major studies on Loutherbourg are Geneviève Levallet-Haug, "Philippe Jacques Loutherbourg 1740–1812," in *Archives Alsaciennes* 16 (1948), pp. 77–134, and Rüdiger Joppien, *Philippe Jacques de Loutherbourg, RA, 1740–1812*, exh. cat., Kenwood, The Iveagh Bequest (London, 1973).

2. See A. de Vesme and A. Calabi, *Francesco Bartolozzi: Catalogue des*

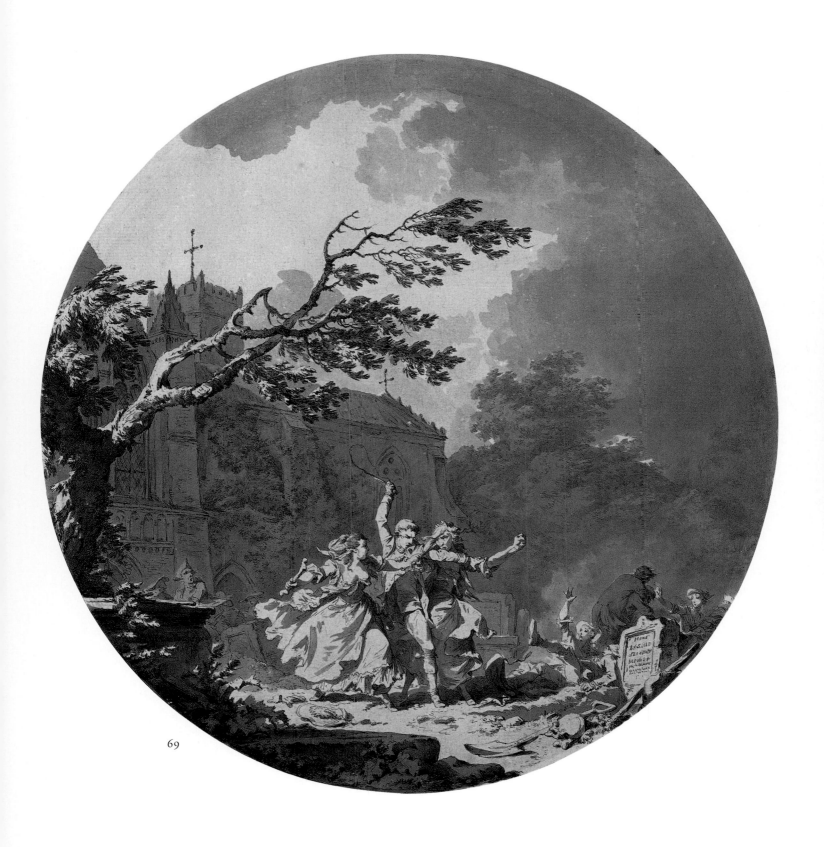

69

estampes et notice biographique (Milan, 1928), p. 365, no. 1385 (etching with engraving, 1776, published by V. M. Picot, landscape by W. Woollett, figures by F. Bartolozzi, dedicated to John Pitt, Esq.); reproduced in Eric M. Zafran, *The Rococo Age: French Masterpieces of the Eighteenth Century*, exh. cat., Atlanta, High Museum of Art (Atlanta, 1983), p. 160.

 Fielding was very popular in France, and Loutherbourg would likely have been aware of the novel before he came to England. *Tom Jones* appeared in a French translation in 1750, with sixteen engravings after drawings by Gravelot.

3. Algernon Graves, *The Royal Academy of Arts: A Complete Dictionary of Contributors and Their Work from its Foundation in 1769 to 1904*, 8 vols. (London, 1905–6), vol. 2, p. 300.

4. Catherine M. Gordon, *British Paintings of Subjects from the English Novel, 1740–1870*, Outstanding Theses in the Fine Arts from British Universities (New York and London, 1988), p. 259.

5. Gordon, *British Paintings of Subjects from the English Novel*, also lists a 1782 engraving after Loutherbourg with the title *Tom Jones Threatening Partridge*, p. 260. In addition, the estate sale that took place after Loutherbourg's death listed "eleven [prints], after [de Loutherbourg]—Proofs and Etchings, from 'Tom Jones'" (London, June 19, 1812, lot 6).

JEAN-HONORÉ FRAGONARD

Grasse 1732–1806 Paris

70. A Gathering at Woods' Edge

Red chalk, 14⅞ x 19⅜ in. (37.9 x 49.1 cm). Signed at lower center in red chalk: *frago* . . .

The Metropolitan Museum of Art, Purchase, Lila Acheson Wallace Gift, 1995 (1995.101)

Among Fragonard's most admired drawings are the concentration of sanguine landscapes he produced in the summer of 1760, recording, in the company of the abbé de Saint-Non, the towering poplars and crumbling statuary of the steep and overgrown gardens of the Villa d'Este in Tivoli. Mariette saw in these landscapes a "spirited execution, where reigns a great intelligence."[1] Although Fragonard's use of the medium over the next decade, following his return to France, was more sporadic, his mastery was, if anything, more inspired. In *A Gathering at Woods' Edge*, the handling is unhesitating; a wide range of marks and tones evokes the varied forms and textures of the natural setting, and the descriptive and decorative potentials of the red chalk are explored simultaneously, without one diminishing the other.

As Fragonard approached what can be called his maturity, the chronology of his drawings becomes less rather than more clear, because of both his gradual drifting away from the institutions of official patronage and his tendency throughout his career to rework and reinvent motifs from a set repertoire. There are few benchmarks, for example, by which to date the red-chalk landscapes made in France, and scholarly opinion on the dating of the present sheet ranges from the early 1760s to the early 1770s.[2] To this decade can be traced a number of stylistic influences that Fragonard added to the early lessons of Boucher's studio and Italy. Foremost among these was his interest in the dramatic naturalism associated with the seventeenth-century Dutch landscapists, especially Jacob van Ruisdael, a taste shared by many of his Parisian contemporaries, who also preferred the ostensibly wild *jardin à l'anglaise* to the manicured *parterres* favored under Louis XIV. Yet Fragonard's massive trees here provide shelter not for resting cowherds but for leisured aristocrats, a legacy of Watteau's *fêtes galantes*. While the figures in the Metropolitan's *Gathering* are diminutive and half lost in shadow, Fragonard's description of nature is eloquent: in his robust and sensuous treatment of plant life, one perceives compositional and metaphorical extensions of the figural subjects, offering a parallel to Fragonard's treatment of similar themes in oil, such as the Frick Collection's *Progress of Love*, of about 1770–73.

Based on a study presumably made *en plein air*, today in a private collection (fig. 70.1),[3] *A Gathering at Woods' Edge* should be seen as an independent work, produced in the studio. The central stand of mature trees, with dead branches among the live, is easily recognizable in both sheets. Fragonard also carried over the palpable contrast of sunlit foliage and welcoming shadow. In the Metropolitan's

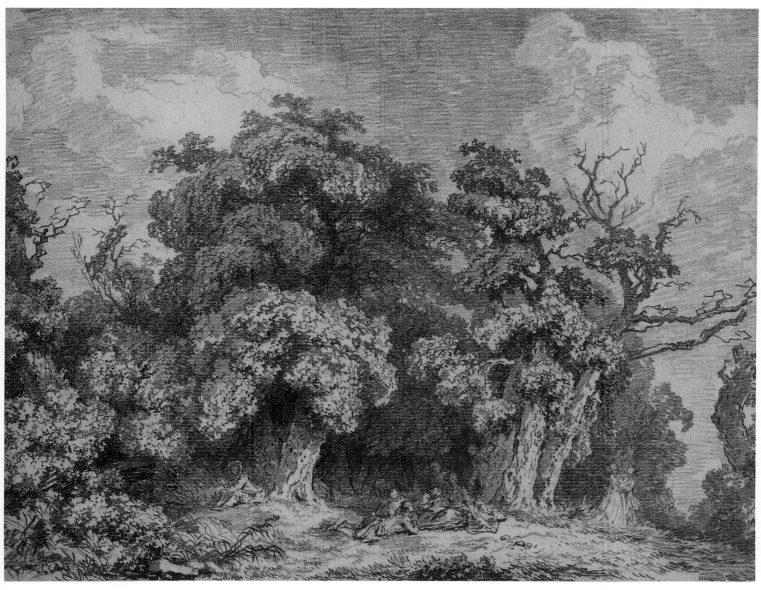

70

70.1. Jean-Honoré Fragonard, *Study of Trees*. Red chalk, 12 x 18 in. (30.8 x 45.5 cm). Private collection

finished version, not only have the edges of the composition been worked up in convincing detail (repoussoir on the left, deep perspective on the right), but numerous small adjustments to the trees (the trunks on the left are less squat, the entrance to the woods is more rounded) quietly improve upon nature.

PS

PROVENANCE: Jacques Doucet, Paris; his collection sale, Galerie Georges Petit, Paris, I, June 5, 1912, lot 14 (ill.); acquired by Marius Paulme (per Ananoff); Maurice Fenaille, Paris; his daughter and son-in-law, M. and Mme François Panafieu; M. Panafieu's anonymous sale, Hôtel Drouot, Paris, June 23, 1959, lot 6, to Georges Wildenstein; [Wildenstein & Co., Inc., New York]; purchased by The Metropolitan Museum of Art.

LITERATURE: *Exposition d'oeuvres de J.-H. Fragonard*, exh. cat., Paris, Musée des Arts Décoratifs (Paris, 1921), p. 56, no. 198; *Exposition de dessins de Fragonard*, exh. cat., Paris, Jacques Seligmann et Fils (Paris, 1931), p. 50, no. 101 (collection Maurice Fenaille); *Exposition de l'art français au XVIIIe siècle*, exh. cat., Copenhagen, Palais de Charlottenborg (Copenhagen, 1935), p. 113, no. 369; *Beautés de la Provence*, exh. cat., Paris, Galerie Charpentier (Paris, 1947), no. 212; François Daulte, *Fragonard*, exh. cat., Berne, Musée des Beaux-Arts (Bern, 1954), p. 38, no. 73, pl. xv (image reversed); François Fosca, *Les dessins de Fragonard* (Paris and Lausanne, 1954), p. 53, no. 9, pl. 9; Ananoff 1961–70, vol. I, p. 151, no. 336, vol. 3, p. 298 (erroneously listed as acquired by the Museum of Fine Arts, Boston), vol. 4, p. 355, ill. vol. I, fig. 118 and pl. E (detail); Ira Moskowitz, ed., *Great Drawings of All Time*, 4 vols. (New York, [1962]), vol. 3, no. 699 (entry by Agnes Mongan); Colin Eisler, *Paintings from the Samuel H. Kress Collection: European Schools Excluding Italian* (Oxford, 1977), pp. 329 (under no. K 2050), 330, n. 3; 331–32 (under nos. K 1338 and K 1339), 332, n. 3; *Sanguines, dessins français du dix-huitième siècle*, exh. cat., Paris, Galerie Cailleux; Geneva, Galerie Cailleux (Paris, 1978), p. 37, under no. 12; Williams 1978, p. 126, under no. 49; Denys Sutton, *Fragonard*, exh. cat., Tokyo, The National Museum of Western Art; Kyoto Municipal Museum (Tokyo, 1980), n.p., no. 116; *MMA Recent Acquisitions, 1996–1997*, The Metropolitan Museum of Art (New York, 1995–96), p. 39 (entry by Perrin Stein).

1. See Mariette 1851–60, p. 263.
2. Jean Massengale suggests a date of about 1762–63 (in conversation, April 1996). Both Pierre Rosenberg (in conversation, April 19, 1996) and Eunice Williams (in conversation, January 28, 1998) lean toward a date closer to Fragonard's second departure for Italy in 1773, as does the present author. Fragonard's approach to landscape seems to have undergone another transformation during his second Italian trip.
3. See Jean Montague Massengale, *Jean-Honoré Fragonard* (New York, 1993), p. 31, and Marianne Roland Michel, *Aspects de Fragonard: Peintures, dessins, estampes*, exh. cat., Paris, Galerie Cailleux (Paris, 1987), no. 48.

JEAN-HONORÉ FRAGONARD

Grasse 1732–1806 Paris

71. *The Fête at Rambouillet*

Gouache, 10½ x 14 in. (26.7 x 35.6 cm)

John W. Straus

The Straus gouache is a close variant of the painting in the Museu Calouste Gulbenkian, Lisbon (fig. 71.1). The traditional title dates from no earlier than the nineteenth century. In the 1868 de Villars sale, the drawing is described as depicting "the celebration given for the royal family by the duc de Penthièvre in the park at Rambouillet." As Pierre Rosenberg points out, other interpretations have been suggested, but all are equally lacking in solid evidence.[1] Fragonard's intention that the images, however loosely based on real events or places, evoke a mythic time and place is made clear in the contrasts within the landscape itself, between overgrown disarray and the refinements of cultivation, where the tension between ordered nature and nature in full riot is held in careful balance. The extremities of scale as well—the huge waterside pergola hidden beneath a thick tangle of flowering bushes, which dwarfs the luxurious gondola and elegant passengers and the figures in the shoreside pavilion—are further indications that we are in an idyllic realm.

The size of this masterpiece is always a surprise, for one expects the scale of the paper to match the immensity of the artist's vision. Only in the work of Gabriel de Saint-Aubin (see no. 78) do we find a comparable alliance of close detail with sweeping effect handled with equal dexterity. Using a technique which contrasts strikingly with that of most of his wash drawings, where the fluidity and transparency of the medium lends itself to larger strokes, Fragonard took full advantage of the opacity and thickness of the gouache to make a carpet of small dots, creating a smooth, detailed image that vibrates with pearly light.[2] If we compare the oil

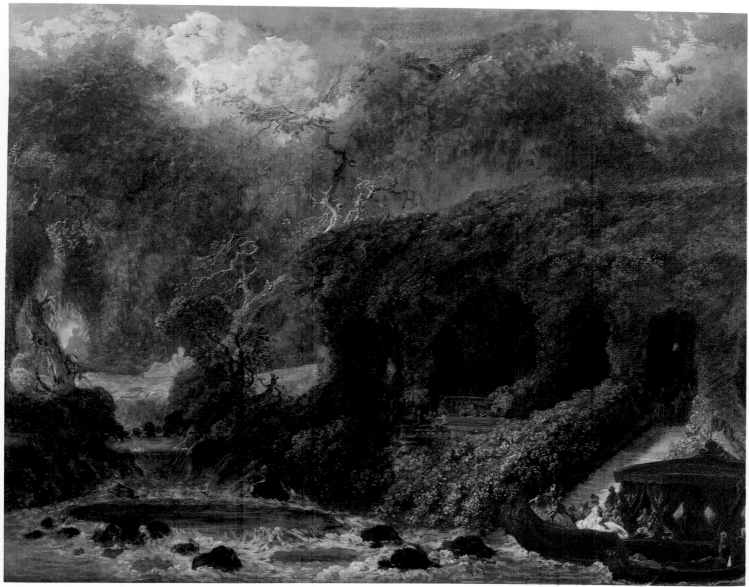

71

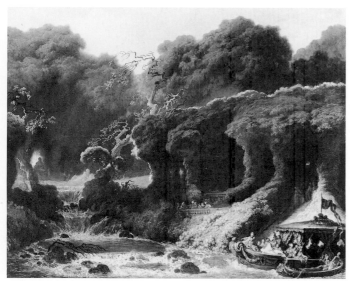

71.1. Jean-Honoré Fragonard, *The Fête at Rambouillet*. Oil on canvas, 28 x 35⅜ in. (71 x 90 cm). Museu Calouste Gulbenkian, Lisbon

with the gouache, the one may be seen to have a golden luster, the other a silver sheen.[3] The proto-Romantic quality of the image, which some have called "enchanting," others "threatening,"[4] is in some measure the result of Fragonard's admiration for the work of Ruisdael and Watteau.

MTH

PROVENANCE: Baron A. Saint; his sale, Paris, May 7, 1846, lot 287; Eugène Tondu; his sale, Hôtel Drouot, Paris, April 24–26, 1865, lot 127; F. de Villars, sale, Hôtel Drouot, Paris, March 13, 1868, lot 37; Étienne-François Haro; Mme Périer, Paris; Sigismond Bardac, Paris; Joseph Bardac, Paris; [Wildenstein & Co., Inc., New York]; Mr. and Mrs. Herbert N. Straus; John W. Straus.

LITERATURE: Roger Portalis, *Honoré Fragonard: Sa vie et son oeuvre* (Paris, 1889), pp. 303–4; Georges Wildenstein, ed., *Exposition d'oeuvres de J.-H. Fragonard,* exh. cat., Paris, Musée des Arts Décoratifs (Paris, 1921), no. 112; Georges Wildenstein, "L'exposition Fragonard au Pavillon de Marsan," *Renaissance de l'Art Français* 4 (July 1921),

p. 361; Prosper Dorbec, "L'exposition Fragonard au Pavillon de Marsan," *Gazette des Beaux-Arts*, ser. 5, 4 (1921), p. 31; Agnes Mongan, *Master Drawings*, exh. cat., Buffalo, Albright Art Gallery, no. 84; (Buffalo, 1935), Henry Russell Hitchcock, *Landscape*, exh. cat. (Brooklyn, 1945), no. 34 (ill.); Felice Stampfle, *An Exhibition of Paintings, Landscape Drawings and Water-colors, Brueghel to Cézanne,* exh. cat., New York, The Pierpont Morgan Library (New York, 1953), no. 31; *European Masters of the 18th Century*, exh. cat., London, Royal Academy (London, 1954), no. 603; Louis Réau, *Fragonard: Sa vie et son oeuvre* (Brussels, 1956), pp. 185, 228; Rotterdam, Paris, and New York 1959, no. 52; Ananoff 1961–70, vol. 1, no. 246, vol. 2, p. 303; Williams 1978, pp. 130–31, no. 51 (ill.); Rosenberg 1988, pp. 357–58, no. 169 (ill.).

1. Rosenberg (1988, pp. 356–57, under no. 168) suggests the possible input of the painting's first owner, Jean-Benjamin Delaborde, a friend of Fragonard's, an art collector, and an admirer of Italy, speculating that the inclusion of the gondola may have been Delaborde's inspiration.
2. For a detailed description of Fragonard's technique, see Williams 1978, p. 130, no. 51.
3. Eunice Williams dates the painting to 1775–82, and believes the gouache was done after the painting (Williams 1978, p. 130, under no. 51). Jean-Pierre Cuzin (1988, pp. 100–101), citing its similarity to other works of the 1760s, dates the painting to 1768–70, "between *The Waterfalls at Tivoli* and the panels at Louveciennes."
4. Williams 1978, p. 130; Cuzin 1988, p. 101.

JEAN-HONORÉ FRAGONARD

Grasse 1732–1806 Paris

72. *View of a Park*

Recto: Black chalk with gray wash and touches of green and pink watercolor over graphite underdrawing. Stamp of Alfred Beurdeley (Lugt 421) in lower left and right corners. Verso: Black chalk, 14 x 16⅞ in. (35.4 x 43.0 cm)

The Metropolitan Museum of Art, Robert Lehman Collection, 1975 (1975.1.628)

A lifetime of studying gardens—the play of light on water, stone, and foliage, and the placement of elegant figures—is reflected in Fragonard's *View of a Park*. Its freedom of handling, deft use of color, and joyful, spirited figures create an illusion of total spontaneity. In fact, Fragonard often worked and reworked such scenes in both paintings and drawings. This particular setting he explored at least three times—in a drawing in gray wash now in the Rijksmuseum, Amsterdam (fig. 72.1), in this sheet with touches of color, and on the verso in black chalk (fig. 72.2). In each drawing the same children remain at the center, while the garden that surrounds them and the technique in which the whole is rendered are altered. Fragonard, like Natoire before him, enjoyed experimenting with media, gauging the changes that different techniques would impose on a similar scene. In the Lehman recto, the easy, colorful wash over a brief architecture of black chalk creates an atmospheric unity; the Amsterdam drawing, in tones of gray, is more precise and descriptive; and the verso of the Lehman sheet, a free copy in black chalk of the Amsterdam drawing, has the appearance of sketchy underdrawing.[1] Chronologically close, the drawings were made in the late 1770s, after Fragonard's second trip to Italy.[2] The Rijksmuseum drawing must have been done first, then the Lehman verso, and finally the Lehman recto, whose less regimented and less conventional composition and fluid technique depart significantly from the Rijksmuseum example. They need not be viewed as a sequence, however, but rather as independent variations on a theme.

Viewed from this perspective, Fragonard's monumental painting *La fête à Saint-Cloud* (Banque de France, Paris), commissioned about 1775 by the duc de Penthièvre and for which the present drawing was long considered a preliminary study, should be understood as a fourth variant. For although the Lehman recto corresponds loosely to the central section of the painting, there are too many differences for it to be considered truly preparatory, except in the sense that Eunice Williams describes, as a study "in spirit if not in detail."[3] Williams has further observed that Fragonard's paintings and drawings "complement each other but are rarely coordinated."[4]

Whether the composition is in fact the garden at Saint-Cloud is not documented, and the drawing is now usually titled *View of a Park*.

MTH

72

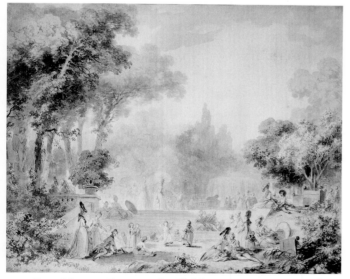

72.1. Jean-Honoré Fragonard, *Children Dancing in a Park,* ca. 1775–80. Brush with gray wash and traces of brown wash, over black chalk underdrawing, 13¾ x 17 in. (34.8 x 43.3 cm). Rijksmuseum, Amsterdam

72.2. Jean-Honoré Fragonard, *View of a Park* (verso), ca. 1775–80. Black chalk, 14 x 16⅞ in. (35.4 x 43 cm). The Metropolitan Museum of Art, Robert Lehman Collection (1975.1.628)

PROVENANCE: Mme la baronne de Ruble (1889) (according to de Portalis); possibly René Gimpel, Paris (according to Agnes Mongan in a letter to R. Lehman, 1953); Alfred Beurdeley, Paris (Lugt 421); his sale, Galerie Georges Petit, Paris, March 13–15, 1905, lot 80 (ill.); Walter Gay, Paris (d. 1938); André Weill, Paris (according to Szabo in Bordeaux 1981); in Germany during World War II (according to Paris, 1946); [César de Hauke, Paris]; Robert Lehman, New York; bequeathed to The Metropolitan Museum of Art.

LITERATURE: Roger Portalis, *Honoré Fragonard: Sa vie et son oeuvre* (Paris, 1889), p. 81; *Société de reproduction des dessins de maître* I (1909), n. p. ; *Exposition d'oeuvres de J. H. Fragonard*, exh. cat., Paris, Musée des Arts Décoratifs (Paris, 1921) no. 114; Jacques Seligmann et Fils, *Exposition de dessins de Fragonard*, exh. cat., Paris, Hôtel de Sagan (Paris, 1931), no. 66; London 1932, no. 798; *Art News of Paris 36*, (February 5, 1938), p. 20; *Les chefs-d'oeuvre des collections françaises: retrouvés en Allemagne par la Commission de Récupération Artistique et les Services Alliés*, exh. cat., Paris, Orangerie des Tuileries (Paris, 1946), drawings catalogued by Michel Florisoone, no. 122; *Exposition de la Collection Lehman de New York*, exh. cat., Paris, Musée de l'Orangerie (Paris, 1957), Charles Sterling et. al., no. 97/2; *The Lehman Collection, New York*, Cincinnati Art Museum, exh. cat. (Cincinnati, 1957), no. 262; Georges Wildenstein, "La Fête de Saint-Cloud et Fragonard," *Gazette des Beaux-Arts* 55 (January 1960), p. 46, fig. 2; Ananoff 1961–70, vol. 2, pp. 86–87, no. 790; Williams 1978, p. 106, no. 39; George Szabo, *Seventeenth- and Eighteenth-Century French Drawings from the Robert Lehman Collection*, exh. cat., New York, Metropolitan Museum of Art (New York, 1980), nos. 13a and 13b; *Profil du Metropolitan Museum of Art de New York: De Ramsès à Picasso*, exh. cat., Bordeaux, Galerie des Beaux-Arts (Paris, 1981), no. 160; Thomas W. Gaehtgens, "Fragonard: Fest von Saint-Cloud," in *Bilder vom irdischen Glück: Giorgione, Tizian, Rubens, Watteau, Fragonard*, exh. cat., Berlin, Schloss Charlottenburg (Berlin, 1983), p. 33 (ill.); Marianne Roland Michel, "French Eighteenth-Century Drawings," *Apollo* 117, no. 256 (June 1983), p. 475; Rosenberg 1988, pp. 534–35, no. 274 (ill.); Roland Michel 1987, p. 210, figs. 251, 252; Cuzin 1988, pp. 201–2 (ill. p. 201); Ludwig Tavernier, "Kunst als Entwurf einer Parallelwelt: Jean-Honoré Fragonard, 'La Fête de Saint-Cloud,'" in *Die Trauben des Zeuxis: Formen künstlerischer Wirklichkeitsaneignung* (Hildesheim, 1990), pp. 177, 180–82, and 187; Launay 1991, p. 300, under no. 103; Sotheby's, London, *Old Master Drawings*, July 2, 1997, under lot 69.

1. Although the sketchy technique of the verso gives the impression that it is a study for the Amsterdam sheet (see Marianne Roland Michel, "French Eighteenth-Century Drawings," *Apollo* 117, no. 256 [June 1983], p. 475), Eunice Williams (1978, p. 106, under no. 39) is surely correct in her determination that it is a copy made by Fragonard *after* the Amsterdam drawing.
2. This date, based on the costume in the Amsterdam drawing and the fluidity of the wash manner, has universal consensus; see Williams 1978, p. 106, no. 39; Rosenberg 1988, p. 535; and Roland Michel, "French Eighteenth-Century Drawings," p. 475.
3. Williams 1978, p. 106, under no. 39.
4. Williams 1978, p. 23.

JEAN PILLEMENT

Lyon 1728–1808 Lyon

73. *Peasant Herding His Flock Alongside a Stream*

Black chalk, heightened with white, on faded blue paper, 9¾ x 13⅞ in. (24.7 x 35 cm)

Robert Tuggle

Pillement was a prolific ornamentalist; his playful and inventive Rococo designs of flowers, landscapes, and Chinese figures were widely disseminated through prints and thus found their way onto fabrics, wallpapers, and porcelains throughout Western Europe. He also worked as a painter and draftsman of landscapes and chinoiseries, and these efforts invariably contain muted echoes of his predilection for ornament and whimsy.

Born to an artistic family in Lyon, Pillement led a peripatetic existence, only partially sketched in by the surviving biographical documents and anecdotal evidence. In addition to extended stays in Lisbon and London, he is known to have worked in Madrid, Rome, Milan, Turin, Vienna, Warsaw, and Avignon, as well as Paris. According to his own summary of his early career as penned in a memoir of 1764, he settled upon his specialty of landscape during an early stay in England, where "he studied the taste of the nation; and as he realized that in general the genre of landscape was preferred to that of history and drawings to paintings, he devoted himself to drawing."[1]

Although his seascapes in oil and gouache variously recall the work of Marco Ricci (1676–1729) and Claude-Joseph Vernet (1714–1789), his bucolic, wooded scenes with herdsmen and animals invoke the precedent of seventeenth-century Holland, especially Nicolaes Berchem (1620–1683). Yet like Fragonard, Loutherbourg, and other French artists enamored of Northern landscape, Pillement has his craggy trees, plodding cows, and rustic peasants conform to an

73

73.1. Jean Pillement, *A Rocky Landscape*, 1783. Gouache and pastel on paper, mounted on canvas, 14⅛ x 20⅜ in. (35.9 x 51.6 cm). Detroit Institute of Arts, Founders' Society Purchase, Robert H. Tannahill Fund

underlying Rococo aesthetic. Here, the generous use of white chalk to describe a diagonal swath of light against a range of velvety blacks gives the scene a moonlit artificiality. Little concerned with either nature or antiquity, Pillement created enchanting imaginary topographies using otherworldly, usually cool, color harmonies, in this case suggestive of Oudry's drawings of Arcueil (see no. 21). Pillement's work can be difficult to date, although this composition has several motifs in common with a gouache in the Detroit Institute of Arts that bears a date of 1783 (fig. 73.1), suggesting it may have been made around the time of Pillement's sojourn in Portugal.[2]

PS

PROVENANCE: John O'Brien, Princeton (purchased at auction in London in the early 1960s); [Benjamin Rifkin, New York]; Robert Tuggle.

LITERATURE: Alan Wintermute, ed., *Claude to Corot: The Development of Landscape Painting in France*, exh. cat., New York, Colnaghi (New York, 1990), pp. 224–25, no. 49 (entry by Stephen R. Ongpin).

1. Quoted in Georges Pillement, *Jean Pillement* (Paris, 1945), p. 19.
2. Ellen Sharp et al., *The Collections of the Detroit Institute of Arts: Italian, French, English, and Spanish Drawings and Watercolors, Sixteenth through Eighteenth Centuries* (New York and Detroit, 1992), pp. 222–23, no. 106 (entry by Victor Carlson).

ANNE VALLAYER-COSTER

Paris 1744–1818 Paris

74. Study of Two Roses

Pen and black ink, brush and gray wash, background tinted with a light brown wash, 9½ x 14 in. (24.1 x 35.6 cm). Signed or inscribed in pen and black ink at lower right corner: *M*^{de}. *Vallayer Coster*

Cooper-Hewitt, National Design Museum, Smithsonian Institution, Gift of the Council (1925-1-349)

Although often denigrated as another "victim of Chardin," Anne Vallayer-Coster had a manner quite distinct from that master, one that steered a middle course between the poles of painstaking description (see, for example, no. 20) and atmospheric painterliness that characterized eighteenth-century French flower painting. Vallayer-Coster was one of the famed trio of women artists, the so-called Immortelles, who pursued painting careers in Paris in the last decades of the eighteenth century. Unlike her sister artists, Elisabeth-Louise Vigée Le Brun and Adélaïde Labille-Guiard, she was not primarily a portraitist, but a specialist in still life. Success and renown followed her earliest efforts.

Vallayer-Coster was one of four daughters born to a goldsmith at the Gobelins tapestry manufactory. Nothing is known of her training as a painter, but one might speculate that she was guided by one of the still-life painters employed at the Gobelins. In any case, she was not yet twenty when she received the commission for her first known work. *Agréé* and *reçue* the same day, in 1770, with her *Allegory of the Visual Arts* and *Allegory of Music* (both Musée du Louvre, Paris), she was praised for her Salon entries and patronized by Marie-Antoinette. She was married, at the age of thirty-seven, to Jean-Pierre-Silvestre Coster, a wealthy member of Parlement.[1]

This study of two roses was made to be printed in the same direction in *gravure au pointillé*, a combination of etching and engraving, by Louis-Jean Allais (1762–1839),[2] an engraver who made two compilations of prints after the artist's drawings. The prints by Allais, as Marianne Roland Michel has pointed out, "strike a balance between scientific illustration and works of art."[3]

Vallayer-Coster's style was ideally suited to such a balance. The combination of botanical precision with subtle grada-

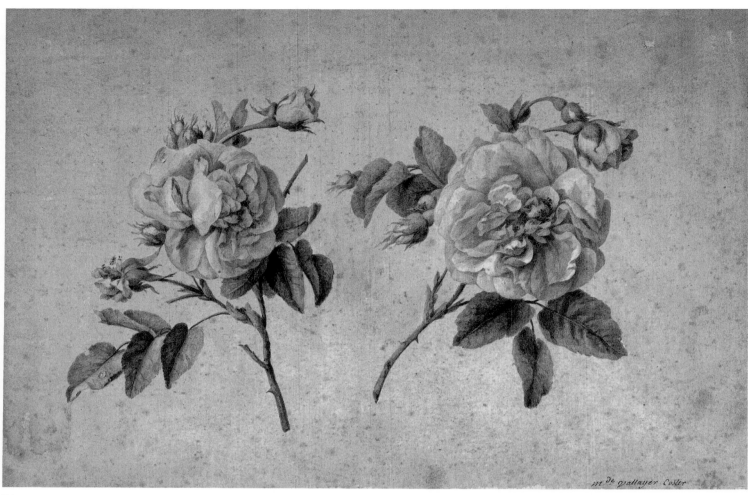

74

tions of tone creates a rich atmospheric harmony. The two cut blossoms, the dew still clinging to their leaves, are rendered in delicate shades of gray wash applied with a tiny brush; the tonal sophistication is completed by the application over the entire ground of a thin wash the color of weak tea. The reserved white paper serves as highlighting. MTH

PROVENANCE: Cooper-Hewitt, National Design Museum, Smithsonian Institution.

LITERATURE: Roland Michel 1987, p. 163, pl. 191.

1. For her life and work, see Marianne Roland Michel, *Anne Vallayer-Coster, 1744–1818* (Paris, 1970).

2. Bibliothèque Nationale, Cabinet des Estampes, Ef 140 fol. This publication of ten plates appeared in two batches under the title "Cahier d'études de fleurs." The Cooper-Hewitt drawing is for plate 3 of the first lot. See also Roland Michel, *Anne Vallayer-Coster*; the engraving is illustrated on p. 241, and the publication is discussed on p. 245, under nos. 416–25.

3. Marianne Roland Michel, "Sur quelques représentations de fleurs dans la seconde moitié du XVIIIe siècle," *Bulletin de la Société de l'Histoire de l'Art Français*, 1966, p. 172; for a discussion of Vallayer-Coster's combining of art and science, see Madeleine Pinault Sørensen and Marie-Catherine Sahut, "'Panaches de mer, lithophytes et coquilles' (1769): Un tableau d'histoire naturelle par Anne Vallayer Coster," *La Revue du Louvre et des Musées de France* 48, no. 1 (February 1998), pp. 57–70.

JEAN-HONORÉ FRAGONARD

Grasse 1732–1806 Paris

75. Young Woman Dozing

Red chalk, 9½ x 7⅜ in. (24.1 x 18.8 cm)

Private collection

This elegant, deceptively simple sheet by Fragonard is similar in subject, style, and medium to a group of figure studies of young women, often standing, dated by Eunice Williams to the 1770s and 1780s.[1] The young women are usually identified with Marguerite Gérard (1761–1837), Fragonard's sister-in-law and pupil, or with Fragonard's daughter Rosalie (1770–1788). Based on the resemblance to two other drawings identified with Rosalie, both dated to 1785, the model for this sheet is indeed believed to be the artist's daughter, leading to a plausible approximate date of 1785.[2] The drawings, as noted by Williams, were not intended as conventional portraits. Rather, Fragonard in these studies was using his relatives as models for poses and types.

The charm of the sheet derives in part from the sweet face of the sitter, crowned by a doodle of curls atop her head. Unaware that we spy, she smiles in her dreams. Fragonard sets off her limp motionlessness with crisp, energetic strokes that define the stiff, rich fabric, and fixes her passive body with the insistent vertical of the border of her overdress. Although it is tempting to associate Rosalie's early death from tuberculosis with Fragonard's depiction of her as sleeping (long a metaphor for death), the tone of the drawing is so serene and the identifying characteristics of the sitter so generic that it is difficult to support such an interpretation. Rather, one is reminded, in the implied intimacy of the relationship of viewer/artist to subject and in the seductive tension of the dress, of the erotic potential of sleeping women—teased awake by suitors, keenly observed by voyeurs, always dreaming of love. MTH

PROVENANCE: M. E. N[orblin]; his sale, Paris, March 16–17, 1860, lot 58; Hippolyte Destailleur; his sale, Paris, April 27–28, 1866, lot 70; private collection.

LITERATURE: Ananoff 1961–70, vol. 4. p. 68, no. 2068, fig., 562. Williams 1978, pp. 136–37, no. 54 (ill.); Rosenberg 1988, p. 569, no. 299 (ill.).

1. Williams 1978, p. 136, under no. 54; several studies are illustrated in Rosenberg 1988, pp. 432–33, under no. 203; see also pp. 434–36, nos. 204–6.
2. Williams 1978, p. 136.

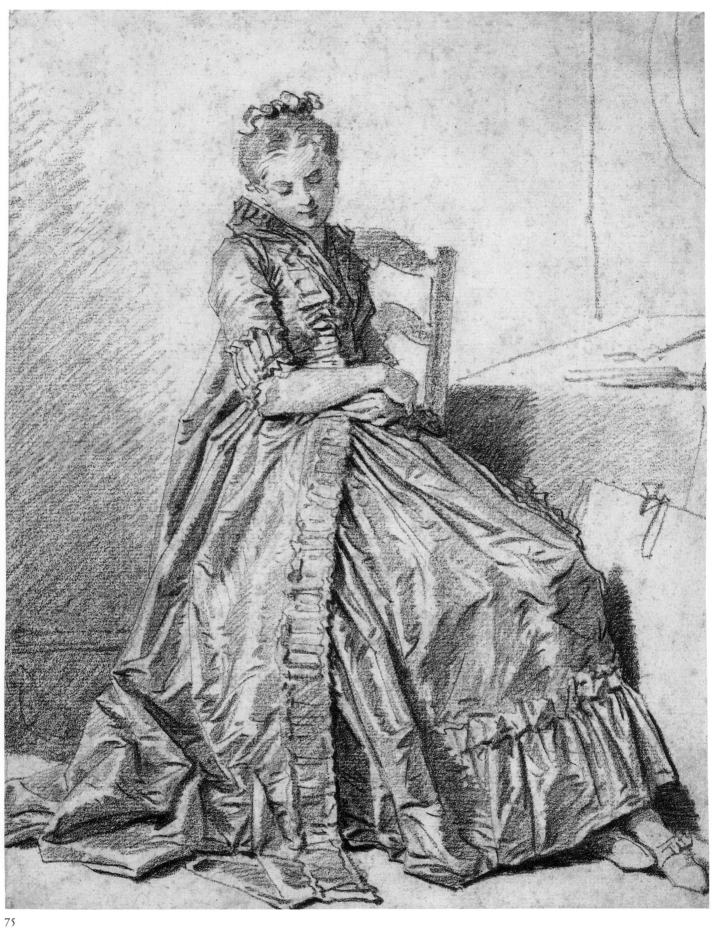

75

PIERRE-ANTOINE BAUDOUIN

Paris 1723–1769 Paris

76. *La nuit*

Gouache on paper, pasted onto board, 10⅛ x 7⅞ in. (25.9 x 20 cm)

The Metropolitan Museum of Art, Gift of Ann Payne Blumenthal, 1943 (43.163.20)

Baudouin owed much of his success to the influence of Boucher, an immense presence in the art world of mid-century France. He was Boucher's pupil and protégé, and it was Boucher who engineered his 1763 acceptance into the Académie Royale. In 1758 he married Boucher's youngest daughter, Marie-Émilie. Baudouin did not, however, follow Boucher's example in producing grand decorations; his forte throughout his short career was small erotic genre scenes, usually in gouache, painstaking in their depictions of eighteenth-century decoration and costumes. They brought down on him the impressive ire of Diderot, the self-appointed arbiter of moral standards in the visual arts, who attacked him viciously in print. For Diderot, Baudouin was an artist as debased with his brush as in his morals and whose work was admired only by hunchbacks and libertines.[1] The Goncourt brothers, however, who owned a variant of the pendant to the present drawing, ranked him on a level with Gabriel de Saint-Aubin and Fragonard.[2]

Baudouin's fondness for gouache was shared by his near contemporaries Philibert-Louis Debucourt, Jean-Frédéric Schall, Nicolas Lavreince (Niklas Lafrensen), and Jean-Baptiste Mallet,[3] all of whom also produced fashionable narrative genre scenes often erotic in tone. More stable and less fluid than watercolor, and capable of great range and subtlety of color, gouache was the perfect medium for the rich description of eighteenth-century affluence.

Baudouin's *La nuit* formed part of a Four Parts of the Day series, a popular theme in eighteenth-century France.[4] The delicate handling of the gouache gives the lovers' awkward embrace, Hogarthian in its abruptness, a certain elegance, bathing them in silver-blue moonlight. The same translucent light washes over Baudouin's rendering of Étienne Falconet's celebrated sculpture *Amour meneçant*, 1757 (Musée du Louvre, Paris), situated here in an imaginary garden. Falconet's *Amour* was also witness to that most famous of eighteenth-century indiscretions—that contemplated by the young woman in Fragonard's *Swing* (Wallace Collection, London). MTH

PROVENANCE: George and Florence Blumenthal; Blumenthal sale, Hôtel Drouot, Paris, April 5–6, 1933, no. 7, "d'après Baudouin," presumably bought in; Ann Payne Blumenthal; given to The Metropolitan Museum of Art.

LITERATURE: *Catalogue of the Collection of George and Florence Blumenthal, New York*, compiled by Stella Rubinstein-Bloch, 6 vols. (Paris, 1926–30), vol. 5, *Paintings, Drawings, Sculptures, XVIII Century*, pl. x; Gillies and Ives 1972, no. 2; Bean and Turčić 1986, no. 6 (ill.).

1. Seznec and Adhémar 1975–83, vol. 2, p. 140.
2. Launay 1991, pp. 219–20, no. 9.
3. For a discussion of these artists, see Hunter-Stiebel 1987, pp. 36ff.
4. It was probably the model for one of the Four Parts of the Day etched (with engraving) by Emmanuel de Ghendt in 1778. The print is in reverse, and some details differ. For the pendant, *Le matin,* see Bean and Turčić 1986, pp. 21–22, no. 5 (ill.). For a discussion of this theme in eighteenth-century art, see Holmes 1991, pp. 90–91.

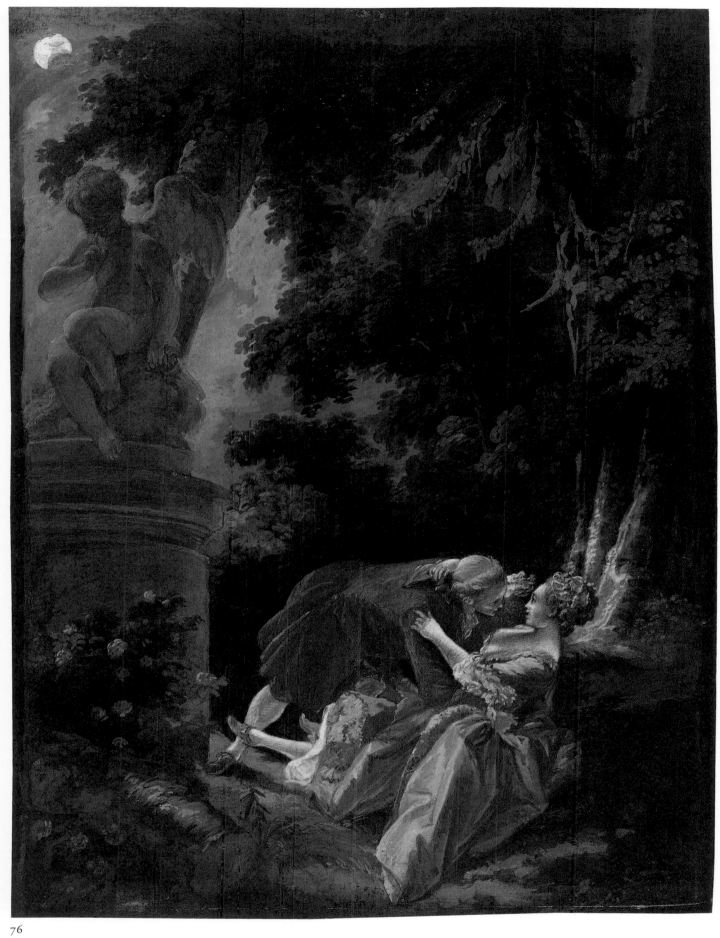

76

JEAN-MICHEL MOREAU, CALLED MOREAU LE JEUNE

Paris 1741–1814 Paris

77. *Perfect Harmony*

Pen and brown ink, brush and brown wash, over traces of graphite, 10½ x 8½ in. (26.7 x 21.6 cm). Signed and dated in pen and brown ink at lower left: *J. M. Moreau Lejeune 1776*

The Metropolitan Museum of Art, The Lesley and Emma Sheafer Collection, Bequest of Emma A. Sheafer, 1973 (1974.356.48)

Jean-Michel Moreau, called Moreau *le jeune* to distinguish him from his older brother Louis, a landscape painter, began his training intending to become a painter, and studied toward that end with Louis-Joseph Le Lorrain (1715-1759). On Lorrain's death, however, he turned exclusively to engraving and drawing, entering the studio of the well-known engraver Jacques-Philippe Le Bas (1707–1783). Moreau succeeded Charles-Nicolas Cochin in 1770 as *dessinateur des Menus-Plaisirs*, recording the official events and celebrations of the crown, and the decades of the 1770s and 1780s marked the height of his artistry and productivity.

This elegant and evocative drawing formed part of Moreau's most famous commission, the designs for the *Monument du costume physique et moral de la fin du dix-huitième siècle*.[1] This enterprise, sponsored by the financier and print collector Jean-Henri Eberts, was published in three parts, each comprising twelve to fourteen plates. The first set of twelve plates was commissioned from the Swiss artist Sigmund Freudenberger (1745–1801). Evidently it did not sell, so Eberts turned to Moreau. A set of twelve plates appeared in 1777, and in 1783 a set of fourteen, Freudenberger providing two of the designs for the third set. The Moreau plates were reprinted in 1789, with a text by Restif de la Bretonne.

In their narrative aspect, the plates exemplify eighteenth-century genre imagery in combining elements of costume prints from the world of fashion and theater with scenes of everyday life (see also nos. 2 and 94). The Freudenberger group describes the marriage of an affluent young woman, a lady *de bon ton* named Céphise. The second set, by Moreau, delineates her idyllic family life and follows her in her daily activities in society. And the third set focuses on the habits and occupations of a young man, a *cavalier à la mode*.

Perfect Harmony, the eighth scene in Moreau's first set, shows Céphise playing a harp in the company of two gentlemen.[2] The engravings after the drawings were intended to serve as documents of contemporary style and taste—in fashion, interior design, and pastimes. It is noted, for example, in the heading for the first set, that they are a precise representation of the style of 1774–75. Moreau's drawings do not, however, conform to the traditional idiom of drawings for engravings, with their painstaking rendition of detail. Rather, they impart a more painterly sense of light and space through the adept handling of wash and the use of an extremely delicate ink line. Moreau's drawings thus achieve a luminosity and fluidity rare to the genre, evoking the period in spirit as well as detail.

MTH

PROVENANCE: Possibly King Ludwig II of Bavaria; sale, Berlin, Lepke, May 1891 (according to Clayton); Baroness Willie de Roth-schild (according to Clayton); Baroness Mathilde von Rothschild; Erich von Goldschmidt-Rothschild; Goldschmidt-Rothschild sale, Berlin, March 23–25, 1931, lot 39 (ill.); Irwin Laughlin; Mrs. Hubert Chanler; sale, Sotheby's, London, June 10, 1959, lot 40 (ill.); [Rosenberg and Stiebel, Inc., New York]; Lesley and Emma Sheafer; bequeathed to The Metropolitan Museum of Art.

LITERATURE: Edward Clayton, *French Engravings of the Eighteenth Century in the Collection of Joseph Widener, Lynnewood Hall*, 4 vols. (London, 1923), vol. 4, p. 529; Campbell Dodgson, "Jean Michel Moreau (Moreau de jeune), 1741–1814," *Old Master Drawings* 6 (September 1927), p. 24; London 1932, no. 847; Royal Academy of Arts, London, *Commemorative Catalogue of the Exhibition of French Art, 1200–1900*, 1933, no. 714; Regina Schoolman and Charles E. Slatkin, *Six Centuries of French Master Drawings in America* (New York, 1950), p. 100, pl. 56; Rotterdam, Paris, and New York 1959, no. 68, pl. 86; *MMA Annual Report*, 1974–75, p. 48; Bean 1975, no. 53; Jean-Richard 1985, pp. 67–68; Bean and Turčić 1986, p. 179, no. 196.

1. For this publication, see Marie-Joseph-François Mahérault, *L'oeuvre gravé de Jean Michel Moreau le jeune (1741–1814)* (Paris, 1880), pp. 381–93; Ray, *The Art of the French Illustrated Book*, vol. 1, pp. 97–98, under no. 55; and Jean-Richard 1985, nos. 65–83.

2. For the engraving, see Bocher 1882, no. 1355.

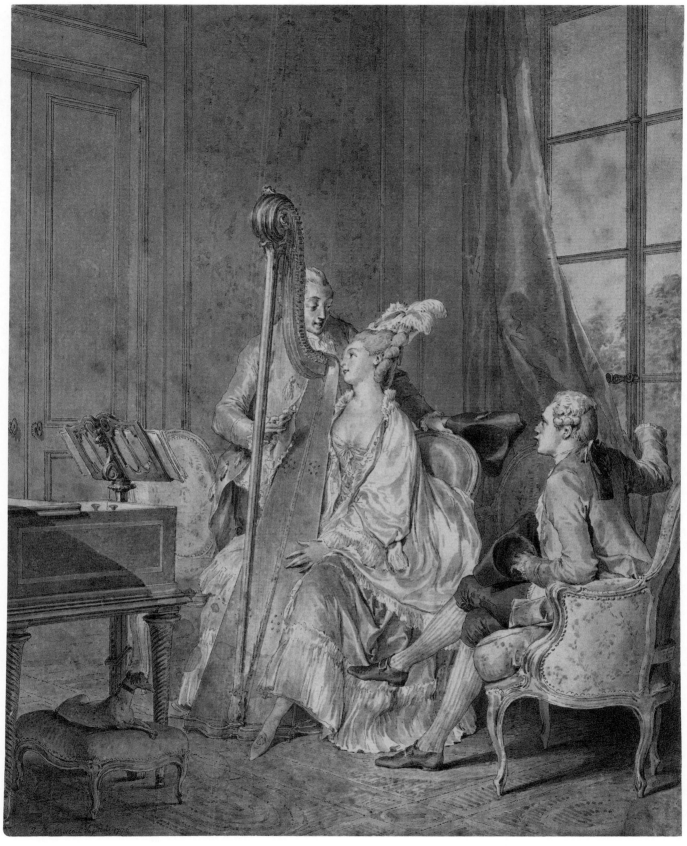

77

GABRIEL DE SAINT-AUBIN

Paris 1724–1780 Paris

78. The Lesson of the Chemist Sage at the Hôtel des Monnaies

Black chalk with stumping, graphite, point of brush and brown ink, brush and gray wash, gouache, 7¾ x 5⅛ in. (19.8 x 13 cm). Signed and dated in pen and black ink, lower edge: *par Gabriel de Sᵗ Aubin 1779*; inscribed in graphite, lower edge: *La leçon de M. Sage à l'hotel de la Monaye*

The Pierpont Morgan Library, Purchased on the Martha Crawford von Bulow Memorial Fund (1991.4)

The lecture demonstrations at which Balthazar Georges Sage (1740–1824) held forth in the grand salon of the Hôtel des Monnaies in Paris in the 1770s attracted large crowds. Gabriel de Saint-Aubin shared the interest of his enlightened age in the natural sciences, and recorded Sage's sessions no fewer than three times in the year following his appointment to the chair of minerology and metallurgy—in the present drawing, in a drawing at the Musée Carnavalet (fig. 78.1),[1] and in a third study, known only from old photographs.[2] All three depict a similar moment, that of Sage in front of the great fireplace conducting an experiment with a glass vessel. In the Morgan Library drawing, he raises it aloft. This drawing and the third have similar compositions, visions of a vast salon filled with onlookers and, on the ceiling, allegorical figures. In fact, the grand salon did not receive its final decoration, a trompe l'oeil coffered vault, until 1785.[3] In the Morgan Library drawing, Sage is visible only in profile, in the third, hardly at all. The Carnavalet drawing is a more close-up view, concentrating on a few students and on Sage himself, who is seen full-face.

Above Sage's head in the Carnavalet version is an elaborate mantelpiece with allegorical figures that have elicited a variety of interpretations, including one by Edmond de Goncourt, who owned the drawing in the nineteenth century.[4] These interpretations fail, however, to take into account Saint-Aubin's frequent pairing of contemporary events with allegorical scenes, nor do they note that the ceiling in the Morgan Library drawing includes the same allegory.[5] In the more legible Carnavalet drawing, on the mantelpiece we can see Apollo at the left, a crown of laurel on his head and a lyre behind him. Around his head is an aura like the sun, and he directs its light through a large magnifying glass to illuminate a crown. Holding the magnifying glass is Vulcan, with a

hammer slid rakishly beneath his belt. Visible on the ceiling of the Morgan Library drawing are many of the same elements, such as the figure of Apollo with his lyre and the magnifying glass. A smelting cauldron with a fire beneath replaces the forge as an emblem of Vulcan. Mercury is seen with his caduceus, here in his capacity as bearer of fame and glory, as is the figure of Fame blowing his trumpet. Apollo is clearly meant to symbolize Louis XV, and Vulcan, the god devoted to things metal and mineral, may be identified with Sage. Thus Sage's work brings glory to the reign of Louis XV.

The Morgan Library drawing demonstrates Saint-Aubin's ability to work on the scale of a near-miniaturist without sacrificing the grand scale of his vision and to retain a

78.1. Gabriel de Saint-Aubin, *Le cours du chimiste Sage à la Monnaie*, 1779. Pen and blue ink, brush and gray wash over black chalk, 7¼ x 5 in. (18.3 x 12.7 cm). Musée Carnavalet, Paris

78

flamboyant line even when working so small. It demonstrates also Saint-Aubin's interest in enormous spaces that dwarf human figures, a characteristic of his late style. In combining allegory with contemporary life, two dimensions coexist in time and space, natural science and the supernatural informing each other in the service of mankind. MTH

PROVENANCE: Jacques Doucet; his sale, Galerie Georges Petit, Paris, June 5, 1912, vol. 1, lot 54; G. Pardinel; François Coty, Paris; sale, Galerie Jean Charpentier, Paris, November 30–December 1, 1936, lot 15 (ill.); Samuel Kress, New York; Mrs. Kilvert, New York; Audrey Cory de Ayala, New York and Paris; Mr. and Mrs. Robert H. Smith, Bethesda, Maryland; [Rosenberg and Stiebel, Inc., New York]; The Pierpont Morgan Library.

LITERATURE: Lady Dilke, *French Engravers and Draughtsmen of the 18th Century* (London, 1902), p. 134 (ill. opp. p. 134); Maurice Tourneaux, "Collection de M. Jacques Doucet: Pastels et dessins," *Les Arts* 36 (December 1904), p. 28 (ill.); *Société de Reproductions des Dessins de Maîtres* 3 (1911), n.p.; Dacier 1929–31, vol. 1, pp. 71, 95, 138, vol. 2, pp. 69–70, no. 435; *The World of Voltaire*, exh. cat., Museum of Art, University of Michigan (Ann Arbor, 1969), no. 69; Middletown and Baltimore 1975, no. 57; Launay 1991, p. 454, under no. 306; Denison 1993, p. 146, no. 64; Denison 1995, p. 32, no. 12; Moscow and Saint Petersburg 1998, no. 63 (ill.).

1. For this drawing, see Dacier 1929–31, vol. 2, p. 70, no. 437; and Launay 1991, p. 454, no. 306.
2. Dacier 1929–31, vol. 2, p. 70, no. 436 (pl. XIV). A possible fourth drawing is listed in vol. 2, p. 115, no. 656. Anne de Bayser and Alexandre Lacroix suggest a fifth; see *Peintures et dessins du XVIe au XIXe siècle*, Galerie "Correspondances" (Paris, 1997), no. 12, reproduced on the cover. Marianne Roland Michel kindly brought this drawing to my attention (in conversation, 1997). She believes, however, that the drawing may portray the abbé de Nollet rather than Sage.
3. See Monique Mosser, "L'hôtel des Monnaies de Paris, oeuvre de J.-D. Antoine," *L'Information d'Histoire de l'Art* 16, no. 2 (March–April 1971), p. 99. An engraved view, which shows the coffering and a small figure, perhaps Sage, lecturing, was made by Lepagelet in 1791, *La lecture du chimiste à l'hôtel des Monnaies* (Bibliothèque Nationale, Cabinet des Estampes, VA. 262a; Topographic, 6ième arron., La Monnaies Intèrieurs). Kim de Beaumont kindly brought this engraving to my attention.
4. In 1875 (*Notules, additions, errata . . .* , p. 42, cited in Launay 1991, p. 454), Edmond de Goncourt interpreted the protagonist as a "génie de la Science." For Goncourt's analysis of the iconography, see Launay 1991, p. 454. Dacier (1929–31, vol. 1, p. 76) saw the subject as "Vérité regardant une couronne à la loupe."
5. The ceiling in the third example is harder to decipher owing to the poor reproductions, but the figure of Apollo is again prominent, this time riding his chariot across the center of the ceiling.

JEAN-SIMON BERTHÉLEMY
Laon 1743–1811 Paris

79. Aurora's Awakening

Red chalk, over graphite, heightened with white, on blue paper, with pen and brown ink framing lines, 15⁵⁄₁₆ x 15¼ in. (39 x 38.8 cm)

Private collection

While his later, public works achieved a certain level of classicizing severity, Berthélemy never completely shed the aesthetic lessons of the great Rococo decorators Le Moyne, Boucher, and his own teacher, Noël Hallé. Early in his career Berthélemy gained a reputation as a painter capable of large-scale decoration. The ceilings that survive are characterized by airy expanses of pastel cloud and sky punctuated by artfully placed mythological figures of a cold and graceful eroticism.

Berthélemy typically prepared for ceiling designs in three stages: fluid oil sketches on canvas, compositional drawings in chalk, and, finally, more detailed studies of individual figures, often in black chalk with white heightening. Nathalie Volle, in her 1979 monograph on Berthélemy, gives this sheet the title *Le triomphe de Flore* and connects it with a round oil sketch (fig. 79.1) of the same title that had previously been attributed to Fragonard, dating them both to 1770–80 and considering them studies for a lost or never-executed ceiling project.[1]

79.1. Jean-Simon Berthélemy, *Le lever de l'Aurore*, ca. 1786. Oil on paper, diameter 14⅛ in. (36 cm). Musée de Laon

79

Another possibility, not considered by Volle, is that the present sheet and the related oil sketch (which was acquired by the Musée de Laon in 1985)[2] depict not Flora but Aurora, and form part of the preparatory process for Marie-Antoinette's boudoir ceiling at the Château de Fontainebleau, *Le lever de l'Aurore* (fig. 79.2), completed in 1786.[3] The confusion arises because of the flowers in the hands of the central figure, though a depiction of Aurora scattering roses would not be unprecedented and alludes to

the often cited Homeric phrase "rosy-fingered dawn." The connection between the New York study and the Fontainebleau ceiling is also easily overlooked on a formal level, as a subsidiary group has been omitted and the central group reversed. The reversal of a central figure in the final preparatory stage is not unknown in Berthélemy's oeuvre. One can point to another ceiling sketch, *L'Aurore entourée d'amours*, in which the figure of Aurora follows the counterproof of a figure study, presumably reversing the pose

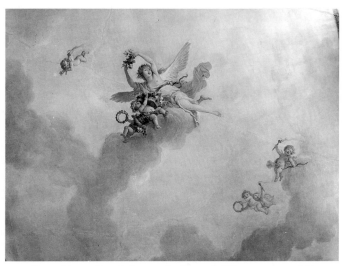

79.2. Jean-Simon Berthélemy, *Le lever de l'Aurore*, 1786. Oil on plaster, 157½ x 181⅛ in. (400 x 460 cm). Château de Fontainebleau

It was surely the restricted space of the boudoir that dictated the gradual reduction in the number of figures from sketch to drawing to ceiling. Only the winged figure of Aurora, buoyed on her funnel-shaped support of dark clouds and accompanied by her playful band of putti, remains. It was a happy solution for an intimate space, allowing Berthélemy to showcase his skills as a colorist in the uncluttered expanse of pastel clouds, lit by dawn's rosy light. PS

PROVENANCE: Private collection, Cannes; [Galerie de Bayser S.A., Paris, 1979]; [W. M. Brady & Co., Inc., New York]; private collection.

LITERATURE: Nathalie Volle, *Jean-Simon Berthélemy (1743–1811), peintre d'histoire* (Paris, 1979), p. 113, no. 144, fig. 48; *7 ans d'enrichissement des musées de la région Picardie, 1982–1988*, exh. cat., Beauvais, Musée Départemental de l'Oise (n.p., 1988), p. 124, under no. 93 (entry by Caroline Jorrand).

1. Nathalie Volle, *Jean-Simon Berthélemy (1743–1811), peintre d'histoire* (Paris, 1979), pp. 87–88, 113, nos. 67, 144, figs. 48, 50.
2. *7 ans d'enrichissement des musées de la région Picardie, 1982–1988*, exh. cat., Beauvais, Musée Départemental de l'Oise (n.p., 1988), p. 124, no. 93 (entry by Caroline Jorrand).
3. See Volle, *Jean-Simon Berthélemy*, no. 84, pp. 16, 25, 34, 93–94, fig. 59. Three other depictions of Aurora, with arms spread and without wings, are catalogued by Volle as nos. 65, 66, and 145, pp. 87, 113–14, figs. 47, 49, and 52. No. 65 appeared recently at auction (Sotheby's, New York, May 21, 1998, lot 296) as "attributed to Berthélemy."
4. The counterproof was sold at Christie's, Monaco, July 2, 1993, lot 110. For the oil sketch, see Volle, *Jean-Simon Berthélemy*, no. 66, fig. 47.

from its initial conception.[4] The identification of the subject of the New York drawing as Aurora is further supported by the clusters of torch-brandishing putti (bringing the light of Dawn) and the two figures in the lower register, one of whom—even more clearly in the oil sketch than in the drawing—has her head covered in drapery, signifying departing Night. The choice of Dawn as the subject for the Fontainebleau ceiling allowed for the dramatic effects of luminosity, which are explored by Berthélemy in the drawing through the use of white heightening.

CHARLES-NICOLAS COCHIN LE FILS

Paris 1715–1790 Paris

80. *Portrait of Joseph Vernet*

Black chalk with brush and gray wash, heightened with white, 5½ x 4 in. (13.9 x 10.2 cm). Signed and dated below the framing line in pen and gray ink: *C. N. Cochin f. delin 1779*; inscribed below in black chalk: *JOSEPH VERNET*

Private collection

Charles-Nicolas Cochin's career placed him at a critical juncture of the arts in the mid-eighteenth century. A respected graphic artist, he also held influential administrative posts at the Académie and the Bâtiments du Roi, and produced a large body of theoretical writings.[1] He began his career designing book illustrations and recording court celebrations for the Menus-Plaisirs. In 1749 Cochin was among a small group selected to accompany Abel-François Poisson de Vandières, the younger brother of Mme de Pompadour and future marquis de Marigny, on his journey to Italy. Their resulting friendship eventually led to Cochin's appointment to the powerful post of secretary to the Académie in 1755.

Through his various connections, Cochin had access to members of the intellectual, social, and artistic elite of the Enlightenment, many of whom he drew for both profit and

80

80.1. Adélaïde Labille-Guiard (1749–1803), *Portrait of Joseph Vernet,* 1783. Oil on canvas, 22 x 18¼ in. (56 x 46.5 cm). Musée Calvet, Avignon

pleasure. Over two hundred fifty of Cochin's portrait drawings have survived, as a group fairly consistent in their small scale, bust-length format, unadorned backgrounds, and drawn borders. The vast majority are profile portraits set in round medallions inspired by the antique cameos Cochin had seen in Rome, and his submission of forty-six of the portraits to the Salon of 1753 was responsible for establishing the popularity of this portrait type in France.[2]

This portrait of Joseph Vernet (1714–1789) is among a small group that departs from the self-imposed formula, suggesting that it was never intended as part of an engraved series. It is rectangular rather than round, and presents its sitter in a more intimate and engaging three-quarter view. By 1779, the year the drawing is dated, Vernet and Cochin had been close friends for over a quarter century. They had first worked together in the 1750s, when Cochin supervised the engraving of Vernet's *Ports de France* (1754–65), panoramic views of commerce and industry in various French ports, the largest single commission by the crown in the reign of Louis XV. Vernet was considered the greatest

marine and landscape painter of his generation. That both artists commissioned Adélaïde Labille-Guiard to paint each other's portrait in 1783 attests to their continuing friendship.[3] The identity of the sitter, given in this drawing's inscription, can be confirmed by comparison with known portraits of Vernet by other artists, the closest being the 1783 painting by Labille-Guiard (fig. 80.1), the composition of which is a mirror image of the Cochin drawing.[4]

With Chardin, Vernet was one of the two artists whose work was most extolled by Cochin in print, both exemplifying Cochin's theory of the imitation of nature as the basis of art and his belief in the importance of the individual hand of the artist and its appropriateness to the particular style and subject chosen. Cochin and Vernet shared an avowed disapproval of the excesses of Rococo style and decoration, yet neither went so far as to reject entirely the prevailing aesthetic of their time. For Cochin, this often resulted in a marked dichotomy between the critical stance of his theoretical writings and his vast production for the print industry, which reflected the realities of popular taste and commercial viability. More than his book illustrations, allegories, and fêtes, his portrait drawings conform to his stated preference for the skilled transcription of nature—free from the restrictions imposed by notions of ideal form, uncluttered by ornament, and expressed in the accomplished, yet personal, hand of the artist. PS

PROVENANCE: Private collection, France; sale, Hôtel Drouot, Paris, April 2, 1993, lot 3; [Thomas le Claire, Kunsthandel, Hamburg]; private collection.

Unpublished.

1. On Cochin, see Christian Michel, *Charles-Nicolas Cochin et l'art des Lumières* (Rome, 1993).
2. See Michel, *Charles-Nicolas Cochin*, pp. 172–74.
3. See Anne Marie Passez, *Adélaïde Labille-Guiard, 1749–1803: Biographie et catalogue raisonné de son oeuvre* (Paris, 1973), pp. 151–52, nos. 59–60.
4. Eight additional portraits of Vernet are listed by Philip Conisbee in his 1976 entry on the Labille-Guiard painting in Philip Conisbee, *Claude-Joseph Vernet, 1714–1789*, exh. cat., Kenwood, The Iveagh Bequest (London, 1976), under no. 2, n.p. To these can be added the untraced profile portrait by Cochin known through the 1781 etching by Bernard Antoine Nicolet, a red-chalk, bust-length drawing by Louis-Roland Trinquesse in the Musée Carnavalet, Paris (Pierre Quarré, *Trois peintres bourguignons du XVIIIe siècle: Colson, Vestier, Trinquesse*, exh. cat., Dijon, Musée des Beaux-Arts [Dijon, 1969], p. 48, no. 65, pl. xv), and the 1767 profile drawing by Jean-Michel Moreau, called Moreau *le jeune*, acquired by the Louvre in 1984 (Paris 1990, no. 159, pp. 106–7).

BENOÎT-LOUIS PRÉVOST
Paris 1747–1804 Paris

81. *Portrait of Mme Michel de Grilleau*

Black chalk with brush and gray wash, 9 1/16 x 7 1/16 in. (23 x 18 cm). Dated, lower right, in pen and black ink: *1787*

Private collection

This engaging portrait is typical, in its frankness and simplicity, of the portrait manner of the late eighteenth and early nineteenth centuries. Mme Michel de Grilleau, whose identity is known from an inscription on the original backing,[1] is neither flattered nor idealized, and there is an endearing quality in the contrast between the fancy furbelows in her hair and the directness and honesty of her expression.

Benoît-Louis Prévost was a gifted engraver. One of the most diligent transcribers of the work of Charles-Nicolas Cochin, etching the frontispiece for the *Catalogue de l'oeuvre de Cochin* and the frontispiece after Cochin's drawing for *L'encyclopédie* (both 1770), he was also employed by the abbé de Saint-Non for the illustrations in the *Voyage pittoresque . . .* (1781–86; see no. 66).

Prévost's drawn oeuvre is quite scarce.[2] Another portrait of a lady was sold at auction in 1994.[3] Dated 1770, it includes a medallion-style frame that suggests it was to be engraved. It is in the same medium as the present sheet, and the manner of describing the sitter's features and hair is very similar. One notices especially the feathering of the brows.

Not surprisingly, it is Prévost's ties to Cochin that informs

81

this fine small portrait and the few others known from his hand. The two men, one must assume, knew each other well. Cochin had developed a genre of small drawn portraits—often, but not always, in profile, and often, but not always, in red chalk—that is notable for its naturalism and unadorned truthfulness. His *Portrait of Joseph Vernet* in this exhibition (no. 80) is an excellent example, as is a drawing in black chalk of 1782, *Presumed Portrait of Mme de Beaufort,* which displays a marked kinship to Prévost, the plain features of the sitter sensitively drawn, the face slightly turned to add a sense of movement.[4] Working in a small scale, both artists had a delicate touch and an informal manner, creating images of striking immediacy and charming intimacy.

MTH

PROVENANCE: [W. M. Brady & Co., Inc., New York]; private collection.

Unpublished.

1. *Mme. Michel de Grilleau / epouse de N. Rousseau delalane /* last line illegible.
2. E. Bénézit, *Dictionnaire critique et documentaire des peintres, sculpteurs, dessinateurs et graveurs de tous les temps et de tous les pays,* new ed. (Paris, 1976), vol. 8, p. 485, lists eight drawings, all portraits, in various unillustrated sales. Prévost's etchings after his own drawings number considerably fewer than those after the work of others, and tend to be allegories rather than portraits; see Roger Portalis and Henri Béraldi, *Les graveurs du dix-huitième siècle,* 3 vols. (Paris, 1880–82), vol. 3, pp. 349–50.
3. Christie's, Monaco, June 20, 1994, lot 100 (ill.), with its pendant, *Portrait of a Man.*
4. Present whereabouts unknown, signed and dated 1782, 5¾ x 4½ in. (14 x 10 cm). Photograph in the Frick Art Reference Library; illustrated in *Société de reproduction des dessins de maîtres* 3 (1911), n.p.

ADÉLAÏDE LABILLE-GUIARD

Paris 1749–1803 Paris

82. Marie Gabrielle Capet and Marie Marguerite Carreaux de Rosemond

Black chalk with stumping, red and white chalk on beige paper, 15 x 19 in. (38 x 48.2 cm)

The Metropolitan Museum of Art, Purchase, Gifts from Mrs. Gardner Cassatt, Mrs. Francis Ormond, Bessie Potter Vonnoh, William Benton, Donald Silve, William M. Ivins Jr., and Mrs. Harry Payne Whitney, and other gifts, bequests, and funds, by exchange, 1998 (1998.186)

82.1. Adélaïde Labille-Guiard, *Self-Portrait with Two Pupils,* 1785. Oil on canvas, 83 x 59½ in. (210.8 x 151.1 cm). The Metropolitan Museum of Art, Gift of Julia A. Berwind, 1953 (53.222.5)

This previously unpublished drawing is a study for one of Labille-Guiard's best-known works, her life-size *Self-Portrait with Two Pupils,* which made her reputation in the Salon of 1785 and hangs today in the Metropolitan Museum (fig. 82.1). The daughter of a shopkeeper, Labille-Guiard trained first with her neighbor François-Élie Vincent, then with Maurice-Quentin de La Tour, then with François-André Vincent, the son of her first teacher, whom she later married. Producing portraits in miniature, in pastel, and in oil, she earned admittance to the Académie in 1783, the same day as Elisabeth-Louise Vigée Le Brun (see no. 93), thus bringing to four—and the official limit—the number of women granted membership in the respected institution.[1]

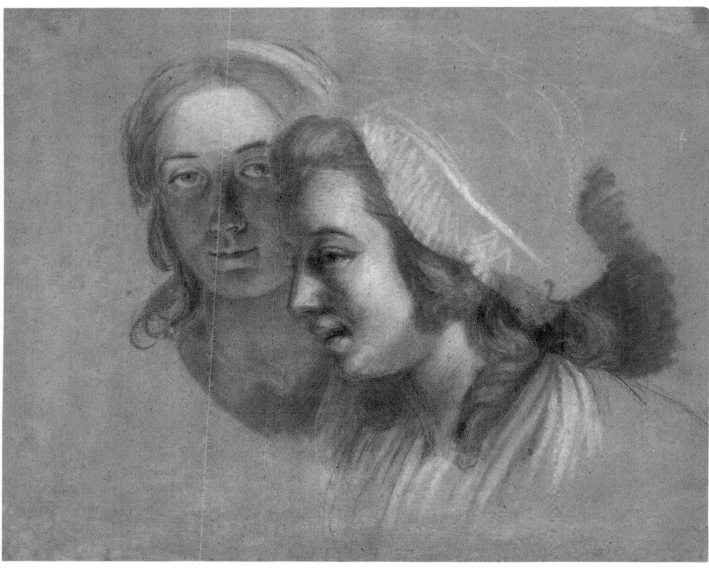

82

As is the case with many eighteenth-century portraitists, only a tiny corpus of drawings has been connected to her oeuvre. This delicate *trois crayons* study must have been made well into the planning of the Metropolitan's canvas, after the overall composition had been set. Labille-Guiard's goal was not primarily to record a likeness (her students would have been available to model before the canvas), but to explore the nuances of light and cast shadow resulting from the sitters' unusual proximity to one another, with Capet absorbed in her teacher's work and Carreaux de Rosemond meeting the viewer's gaze. Partially visible pentimenti reveal that Capet's head, seen in profile, was moved a few centimeters to the left after the drawing was begun. That the exercise concerned the relative positions of the two heads and was made as part of the preparatory process rather than as a record is further confirmed by the various details

of the finished painting, which differs from the drawing in the arrangement of Capet's hair, in her prominent earring, and in details of clothing.

Marie Gabrielle Capet was Labille-Guiard's favorite student, living with the artist both before and after her marriage to Vincent in 1800. She remained in Vincent's household after Labille-Guiard's death in 1803, caring for him until his death in 1816, one year before her own. Capet was a respected portraitist in her own right, and the three often depicted one another, especially in the years around that of the Metropolitan's self-portrait.[2] Vincent used Capet as a model on several occasions during this period,[3] coming particularly close to Labille-Guiard's technique in the *trois crayons* drawing in the Petit Palais (fig. 82.2), with its delicate porcelain coloring in the complexion and the extensive use of stumping.[4] This and other drawings by Vincent of

82.2. François-André Vincent (1746–1816), *Portrait of Marie Gabrielle Capet*. Black, red, and white chalk, 17 x 13¼ in. (43.2 x 33.5 cm). Musée du Petit Palais, Paris

Capet feature dedicatory inscriptions in Vincent's hand, dated the year before his death. The fact that the Metropolitan's sheet lacks such an inscription suggests that it was not left to Vincent at Labille-Guiard's death, but more likely left the artist's studio during her lifetime.

PS

PROVENANCE: Private collection, France; [Galerie de Bayser S.A., Paris]; purchased by The Metropolitan Museum of Art.

Unpublished.

1. They joined Marie Thérèse Vien, *reçue* 1757, and Anne Vallayer-Coster, *reçue* 1770.
2. Labille-Guiard and Vincent in several cases also seem to have made portraits of the same sitter, working side by side. See Passez, *Adélaïde Labille-Guiard*, p. 51. On Capet, see Arnauld Doria, *Gabrielle Capet* [Paris, (1934)].
3. See Cuzin, *François-André Vincent, 1746–1816*, nos. 36, 50, 56. No. 37 bears a strong resemblance to Mlle Carreaux de Rosemond as depicted by Labille-Guiard in the Metropolitan's painting.
4. Jean-Pierre Cuzin called the identification of the sitter of this sheet into question in 1988 (*François-André Vincent, 1746–1816*, p. 22, no. 56).

JEAN-BERNARD RESTOUT

Paris 1732–1797 Paris

83. Dido's Sacrifice to Juno

Oil paint, over pen and brown ink, brush and brown wash, on paper, mounted on canvas, 12⅝ x 15⅜ in. (32 x 39 cm)

The Metropolitan Museum of Art, Van Day Truex Fund, 1983 (1983.429)

Appearing on the market in 1980 as "attributed to Pierre," this Neoclassical oil sketch was purchased by the Metropolitan Museum in 1983 as the work of Joseph-Marie Vien (1716–1809), one of the proponents of the *goût grec*, a fashionable alternative to the Rococo in the early 1760s. It was published several times under that attribution with a range of titles ("Virgins Offering Sacrifice to Vesta," "Maiden Offering Incense before a Statue of Juno," and so forth). The correct attribution emerged only after an old label was discovered on the verso of a closely related work in a private collection. The label identified that work as a sketch associated with a project for a series of tapestry cartoons depicting the story of Dido and Aeneas which had been commissioned by the marquis de Marigny for the Gobelins manufactory in 1772 from Jean-Bernard Restout, son of the religious painter Jean Restout.[1] J. Patrice Marandel then observed that the Metropolitan's "Vien" must be part of the same group, thereby confirming the identification of the subject as the Sacrifice of Dido, as given in the 1980 auction catalogue.[2]

83

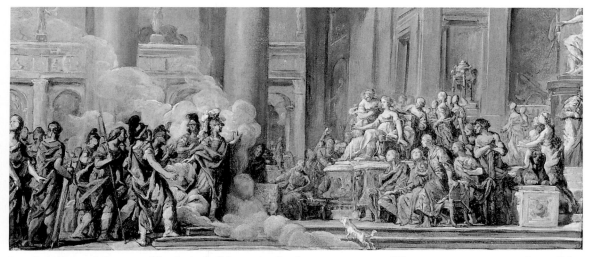

83.1. Jean-Bernard Restout, *The Arrival of Aeneas in Carthage*, ca. 1772–74. Oil on paper on canvas, 12¼ x 27¾ in. (31.1 x 70.5 cm). The University of New Mexico Art Museum, Albuquerque, Anonymous loan

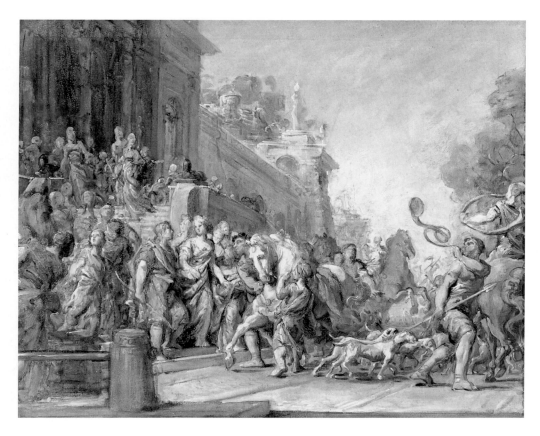

83.2. Jean-Bernard Restout, *The Departure of Dido and Aeneas for the Hunt,* ca. 1772–74. Oil on paper on canvas, 12⅝ x 15¾ in. (32.1 x 40 cm). The University of New Mexico Art Museum, Albuquerque, Anonymous loan

It was Jean-Baptiste Marie Pierre, acting in the capacity of *premier peintre du roi,* who first proposed the commission based on the story of Dido in Virgil's *Aeneid,* to be illustrated in five compositions. He suggested that the fourth canvas might represent "the sacrifice made by Dido, during which she perceives a sinister omen. Having this scene take place in a temple is unavoidable; the detailed description of sumptuous accessories found in similar subjects would be superfluous here."[3] Marigny heartily approved the plan, and then nothing at all is mentioned of the progress of the commission until 1774, when an entry in a document entitled "État des ouvrages ordonnés" reads, "Restout. A lui ordonné cinq grands tableaux dont les sujets sont choisis de l'histoire de Didon et Énée dans *l'Énéide.* Ils sont destinés pour être exécutés en tapisserie aux Gobelins. Les esquisses sont faites. Estimés chacun 4,500 livres. Ensemble 22,500 livres."[4] It would seem, therefore, that not only had Restout *fils* planned all five compositions by 1774, but that he had completed larger and more detailed paintings for each subject, as it is unlikely that the three surviving sketches—two in a private collection (figs. 83.1, 83.2) and this one in the Metropolitan— would have commanded 4,500 livres apiece. The authorship of the three small sketches seems beyond question nonetheless when one compares the physiognomy of the female figures with similar types in two allegorical etchings Restout executed in 1774.[5] Typical for this artist are the small flat ovoid heads that swivel on disproportionately long necks.

The story of Dido had previously provided the subject for a tapestry series in eight parts designed by Giovanni Francesco Romanelli and woven in Antwerp in the 1670s.[6] The basic elements of Romanelli's scene of *Dido's Sacrifice to Juno*[7] also appear in the sketch by Restout *fils,* although in his rendition the number of figures is increased and their scale reduced. Dido, queen of Carthage, has been smitten by love for Aeneas, who was shipwrecked near her city. Urged by her sister Anna, Dido makes sacrifices to Juno in an attempt to prevent Aeneas's departure. Before an elevated statue of a seated Juno with her attribute, a peacock, the crowned Dido solemnly pours a libation at the altar while other female figures supplicate the stone goddess. In Restout's composition, the woman in the foreground seen from behind must be Anna.

It is notable that Restout's designs for the story of Dido never progressed beyond the sketch stage, while Amédée Vanloo's *Costume turc,* commissioned at the same time, was both woven and reproduced in porcelain up until the Revolution.[8] One explanation would involve the differences in style between the ornate luxury of the harem interiors and gardens envisioned by Vanloo and the austere architecture employed as a backdrop by Restout, which would have offered the tapestry workers little opportunity to demonstrate their skills. Nor were Neoclassical interiors as accommodating to tapestries as earlier architecture. Nevertheless, all these considerations may have been secondary to the

quickly shifting sands of loyalty within officially sponsored institutions in the 1770s. John Goodman has traced a consistent and escalating program of antibureaucratic activism on the part of Restout, suggesting that his prolonged campaign against the Salon review committee, initiated in 1769, grew out of his Jansenist education and was modeled on pro-*parlementaire* discourse.[9] By 1773 Restout had begun to boycott the officially sponsored Salon exhibitions and was the (anonymous) author the following year of two allegorical prints sympathetic to the *parlementaire* cause. Thus, despite his ability to gain a prestigious and lucrative Gobelins commission in 1772, due in part to his father's standing at the Académie and in part to his own early promise, Restout's increasingly open gestures of protest by 1775 may well have precluded further support of the project from the Bâtiments du Roi, the Académie, or the Gobelins, all crown-sponsored institutions.

PS

PROVENANCE: Anonymous sale, Angers, April 30, 1980, lot 261 (as attributed to J.-B.-M. Pierre); [Lynven, Inc., New York]; purchased by The Metropolitan Museum of Art.

LITERATURE: *MMA Annual Report*, 1983–84, p. 24 (as Vien); Bean and Turčić 1986, p. 273, no. 308 (as Vien); Gaehtgens and Lugand 1988, no. 39a ("peintures non datables, incertaines ou refusées"), p. 213 (ill.); Los Angeles, Philadelphia, and Minneapolis 1993, pp. 142–44, no. 14 (as Vien); Peter Walch et al., *French Oil Sketches and the*

Academic Tradition, exh. cat., Charlotte, N.C., Mint Museum of Art, and elsewhere (New York, 1994), pp. 71–72, under nos. 38–39 (entry by J. Patrice Marandel), fig. 7; Alan Wintermute, "Reviews: 'Visions of Antiquity: Neoclassical Figure Drawings,'" *Master Drawings* 34, no. 4 (Winter 1996), pp. 439–40.

1. The elder Restout had also painted a number of subjects from the *Aeneid*, including the tapestry cartoon *Dido Showing Aeneas the Buildings of Carthage* (Hôtel de la Préfecture, Lyon), in 1751; see Bailey 1992, p. 326.
2. Peter Walch et al., *French Oil Sketches and the Academic Tradition*, exh. cat., Charlotte, N.C., Mint Museum of Art (New York, 1994), under nos. 38–39 (entry by J. Patrice Marandel), pp. 71–72, fig. 7.
3. The document is published in Maurice Fenaille, *État général des tapisseries de la manufacture des Gobelins depuis son origine jusqu'à nos jours, 1600–1900*, 6 vols. in 5 (Paris, 1903–23), vol. 4, p. 329.
4. The excerpt is published in Fernand Engerand, *Inventaire des tableaux commandés et achetés par la direction des Bâtiments du Roi (1709–1792)* (Paris, 1901), p. 426, n. 3.
5. They are illustrated in Goodman 1995a, fig. 5, p. 85, and fig. 7, p. 87.
6. Six of the eight cartoons appeared on the market in 1969 and were acquired by the Norton Simon Museum, Pasadena. See Ruth Rubinstein, "Giovanni Francesco Romanelli's Dido and Aeneas Tapestry Cartoons," in *Art at Auction: The Year at Sotheby's and Parke-Bernet, 1968–69* (New York, 1969), pp. 106–19.
7. An example of the tapestry is in the Cleveland Museum of Art (inv. 1915.79.3).
8. For that series, see Perrin Stein, "Amédée Van Loo's 'Costume turc': The French Sultana," *Art Bulletin* 78, no. 3 (September 1996), pp. 417–38.
9. Goodman 1995a.

JEAN-BAPTISTE GREUZE

Tournus 1725–1805 Paris

84. *The Angry Wife*

Pen and black ink, brush and gray and black wash, heightened with white, over graphite; framing lines in pen and brown ink, 20½ x 25³⁄₁₆ in. (51.5 x 63.4 cm)

The Metropolitan Museum of Art, Purchase, Joseph Pulitzer Bequest, 1961 (61.1.1)

The brilliant, if unlikely, pairing of Greuze's confident mature style with the calamity of his personal life makes this monumental sheet one of his most intriguing. The innovative alliance of history painting with domestic genre is here present in full force. Two main sources of inspiration are evident, the venerable tradition of the world upside-down, one in which furious wives berate hapless husbands, and Greuze's own disastrous marriage. Greuze would have had easy access to images of role reversal in the French print tradition, all of them tracing their roots back to the Middle Ages. Richard Rand has commented on the masculinity of the wife, her pose more characteristic of a male warrior than a female householder, and the femininity of the husband, his wilting S-curve posture

in contrast to her martial stance, his weak hand feebly grasping the train of his coat, a gesture associated with women. He further notes the disapprobation with which Enlightenment society would have regarded such a domestic arrangement, viewing it as against the natural order.[1]

By all accounts, Greuze's wife, Anne-Gabrielle Babuti, was a harridan; her temper and the couple's domestic quarrels were well known in Paris and gossiped about in print, and eventually the couple divorced (virtually the moment it became legal to do so).[2] This drawing surely reflects Greuze's unhappy home life, and is plausibly the work referred to in an account given by Greuze to his friend Charles Dufresne of an occasion on which he had to fight off his wife and her lover with a chair. He described his wife as armed with fire tongs and her lover with andirons. In the midst of the quarrel, "struck by the picture I had before my eyes, I returned trembling to my room. I took a *crayon* and made a sketch of this horrific scene. It is one of the most beautiful designs that I have made. I invite you to come see it."[3] Edgar Munhall has convincingly matched the furniture shown here to that in Greuze's own establishment;[4] the two girls protecting the miserable spouse surely recall Greuze's own two daughters.

Such a view into the life of an eighteenth-century artist is rare indeed; more often, one sees the artist with his family through the rosy, and more formal, lens of a group portrait. It is interesting to compare the sheet with the other autobiographical drawing in this exhibition, Coypel's *Allegorical Figure of Painting* (no. 15). Coypel is obviously more comfortable cloaking his personal struggle in the universal language of allegory, while Greuze, in contrast, depicts the recognizably personal. As remarkable as the revelation of the intimate scene is that Greuze had it engraved,[5] further disseminating popular knowledge of the sorry state of his household. It was not, however, unusual for him to have his highly finished drawings engraved. The drawings, usually genre scenes, were often exhibited at the Salon, and Greuze obviously regarded them as finished works of art.[6]

In these modern genre scenes, Greuze deliberately aligns himself with the grand tradition of French history painting by focusing on the expression of human emotion. Here, the display of driving passion gives the image its rhythm and power, the bottle-wielding Fury dominating one half the scene, pleading Misery the other, neatly capturing the emotional poles of Greuze's riven home.　MTH

PROVENANCE: Joseph Joubert (according to the inscription on the back of the old mount); Hesme de Villeneuve; his sale, Paris, March 3–4, 1856, lot 89; sale, Hôtel Drouot, Paris, March 9, 1950, lot 16; [Galerie Cailleux, Paris]; purchased by The Metropolitan Museum of Art.

LITERATURE: Martin 1908, p. 11, no. 143; *MMA Annual Report*, 1960–61, p. 64; Bean 1964, no. 59 (ill.); London 1968, p. 82, no. 326, fig. 236; Paul Hulton, "Reviews: 'France in the Eighteenth Century' at the Royal Academy," *Master Drawings* 6, no. 2 (1968), p. 167; Gillies and Ives 1972, no. 25; Munhall 1976, pp. 13–14, and pp. 192–93, no. 96 (ill.); Mario Amaya, "The Moralist," *Art in America* 64, no. 6 (November/December 1976), p. 84 (ill.); Bean and Turčić 1986, p. 119, no. 125 (ill.); James Thompson, "Jean-Baptiste Greuze," *The Metropolitan Museum of Art Bulletin* 47, no. 3 (Winter 1989–90), pp. 38–39 (ill.); Richard Rand, "Civil and Natural Contract in Greuze's 'L'accordée de village,'" *Gazette des Beaux-Arts*, ser. 6, 127 (1996), pp. 230–31, fig. 9.

1. Richard Rand, "Civil and Natural Contract in Greuze's 'L'accordée de village,'" *Gazette des Beaux-Arts*, ser. 6, 127 (1996), pp. 229–31.

2. For an account of their married life, see Munhall 1976, pp. 13–14.

3. Michel Niton, called Charles Dufresne, "Cahiers," ms. Paris, Musée des Arts Décoratifs, Bibliothèque, vol. 8, p. 49, cited in Munhall 1976, p. 14, and p. 15, n. 19.

4. Munhall 1976, p. 192, under no. 96.

5. The death of the engraver, Robert Gaillard, in 1785, provides a *terminus post quem* for this drawing. This was also the year Greuze and his wife set up separate living quarters.

6. Munhall (1976, p. 192, under no. 96, and pp. 194–95, no. 97) suggests that Greuze's drawing *The Reconciliation* (Phoenix Art Museum) "may be considered" a pendant to *The Angry Wife*. The many differences between the sheets, however—including their size, the participants in the two dramas, and the fact that *The Reconciliation* was not engraved—make this unlikely.

84

ANTOINE-FRANÇOIS CALLET

Paris 1741–1823 Paris

85. Ulysses Entering Troy

Pen and brown ink, brush and brown wash (recto), faint black chalk
sketch of the same subject (verso), 8¾ x 11½ in. (22.1 x 29.2 cm).
Unidentified collector's mark at lower left.

Philippe and Edith de Montebello

Callet's oeuvre, still in the early stages of being recon-
structed, can create a disjointed impression, ranging
from elegant state portraits of Louis XVI to *sotto in
sù* ceilings representing erotic assemblies of the gods to works
such as this one, in which violent episodes of ancient histo-
ry are inflected with a high Baroque tenor.[1] Such treatments
stand in direct opposition to the more common currents of
the emerging Neoclassical style, in which the same sources
would be tapped for examples of noble acts to be portrayed
in calm tableaux of idealized form and linear style.

The subject of this unpublished drawing, datable on the
basis of style to the early 1780s, was identified by Brigitte
Gallini as the fall of Troy, with Ulysses entering the burning
city on horseback and Astyanax being thrown from the city
walls in the background.[2] Gallini further suggests that the
de Montebello sheet may have been made in connection
with a proposed series illustrating events from the Trojan
War, an idea arising from the existence of a stylistically sim-
ilar ink and wash drawing in the Kupferstichkabinett,
Staatliche Museen Preussischer Kulturbesitz, Berlin (fig. 85.1),
previously published by Gallini with the title *Alcibiade enlev-
ant sa femme au tribunal,* which she now retitles *The Death
of Polyxena.*[3] The deaths of Astyanax and Polyxena would
have been a logical pairing, as both figures are innocents
slaughtered in the aftermath of the sack of Troy and they
represent the two groups usually spared in European con-
ventions of warfare, women and children.

Set off by Paris's abduction of Helen, the Trojan War
raged for nine years. The Greeks ultimately prevailed, with
Ulysses, wearing the armor of the slain Achilles, leading the
sack of Troy. In Ovid's telling of the tale, the young Astyanax

is taken from his mother and hurled from a tower to ensure
the end of King Priam's line.[4] Subjects from the Trojan War
were frequently depicted by eighteenth-century artists,
although this particular episode is rare. Carle Vanloo's famed
painting *Aeneas Rescuing Anchises from the Fire of Troy,* for
example, was acquired by Louis XVI in 1777,[5] and François-
Guillaume Ménageot's *Astyanax arraché des bras d'Andro-
maque par ordre d'Ulysse* was exhibited at the Salon of 1783.[6]
In the present sheet and the group to which it belongs, how-
ever, bloodshed and destruction are not foils to acts of nobil-
ity or sentiment, but the primary focus.

PS

PROVENANCE: [P. & D. Colnaghi & Co., Ltd., London, in 1971];
Philippe and Edith de Montebello.

Unpublished.

1. For Callet, see Marc Sandoz, *Antoine-François Callet (1741–1823)*
 (Paris, 1985). A catalogue raisonné by Brigitte Gallini is forthcoming.
2. Correspondence, October 7, 1997.
3. Also in the Kupferstichkabinett (KDZ 14734) is another related draw-
 ing, presumably a variant of the same subject and belonging stylisti-
 cally to the same group. Gallini includes in this group an untraced
 drawing of *The Death of Ajax,* of similar dimensions and medium
 (correspondence, December 19, 1997).
4. Ovid, *Metamorphoses,* translated by Frank Justus Miller, 3d ed.,
 revised by G. P. Goold (Cambridge, Mass., and London, 1976),
 8.415–17, p. 259.
5. See Pontus Grate, *French Paintings II, Eighteenth Century*
 (Stockholm, 1994), pp. 337–38, no. 304.
6. The painting is today in the Musée des Beaux-Arts, Angers; see
 Nicole Willk-Brocard, *François-Guillaume Ménageot (1744–1816)*
 (Paris, [1978]), pp. 70–71, no. 18.

85

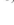

85.1. Antoine-François Callet, *The Death of Polyxena.* Brush and brown
wash over black chalk, 10⅞ x 9⅞ in. (27.6 x 25.2 cm). Kupfer-
stichkabinett, Staatliche Museen Preussischer Kulturbesitz, Berlin

LOUIS-JEAN DESPREZ

Auxerre 1743–1804 Stockholm

86. The Tomb of Agamemnon

Pen and black ink, brush and gray washes, heightened with white gouache, on beige paper, 30⅞ x 37½ in. (78.6 x 95 cm)

The Metropolitan Museum of Art, Purchase, Gifts from Mrs. Gardner Cassatt, Mrs. Francis Ormond, Bessie Potter Vonnoh, William Benton, Donald Silve, William Ivins Jr., and Mrs. Harry Payne Whitney, and other gifts, bequests, and funds, by exchange, 1998 (1998.187)

When Gustav III engaged the forty-one-year-old Desprez to come to Sweden to serve as director of stage design at the Royal Opera in Stockholm, he was hiring a kindred spirit, both men having a passionate interest in the theater. Desprez's early training as an architect would prove the ideal grounding for this endeavor. He began work in Stockholm in 1784, and two years later he was appointed director of stage design at the royal theater in Drottningholm. *Electra*, an opera by Johann Christian Friedrich Haeffner, with libretto by Nicolas François Guillard, had its Swedish premiere in 1787 to mark the birthday of the queen. The opera relates a violent chapter in the history of the house of Atreus. Clytemnestra and her lover, Aegisthus, have murdered her husband, Agamemnon, king of Mycenae. Electra, the daughter of Agamemnon and Clytemnestra, and Orestes, their son, plot their revenge.

Desprez created designs for at least three scenes. Although we do not know the precise function of these large-scale, fully realized drawings, they appear to depict scenes from the opera. It is possible they were made as presentation pieces to Gustav. Two of the compositions describe an elaborate Corinthian colonnade culminating in a triumphal arch surmounted by a pyramid housing an equestrian statue. The present nighttime image recently acquired by the Metropolitan Museum, was perhaps intended for the prologue to the opera, as it surely depicts the burial of Agamemnon, whose murder sets in motion the events related in the opera. Another drawing, in the Teatermuseum, Drottningholm (fig. 86.1), uses roughly the same setting, shown in daylight, for the scene in which Orestes, hidden in an urn, reveals himself and stabs Aegisthus.[1] The third design for the opera, an interior scene known through a print, represents the crypt of Agamemnon.[2]

The Metropolitan drawing is a spectacular marriage of architecture and human drama. A bizarre grouping of massive architectural elements is cloaked in midnight black, lit by a spectral film of incense smoke and moonlight. The body of the dead hero, glowing and slung between three spears, is delivered on a chariot, accompanied by standard-bearers and trumpet-sounding heralds. Priestesses wait to tend the body, and a distraught figure, most likely Electra, is visible in the right foreground. Owls fly about the ribbed archway above.

Desprez's sets for *Electra* reveal his involvement in the kind of monumental romantic eclecticism emerging at roughly the same moment in the work of the architects Étienne-Louis Boullée and Nicolas Ledoux that offered an alternative to current Neoclassical modes and had an international following. Characterized by an exuberant and resolutely antiacademic combination of styles—Roman, Gothic, and Egyptian—its grandiosity made it an ideal vehicle for operatic set design.

MTH

PROVENANCE: Private collection; [Didier Aaron, Inc.]; private collection, France; [Galerie de Bayser S.A., Paris]; purchased by The Metropolitan Museum of Art.

LITERATURE: Olivier Aaron, *Dessins insolites du XVIIIe français* (Paris, 1985), p. 107, no. 39 (ill. p. 48).

1. See Nils G. Wollin, *Desprez en Suède: Sa vie et ses travaux en Suède, en Angleterre, en Russie, etc., 1784–1804* (Stockholm, [1939]), p. 47, fig. 25.
2. See Barbro Stribolt and Ulf Cederlöf, "Desprez scénographe," in *La chimère de Monsieur Desprez*, exh. cat., Paris, Musée du Louvre (Paris, 1994), p. 41, fig. 22.

86

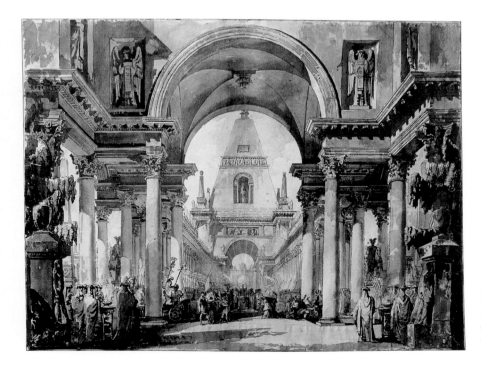

86.1. Louis-Jean Desprez, *The Tomb of Agamemnon*, 1787. Pen and black ink, brush and gray wash, and watercolor, 22½ x 30⅛ in. (57 x 76.5 cm). Teatermuseum, Drottningholm

PIERRE PEYRON

Aix-en-Provence 1744–1814 Paris

87. The Despair of Hecuba

Pen and black ink, brush and gray wash, over slight traces of black chalk, 6½ x 9 in. (16.6 x 22.7 cm). Scattered spots of brown pigment. Signed in pen and black ink at lower left: *P. Peyron. f.*; inscribed at center of lower margin in black ink in the artist's hand: *hecube*

The Metropolitan Museum of Art, Rogers Fund, 1965 (65.125.2)

Pierre Peyron's mature style developed early and evolved little. His subjects, nearly always drawn from ancient history, often deal with death and despair, and the distinctive grace of his figures, in their flowing drapery, lends them a marked poignancy. Born and initially trained in Aix-en-Provence, Peyron went to Paris in 1767 at the age of twenty-three and entered the atelier of Louis Lagrenée. He won the Prix de Rome in 1773 with a *Death of Seneca*, now lost. As a pensionnaire in Rome from 1775 to 1782, under Vien, he painted some of his best work—the *Belisarus* (Musée des Augustins, Toulouse), *Cimon and Miltiades* (Musée du Louvre, Paris), and *Hagar and the Angel* (private collection, Paris), among others. His ordained stay of four years extended to seven, and he did not return to Paris until 1782. Following the success of David's *Oath of the Horatii* and the critical rejection of Peyron's *Death of Alcestis* at the Salon of 1785, Peyron suffered a loss of confidence; after that date, according to Pierre Rosenberg and Udolpho van de Sandt, "Peyron was a mere shadow of his former self."[1]

The subject of this drawing, once identified as the Death of Hecuba based on an inscription on the verso, has been reinterpreted by Rosenberg and van de Sandt as the Despair of Hecuba, which relates Hecuba's distress as her daughter Polyxena is taken by Ulysses to be sacrificed at the tomb of Achilles.[2] In Euripedes' drama *Hecuba* (line 432), Polyxena tells Ulysses: "Cover my head and take me away." The wretched figure of Hecuba, here at the center of a triangle, is shown, in a last futile effort to keep her fate at bay, clutching the shroud that covers the head of the figure at her feet, who must be Polyxena.[3] The elegiac composition, with graceful, draped figures flowing into each other, is the kind perfected in the pediment sculptures and friezes of ancient Greece and Rome, on which Peyron surely modeled the scene. Peyron's sure hand at massing volume and his deft manipulation of wash are characteristic of his draftsmanship. He favored pen and ink with gray wash on light paper, only rarely using chalk except for highlighting or for underdrawing, as here.

Rosenberg and van de Sandt suggest that the drawing dates from 1784, and that Peyron made two studies, both drawn from Euripides, as options for the painting that he planned to submit as his Salon entry of 1785, this one and a *Death of Alcestis* (fig. 87.1). Ultimately, he chose the Alcestis (the painting is now in the Louvre), perhaps, as suggested by Rosenberg and van de Sandt, because François-Guillaume Ménageot had exhibited *Polyxena's Farewell to Hecuba* at the Salon of 1777.[4] MTH

PROVENANCE: [Henri Baderou]; purchased by The Metropolitan Museum of Art.

LITERATURE: *MMA Annual Report*, 1965–66, p. 75 (as "Death of Hecuba"); Rosenberg 1972, p. 194, under no. 109 (as "Death of Hecuba"); Pierre Rosenberg and Udolpho van de Sandt, *Pierre Peyron 1744–1814* (Neuilly-sur-Seine, 1983), p. 121, no. 109, fig. 92; Bean and Turčić 1986, pp. 210–11, no. 233 (ill.); Patrick Ramade, *Première idée*, exh. cat., Musée des Beaux-Arts de Rennes (Rennes, 1987), no. 12a, p. 40, under no. 12.

1. Pierre Rosenberg and Udolpho van de Sandt, *Pierre Peyron 1744–1814* (Neuilly-sur-Seine, 1983), p. 9.

2. Ibid., p. 121, under no. 109.

3. The subtle and affecting poignancy of Peyron's conception of the scene is well illustrated by a comparison with Ménageot's *Les adieux de Polyxène à Hécube* (Musée des Beaux-Arts, Chartres), an operatic display with large gestures and anguished faces.

4. Rosenberg and van de Sandt, *Pierre Peyron*, p. 121, under no. 109; see also note 3, above.

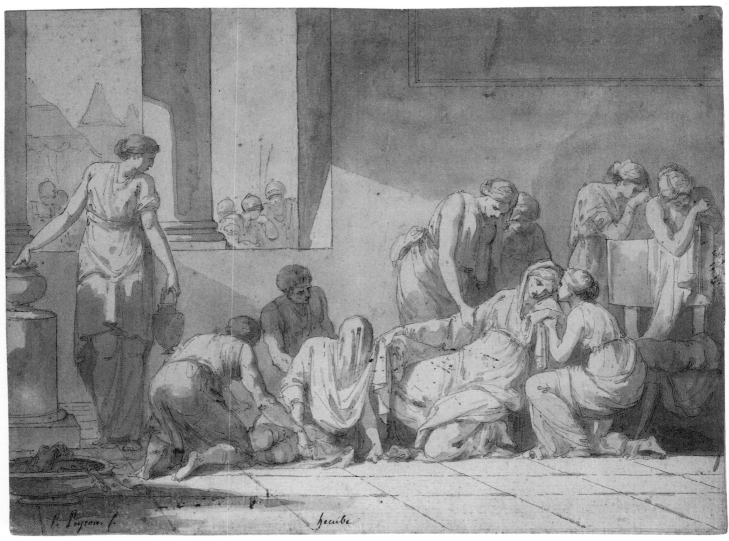

87

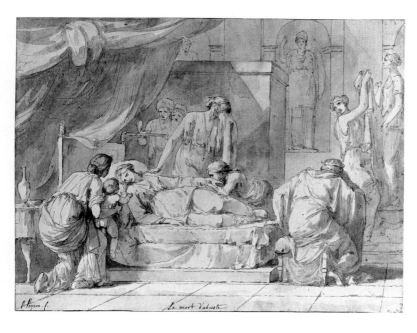

87.1. Pierre Peyron, *The Death of Alcestis*, ca. 1784. Pen and black ink, brush and gray wash, heightened with white, on beige paper, 13⅛ x 13⅛ in. (33.2 x 33.2 cm). Private collection, Paris

JACQUES-LOUIS DAVID

Paris 1748–1825 Brussels

88. The Death of Camilla

Black chalk with brush and gray wash, 14⁷⁄₁₆ x 15⁹⁄₁₆ in. (36.7 x 39.5 cm)

The Metropolitan Museum of Art, Gift of Joan K. Davidson, in memory of her mother, Alice M. Kaplan, 1998 (1998.203)

It is difficult to trace the precise origins of certain ideas in David's oeuvre. His Roman albums of copies after the antique, for example, demonstrate an early interest in the same themes and motifs that infuse his mature work—heroism, death, and mourning.[1] In the case of his groundbreaking Neoclassical icon *The Oath of the Horatii* (Musée du Louvre, Paris), commissioned by the crown after the 1781 Salon, echoes of figural types from ancient tombs and sarcophagi informed the conceptualization of the subject from its earliest stages.

To spare lives, the ancient tribes of the Romans and the Albans each delegated three warriors to engage in a battle that would settle a larger dispute that had been raging for some time. Unfortunately, it was the three Curiatii brothers who were chosen by the Albans to fight the three sons of the Roman Horatia clan, for there were strong ties between the families. Sabina, a sister of the Curiatii, was married to the Roman Horatius, and Horatius's sister, Camilla, was engaged to one of the Curiatii. The theme of love and duty opposed held a strong attraction for David and would find resonance in light of the historical events of the following decades.

The surviving studies for the painting record David's exploration of various closely related episodes of the story, before he settled on the atextual, yet visually gripping, moment of the brothers' pledge to their father.[2] The Metropolitan's sheet, which appears to be David's first idea for the composition, represents a later moment in the story. Horatius returns victorious to Rome, having slain the enemy but having also lost his two brothers in battle. Soldiers bearing trophies march behind. Camilla, distraught upon learning that her fiancé is dead, accosts her brother in her grief. Angered by her lack of patriotic spirit, Horatius, to the horror of the onlookers, kills her on the spot.

David begins, as was his practice, by studying the poses of the central figures, in this case placing them over a very faint architectural backdrop. On the ground, Camilla, just or about to be stabbed, reaches back, imploring her brother, who displays no pity but only points at her accusingly, nearly treading on her hair. Either because the pathos was

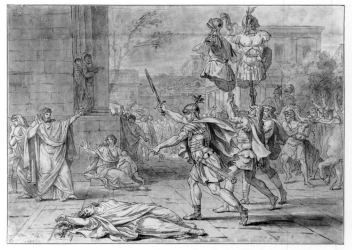

88.1. Jacques-Louis David, *The Victorious Horatius Returning to Rome.* Pen and black ink, brush and gray wash, over black chalk. Albertina, Vienna

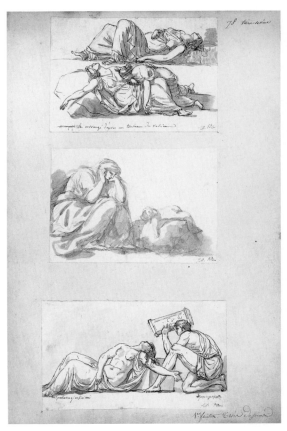

88.2. Jacques-Louis David, *Sheet of Studies,* Roman Album no. 11. Getty Research Institute, Research Library, Los Angeles

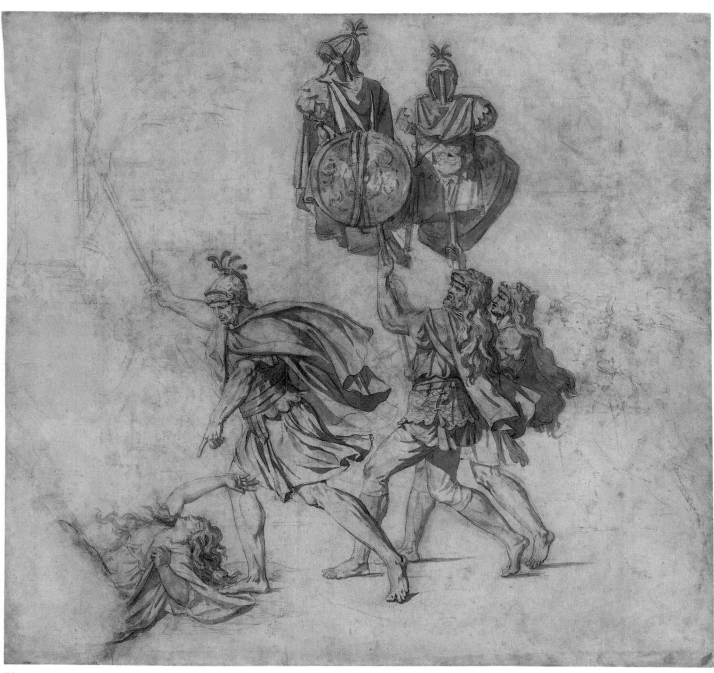

88

too great or the pose too awkward, David turned Camilla around in the more finished compositional study in the Albertina (fig. 88.1), showing her dead rather than writhing. Another compositional study, in the Louvre, shows David considering yet another scene, in which the patriarch of the Horatia clan pleads with the lictors to pardon his son for the murder of his daughter. This was apparently the episode preferred by the crown.[3] According to a contemporary, David was discouraged by his friends from pursuing this unpalatable subject, at which point he began work on *The Oath of the Horatii*.[4] The Louvre study presumably follows the New York and Vienna sheets, as the poses of Horatius and Sabina approach those of the final version.

Female expressions of grief were, for David, an effective counterpoint to male acts of bravery and patriotism. As Dorothy Johnson has discussed, David rejected Le Brun's method of representing the passions through facial expression in favor of a corporal language in which the pose of the body and its gestures convey a figure's inner state.[5] For poses of intrepid warriors and grieving women, David made constant reference to his Roman sketchbooks (for example, fig. 88.2),[6] which he kept in his studio until his death. While he never made a painted version of the Death of Camilla, his drawings of the scene were the basis of a painting made by his young student Anne-Louis Girodet in 1784, after David had returned to Rome to complete *The Oath of the Horatii*.[7]

P S

PROVENANCE: [Gilbert Pelham, New York, in 1973]; Alice M. Kaplan, New York; by descent to Joan K. Davidson; given to The Metropolitan Museum of Art.

LITERATURE: Linda Bantel, *The Alice M. Kaplan Collection* (New York, 1981), pp. 98–99, no. 42; Paris and Versailles 1989, pp. 138, 164.

1. Arlette Sérullaz, "Les dessins du premier séjour romain," in Paris and Versailles 1989, pp. 65–71.
2. Although it was published before the discovery of the present sheet, Arlette Calvet's article, "Unpublished Studies for 'The Oath of the Horatii' by Jacques-Louis David," *Master Drawings* 6, no. 1 (1968), pp. 37–42, describes the general evolution of the composition.
3. Paris and Versailles 1989, p. 164.
4. Paris and Versailles 1989, p. 166.
5. Dorothy Johnson, *Jacques-Louis David: Art in Metamorphosis* (Princeton, 1993), especially "The Eloquent Body," pp. 11–69.
6. Album 11, which contains the studies illustrated as fig. 88.2, was acquired by the Getty Center in 1994; see Kevin Salatino, "Acquisition in Focus: J.-L. David's Roman Album 11 at the Getty Center," *Apollo* 140, no. 393 (November 1994), pp. 50–51.
7. Even closer to Girodet's conception of the subject than the New York or Vienna sheets is a quick sketch in black chalk on the verso of a wash study for *The Death of Socrates* in a private collection; see Paris and Versailles 1989, pp. 178–79, no. 76.

Horatius Killing His Sister was also the Grand Prix subject of that year, and Girodet may have intended his canvas as a kind of shadow entry; see Crow 1995, pp. 89–90.

JEAN-GERMAIN DROUAIS

Paris 1763–1788 Rome

89. *Marius at Minturnae*

Pen and brown ink, brush and brown and gray wash, over black chalk, 7⅛ x 9⅞ in. (18.2 x 25.2 cm)

Private collection

The premature death in Rome at the age of twenty-four of Jean-Germain Drouais, the son of the court portraitist François-Hubert Drouais (1727–1775) and a favorite student of Jacques-Louis David, left a legacy of unfulfilled hopes. When he had completed six large-scale paintings, Drouais's reputation was such that Jean-Baptiste Marie Pierre, *premier peintre du roi,* predicted that he would soon surpass his celebrated teacher.

Drouais, despite his ambition and obvious gifts, was painfully insecure, and the process of preparing these canvases was often a tortured and protracted one. Straining against the proscribed routines and regulations of the Académie, he continued to be highly dependent on David for guidance. To prepare *Marius at Minturnae* (fig. 89.1), the painting for which this sheet is a study, Drouais closeted himself away from Lagrenée, the director of the Académie de France in Rome, working in secret while sending compositional sketches to David in Paris for approval.[1]

An early study for the painting in the Musée des Beaux-Arts, Lille (fig. 89.3), offers direct evidence of this process. Bearing visible fold marks, presumably from having been enclosed with a letter, the Lille study is reworked in areas and marked, in David's hand, "Ne changez rien / Voilà le bon" (Don't change a thing / This is the good one.).[2] Drouais continued to refine his treatment of the subject in at least six further studies: the present sheet, two compositional studies now at Lille, a figure study now at Besançon for the Cimbrian soldier and a drapery study for the same figure at the École Nationale Supérieure des Beaux-Arts in Paris,[3] and an oil sketch in a New York private collection.[4] The wash study at Lille (fig. 89.2) must be the earliest of the group, perhaps followed by the figure study at Besançon. The sheet with two figure studies sent to David (fig. 89.3) most likely came after. Marius is now given a melancholy aspect and is wrapped in a heavy shawl (in the painting his only garment); the soldier lifts his cape to cover his face; and the idea for changing the design of the table appears.

In the present sheet, perhaps most evocative of the tension and the dramatic lighting of the final version, Drouais has simplified both the round table and the wall at the left, leaving the figures as they were approved by David, but adding Marius's helmet to the table as a sign of his former vocation. In the squared compositional study (fig. 89.4) and in the oil sketch that followed (in which he approached the final dress of the two figures), Drouais departed unexpectedly from his earlier characterization of Marius, distorting

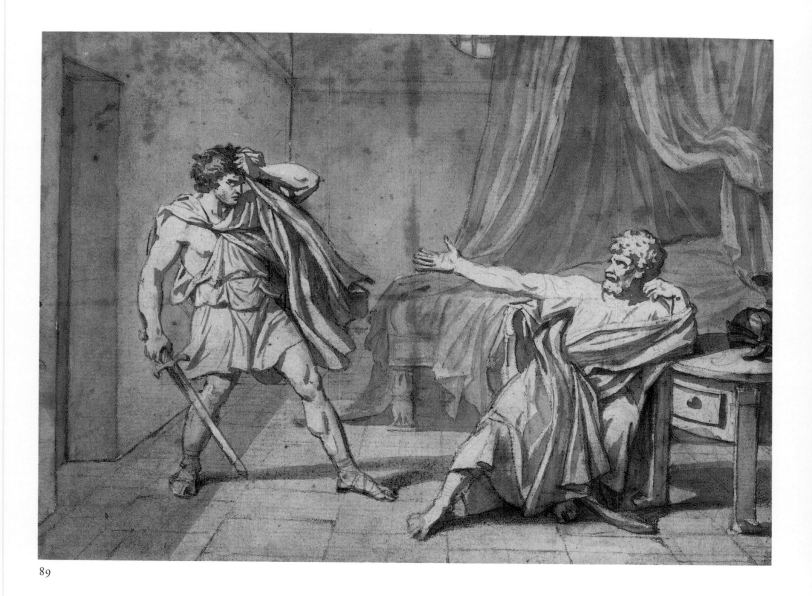

89

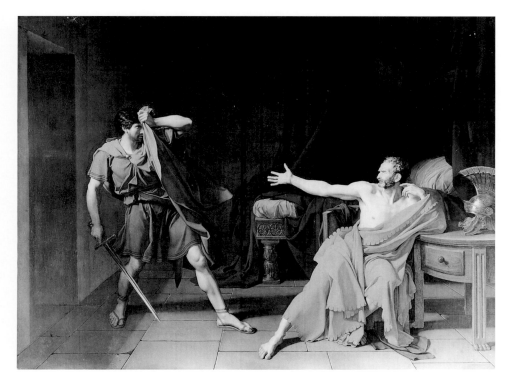

89.1. Jean-Germain Drouais, *Marius at Minturnae,* 1786. Oil on canvas, 106¾ x 143¾ in. (271 x 365 cm). Musée du Louvre, Paris

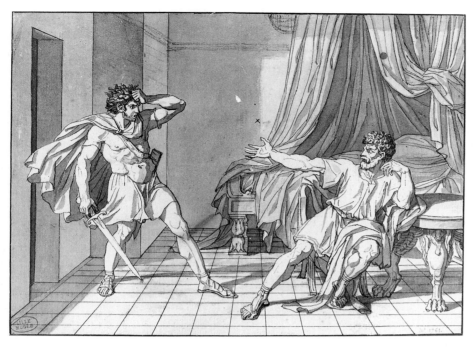

89.2. Jean-Germain Drouais, *Marius at Minturnae*. Pen and black ink, brush and gray wash, over graphite underdrawing, 7¼ x 10⅛ in. (18.5 x 25.6 cm). Musée des Beaux-Arts, Lille

his features into a bloodthirsty mask and replacing nobility with avarice, an idea he abandons in the final painting.

On one level, Drouais's vacillations over Marius's character have their source in Plutarch's *Lives,* where his history is one of vengeful bloodshed as well as valiant leadership. Having led many victorious battles, the aging general is exiled by his enemies in the Senate and flees Rome, only to be captured and taken prisoner outside the town of Minturnae, where local authorities order that he be executed. Drouais, like many other Neoclassical artists,[5] chose to depict the moment when the soldier assigned to carry out the execution approaches Marius in his gloomy cell but is stricken with fear and ultimately rendered incapable of carrying out his task by his encounter with the forceful personality of the unarmed former general.[6]

Completed and unveiled in August 1786, the painting met with great acclaim in Rome and was sent back to Paris, where it created a sensation in the two months it was exhibited in the artist's mother's house—forcing her to hire guards to control the crowds. Painted on the same scale as

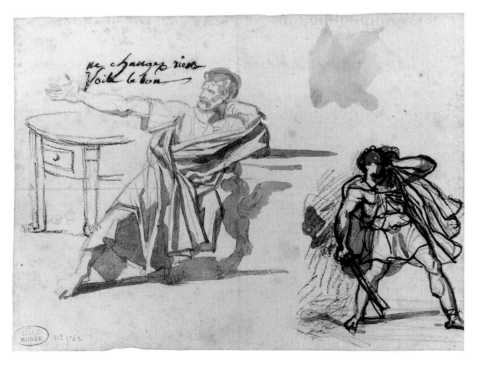

89.3. Jean-German Drouais (with additions by Jacques-Louis David?), *Study for "Marius at Minturnae."* Pen and black ink, brush and gray wash, over black chalk and graphite underdrawing, 6⅛ x 8⅛ in. (15.4 x 20.7 cm). Musée des Beaux-Arts, Lille

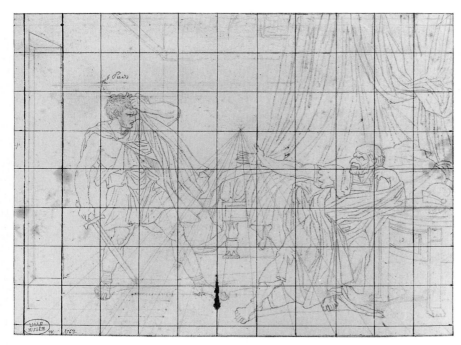

89.4. Jean-Germain Drouais, *Study for "Marius at Minturnae."* Graphite, 8⅜ x 11⅛ in. (21.4 x 28.3 cm). Musée des Beaux-Arts, Lille

The Oath of the Horatii (in which he assisted David), *Marius at Minturnae* shows Drouais having assimilated the lessons of his master without falling prey to imitation. In a dramatically lit shallow space, classically inspired figures convey their inner states through highly expressive poses. Given the close working relationship between the two painters, it is not surprising to find parallels in their methods of preparation as well as shared pictorial devices. After ideas for figural groups and poses had been established, the entire composition would be laid out in a blocky, expressive wash, as here, and finally, large-scale drapery studies would be prepared for each major figure (see no. 90). David's words at receiving the news of Drouais's untimely death were, most poignantly, "I have lost my emulation."[7]

P S

PROVENANCE: [Galerie de Staël, Paris]; Jérôme Fourier, Paris; [David and Constance Yates, New York]; sale, Christie's, New York, May 22, 1996, lot 4; private collection.

Unpublished.

1. A number of surviving documents describing Drouais's behavior during this period are quoted in the entry on the painting in Ramade 1985, pp. 48–50.

2. Drouais acknowledged David's aid in a letter of August 30, 1786: "Grâce à vos bons avis, on a été content de mon tableau, au delà de mes espérances." Quoted in Paris and Versailles 1989, p. 571.

 Patrick Ramade has plausibly suggested that the original idea for the subject may have come from a quick sketch made by David on his first trip to Italy and kept in one of the albums of drawings that must have been available to members of his studio. See Patrick Ramade, "Jean-Germain Drouais: Recent Discoveries," *The Burlington Magazine* 130, no. 1022 (May 1988), pp. 366–67.

3. Ramade 1985, p. 53, no. 15.

4. Ramade 1985, pp. 53–54, no. 16.

5. For a list of other artists treating this subject, see Ramade 1985, p. 50, and Ramade, "Jean-Germain Drouais: Recent Discoveries," p. 367. Judging from a photograph, a drawing attributed to Drouais in the Musée des Beaux-Arts, Rouen (inv. 975.4.1241), seems more likely to be by François-Xavier Fabre (1766–1837).

6. Drouais's choice of subject—and his indecisiveness over how to portray it—may reflect his anxieties over his own relationship to authority in general and to his master in particular, as Thomas Crow has argued in Crow 1995, pp. 63–69.

7. Crow 1995, p. 1.

JACQUES-LOUIS DAVID

Paris 1748–1825 Brussels

90. Figure Study for "The Death of Socrates"

Black chalk, stumped, heightened with white, squared in black chalk, 21⅛ x 16⅜ in. (53.6 x 41.5 cm). Inscribed in graphite at lower right: *David à son ami chaudet*

The Metropolitan Museum of Art, Rogers Fund, 1961 (61.161.1)

Just as he had for *The Oath of the Horatii* (see no. 88), David made large-scale, highly nuanced drapery studies in preparation for his 1787 painting *The Death of Socrates* (fig. 90.1), commissioned by his friend and supporter Charles-Michel Trudaine de la Sablière.[1] A compositional study in wash (fig. 90.2), dated 1782, suggests that David had conceived of the subject well before the painting was commissioned. The subject of the Death of Socrates was a popular one with painters in the last decades of the *ancien régime*, spurred in part by Diderot's *De la poésie dramatique* (1758), in which the philosopher envisions the subject as suitable for pantomime. David's rival Pierre Peyron had been working on a painting of the same subject since 1780, although the public comparison of Peyron's sketch and David's finished canvas in the Salon of 1787 undoubtedly benefited the reputation of the latter.[2]

The Metropolitan's sheet is a study for the figure of Crito, a wealthy Athenian disciple of Socrates who had offered to help him escape from prison. In the wash drawing he holds a large book on his lap, but his pose is rethought in the New York study for the painting, in which he inclines forward, his hand extended to clutch the philosopher's leg as he gazes into the older man's face, beseeching him not to drink the poison. Plato, by contrast, sits passively at the foot of the bed, facing away. Others lean against the wall or cover their faces with their hands. The differentiation between the reactions of Socrates' followers was, for David, as much the subject of the painting as Socrates' act itself.

Revisions in details of facial features, hair, and extremities in the final canvas reveal David's continual process of focus and refinement. By contrast, the drapery, as studied in the six surviving studies, is transferred, via squaring, to the canvas with minimal alterations. In this example, gentle gradations of black chalk and white heightening describe the folds of Crito's himation in sensuous and restrained monochrome, bringing to mind the sixteenth-century forerunners of this artistic tradition. PS

PROVENANCE: Antoine-Denis Chaudet (according to the inscription); [Wildenstein & Co., London, 1961]; purchased by The Metropolitan Museum of Art.

LITERATURE: Jacob Bean, "The Drawings Collection," *The Metropolitan Museum of Art Bulletin* 20, no. 5 (January 1962), pp. 170–71,

90.1. Jacques-Louis David, *The Death of Socrates*, 1787. Oil on canvas, 51 x 77¼ in. (129.5 x 196.2 cm). The Metropolitan Museum of Art, Wolfe Fund, 1931 (31.45)

90.2. Jacques-Louis David, *The Death of Socrates*, 1782. Brush and gray wash over black chalk, 9¼ x 14¾ in. (23.5 x 37.5 cm). Private collection

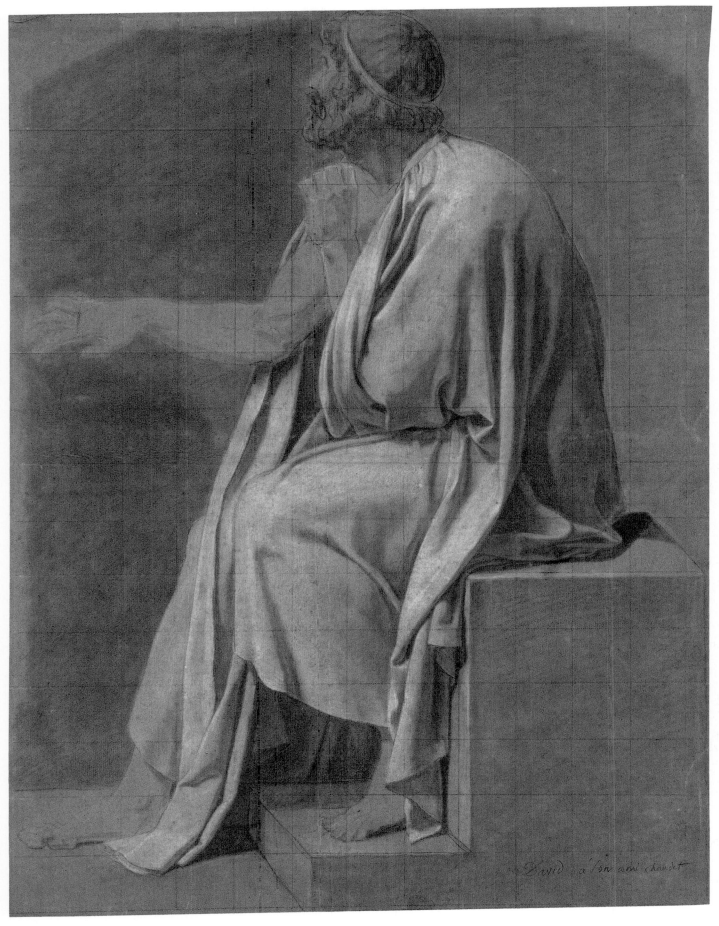

90

fig. 16; *MMA Annual Report,* 1961–62, p. 67; Bean 1964, no. 62; London 1968, p. 64, no. 182, fig. 330; *Dessins français du Metropolitan Museum of Art, New York, de David à Picasso,* exh. cat., Paris, Musée du Louvre, Cabinet des Dessins (Paris, [1973]), pp. 30–31, no. 23, pl. 2; *Le néo-classicisme français: Dessins des musées de province,* exh. cat., Paris, Grand Palais (Paris, 1974), p. 36, no. 18 (entry by Arlette Sérullaz); *French Painting 1774–1830: The Age of Revolution,* exh. cat., Paris, Grand Palais; The Detroit Institute of Arts; New York, The Metropolitan Museum of Art (Detroit, [1975]), p. 368, under no. 32 (entry by Antoine Schnapper); Bean and Turčić 1986, pp. 87–89, no. 90; Jean-Jacques Lévêque, *La vie et l'oeuvre de Jacques-Louis David* (Paris, 1989), p. 84; Paris and Versailles 1989, p. 180, under no. 77

(entry by Arlette Sérullaz); Los Angeles, Philadelphia, and Minneapolis 1993, p. 191, no. 40.

1. In addition to the present study, which was given by David during his lifetime to his friend the sculptor Antoine-Denis Chaudet (1736–1810), the other five drapery studies for *The Death of Socrates* (three in the Musée Léon Bonnat, Bayonne, one in the Musée des Beaux-Arts, Tours, and one in the Musée Magnin, Dijon) were in all likelihood the five sold as a single lot in David's estate sale (Paris, April 17, 1826, lot 97).
2. Pierre Rosenberg and Udolpho van de Sandt, *Pierre Peyron 1744–1814* (Neuilly-sur-Seine, 1983), pp. 124–27, no. 114.

ANNE-LOUIS GIRODET

Montargis 1767–1824 Paris

91. *The Mourning of Pallas*

Pen and brown ink, brush and gray and brown wash, heightened with white, 9¹⁵⁄₁₆ x 6⁷⁄₁₆ in. (25.2 x 16.4 cm). Inscribed at lower left in graphite: *Girodet inv.;* at lower center in brown ink: . . . *HEI MIHI! QUANTUM / PRÆSIDIUM AUSONIA ET QUANTUM TU PERDIS, IULE!;* at lower right in graphite: *Eneide liv. XI*

The Metropolitan Museum of Art, The Elisha Whittelsey Collection, The Elisha Whittelsey Fund, 1996 (1996.567)

91.1. Jacques-Louis David (1748–1825), *Andromache Mourning Hector,* 1783. Oil on canvas, 108¼ x 79⅞ in. (275 x 203 cm). École Nationale Supérieure des Beaux-Arts, on deposit at the Musée du Louvre, Paris

Pierre Didot *l'aîné*'s project to revive the art of fine book publishing in the years following the Revolution provided welcome income for a number of David's students. Some of the greatest examples of French Neoclassical book illustration were the result of these ambitious undertakings, most notably the designs for the 1798 edition of Virgil and the Racine that began publication in 1801. David worked on both these projects in a supervisory capacity and apparently delegated the commissions. As with many projects originating in David's studio, the precise nature of the working relationship between master and student is difficult to discern. Presumably it was Didot who first approached David, and David who then divided the commission between two of his most talented students, François Gérard and Girodet. Including the frontispiece, Girodet contributed seven designs to the Virgil, for which a number of preliminary studies are known; the present, previously unpublished, sheet is only the second finished drawing to surface.[1]

In the 1797 prospectus announcing the publication of the Virgil, Didot traces the project back seven years, to when David had agreed either to produce the drawings or, if his commitments prevented it, to entrust them to two of his students.[2] The arrangement described by Didot finds confirmation in a letter written in January 1791 by Girodet, who was in Rome, to David, who was in Paris. Enclosed with the letter were six drawings for the Virgil, three by Gérard and three by Girodet. In the letter Girodet mentions four compositions that had already been sent, and requests that David make suggestions and changes for the present six.[3]

Whether chosen by Didot, David, or Girodet himself, the passage represented in the Metropolitan's drawing features one of Girodet's most beloved motifs, the beautiful, even erotic, corpse.[4] Taken from book 11 of *The Aeneid*, the scene shows Aeneas comforting his son, Iulus, at the loss of the young prince Pallas, who had been felled in battle. The grieving old man who embraces the corpse is Acoetës, the prince's appointed companion. Girodet, the best educated of David's students,[5] follows Virgil closely. The importance of certain details described in the text—"the snow-white face of Pallas, the smooth chest and the open wound"[6]—becomes clear in Aeneas's address to Pallas's absent father, Evander—"you will see no shameful wound of one who ran, hit from behind."[7]

Neoclassical deathbed scenes of the 1790s had long pedigrees, and Girodet's compositional debts are easily enumerated.[8] The most obvious is to David's *Andromache Mourning Hector*, 1783 (fig. 91.1). Girodet's drawing anticipates the reversal of the printing process in what can only be seen as an intentional act of homage. However, the residual Baroque vocabulary of David's grieving Andromache is nowhere to be found in Girodet's tableau of noble male grief.

David himself continued to draw on the motif of the dead warrior into the 1790s, adeptly refashioning classical iconography to glorify the martyrs of the Revolution, most notably in *The Death of Marat* (Musées Royaux des Beaux-Arts de Belgique, Brussels) and in the public ceremony he orchestrated honoring Le Pelletier de Saint-Fargeau.[9] Executed between 1790 and 1797, Didot's edition of *The Aeneid* flowed from the same mixed current, Virgil's epic story of the founding of the Roman republic providing a natural symbolic association with the founding of the French republic by the heroes and martyrs of the Revolution.[10]

Debts to David notwithstanding, the present sheet is an object of exquisite refinement which transcends its sources and offers ample illustration of the stylistic eccentricities and mastery of technique that set Girodet apart from other Davidian artists. To render the scene on a scale appropriate to book illustration, Girodet reduced the cast of characters to the four essential figures standing for youth, maturity, old age, and death. The body of Pallas and the grieving Acoetës are bathed in ethereal moonlight, an effect for which Girodet had a lifelong affection. Balancing them, and similarly locked in an embrace of grief, are Aeneas and Iulus—among the living, but cast in shadow. In addition to the idealized and painstakingly modeled nudes,[11] Girodet lavished attention on details of Neoclassical design—from the bed, with its battle scene motif, to the carefully wrought frieze of antique arms and armor along the top band of the composition. The delicacy of the technique, evident in such details as the effect of smoke suggested by thinned gouache, goes beyond the visual information required by the printmaker and suggests that Didot's second use of the drawings—bound in a vellum copy of *The Aeneid* and presented to his brother Firmin, as a gift in appreciation of his labors in developing the Neoclassical typeface used in the book—was part of his plan early on.

P S

PROVENANCE: Pierre Didot *l'aîné*; given by him to Firmin Didot; offered at his sale, 1810 (*Catalogue des livres . . .* , lot 488), but failed to meet its reserve; sale, about 1814; Coutant-Schubert collection; sale, Pascal Berquat, Marseille, September 29, 1996, lot 153; [Katrin Bellinger, Kunsthandel, Munich]; acquired by The Metropolitan Museum of Art.

Unpublished.

1. The other is *Enée et ses compagnons abordent dans le Latium à l'embouchure du Tibre*, in the Musée Fabre, Montpellier (inv. 836-4-255), reproduced in *Le néo-classicisme français: Dessins des musées de province*, exh. cat., Paris, Grand Palais (Paris, 1974), p. 70, no. 63.

2. See Carol Margot Osborne, "Pierre Didot the Elder and French Book Illustration, 1789–1822" (Ph.D. diss., Stanford University, 1979), p. 107.

3. The letter is quoted in ibid., pp. 107–8.

4. Concurrently with the Virgil illustrations, Girodet was at work on the painting that would ultimately make his reputation, *The Sleep of Endymion* (Musée du Louvre, Paris), which featured not a corpse but a moonlit sleeping nude. *The Burial of Atala* (Musée du Louvre, Paris) presents a corpse as an object of erotic interest.

5. Crow (1995, p. 86) makes this point, drawing on an unpublished dissertation by Stephanie Nevison Brown, "Girodet: A Contradictory Career" (Ph.D. diss., University of London, 1980).

6. Virgil, *The Aeneid,* translated by Robert Fitzgerald (New York, 1990), 11.52–53, p. 332. Girodet departs slightly from the text, including, among the foreground elements, Pallas's sword, while in the poem Turnus, who has inflicted the fatal wound, is described as taking the sword, with the sword belt, as a trophy (10.694 and 11.121–23).

7. Ibid., 11.75–76, p. 333. When Girodet returned to the subject of *The Aeneid* later in life (a vast project left incomplete at his death), he chose an earlier moment to depict: the body of Pallas carried off the battlefield by his comrades (Musée des Beaux-Arts, Saintes, inv. 72.2.1). For a discussion of this group as a whole, see *Le néo-classicisme français*, p. 73.

8. See Osborne, "Pierre Didot the Elder," pp. 112–13.

9. Paris and Versailles 1989, pp. 581–82.

10. Osborne, "Pierre Didot the Elder," pp. 111–13.

11. The depiction of Roman soldiers as nude was a novelty that certainly owed its impetus to David, who was at the time working on his *Sabine Women* (1799) and would prepare, in connection with its exhibition, a pamphlet defending the practice. See Dorothy Johnson, *Jacques-Louis David: Art in Metamorphosis* (Princeton, 1993), pp. 128–30, and Osborne, "Pierre Didot the Elder," p. 114.

GUILLAUME BOICHOT

Chalon-sur-Saône 1735–1814 Paris

92. Meleager Presenting the Head of the Calydonian Boar to Atalanta

Pen and brown ink, brush and gray-brown wash, heightened with white, over traces of black chalk. Framing lines in pen and brown ink, 7 x 14¼ in. (17.7 x 36.2 cm). Blind stamp at lower right: ARP (Lugt 172, unidentified, considered to be an eighteenth-century mountmaker's stamp)

The Metropolitan Museum of Art, Van Day Truex Fund, 1993 (1993.12.1)

Born in Chalon-sur-Saône, Boichot went to Paris to study with the sculptor Simon Challe (1719–1765). Failing to win the Prix de Rome, he went on to make two trips to Rome at his own expense, soaking up not only the glories of classical antiquity but those of sixteenth-century Italy as well. He settled in Paris in 1771, employed primarily through provincial commissions. He was not *agréé* by the Académie until 1788, and he was never *reçu*, although he exhibited his work (drawings as well as paintings) regularly at the Salon beginning in 1789. Boichot's fortunes improved after the Revolution, in part because of his close ties to Alexandre Lenoir, a former student of Doyen's who became guardian to an official warehouse of art displaced by the Revolution. The warehouse evolved under Lenoir's leadership into a museum of French sculpture and tomb monuments.[1] In addition to granting him studio space in the Dépôt des Petits-Augustins, Lenoir privately commissioned small-scale works from Boichot, including a pair of terracotta vases depicting the Calydonian Hunt.

Dating stylistically to about 1800, the two vases are in the shape of urns with handles in the form of serpents. Narrative scenes sculpted in shallow relief wrap around the body of the vases as a circular frieze. One shows Meleager and Atalanta Departing for the Hunt; its pendant, for which the Metropolitan's sheet is a study, depicts the more common scene of Meleager Presenting the Head of the Calydonian Boar to Atalanta (figs. 92.1–92.4).[2] The story of Meleager as told in Ovid's *Metamorphoses* (8:268–444) was a popular one in art. Returning a hero from his quest for the Golden Fleece only to find his homeland ravaged by a savage boar sent by Diana, Meleager organizes a band of his companions to kill the beast. Succeeding in this mission, he presents the boar's head to the huntress Atalanta, whose arrow had drawn the first blood. When two of his uncles protest, Meleager kills them on the spot. His mother's anger at this act later brings about his own death.

In the drawing Boichot has placed the two protagonists at the center of the composition, their poses in elegant balance. Warriors with spears and dogs are shown at Meleager's left, while female onlookers and Bacchic figures fill out the compositional band to the right. Boichot renders the attenuated figures in graceful ink lines and delicate parallel hatching, their drapery falling in repetitive ripples of small pleats.[3] The modeling of certain figures is articulated more persua-

ELISABETH-LOUISE VIGÉE LE BRUN

Paris 1755–1842 Paris

93. *Self-Portrait*

Pastel, 19⅝ x 15¾ in. (50 x 40 cm)

Private collection

Vigée Le Brun's fame rests firmly on her ability to combine in her portraits a seductive intimacy with a sophisticated and flattering technique. Nowhere is that more evident than in her steady stream of self-portraits (her legendary beauty making her the ideal model).

Although pastel was not Vigée's preferred medium, she used it throughout her career. Among her earliest works are a number of pastel portraits of members of her family.[1] She was drawn to the medium for its ease of handling, its range of color and tone, and its suitability for layered effects, qualities that allowed her to replicate in drawing the luminosity achieved in painting through the layering of glazes. That luminosity is much in evidence here. While the image is fully realized, the chalk is often left unblended, adding to the sense of freshness and youth. The more finished face is deftly framed with loose and bewitching strokes of muslin and of chestnut curls. The blooming complexion is flawless, and a tiny red dab enhances limpid brown eyes and peach lips. The modesty of the costume—a simple traveling coat, or carrick, tied with a bit of muslin—adds to the naturalism and feeling of vitality; indeed, simplicity of dress was a popular device in eighteenth-century portraiture for achieving a sense of intimacy. Vigée rims the coat with a chalked black line, giving it a gritty weight.

The dewy youth of the sitter perhaps suggests an element of self-flattery, as Vigée probably made the portrait about 1789, when, exiled from Revolutionary Paris, she arrived in Rome.[2] This would suggest that she was a good decade older than she appears in the drawing. The circumstances of its creation are known to us because of an old inscription on the original backing which states that it was left by M. Ménageot to Mme Nigris, Vigée's daughter Julie, upon his death in 1816. In 1789, François-Guillaume Ménageot had been the director of the Académie de France in Rome for two years. Apparently he invited Vigée and her daughter to stay at the Palazzo Mancini until they found accommodations in Rome. Vigée had been Ménageot's landlady in Paris before his appointment, and it has been speculated that she helped him get the directorship through her court connections. Joseph Baillio has plausibly suggested that this self-portrait was drawn and given to Ménageot at the time the artist was living at the palazzo, when she was working on a commission for the gallery of artists' self-portraits in the Uffizi.[3]

Vigée's move to Rome interrupted a remarkable career bolstered by important social connections. With the aid of her art dealer husband, Jean-Baptiste Pierre Le Brun, she forged a client list that formed a veritable who's who of the *ancien régime* on the eve of the Revolution. She painted her first portrait of Marie-Antoinette in 1778, and would eventually portray the queen some twenty times. Perhaps her most celebrated portrait is the powerful plea for sympathy *Marie-Antoinette et ses enfants,* 1787, now at Versailles. Vigée's admission to the Académie proved to be contentious given her husband's "degrading" commerce in art. Ultimately, the queen intervened on her behalf, and she was *reçue* in 1783. Her forced exile six years later took her to Italy, Austria, Germany, and Russia, where she was highly successful. Vigée did not return to France until 1802. She painted little in her last years. MTH

PROVENANCE: Given by the artist in Rome to François-Guillaume Ménageot (1744–1816); by bequest to Mme Gaétan Bernard Nigris, née Julie Le Brun (1780–1819), Paris; private collection.

LITERATURE: Baillio 1989, p. 55, no. 47; Joseph Baillio, "Vigée Le Brun pastelliste et son portrait de la duchesse de Guiche," *L'Oeil,* no. 452 (June 1993), p. 22, fig. 13.

1. See Joseph Baillio, "Vigée Le Brun pastelliste et son portrait de la duchesse de Guiche," *L'Oeil,* no. 452 (June 1993), pp. 20–22. For Vigée's career as a draftsman, see Pierre Rosenberg, "A Drawing by Madame Vigée-Le Brun," *The Burlington Magazine* 123, no. 945 (December 1981), pp. 739–40.
2. See Baillio 1989, p. 55. The artist's list of sitters in her diary for the year 1789 includes the entry "Mon portrait au pastel" but does not describe it any further (*Souvenirs de Madame Louise-Elisabeth Vigée le Brun . . .* , 3 vols., [Paris, 1835–37], vol. 1, p. 337).
3. Baillio 1989, p. 55.

93

JEAN-BAPTISTE MALLET

Grasse 1759–1835 Paris

94. *The Shoe Salesman*

Gouache over pen and brown ink, 11⁹⁄₁₆ x 8¹¹⁄₁₆ in. (29.3 x 22 cm)

The Phillips Family Collection

Mallet is another of the chroniclers of the habits and finery of affluent society for whom gouache was such an effective medium (see also no. 76). He studied with Simon Julien in Toulon, then in Paris with Jean François Léonor Mérimée and Pierre-Paul Prud'hon, but his work in gouache shows the influence of Nicolas Lavreince (Niklas Lafrensen), Philibert-Louis Debucourt, and Louis-Léopold Boilly as well. Later in his career, he gave up contemporary genre for Neoclassical mythologies and the Gothic Troubadour style. He exhibited at the Salon from 1791 to 1824, and his work was often engraved.[1]

This charming scene, datable to the early 1790s by the clothing, is characteristic of Mallet in the facial types, the precision of its detail, and the inventive use of pattern and texture. Often he would anchor his compositions with a standing female figure at the center, as here. At the end of the century, one can trace Mallet's image of the flirtatious engagement of fashionable merchant and affluent lady back to the same vast repository of genre images from which Claude Simpol also drew inspiration—the seventeenth-century popular print tradition (see no. 2). The purveyance of fashionable goods to stylish women was a subject commonly used for prints, one that translated well to genre painting.[2] Among their most well-known derivatives are Watteau's *Gersaint's Shopsign*, 1720–21 (Schloss Charlottenburg, Berlin), and Boucher's *The Milliner (Morning)*, 1746 (Nationalmuseum, Stockholm). A shoe salesman is especially suitable for a scene of amorous flirtation, such as we have here, as shoes are an old and recognizable symbol of virginity, their loss equated in the eighteenth century with its loss. MTH

PROVENANCE: The Phillips Family Collection.

Unpublished.

1. For Mallet's life and work, see *French Painting 1774–1830: The Age of Revolution*, exh. cat., Paris, Grand Palais; The Detroit Institute of Arts; New York, The Metropolitan Museum of Art (Detroit, [1975]), pp. 538–41; and Thérèse Burollet, *Musée Cognacq-Jay: Peintures et dessins* (Paris, 1980), pp. 281–86.
2. See Holmes 1991, pp. 51–53.

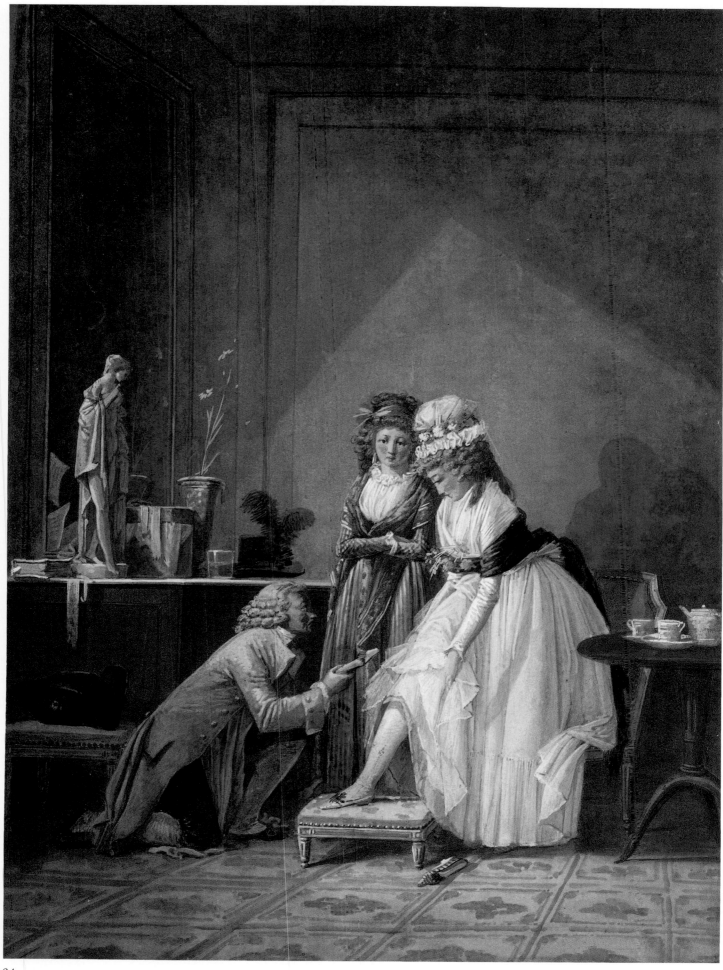

LOUIS-ROLAND TRINQUESSE

ca. 1745–ca. 1800

95. Portrait of François Reidy de Lagrange

Red chalk, diameter 8⅜ in. (21.3 cm). Signed in red chalk at lower margin: *L. Trinquesse. f.*

The Metropolitan Museum of Art, Rogers Fund, 1967 (67.150)

No documents have been found to establish the date or place of Trinquesse's birth or death, though circumstantial evidence suggests that he may have been from Burgundy. He is recorded as having won medals at the school of the Académie Royale in 1770, but he did not continue to be associated with that institution, exhibiting instead at the Salon de la Correspondance from 1779 to 1787 and in the open Salons of 1791 and 1793, following the dismantling of the Académie after the Revolution. The dates inscribed on his surviving works span the years 1763 to 1797.[1]

Trinquesse's oeuvre encompasses portraits and interior genre scenes in oil as well as drawings in sanguine relating to these subjects. His assured handling of red chalk, at once hard and lively, is easily recognizable, and though much has been made of the difference between his treatment of male and female subjects, these differences may ultimately have more to do with the function of the sheet than with the gender of the subject. His women are more often depicted full length. Executed in a fluid yet highly controlled manner, they are stylish and elegant, leading some to suggest that the drawings may have been intended as fashion plates.[2] With almond eyes, pointy chins, and tiny waists and hands, the coquettish sitters are difficult to distinguish one from another. A group of eleven counterproofs in the École Nationale Supérieure des Beaux-Arts, Paris, suggests that these images of women as genre vignettes once had male counterparts.[3]

The surviving drawings of men are, by contrast, often bust length, show in the medallion format popularized by Cochin. The same adept handling of red chalk used for the women to create seductive poses and shimmering silks is for the men put to the service of naturalism and psychological characterization. Individual features and signs of aging are faithfully recorded in parallel strokes of red chalk which follow the direction of the forms they contour, seemingly reconstructing the volumes of the face. The Metropolitan's portrait is typical in its near-profile view, eyes focused off to the side, and stylized locks of hair flying back as if lifted by a light wind, the sitter convincingly situated in light, air, and space.[4]

An inscription on the old backing of the drawing identifies the sitter as "Reddy de la Grange, Colonel de Gendarmerie par L Trinquesse." The archives of the Gendarmerie, kept in the Service Historique de l'Armée de Terre de Vincennes (Val-de-Marne), contain records of a François Reidy de Lagrange born October 18, 1749, in Ivoy-Carignan (Ardennes) to a newly aristocratic family. A career soldier, Lagrange held low-level posts in the French army from 1768 to 1786. He seems to have achieved greater standing following the Revolution, as he was made captain of the Gendarmerie in 1791 and chief of his squadron in 1801; he received the Légion d'honneur in 1804.[5] Taken together with his early retirement in 1815, these facts suggest that Lagrange was an ardent Revolutionary who lost his position following the Restoration. In the Metropolitan's drawing, he wears the uniform of the *capitaine commandant de la Gendarmerie, attaché à la Prévôté,* blue with a red plastron and red collar, both with white piping, and a silver epaulet.[6] Presumably Trinquesse drew Reidy de Lagrange between his appointment in 1791 and his departure for the Vendée in 1794. Reidy de Lagrange is an atypical subject for Trinquesse, whose male portraits are largely of artists and architects and, in two cases, ecclesiastical figures. Perhaps Trinquesse, who described his sitter with such sympathetic honesty, had a personal connection to the captain.

P S

PROVENANCE: [Galerie de Bayser et Strolin, Paris]; purchased by The Metropolitan Museum of Art.

LITERATURE: *MMA Annual Report,* 1967–68, p. 87; Jacques Wilhelm, "Les portraits masculins dans l'oeuvre de L.-R. Trinquesse," *Revue de l'Art,* no. 25 (1974), p. 60, fig. 14; Bean and Turčić 1986, p. 256, no. 289 (ill.).

1. The 1763 date appears on a drawing, *Jeune femme jouant du clavecin,* acquired by the Louvre in 1983 (inv. RF 40 467). Before the appearance of this sheet, the earliest dated drawing had been 1771. However, the style of the Louvre sheet is consistent with sheets bearing later dates, calling into question the accuracy of the inscription; see Paris 1990, no. 163.

95

2. Trinquesse's drawings of female models are the primary subject of Jean Cailleux's article, "The Drawings of Louis Roland Trinquesse," *The Burlington Magazine* 116, no. 851 (February 1974), supplement, pp. i–xiv.

3. All depict full-length male figures in casual but affected poses: reading, leaning on a cane, and so forth; École Nationale Supérieure des Beaux-Arts, Paris (inv. 1763–[1–11]).

4. Four other examples of this type are reproduced in Jacques Wilhelm, "Les portraits masculins dans l'oeuvre de L.-R. Trinquesse," *Revue de l'Art*, no. 25 (1974), pp. 55–65, figs. 13, 15, 16, and 17.

5. I am grateful to L'Adjudant-chef Duplan, of the Musée de la Gendarmerie, Melun, for this biographical information (correspondence, June 11, 1996) and to Émilie d'Orgeix for her assistance.

6. The uniform was identified by Émilie d'Orgeix, who pointed out that the Prévôté was the corps of the Gendarmerie assigned to follow the troops, in charge of arresting and punishing deserters.

JEAN-BAPTISTE ISABEY

Nancy 1767–1855 Paris

97. *Portrait of Hubert Robert*

Black crayon, heightened with white gouache, on tan paper, mounted on canvas, 12⅝ x 9½ in. (32.1 x 24.1 cm). Signed or inscribed at lower right: *Isabey*

Roberta J. M. Olson and Alexander B. V. Johnson

This previously unknown drawing may be the prime version of a portrait of Hubert Robert by Jean-Baptiste Isabey known through a 1799 engraving by Simon Charles Miger (1736–1820; fig. 97.1) and at least five drawn versions of the composition.[1] Both its fine quality and the fact that it corresponds most closely in its details to Miger's print support the thesis of its primacy. By extension, the present drawing would logically have been the one recorded in the sitter's collection and described in the inventory taken after the death of his widow as "un dessin au pointillé par M. Isabey, portrait de M. Robert (probablement le portrait gravé par Miger)."[2] Further along in the inventory, one finds that Robert also owned Miger's copperplate and twenty impressions of the print.[3]

Born in Nancy and entering the studio of David shortly before the Revolution, Isabey weathered political change with ease, finding a seemingly limitless market for his fashionable portrait drawings and miniatures. He was honored and patronized by the Napoleonic court and made numerous portraits of Napoleon and Josephine, as well as of Napoleon's second wife, Marie-Louise, and their son, François-Charles-Joseph, king of Rome. With sheets such as this one, Isabey popularized drawings in the *manière noire*, which emulates the dark-to-light appearance of English mezzotint engraving.[4] The stipplelike technique also reflects his work as a miniaturist, though here harnessed to a dark, proto-Romantic aesthetic. In addition to delicate modeling, Isabey creates impressive effects of naturalism with his judicious use of white heightening, selecting such details as the glint at the center of Robert's lower eyelid, the touch of moisture just above the upper lip, and the light reflected off the edges of the paper in the portfolio.

From Isabey's journal, reprinted in part in 1909, we know how the two artists met. Invited to work at the court of Versailles in 1787, Isabey wrote: "From that time dates my intimacy with Robert, painter of landscape, man of talent and resources. I began to work under his direction at the Château de Beauregard, which belonged in those days to the

97.1. Simon Charles Miger, engraving after Jean-Baptiste Isabey (1767–1855), *Hubert Robert, peintre*, 1799. Bibliothèque Nationale, Paris

comte d'Artois."[5] The two must have met again when Isabey was granted lodging at the Louvre in 1798, about the time this drawing was made. Comparing Isabey's portrait of Robert at age sixty-five with two earlier likenesses, both exhibited at the Salon of 1789—the portrait painted by Elisabeth-Louise Vigée Le Brun (Musée du Louvre, Paris) and the bust sculpted by Augustin Pajou (École Nationale Supérieure des Beaux-Arts, Paris, on deposit to the Musée des Beaux-Arts, Valence)—one imagines that Isabey has transcribed in Robert's features not only the ravages of time but also the trials of the Revolution and the Terror, a period marked, for Robert, by a year of incarceration (see no. 96).

P S

PROVENANCE: Private collection, Paris; [David and Constance Yates, New York]; Roberta J. M. Olson and Alexander B. V. Johnson.

Unpublished.

1. Versions can be found in a French private collection; see Catherine Boulot, Jean de Cayeux, and Héléne Moulin, *Hubert Robert et la Révolution,* exh. cat., Le Musée de Valence (Valence, 1989), pp. 162–63, no. 53; the Musée des Beaux-Arts, Orléans; the Musée des

97

Beaux-Arts André-Malraux, Le Havre; and the Minneapolis
Institute of Arts. Another was with Hazlitt, Gooden, & Fox, Ltd.,
London in 1994, and one was sold in Paris at Hôtel Drouot, June 11,
1990 (lot 58), as "attributed to Isabey."

2. Extracts of the inventory, taken on August 18, 1821, are published in
C. Gabillot, *Hubert Robert et son temps* (Paris, [1895]), p. 252, no. 256.

3. Ibid., p. 255, no. 320.

4. See Tony Halliday, "Academic Outsiders at the Paris Salons of the
Revolution: The Case of Drawings *à la manière noire*," *Oxford Art
Journal* 21, no. 1 (1998), pp. 69–86.

5. E. de Basily-Callimaki, *J.-B. Isabey: Sa vie, son temps, 1767–1855*
(Paris, 1909), p. 14.

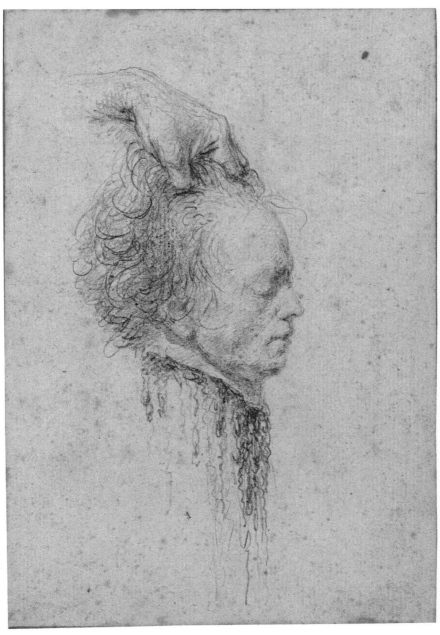

98b

XVI (fig. 98.1),[5] and it is certainly no accident that Denon compared the fall of these two powerful "heads" in this way.[6] Ronald Paulson has devoted a disturbing study to the act of beheading and its significance as a visual metaphor. He characterizes its impact as follows: "Not hanging or shooting or drinking hemlock but a severance of the rational part of the body which had the effect of dehumanization. . . . The public, popular, spectacular, scopophilic qualities were emphasized by the French in the press and in prints." He notes that the mechanical aspect of the guillotine was part of what made it terrifying: "It carried a disquieting implication that the machine would continue to cut off heads, as a pinmaker continues to make pins, as long as it is supplied with bodies."[7] Denon evokes this fear in the startling image, in which the sketches from the present group are reused, of victims clustered beneath a single blade (fig. 98.2). MTH

PROVENANCE: Lady Shelley-Rolls, London; anonymous sale, Christie's, London, December 5, 1961, lot 74; [Colnaghi, London]; purchased by The Metropolitan Museum of Art.

LITERATURE: Alan Wintermute, ed., *1789: French Art During the Revolution,* exh. cat., New York, Colnaghi (New York, 1989), pp. 141–50, no. 15.

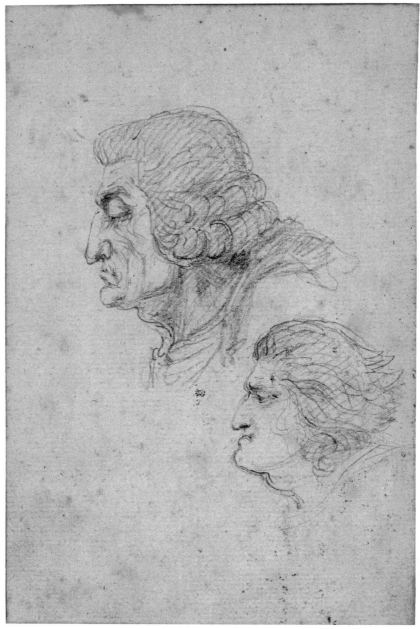

98c

1. Alan Wintermute, ed., *1789: French Art During the Revolution,* exh. cat., New York, Colnaghi (New York, 1989), p. 141. Denon made several of these small Revolutionary portraits, many of which are included in the forthcoming exhibition of his work at the Louvre.

2. Ibid., pp. 142–50.

3. The inscription in pen and brown ink on the verso of the mount reads, "No. 3. Gobel archevèque de Paris— / [et?] Chaumette procureur de la Commune / Sur la Charrette / en Prairial an 2," although the drawing shows no *charrette,* or cart. Each of the drawings in the Metropolitan has an identifying inscription on its verso. Wintermute, *1789: French Art During the Revolution,* p. 149, suggests that they were made by Denon himself, in his role as witness to the events shown.

4. Ibid., pp. 149–50; Baillio 1989, pp. 81–82, under no. 80, and pp. 87–88, under no. 86.

5. Wintermute, *1789: French Art During the Revolution,* pp. 147–48.

6. Ultimately, both derive from images of ancient and Christian martyrs, in particular, those of the beheaded John the Baptist in which the head is presented to Salome by an executioner who grips the head by the hair.

7. Ronald Paulson, "The Severed Head: The Impact of French Revolutionary Caricatures on England," in *French Caricature and the French Revolution, 1789–1799,* exh. cat., Los Angeles, Wight Art Gallery, UCLA; The Grey Art Gallery and Study Center, New York University; Paris, Bibliothèque Nationale; and Vizille, Musée de la Révolution Française (Los Angeles, 1988), p. 58.

FRANÇOIS GÉRARD

Rome 1770–1837 Paris

99. Figure Study for "The Tenth of August, 1792"

Black chalk, 8⅝ x 6¾ in. (22 x 17.1 cm)

Charles Ryskamp

In the decade following the storming of the Bastille, dramatic shifts in the political climate often outpaced the ability of the state to award commissions and the ability of artists to complete them, which explains, in part, the number of large-scale narrative paintings begun and subsequently abandoned during this period. On the other hand, the conceptualization of novel subjects of contemporary history presented new challenges, the results of which are often chronicled in drawings and oil sketches. Many such ambitious but unfulfilled projects originated with the artists' competition that came to be known as the *concours de l'an II*, staged by the Committee of Public Safety at the height of the Terror in 1794 with the express aim of galvanizing the leading talents of the day to depict and glorify the events of the Revolution. The judging of the 140 entries, however, took place later in the year, in a post-Thermidor atmosphere, by a jury including many former academicians.[1]

This sheet is part of the preparatory work for Gérard's entry, a large, highly finished drawing now in the Louvre (fig. 99.1) that depicts one of the defining moments of the Revolutionary period, "the French People Demanding the Overthrow of the Tyrant on the Tenth of August, 1792," and for which Gérard was awarded first place (shared with Vincent), studio space in the Louvre, and a commission to produce a finished painting. Because of a number of factors—changing political tides chief among them—the life-size canvas was never completed.

The composition submitted by Gérard distills the events of August 10, 1792, into a powerful tableau that merges realism, classicism, and dramatic theatrical lighting. Having first stormed the Palais des Tuileries, the Revolutionaries enter the National Assembly to demand the deposition of the monarchy. Brandishing weapons, Phrygian caps, and banners bearing the slogans *Plus de Roi* and *Patrie, Egalité, Liberté*, they point angrily to the reporter's box, where Louis XVI and Marie-Antoinette have taken refuge. By day's end, four hundred insurgents and six hundred National Guard and Swiss Guard were dead, making it one of the bloodiest episodes of the Revolution. The foreground detail of caskets of jewels, suggesting the immorally gained riches of the royal family,

reinforces the clear distinction in Gérard's composition between good and evil. More ambiguous is the status of the deputies, some of whom seem to welcome the intruders while others cower and glare. The Ryskamp drawing is a study for the foreground deputy, with coat open to reveal his culottes, his passive pose in contrast to the active gestures of the sans-culottes who have forcefully entered the room.

At the time of the *concours*, Gérard was twenty-four, a precocious and favored student of David. His entry seems to have been consciously intended to form a pendant, in both subject and format, to David's projected painting *The Oath of the Tennis Court*.[2] One can also see Gérard's debt to David in the method of preparation. Individual figures are studied in brusque black-chalk sketches, not so much for details of dress or facial features but to test whether the poses effectively convey the inner state of the characters.[3] In the present example, Gérard made two small adjustments between the chalk sketch and the presentation drawing: he added a crumpled paper (or handkerchief?) to the man's right hand, and he altered his face from that of a younger man, with his expression lost in shadow, to that of an older man whose well-lit features betray a fearful cringing.

PS

99.1. François Gérard, *The Tenth of August, 1792*, 1794–95. Pen and brown ink, brush and brown wash, heightened with white, 26¼ x 36⅛ in. (66.8 x 91.7 cm). Musée du Louvre, Paris

99

PROVENANCE: Collection of the artist; by descent in his family; [Colnaghi, New York, in 1982]; Charles Ryskamp.

LITERATURE: Alan Wintermute, ed., *1789: French Art During the Revolution,* exh. cat., New York, Colnaghi (New York, 1989), pp. 219–25, no. 31B (entry by J. Patrice Marandel).

1. See Udolpho van de Sandt, "Institutions et concours," in Philippe Bordes and Régis Michel, eds., *Aux armes et aux arts!: Les arts de la Révolution 1789–1799* (Paris, 1988), pp. 138–65; William Olander, "French Painting and Politics in 1794: The Great *Concours de l'an II,*" in Alan Wintermute, ed., *1789: French Art During the Revolution,* exh. cat., New York, Colnaghi (New York, 1989), pp. 29–45; Régis Michel, *Le beau idéal, ou l'art du concept,* exh. cat., Paris, Musée du Louvre (Paris, 1989), pp. 122–25; and Crow 1995, pp. 195–200.

2. Never completed, the composition is known today from a drawing in the Musée National des Châteaux de Versailles et de Trianon, on deposit from the Musée du Louvre, Paris (inv. RF 1914; MV 8409).

3. Two comparable sheets have been published in Marandel 1975, p. 36. The verso of one of those sheets (now Fogg Art Museum, Harvard University Art Museums, Loan from the Collection of Jeffrey E. Horvitz) has an additional sketch which is illustrated in Nicolas Joly, *Dessins et tableaux de maîtres avec la participation du Musée Pouchkine,* XVe Biennale Internationale des Antiquaires, exh. cat., Paris, Grand Palais (Paris, [1990]), p. 59, no. 27.

JEAN-BAPTISTE GREUZE

Tournus 1725–1805 Paris

100. Portrait of Baptiste Aîné

Pastel on cream paper, the original sheet, 16½ x 13¼ in. (41.9 x 33.7 cm), affixed to a larger sheet, 17¾ x 14¾ in. (45.1 x 37.5 cm)

The Frick Collection, Purchased with Funds Bequeathed in Memory of Suzanne and Denise Falk (96.3.126)

Less affected by the critical vagaries that have periodically undermined the reputation of the rest of his oeuvre, Greuze's portraits have long been admired and even compared favorably to those of artists specializing in the genre.[1] This portrait of the actor Baptiste Aîné and its pendant of his wife, *Mme Baptiste Aîné* (fig. 100.1), were not well known, or even reproduced, before they were acquired by the Frick Collection from a South American private collection in 1996. Stellar examples of Greuze's late style, they differ from the majority of his portraits in his choice of pastel as the medium. Like the late pastels of Chardin, the Frick portraits employ an open technique of visible lines and contrasting colors, with highlights left unblended. Since his earliest painted portraits, whose disarming naturalism and naïveté elicited praise in some viewers and consternation in others, Greuze had evolved considerably as a portraitist over four decades. In his treatment of Baptiste Aîné and his wife, Greuze no longer displays any interest in the minutiae of physiognomy. Close detail is replaced by a more open facture, a melting appearance in the service of unity and idealization, but at no cost to the depiction of character and inner spirit.

Edgar Munhall has produced a vivid portrait of Baptiste Aîné, an actor with the Comédie Française, whose ties with the artistic community are suggested by his inclusion in

100.1. Jean-Baptiste Greuze, *Mme Baptiste Aîné.* Pastel, 18 x 14⅝ in. (45.7 x 37.1 cm). The Frick Collection, New York

100

Louis-Léopold Boilly's *Gathering of Artists in Isabey's Studio,* of 1798 (Musée du Louvre, Paris).[2] Nicolas-Pierre Baptiste Anselme, called Baptiste Aîné (1761–1835), was born to a family of actors in Bordeaux and went on to pursue a successful career, performing, as did his wife, Anne-Françoise Gourville, in a number of Parisian theatrical companies. Based on evidence of costume, Munhall suggests a date of about 1798–1800 for the pair, proposing a possible link between the commission and Baptiste Aîné's joining the Comédie Française in 1799.

Greuze does not present the actor as either plying his trade or with its associated attributes. Set against an airy, pale blue background, Baptiste appears to be outdoors, illuminated by natural light, his white stock billowing in the breeze.

<div align="right">P S</div>

PROVENANCE: L. Godard, Paris, 1860; Senator Antonio Santamarina, Buenos Aires, acquired about 1950–52 in Paris, until 1974; bequeathed to his son Miguel M. Santamarina, Buenos Aires; The Frick Collection.

LITERATURE: Ph. Burty, ed., *Catalogue de tableaux et dessins de l'école française principalement du XVIIIe siècle*, exh. cat., Paris, Association des Artistes (Paris, 1860), no. 315; J[ean] Martin and Ch[arles] Masson, *Catalogue raisonné de l'oeuvre peint et dessiné de Jean-Baptiste Greuze*, in Camille Mauclair, *Jean-Baptiste Greuze* (Paris, [1905]), p. 66, no. 1067 (dimensions incorrectly given as 57 x 45 cm).

1. See, for example, entries on the portraits of François Babuti (no. 26) and Johann Georg Wille (no. 39) in Munhall 1976.
2. Munhall's research will be presented in the forthcoming vol. 9 of *The Frick Collection, An Illustrated Catalogue* (New York, 1968–). The present entry draws heavily on his work, which he kindly shared with me in advance of the catalogue's publication.

REFERENCES
INDEX OF ARTISTS

References Cited in Abbreviated Form

Ananoff 1961–70

Alexandre Ananoff. *L'oeuvre dessiné de Jean-Honoré Fragonard (1732–1806): Catalogue raisonné.* 4 vols. Paris, 1961–70.

Ananoff 1966

Alexandre Ananoff. *L'oeuvre dessiné de François Boucher (1703–1770): Catalogue raisonné.* Vol. 1. Paris, 1966.

Ananoff 1976

Alexandre Ananoff. *François Boucher.* 2 vols. Lausanne and Paris, 1976.

Bailey 1992

Colin B. Bailey et al. *The Loves of the Gods: Mythological Painting from Watteau to David.* Exh. cat., Paris, Galeries Nationales du Grand Palais, October 15, 1991–January 6, 1992; Philadelphia Museum of Art, February 23–April 26, 1992; Fort Worth, Kimbell Art Museum, May 23–August 2, 1992. New York, 1992.

Baillio 1982

Joseph Baillio. *Elisabeth Louise Vigée Le Brun, 1755–1842.* Exh. cat., Fort Worth, Kimbell Art Museum, June 5–August 8, 1982. Fort Worth, 1982.

Baillio 1989

Joseph Baillio. *The Winds of Revolution.* Exh. cat., New York, Wildenstein, November 14–December 28, 1989. New York, 1989.

Baltimore, Boston, and Minneapolis 1984

Victor I. Carlson and John W. Ittmann et al. *Regency to Empire: French Printmaking 1715–1814.* Exh. cat., The Baltimore Museum of Art, November 10, 1984–January 6, 1985; Boston, Museum of Fine Arts, February 6–March 31, 1985; The Minneapolis Institute of Arts, April 27–June 23, 1985. Minneapolis, 1984.

Bean 1964

Jacob Bean. *100 European Drawings in the Metropolitan Museum of Art.* New York, [1964].

Bean 1972

[Jacob Bean]. *Drawings Recently Acquired, 1969–1971.* Exh. cat., The Metropolitan Museum of Art, January 18–April 16, 1972. [New York, 1972].

Bean 1975

Jacob Bean. *European Drawings Recently Acquired, 1972–1975.* Exh. cat., The Metropolitan Museum of Art, October 7, 1975–January 4, 1976. [New York, 1975].

Bean and Turčić 1986

Jacob Bean, with the assistance of Lawrence Turčić. *15th–18th Century French Drawings in the Metropolitan Museum of Art.* New York, 1986.

Berckenhagen 1970

Ekhart Berckenhagen. *Die französischen Zeichnungen der Kunstbibliothek Berlin.* Staatliche Museen Preussischer Kulturbesitz. Berlin, 1970.

Bjurström 1982

Per Bjurström. *French Drawings, Eighteenth Century.* Drawings in Swedish Public Collections, 4. Stockholm, 1982.

Bocher 1882

Emmanuel Bocher. *Jean-Michel Moreau le jeune.* Les gravures françaises du XVIIIe siècle. Paris, 1882.

Bordeaux 1974

Jean-Luc Bordeaux. "François Le Moyne's Painted Ceiling in the 'Salon d'Hercule' at Versailles, a Long Overdue Study." *Gazette des Beaux-Arts,* ser. 6, 83 (May–June 1974), pp. 301–18.

Bordeaux 1984

Jean-Luc Bordeaux. *François Le Moyne and His Generation, 1688–1737.* Neuilly-sur-Seine, 1984.

Carlson 1978

Victor Carlson. *Hubert Robert: Drawings and Watercolors.* Exh. cat., Washington, D.C., National Gallery of Art, November 19, 1978–January 21, 1979. Washington, D.C., 1978.

Cholet 1973

Jean-François Méjanès et al. *Pierre-Charles Trémolières (Cholet, 1703–Paris 1739).* Exh. cat., Musée de Cholet, June 29–September 30, 1973. [Cholet, 1973].

Compin and Roquebert 1986

Isabelle Compin and Anne Roquebert. *Catalogue sommaire illustré des peintures du Musée du Louvre et du Musée d'Orsay.* [Vols. 3–5.] *École française.* Paris, 1986.

Cormack 1970

Malcolm Cormack. *The Drawings of Watteau.* London, New York, Sydney, Toronto, 1970.

Crow 1985

Thomas E. Crow. *Painters and Public Life in Eighteenth-Century Paris.* New Haven and London, 1985.

Crow 1995

Thomas [E.] Crow. *Emulation: Making Artists for Revolutionary France.* New Haven and London, 1995.

Cuzin 1988

Jean-Pierre Cuzin. *Jean-Honoré Fragonard, Life and Work: Complete Catalogue of the Oil Paintings.* New York, 1988.

Dacier 1909–21

Émile Dacier. *Catalogues de ventes et livrets de Salons illustrés par Gabriel de Saint-Aubin.* 6 vols. Paris, 1909–21.

Dacier 1929–31
Émile Dacier. *Gabriel de Saint-Aubin: Peintre, dessinateur et graveur (1724–1780)*. 2 vols. Paris and Brussels, 1929–31.

Dacier, Hérold, and Vuaflart 1921–29
Émile Dacier, Jacques Hérold, and Albert Vuaflart. *Jean de Jullienne et les graveurs de Watteau au XVIIIe siècle*. 4 vols. Paris, 1921–29.

Dayton 1971
Jane van Nuis Cahill. *French Artists in Italy, 1600–1900*. Exh. cat., Dayton Art Institute, October 15–November 28, [1971]. [Dayton, Ohio, 1971].

Denison 1993
Cara Dufour Denison. *French Master Drawings from the Pierpont Morgan Library*. Exh. cat., Paris, Musée du Louvre, June 1–August 30, 1993; New York, The Pierpont Morgan Library, September 15, 1993–January 2, 1994. New York, 1993.

Denison 1995
Cara Dufour Denison et al. *Fantasy and Reality: Drawings from the Sunny Crawford von Bülow Collection*. Exh. cat., New York, The Pierpont Morgan Library, September 14, 1995–January 7, 1996. New York, 1995.

Dimier 1928–30
Louis Dimier, ed. *Les peintres français du XVIIIe siècle: Histoire des vies et catalogue des oeuvres*. 2 vols. Paris and Brussels, 1928–30.

Duclaux 1991
Lise Duclaux. *Charles Natoire 1700–1777*. Cahiers du Dessin Français, no. 8. Paris, 1991.

Dussieux 1854
Louis Dussieux et al., *Mémoires inédits sur la vie et les ouvrages des membres de l'Académie Royale de Peinture et de Sculpture*. Vol. 2. Paris, 1854.

Eidelberg 1967
Martin P. Eidelberg. "Watteau's Use of Landscape Drawings." *Master Drawings* 5, no. 2 (1967), pp. 173–82, pls. 29–33.

Faré and Faré 1976
Michel and Fabrice Faré. *La vie silencieuse en France: La nature morte au XVIIIe siècle*. Fribourg, 1976.

Frankfurt am Main 1986
Hildegard Bauereisen and Margret Stuffmann. *Französische Zeichnungen im Städelschen Kunstinstitut, 1550 bis 1800*. Exh. cat., Frankfurt am Main, Städtische Galerie im Städelschen Kunstinstitut, November 14, 1986–March 1, 1987. Frankfurt am Main, 1986.

Gaehtgens and Lugand 1988
Thomas W. Gaehtgens and Jacques Lugand. *Joseph-Marie Vien, peintre du roi (1716–1809)*. Paris, 1988.

Garnier 1989
Nicole Garnier. *Antoine Coypel (1661–1722)*. Paris, 1989.

Gillies and Ives 1972
Linda Boyer Gillies and Colta Feller Ives. *French Drawings and Prints of the Eighteenth Century*. Exh. cat., The Metropolitan Museum of Art, August 8–October 15, 1972. New York, 1972.

Goncourt 1875
Edmond de Goncourt. *Catalogue raisonné de l'oeuvre peint, dessiné et gravé d'Antoine Watteau*. Paris, 1875.

Goncourt 1880–82
Edmond and Jules de Goncourt. *L'art du dix-huitième siècle*. 3d ed. 2 vols. Paris, 1880–82.

Goodman 1995a
John Goodman. "Jansenism, Parlementaire Politics, and Dissidence in the Art World of Eighteenth-Century Paris: The Case of the Restout Family." *Oxford Art Journal* 18, no. 1 (1995), pp. 74–95.

Goodman 1995b
John Goodman, ed. *Diderot on Art*. 2 vols. New Haven and London, 1995.

Grasselli 1986
Margaret Morgan Grasselli. "Eleven New Drawings by Nicolas Lancret." *Master Drawings* 23–24, no. 3 (Autumn 1986), pp. 377–89.

Grasselli 1987a
Margaret Morgan Grasselli. *The Drawings of Antoine Watteau: Stylistic Development and Problems of Chronology*. 3 vols. Ph.D. diss., Harvard University, 1987.

Grasselli 1987b
Margaret Morgan Grasselli. "New Observations on Some Watteau Drawings." In *Antoine Watteau (1684–1721): Le peintre, son temps et sa légende*, edited by François Moureau and Margaret Morgan Grasselli, pp. 95–101. Geneva and Paris, 1987.

Grasselli 1987c
Margaret Morgan Grasselli. "Watteau's Use of the Trois-Crayons Technique." In Konrad Oberhuber et al., *Drawings Defined*, edited by Walter Strauss and Tracie Felker, pp. 181–94. New York, 1987.

Grasselli 1994a
Margaret Morgan Grasselli. "A Curious Link Between Watteau and La Fosse." *The Watteau Society Bulletin* 3 (1994), pp. 9–13.

Grasselli 1994b
Margaret Morgan Grasselli. "News: U.S.A." *The Watteau Society Bulletin* 3 (1994), pp. 51–60.

Grasselli 1996

Margaret Morgan Grasselli. "Landscape Drawings by François Le Moyne, Some Old, Some New." *Master Drawings* 34, no. 4 (Winter 1996), pp. 365–74.

Grasselli and Rosenberg 1984

Margaret Morgan Grasselli and Pierre Rosenberg, with the assistance of Nicole Parmantier. *Watteau, 1684–1721*. Exh. cat., Washington, D.C., National Gallery of Art, June 17–September 23, 1984; Paris, Galeries Nationales du Grand Palais, October 23, 1984–January 28, 1985; Berlin, Schloss Charlottenburg, February 22–May 26, 1985. Paris, 1984.

Haverkamp-Begemann and Logan 1988

Egbert Haverkamp-Begemann and Carolyn Logan. *Creative Copies: Interpretative Drawings from Michelangelo to Picasso*. Exh. cat., New York, The Drawing Center, April 9–July 23, 1988. New York, 1988.

Holmes 1991

Mary Tavener Holmes. *Nicolas Lancret 1690–1743*. Exh. cat., New York, The Frick Collection, November 19, 1991–January 12, 1992; Fort Worth, Kimbell Art Museum, February 15–April 12, 1992. New York, 1991.

Hulton 1980

Paul Hulton. *Watteau Drawings in the British Museum*. London, 1980.

Hunter-Stiebel 1987

Penelope Hunter-Stiebel. *Chez Elle, Chez Lui: At Home in 18th-Century France*. Exh. cat., New York, Rosenberg & Stiebel, April 23–June 13, 1987. New York, 1987.

Jacoby 1986

Beverly Schreiber Jacoby. *François Boucher's Early Development as a Draughtsman, 1720–1734*. Outstanding Dissertations in the Fine Arts. New York and London, 1986.

Jacoby 1992

Beverly Schreiber Jacoby. "Boucher's Late Brown Chalk Composition Drawings." *Master Drawings* 30, no. 3 (Autumn 1992), pp. 255–86.

Jean-Richard 1978

Pierrette Jean-Richard. *L'oeuvre gravé de François Boucher dans la collection Edmond de Rothschild*. Musée du Louvre, Cabinet des Dessins, Collection Edmond de Rothschild, Inventaire général des gravures: École française, 1. Paris, 1978.

Jean-Richard 1985

Pierrette Jean-Richard. *Graveurs français de la seconde moitié du XVIIIe siècle*. XIIIe exposition de la collection Edmond de Rothschild. Exh. cat., Paris, Musée du Louvre, February 14–May 6, 1985. Paris, 1985.

Lamers 1995

Petra Lamers. *Il viaggio nel sud dell'abbé de Saint-Non: Il "Voyage pittoresque à Naples et en Sicile": La genesi, i disegni preparatori, le incisioni*. Naples, 1995.

Launay 1991

Élisabeth Launay. *Les frères Goncourt, collectionneurs de dessins*. Paris, 1991.

Lefrançois 1994

Thierry Lefrançois. *Charles Coypel, peintre du roi (1694–1752)*. Paris, 1994.

Locquin 1912

Jean Locquin. "Catalogue raisonné de l'oeuvre de Jean-Baptiste Oudry, peintre du roi (1686–1755)." *Archives de l'Art Français*, n.s. 6 (1912), pp. i–viii, 1–209.

London 1932

W. G. Constable et al. *Exhibition of French Art, 1200–1900*. Exh. cat., London, Royal Academy of Arts, January 4–March 12, 1932. London, 1932.

London 1968

Denys Sutton. *France in the Eighteenth Century*. Exh. cat., London, Royal Academy of Arts, January 6–March 3, 1968. 2d, rev. ed. London, 1968.

Los Angeles, Philadelphia, and Minneapolis 1993

Richard J. Campbell and Victor Carlson. *Visions of Antiquity: Neoclassical Figure Drawings*. Exh. cat., Los Angeles County Museum of Art, July 22–September 19, 1993; Philadelphia Museum of Art, October 30, 1993–January 2, 1994; The Minneapolis Institute of Arts, February 6–April 3, 1994. Los Angeles, 1993.

Marandel 1975

J. Patrice Marandel. *French Oil Sketches from an English Collection: Seventeenth, Eighteenth, and Nineteenth Centuries*. Exh. cat., Houston, Museum of Fine Arts and elsewhere, 1973–75. Houston, 1975.

Mariette 1851–60

P[ierre] J[ean] Mariette. *Abécédario de P. J. Mariette et autres notes inédites de cet amateur sur les arts et les artistes*. Edited by Ph. de Chennevières and A[natole] de Montaiglon. 6 vols. Paris, 1851–60.

Martin 1908

Jean Martin. *Catalogue raisonné de l'oeuvre peint et dessiné de Jean-Baptiste Greuze, suivi de la liste ses gravures exécutées d'après des ouvrages*. Paris, 1908.

McCullagh 1996

Suzanne Folds McCullagh. "Gabriel de Saint-Aubin's Debt to Antoine Watteau and François Boucher." In *Correspondances: Festschrift für Margret Stuffmann zum 24. November 1996*, edited by Hildegard Bauereisen and Martin Sonnabend, pp. 125–34. Mainz, 1996.

Metz 1988

Jean-Baptiste Le Prince. Exh. cat., Metz, Musée d'Art et d'Histoire, July 1–September 26, 1988. Metz, 1988.

Middletown and Baltimore 1975

Victor Carlson, Ellen D'Oench and Richard S. Field. *Prints and Drawings by Gabriel de Saint-Aubin, 1724–1780*. Exh. cat.,

Middletown, Conn., Davison Art Center, Wesleyan University, March 7–April 13, 1975; Baltimore Museum of Art, April 25–June 8, 1975. [Middletown, Conn., 1975].

MMA Annual Report
The Metropolitan Museum of Art. *Annual Report of the Trustees*. New York, 1871– .

MMA Notable Acquisitions
The Metropolitan Museum of Art. *Notable Acquisitions*. New York, 1975–85.

MMA Recent Acquisitions
The Metropolitan Museum of Art. *Recent Acquisitions: A Selection*. New York, 1986– . From 1989 *Recent Acquisitions* has been published as the Fall issue of *The Metropolitan Museum of Art Bulletin*.

Montaiglon and Guiffrey 1887–1912
Anatole de Montaiglon and Jules Guiffrey, eds. *Correspondance des directeurs de l'Académie de France à Rome avec les surintendants des Bâtiments, publiée d'après les manuscrits des Archives Nationales*. 18 vols. Paris, 1887–1912.

Moscow and Saint Petersburg 1998
Cara Dufour Denison. *Risunki frantsuzskikh masterov iz Biblioteki Morgana, N'iu-Iork*. [French Master Drawings from the Morgan Library, New York]. Exh. cat., Moscow, Pushkin State Museum of Fine Arts, March 2–May 10, 1998; Saint Petersburg, The State Hermitage Museum, May 28–July 26, 1998. New York, 1998.

Musée du Louvre 1907–
Jean Guiffrey and Pierre Marcel et al. *Inventaire général des dessins du Musée du Louvre et du Musée de Versailles: École française*. 13 vols. Paris, 1907– .

Myers 1992
Mary L. Myers. *French Architectural and Ornament Drawings of the Eighteenth Century*. Exh. cat., The Metropolitan Museum of Art, December 10, 1991–March 15, 1992. New York, 1992.

Munhall 1976
Edgar Munhall. *Jean-Baptiste Greuze, 1725–1805*. Exh. cat., Hartford, Wadsworth Atheneum, December 1, 1976–January 23, 1977; San Francisco, The California Palace of the Legion of Honor, March 5–May 1, 1977; Dijon, Musée des Beaux-Arts, June 4–July 31, 1977. Hartford, 1976.

New York, Detroit, and Paris 1986
Alastair Laing et al. *François Boucher, 1703–1770*. Exh. cat., The Metropolitan Museum of Art, February 17–May 4, 1986; The Detroit Institute of Arts, May 27–August 17, 1986; Paris, Grand Palais, September 19, 1986–January 5, 1987. New York, 1986.

New York and Montreal 1993
Cara D. Denison, Myra Nan Rosenfeld, and Stephanie Wiles. *Exploring Rome: Piranesi and His Contemporaries*. Exh. cat., New York, The Pierpont Morgan Library, September 12–November 6, 1989; Montreal, Canadian Centre for Architecture, August 17, 1993–January 2, 1994. New York, 1993.

Oberhuber and Jacoby 1980
Konrad Oberhuber and Beverly Schreiber Jacoby. *French Drawings from a Private Collection: Louis XIII to Louis XVI*. Exh. cat., Cambridge, Mass., Fogg Art Museum, Harvard University Art Museums, 1980. Cambridge, Mass., 1980.

Opperman 1966
H[al] N. Opperman. "Some Animal Drawings by Jean-Baptiste Oudry." *Master Drawings* 4, no. 4 (1966), pp. 384–409, pls. 14–25.

Opperman 1977
Hal N. Opperman. *Jean-Baptiste Oudry*. 2 vols. Outstanding Dissertations in the Fine Arts. New York and London, 1977.

Opperman 1982
Hal [N.] Opperman. *J.-B. Oudry, 1686–1755*. Exh. cat., Paris, Galeries Nationales du Grand Palais, October 1, 1982–January 3, 1983. Paris, 1982.

Opperman 1983
Hal [N.] Opperman. *J.-B. Oudry, 1686–1755*. Exh. cat., Fort Worth, Kimbell Art Museum, February 26–June 5, 1983; Kansas City, The Nelson-Atkins Museum of Art, July 15–September 4, 1983. Fort Worth, 1983.

Paris 1984a
Acquisitions du Cabinet des Dessins 1973–1983. Exh. cat., Paris, Musée du Louvre, March 16–June 4, 1984. Paris, 1984.

Paris 1984b
Marie-Catherine Sahut and Nathalie Volle. *Diderot et l'art de Boucher à David: Les Salons, 1759–1781*. Exh. cat., Paris, Hôtel de la Monnaie, October 5, 1984–January 6, 1985. Paris, 1984.

Paris 1989
Maîtres français 1550–1800: Dessins de la donation Mathias Polakovits à l'École des Beaux-Arts. Exh. cat., Paris, École Nationale Supérieure des Beaux-Arts, April 19–June 25, 1989. Paris, 1989.

Paris 1990
Acquisitions 1984–1989. Exh. cat., Paris, Musée du Louvre, May 31–August 27, 1990. Paris, 1990.

Paris 1992
José–Luis de Los Llanos. *Fragonard et le dessin français au XVIIIe siècle dans les collections du Petit Palais*. Exh. cat., Paris, Musée du Petit Palais, October 16, 1992–February 14, 1993. Paris, 1992.

Paris 1994
Régis Michel et al. *La chimère de Monsieur Desprez*. Exh. cat., Paris, Musée du Louvre, February 10–May 2, 1994. Paris, 1994.

Paris and Versailles 1989
Jacques-Louis David, 1748–1825. Exh. cat., Paris, Musée du Louvre, and Versailles, Musée National du Château, October 26, 1989–February 12, 1990. Paris, 1989.

Parker and Mathey 1957
K. T. Parker and J. Mathey. *Antoine Watteau: Catalogue complet de son oeuvre dessiné*. 2 vols. Paris, 1957.

Posner 1984

Donald Posner. *Antoine Watteau*. Ithaca, 1984.

Ramade 1985

Patrick Ramade. *Jean-Germain Drouais*. Exh. cat., Rennes, Musée des Beaux-Arts, June 7–September 9, 1985. Rennes, 1985.

Raux 1995

Sophie Raux. *Catalogue des dessins français du XVIIIe siècle de Claude Gillot à Hubert Robert: Palais des Beaux-Arts, Lille*. Paris, 1995.

Roland Michel 1984

Marianne Roland Michel. *Lajoüe et l'art rocaille*. Neuilly-sur-Seine, 1984.

Roland Michel 1986

Marianne Roland Michel. *Artistes en voyage au XVIIIe siècle*. Exh. cat., Paris, Galerie Cailleux, May 20–July 5, 1986; Geneva, Galerie Cailleux, October–November, 1986. Paris, [1986].

Roland Michel 1987

Marianne Roland Michel. *Le dessin français au XVIIIe siècle*. Paris, 1987.

Roland Michel 1991

Marianne Roland Michel. *Le rouge et le noir: Cent dessins français de 1700 à 1850*. Exh. cat., Paris, Galerie Cailleux, October 1– November 9, 1991. Paris, 1991.

Rome 1990

J. H. Fragonard e H. Robert a Roma. Exh. cat., Rome, Villa Medici, December 6, 1990–February 24, 1991. Rome, 1990.

Rosenberg 1972

Pierre Rosenberg. *French Master Drawings of the 17th and 18th Centuries in North American Collections*. Exh. cat., Toronto, Art Gallery of Ontario, September 2–October 15, 1972; Ottawa, The National Gallery of Canada, November 3–December 17, 1972; San Francisco, The California Palace of the Legion of Honor, January 12–March 11, 1973; The New York Cultural Center, April 4–May 6, 1973. London, 1972.

Rosenberg 1988

Pierre Rosenberg. *Fragonard*. Exh. cat., Paris, Galeries Nationales du Grand Palais, September 24, 1987–January 4, 1988; The Metropolitan Museum of Art, February 2–May 8, 1988. New York, 1988.

Rosenberg 1990

Pierre Rosenberg. *Masterful Studies: Three Centuries of French Drawings from the Prat Collection*. Exh. cat., New York, National Academy of Design, November 13, 1990–January 20, 1991; Fort Worth, Kimbell Art Museum, February 11–April 21, 1991; Ottawa, National Gallery of Canada, July 1–August 25, 1991. New York, 1990.

Rosenberg 1995

Pierre Rosenberg. *Dessins français de la collection Prat XVIIe–XVIIIe–XIX siècles*. Exh. cat., Paris, Musée du Louvre, April 26–July 24, 1995; Edinburgh, National Gallery of Scotland, August 17–October 1, 1995; Oxford, Ashmolean Museum, October 15–December 15, 1995. Paris, 1995.

Rosenberg and Brejon de Lavergnée 1986

Pierre Rosenberg and Barbara Brejon de Lavergnée. *Saint-Non–Fragonard: Panopticon italiano, un diario di viaggio ritrovato, 1759–1761*. Rome, 1986.

Rosenberg and Prat 1996

Pierre Rosenberg and Louis-Antoine Prat. *Antoine Watteau, 1684–1721: Catalogue raisonné des dessins*. 3 vols. Milan, 1996.

Rosenberg and Sahut 1977

Pierre Rosenberg and Marie-Catherine Sahut. *Carle Vanloo, premier peintre du roi (Nice, 1705–Paris, 1765)*. Exh. cat., Nice, Musée Chéret, January 21–March 13, 1977; Clermont-Ferrand, Musée Bargoin, April 1–May 30, 1977; Nancy, Musée des Beaux-Arts, June 18–August 15, 1977. N.p., n.d.

Rotterdam, Paris, and New York 1959

French Drawings from American Collections, Clouet to Matisse. Exh. cat., Rotterdam, Museum Boymans-van Beuningen; Paris, Musée de l'Orangerie; The Metropolitan Museum of Art, 1958–59. New York, 1959.

Salmon 1996

Xavier Salmon. *Jacques-André Portail 1695–1759*. Cahiers du Dessin Français, no. 10. Paris, 1996.

Salmon 1997

Xavier Salmon. "The Drawings of Jean-Marc Nattier: Identifying the Master's Hand." *Apollo* 146, no. 429 (November 1997), pp. 3–11.

Sandoz 1977

Marc Sandoz. *Jean-Baptiste Deshays, 1729–1765*. Paris, 1977.

Schnapper 1974

Antoine Schnapper. *Jean Jouvenet, 1644–1717, et la peinture d'histoire à Paris*. Paris, 1974.

Scott 1995

Katie Scott. *The Rococo Interior: Decoration and Social Spaces in Early Eighteenth-Century Paris*. New Haven and London, 1995.

Seznec and Adhémar 1975–83

Jean Seznec and Jean Adhémar, eds. *Diderot Salons*. 2d ed. 3 vols. Oxford, 1975–83.

Slatkin 1973

Regina Shoolman Slatkin. *François Boucher in North American Collections: 100 Drawings*. Exh. cat., Washington, D.C., National Gallery of Art, December 23, 1973–March 17, 1974; The Art Institute of Chicago, April 4–May 12, 1974. Washington, D.C., [1973].

Storrs 1973

Frederick den Broeder. *The Academy of Europe: Rome in the 18th Century*. Exh. cat., Storrs, Conn., The William Benton Museum of Art, The University of Connecticut, Storrs, October 13–November 21, 1973. Storrs, Conn., [1973].

Tokyo and Kumamoto 1982

Denys Sutton. *François Boucher (1703–1770)*. Exh. cat., Tokyo Metropolitan Art Museum, April 24–June 23, 1982; Kumamoto Prefectural Museum of Art, July 3–August 22, 1982. Tokyo, 1982.

Troyes, Nîmes, and Rome 1977

Charles-Joseph Natoire (Nîmes, 1700–Castel Gandolfo, 1777): Peintures, dessins, estampes et tapisseries des collections publiques françaises. Exh. cat., Troyes, Musée des Beaux-Arts; Nîmes, Musée des Beaux-Arts; Rome, Villa Medicis, March–June 1977. Nantes, 1977.

Virch 1962

Claus Virch. *Master Drawings in the Collection of Walter C. Baker*. [New York], 1962.

Williams 1978

Eunice Williams. *Drawings by Fragonard in North American Collections*. Exh. cat., Washington, D.C., National Gallery of Art, November 19, 1978–January 21, 1979; Cambridge, Mass., Fogg Art Museum, Harvard University Art Museums, February 16–April 1, 1979; New York, The Frick Collection, April 20–June 3, 1979. Washington, D.C., 1978.

Yavchitz-Koehler 1987

Sylvie Yavchitz-Koehler. "Un dessin d'Hubert Robert: 'Le salon du bailli de Breteuil à Rome.'" *La Revue du Louvre et des Musées de France* 37, no. 5/6 (1987), pp. 369–78.

Index of Artists